RUTGERS FOUNDING DATES

Rutgers, The State University of N

 Rutgers University (192

 Rutgers College

 Queen's (1766)

Rutgers University–New Brunswick

School of Arts and Sciences (2006)

 Faculty of Arts and Sciences (1981)

Douglass Residential College (2006)

 Douglass College (1955)

 New Jersey College for Women (1918)

 Livingston College (1969)

 Rutgers College (1825)

 Queen's College (1766)

University College Community (2006)

 University College–New Brunswick (1934)

School of Environmental and Biological Sciences (2006)

 Cook College (1973)

 College of Agriculture (1921)

 Rutgers Scientific School (1864)

 New Jersey Agricultural Experiment Station (1880)

Mason Gross School of the Arts (1979)

 School for Creative and Performing Arts (1976)

School of Communication and Information (2009)

 School of Communication, Information and Library Studies (1982)

 Graduate School of Library and Information Studies (1978)

 Graduate School of Library Service (1954)

School of Engineering (1999)

 College of Engineering (1914)

 Rutgers Scientific School (1864)

Edward J. Bloustein School of Planning and Public Policy (1992)

School of Management and Labor Relations (1994)

 Institute for Management and Labor Relations (1947)

Graduate School–New Brunswick (1952)

Graduate School of Applied and Professional Psychology (1974)

Graduate School of Education (1923)

School of Social Work (1954)

Rutgers Biomedical and Health Sciences (Established 2013)

Ernest Mario School of Pharmacy (2002)

 Rutgers College of Pharmacy (1927)

 New Jersey College of Pharmacy (1892)

Graduate School of Biomedical Sciences (1956)

New Jersey Medical School (1970)

 New Jersey College of Medicine and Dentistry (1965)

 Seton Hall College of Medicine and Dentistry (1956)

Robert Wood Johnson Medical School (1986) (Part of Rutgers from 1961 to 1971, Rejoined Rutgers 2013)

(continued on inside back cover)

STONE 3¼" 2½"

STONE SILL

PLAN & ELEVATION
OF FIRE PLACE

6" DIA. AT BASE
3½" DIA. AT NECK

BALUSTRADE
FULL SIZE.

NEWEL
1¼" SQ. AT NECK
2⅛" SQ. AT BASE

FLOOR LINE

FIRST FLR. LEVEL

PART ELEVATIONS
OF ORIGINAL STAIRS.

"C–C"

NAME OF STRUCTURE

QUEEN'S BUILDING, RUTGERS

NEW BRUNSWICK, NEW JERSEY.

RUTGERS

A 250TH ANNIVERSARY PORTRAIT

Rutgers

A 250th Anniversary Portrait

III
Third Millennium
Publishing

Rutgers: A 250th Anniversary Portrait
© 2015 Rutgers, The State University of New Jersey

First published in 2015 by Third Millennium Publishing, an imprint of Profile Books Ltd., in conjunction with Rutgers, The State University of New Jersey.

New Brunswick, New Jersey • London

Third Millennium
3 Holford Yard, Bevin Way
London, WC1X 9HD, United Kingdom

Rutgers, The State University of New Jersey
57 U.S. Highway 1
New Brunswick, NJ 08901-8554

www.tmbooks.com

ISBN: 978 1 908990 06 8

Distributed by Rutgers University Press
rutgerspress.rutgers.edu

Edited by Susan Millership and Nita Congress
Designed by Matthew Wilson
Production by Debbie Wayment

Reprographics by Studio Fasoli, Italy
Printed and bound in China by 1010 Printing International Ltd.
on acid free paper from sustainable forestry.

Set in ITC Giovanni Std on 95lb/140gsm matt art

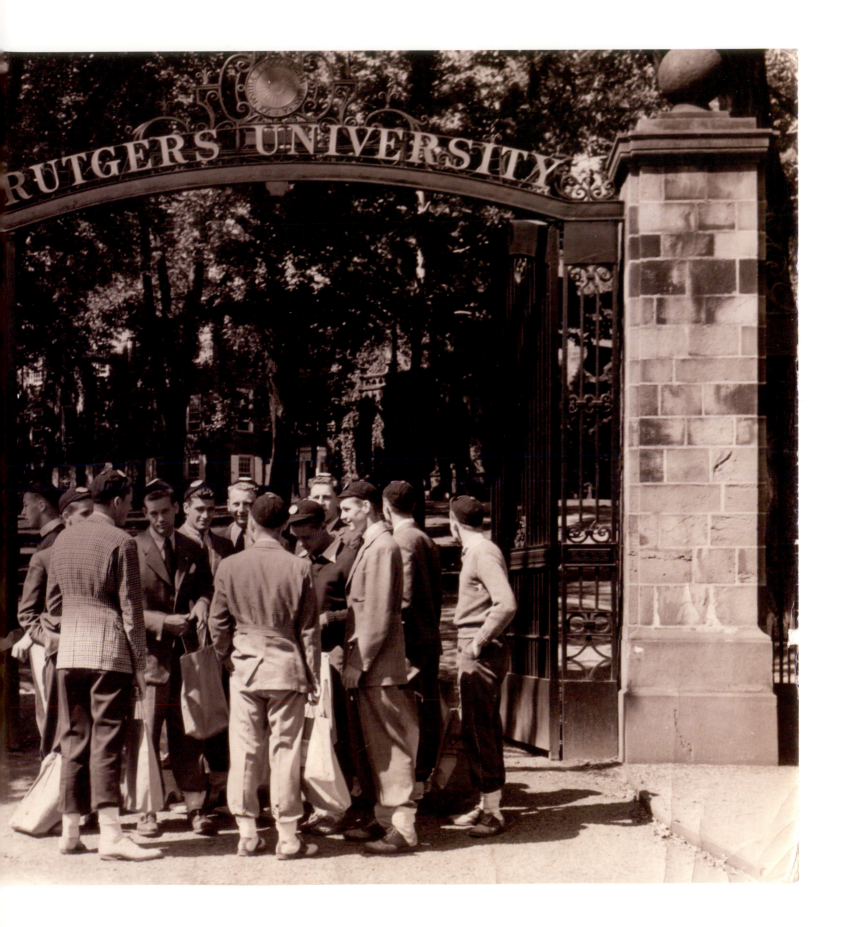

CONTENTS

**PART 1:
HISTORY & POLITICS** 14

**PART 2:
ACADEMICS** 76

156

PART 3:
CAMPUS LIFE

226

PART 4:
STUDENTS & ALUMNI

268

PART 5:
RUTGERS & THE WIDER WORLD

Message from the President | Robert Barchi

Milestone anniversaries seem to bring out the best in Rutgers.

At our 100-year mark in 1866, Rutgers had just become the land-grant institution for the State of New Jersey, a distinction that would have profound effects on our relationship with the state.

As we celebrated our bicentennial in 1966, not long after becoming The State University of New Jersey, we were undergoing a massive building expansion on our campuses and a doubling of our student population.

Now at 250, we have just completed the largest merger in the history of U.S. higher education, welcoming most units of the former University of Medicine and Dentistry of New Jersey into our community of scholars and becoming a truly comprehensive public research university.

This book is the story of these and many other milestone moments that have defined this one-of-a-kind institution—the only one in America to have been a colonial college, a land-grant college, and a state university. As you will notice in reading this book, the evolution of our university has reflected trends in American higher education, social movements, political tides, timely opportunities, and the guiding hand of strong leaders at Rutgers. Along the way, Rutgers people have influenced everything from modern art to literature to monetary policy to AIDS research.

For all the twists and turns of our history, and for all the accomplishments of legendary faculty members, outstanding students, visionary administrators, and world-changing alumni, the story of Rutgers—250 years in the making—has only begun to play out.

Consider this: the vast majority of all the men and women who have ever earned a Rutgers degree in our illustrious history are still living. Numbering almost 500,000, these graduates, spread across the country and around the world, are right now making contributions in every field of human endeavor and building our legacy by their achievements. Many of their stories will, no doubt, fill the pages of our history 50 years from now and further define the impact Rutgers is having on New Jersey and the world.

Just as it was impossible for the signers of our charter in 1766 to imagine the first college football game, or the discovery of streptomycin, or the impact of the Conklin Hall takeover, or Rutgers' contributions to exploration of the oceans' depths, the Antarctic, and Mars, we can't imagine the history our university will make in the years to come. But you can be sure that as the world changes, Rutgers will be in the middle of it.

ACKNOWLEDGMENTS | JORGE REINA SCHEMENT

This book—Rutgers' first illustrated history—celebrates 250 years of achievements and milestones, remembrances and initiatives. You will find this book not only comprehensive in its telling of the Rutgers story, but also refreshingly honest, able to delight you with information, facts, and figures that are not as well known as they should be to our community.

This accomplishment is the result of enormous hard work and commitment on the part of the dedicated writers, editors, faculty members, staff, and alumni who have contributed to this book. As the Chair of the Rutgers 250 celebration, I am pleased to thank the following individuals for their time, expertise, and energy.

This book would not have been possible without the experience, guidance, and support of the Department of University Communications and Marketing. From the earliest conceptual stages through writing, editing, photo selection, and marketing of this project, the leadership and staff of the department—including vice president Kim Manning, Joanne Dus-Zastrow, Jeanne Weber, Cindy Paul, Jane Hart, Lisa Elwood, John VanCleaf, Nick Romanenko, Pam Blake, Rosemary Lyons, Michael Meagher, Todd Slawsky, Debra Diller, Rae Frisch, Gerald Meccia, Jeremee Johnson, Jessica DePaul, and Paula Henry—have dedicated themselves to the task at hand. A team of individuals also took on the critical and arduous work of fact checking; this included Pam Blumenson, Daryl Brower, Adam Kertis, Karen Imperiale, Mary Ann Littell, David Major, Faith Jackson, Priscilla Pineda, Rebecca Turner, and Carole Walker.

Additionally, it was this department that housed the Rutgers 250 Office and its staff, who worked many long and committed hours on this book; our thanks to Matt Weismantel, April Coage, Mohammad Nazmussadad, Renee Milton, Elijah Reiss, Aishwarya Sharma, Julie Park, and Saskia Kusnecov. Thanks are due also to members of the communications teams at each of our Chancellor's Offices, including Peter Englot, Helen Paxton, Michael Sepanic, Monica Buonincontri, and Cathy Donovan. Our principal writers brought the project to life; much gratitude to Tom Frusciano, Benjamin Justice, Barry Qualls, Eileen Crowley, Marie Logue, and Linda Stamato. Their work was supported and enhanced through the efforts of our contributing writers: Richard Aregood, Marco Battaglia, Edward Berger, Myra Bluebond-Langner, Diane Bonanno, Gloria Bonilla-Santiago,

Evelyn Brenzel, Ruth Ann Burns, Abena P.A. Busia, Marian Calabro, María Josefa Canino, Chris Carlin, Joseph Charette, Mark J. Conlin, Eleonora Ciejka Dubicki, Douglas Eveleigh, Jacqueline Fesq, Richard Florida, David J. Fowler, J. Fredo, Lloyd Gardner, Marianne Gaunt, Will Gilkison, Jason Goldstein, Erika Gorder, Lauren Grodstein, Rachel Hadas, Mary Hartman, George Hill, Washington Hill, Jordan Hollander, Eve Jacobs, Sanford M. Jaffe, Frank Jordan, Charles Keeton, Ed Kiessling, Alexi Lalas, Richard Levao, Jack Lynch, Cal Maradonna, Terre Martin, Kenneth Miller, Lisa Miller, Angelo Monaco, Michael Moran, Julie Park, Fernanda Perrone, Tasha Pointer, Elijah Reiss, Julie Ritter, Joel Rosenbaum, Marybeth Schmutz, Michael Sepanic, James C. Selover, Rob Snyder, Kurt Spellmeyer, Jim Stapleton, Carrie Stetler, Mike Teel, Nasir Uddin, Cheryl Wall, William Wetzel, and William J. Whitacre. Additionally, we must thank the many writers who are named in the book and who contributed the personal stories, photos, and reminiscences that have greatly enhanced our narrative and enriched the overall content of the book.

Within the Department of Alumni Relations many thanks go to Donna Thornton, who helped with the concept of this book from its inception, along with Laura Stanik and Ayesha Gougouehi who worked to promote the book within the alumni community, including solicitation of stories and photos, and Kristin Capone who helped verify the accuracy of alumni information.

The support, work, and research undertaken by the Rutgers Special Collections and University Archives team, led by Tom Frusciano and Erika Gorder, were critically important to the accuracy and appearance of this book. Also vital was the encouragement and support the team received from both university librarian Marianne Gaunt and her successor, interim university librarian Jeanne Boyle.

A special thank you to our editorial committee and reviewers, notably president emeritus Richard L. McCormick, Linda Bassett, Jessica DePaul, Paul Clemens, Jan E. Lewis, Matt Matsuda, Isabel Nazario, Flo Hamrick, Diane Hill, Carlos Fernandez, Mary Beth Daisey, Ji Lee, Zaneta Rago, Mark Schuster, and Prosper Godonoo. This committee also included distinguished professor Clement Price, who died suddenly during the writing of this book and whose devoted commitment to Rutgers along with his wisdom and ever-cheerful and dignified countenance will be greatly missed.

Additional thanks to our teams at the publishers, Third Millennium: including our editor here in New Jersey, Nita Congress; and in London, Susan Millership, Matt Wilson, Julian Platt, Joel Burden, Neil Titman, and Sarah Yeatman. Appreciation is also due the Rutgers University Press: Marlie Wasserman, Liz Scarpelli, Lisa Fortunato, and Jeremy Grainger.

Everyone involved should be very proud of this outstanding, first-ever illustrated history of the 250 years since the signing of Rutgers' Charter in 1766. Clearly much has been accomplished, far beyond our founders' greatest hopes, in these first 250 years, and we all look toward the great things to come in our future!

1766-2016
RUTGERS
250

A LABORATORY FOR CHANGE AND CHALLENGE

LINDA STAMATO

The nobility of a public university—the Jeffersonian concept of a secular institution focusing on freedom, philosophy, and education—found its highest expression in America in the public land-grant state university envisioned by Abraham Lincoln and Justin Smith Morrill. Extending educational opportunity beyond the elite social and economic classes, it melded the liberal arts and the sciences with the practical and the applied. It is perforce the story of Rutgers, with a twist.

From a private colonial college, Rutgers has grown to become a comprehensive public research university, acquiring schools and creating new ones, investing in three campuses, expanding undergraduate education to provide access to thousands of the children of immigrants and to immigrants themselves—and in the last century, making major advances in the arts, professional and technical education, and research. As it stepped full into the 21st century, Rutgers added facilities, faculty, students, and staff by merging with seven health-related schools, including medical, dental, nursing, graduate biomedical, public health, and health-related professions schools, as well as several clinics, centers, and institutes with health-related and research missions.

Below left: Rutgers University-Newark biology student field trip to the Meadowlands to observe salt marsh ecosystems and study the impact of contaminants on blue crabs and their link in the food chain.

Below: Rutgers School of Communication and Information professor Jenny Mandlebaum leads a class discussion.

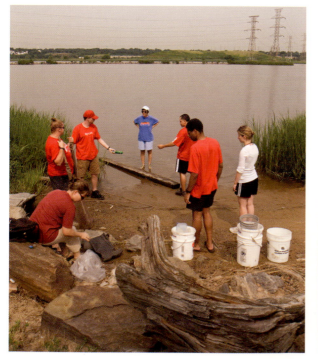

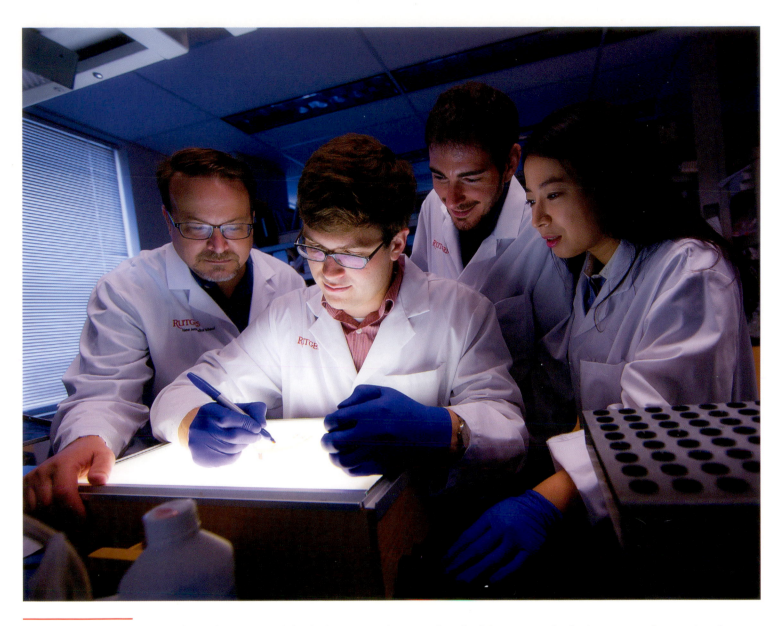

Rutgers New Jersey Medical School microbiology associate professor David Lukac (left) works with students in an International Center for Public Health laboratory.

A large, diverse research institution, Rutgers is now, as it was in the beginning, an arbiter, repository, and transmitter of human knowledge. Pushing boundaries and serving as a catalyst for human progress and change, it has delivered new discoveries and inventions and produced graduates equipped to work in the world and to exercise responsible citizenship. Moreover, Rutgers reflects the communities, cultures, and political economies in which it operates. And because many of the university's students are the first in their family to attend college, Rutgers promotes democratic social mobility. As it was envisioned so many years ago, it offers the opportunity of a higher education to all.

Then, as now, there are opportunities to seize and significant challenges to meet. And, regarding both, Rutgers is a laboratory, an institution recast and reconstituted several times over.

It has resisted change but it has vigorously embraced it too, not least to end discrimination against women and racial/ethnic minorities and to afford opportunities to them, and to commit—deeply—to diversity. It has assumed a responsibility to educate and nourish a desire for lifelong learning; it has become a crucible of civil discourse and social conscience. It is fully committed to its role in sustaining a dynamic, successful, and inclusive society, a role that fuels democratic urges and promotes economic development and that looks increasingly to expand its global reach.

Rutgers has high expectations.

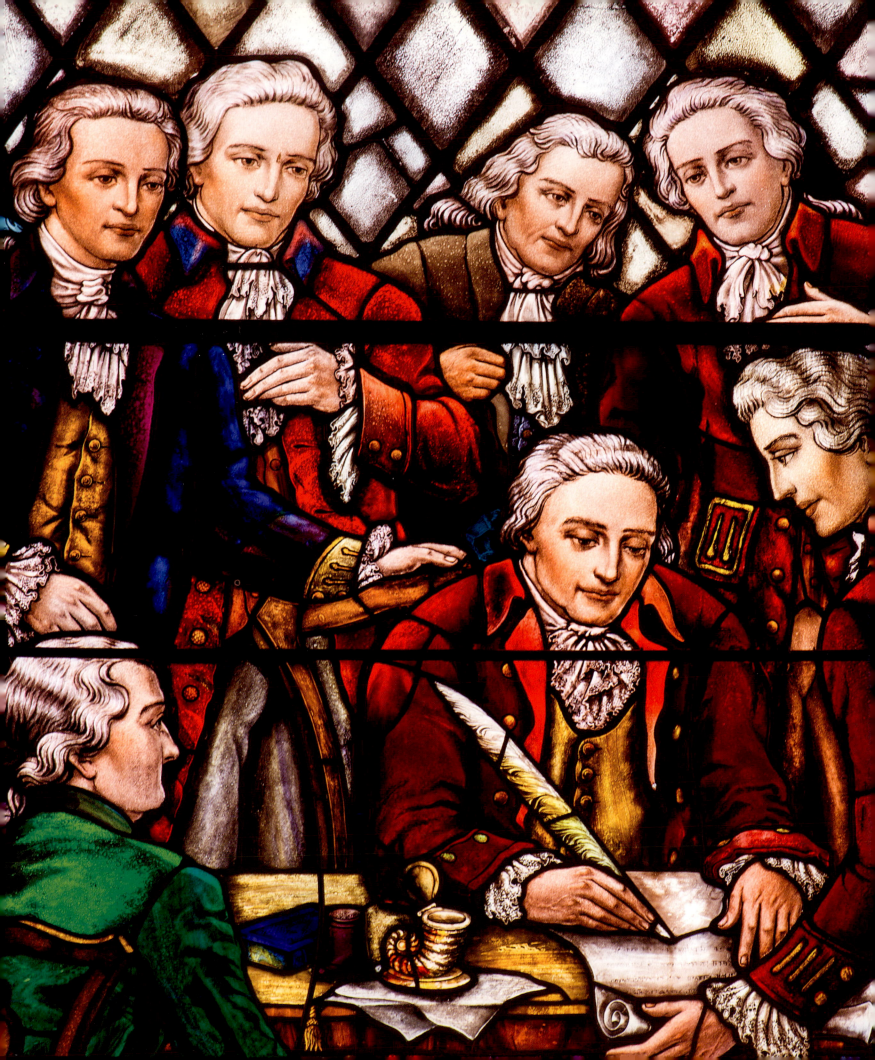

PART 1

HISTORY & POLITICS

THOMAS FRUSCIANO &
BENJAMIN JUSTICE

Two and a half centuries is a long time. Twelve generations, each with its own dreams, great achievements, and dramatic crises, have passed since the founding of what has become Rutgers, The State University of New Jersey. In that time the institution has transformed again and again, gradually unrecognizable to those who once knew it well. These changes have been driven by great questions and mundane ones. How can we make a more just and fair society? What is worth knowing? What is good? But also, what is popular? And of course, how much will it cost? The following history sketches the story of those two and a half centuries of Rutgers, marking institutional evolution and revolution in response to changing times, changing leadership, and chance. The story includes achievements and embarrassments, much as the broader history of the United States does. But in the balance, the emergence of a world-class public university serving a diverse student body in a dizzying array of fields of endeavor and continuing to engage the deepest questions of human experience is something worth celebrating.

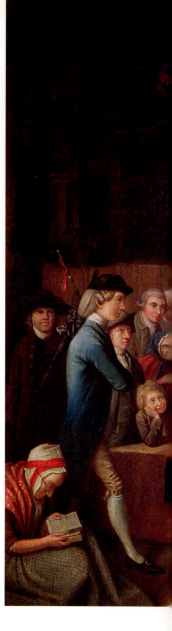

Queen's College—Child of the Awakening

In *Rutgers, A Bicentennial History*, historian Richard P. McCormick (RC '38, GSNB '40) called Queen's College—Rutgers' name in its original charter—a "child of controversy." Indeed, the founding of the eighth college in the American colonies resulted from controversy and schism within the Dutch Reformed Church, the denominational parent of Rutgers University. But the establishment of Queen's also reflected broader social, political, and cultural issues of the 18th century.

The events leading to Queen's College began with the Great Awakening, a period of tremendous religious upheaval that swept the British colonies in the mid-18th century, transforming the religious landscape and loosening the conventional structures of colonial society. The Awakening encouraged people to experience faith with their hearts as well as their minds. Paradoxically, the movement brought not only enthusiasm and religious resurgence, but also bitter conflict within the Protestant churches in the colonies.

In the Province of New Jersey, Theodorus Jacobus Frelinghuysen, a fiery pietistic Dutch minister, had become a highly controversial clergyman. He had arrived in the colonies from East Friesland, Germany, in 1720 to take charge of the churches in the Raritan Valley, including the church in New Brunswick. His enthusiasm, emotional

preaching style, and zealous personality (as well as his inclination to ignore church doctrine) inspired like-minded Dutch ministers in the colonies to challenge Europe's authority, especially on the ordainment of new ministers. His ideas and personality alarmed not only members of his own congregations but also ministers of the established churches in New York City, who questioned his behavior and beliefs. Moreover, Frelinghuysen's association with other revivalists such as the Presbyterian Gilbert Tennent and English Evangelist George Whitefield, who made a highly "sensational" tour of the colonies in 1739, scandalized his critics.

After Frelinghuysen's death in 1747, two of his sons, Theodore and John, kept the faith. Theodore Frelinghuysen preached the reformed gospel from his parish in Albany, New York. John Frelinghuysen, considered by many in the Dutch church to be a prophet of theological education, took charge of his father's former parishes at Raritan, Millstone, and North Branch. He and his wife set aside a room in their home for the training of Dutch Reformed ministers. In 1754, John, just 27, died. A former student, Jacob Rutsen Hardenbergh, took over as pastor of the churches in Raritan and, two years later, married his former mentor's widow. Hardenbergh assumed an active role in the movement to establish a Dutch college, and would go on to become the first president of Queen's College in 1786.

The proliferation of churches resulting from the Great Awakening had created a severe shortage of ministers. (As late as 1771, when Queen's College commenced instruction, only 39 ministers were available for 100 churches.) Those who aspired to the pulpit were required to embark on a long, arduous, expensive, and often dangerous journey to Amsterdam for their training and ordination. This lack of authority to educate and ordain ministers at home in the colonies soon became a contentious issue dividing the Dutch clergy into two factions—one arguing for local autonomy for the colonial churches, the other favoring subordination to Amsterdam. The controversy would continue until 1772 when the "Articles of Union" reunited the two groups.

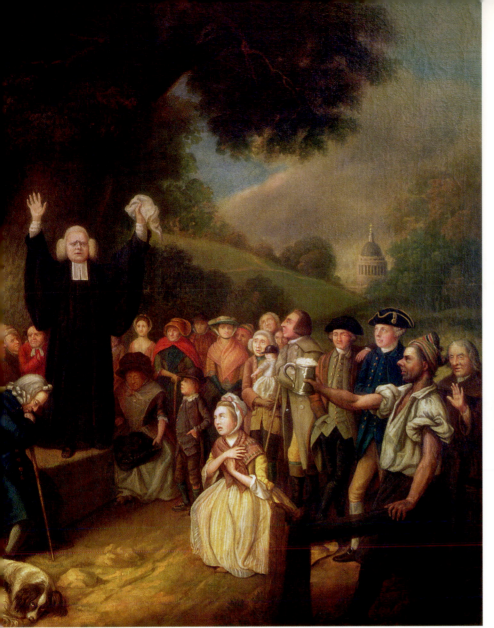

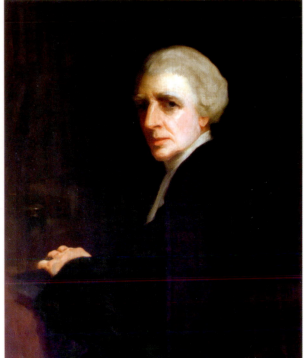

Below: Jacob Rutsen Hardenbergh (1736–90), Reformed minister from Rosendale, Ulster County, New York, was instrumental in obtaining the charter that established Queen's College. His faithful service as a college trustee led to his appointment in 1786 as the first president of Queen's College, a position he held until his death in 1790. (*Portrait by Gordon Stevenson.*)

The factional dispute climaxed in 1755 over a petition to appoint a Dutch professor of divinity at the newly formed King's College, later named Columbia. The Dutch ministers in New York who opposed local autonomy ultimately endorsed the professorship as a way to eliminate the need for an American church body. This calculated move prompted Theodore Frelinghuysen to leave his pulpit in Albany to rally the ministers and congregations to action.

Frelinghuysen viewed the establishment of a new American—and English-speaking—authority as a necessity for the maintenance and preservation of the Dutch Church in the British colonies. The solution, he argued, was that the Dutch colonists should form their own college.

Convening in New York City in May 1755, the ministers selected the Reverend Theodore Frelinghuysen to present a petition to the church leaders in Amsterdam that requested on behalf of the pastors and elders of the Dutch churches in New York and New Jersey:

…to plant a university or seminary for young men destined for study in the learned languages and liberal arts, and who are to be instructed in the philosophical sciences; also that it may be a school of the prophets in which children of God may be prepared to enter upon the sacred ministerial office in the church of God.

Frelinghuysen embarked from New York City to the Netherlands in October 1759. His mission failed. Rebuffed by Amsterdam, he set sail for home in 1761; on the voyage, he mysteriously perished. It was left to others in the church to carry on his vision of a Dutch college.

By this time Jacob Hardenbergh had established himself as a formidable American Dutch church leader and a strong advocate for a Dutch college in the colonies. In 1763, he traveled to Europe on personal business and took the occasion to renew the plea for local church control and establishment of a Dutch college. His petition was

Below: Queen Charlotte of Mecklenburg-Strelitz, wife of King George III, in whose honor Queen's College was chartered. *(Portrait by Thomas Lawrence, 1789.)*

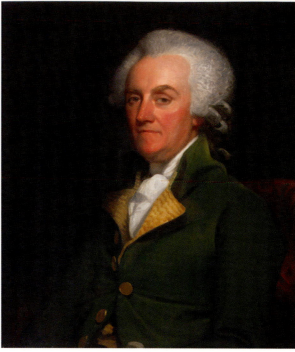

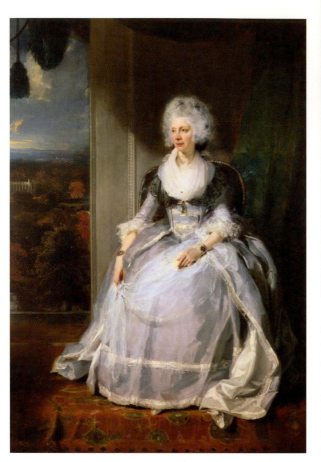

also rejected. Undeterred, the American ministers appealed to King George III of England for a charter to establish a Dutch college, further antagonizing the authorities in Amsterdam. On November 10, 1766, William Franklin, the royal governor of New Jersey (and the illegitimate son of Benjamin Franklin) granted a charter (revised and renewed in 1770) for Queen's College, named in honor of Queen Charlotte, wife of King George III.

Above left: William Franklin, the last royal governor of New Jersey, who granted a charter on November 10, 1766, that established Queen's College in New Jersey. *(Portrait by Mather Brown, ca. 1790. Private Collection)*

Queen Charlotte

Few recall the school's unsung first namesake, Queen Charlotte. Even the lengthy history on Rutgers' official website notes only that she was "King George III's Queen-Consort, Charlotte of Mecklenburg-Strelitz (1744–1818)." Just 17 when she was imported to marry King George in 1761, the skimpy early diplomatic reports on Charlotte mainly noted her "very mediocre education." Perhaps true, but she swiftly learned English and became a skilled amateur botanist (with a role in designing Kew Gardens), as well as a discerning patron of music and the arts. In 1764, she sang an aria in a court musicale accompanied by the 8-year-old Mozart.

One more thing about Queen Charlotte. Between 1762 and 1783, she gave birth to 15 children, nine boys and six girls. The experience may have stirred her sympathies for her less fortunate female subjects. She helped to found orphanages and supported a maternity hospital in London—now a famous teaching facility that still bears her name. Women's education, too, is often cited as a high priority for Queen Charlotte, who made sure her six daughters were better educated than she had been. All who care about Rutgers can be proud of this remarkable namesake of Queen's College, of the stately and elegant Old Queens Building (1809), which has long housed the office of the president of Rutgers, and of the abiding spirit of a young queen consort who cared deeply about the education of daughters as well as sons.

—MARY HARTMAN, UNIVERSITY PROFESSOR OF HISTORY

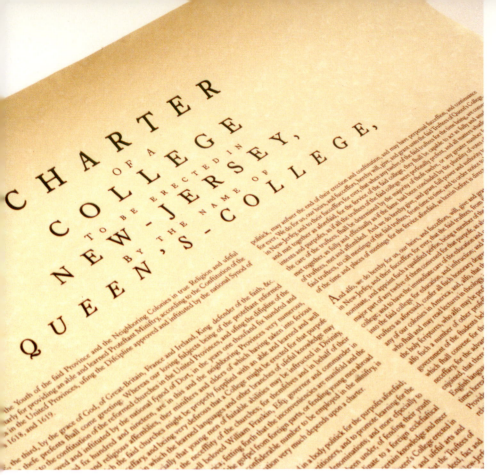

Queen's College charter, 1770. The original charter of 1766, a copy of which has never been found, presumably included features that were unacceptable to the trustees. After repeated efforts by the trustees to amend it, Governor William Franklin issued a new charter on March 20, 1770. It is under this charter (with numerous changes added through the years) that Rutgers has since existed.

The City of New Brunswick as it appeared in 1845. The trustees selected New Brunswick over Hackensack for the location of Queen's College in 1771.

A Seminary to Cultivate Piety, Learning, and Liberty

Though religious motives were of central concern, the founding of Queen's College also reflected broader issues. Its charter was actually a highly secular document that set the purpose of the institution as "the Education of Youth in the Learned Languages and in the Liberal and Useful Arts and Sciences." As historian George P. Schmidt points out, the term "useful" in the charter would assist the trustees a century later in arguing their case against Princeton for the land-grant status of New Jersey. The charter also affirmed the college's ties to the Dutch Reformed Church and its intent on educating youth for the ministry.

By charter, Queen's College was to be governed by a Board of Trustees that included four public officials—the provincial governor, the president of the council, the chief justice, and the attorney general of New Jersey. Forty-one members were appointed to govern the college, of whom 13 were ministers of the Dutch Church in New Jersey, New York, and Pennsylvania. They were to appoint a college president, who was to be a member of the Dutch Reformed Church. While the charter specified no ecclesiastical control over the college, nor any religious restrictions on the faculty

New Brunswick and Raritan Landing

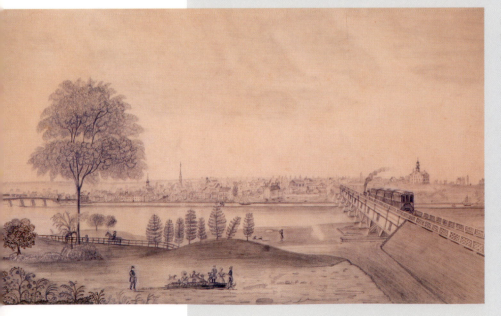

Settled by the Dutch in 1681, New Brunswick is Rutgers' historic birthplace. Strategically situated on the Raritan River, "the hub city" was a key Revolutionary War site: It is where the Declaration of Independence was read on July 9, 1776; the British Army encamped; and Alexander Hamilton led Continental troops in a critical skirmish that set the stage for victory in the Battle of Trenton. The city flourished as a shipping and industrial center, booming after the Delaware and Raritan Canal opened in 1834. Across the river was Raritan Landing, New Brunswick's 19th-century "port city" neighbor. Located in today's Piscataway (home to Rutgers' Busch and Livingston Campuses), Raritan Landing thrived as an inland port. Rutgers launched work on the Raritan Landing archeological site in 1979, sparking interest in this forgotten locale. The historic area is a reminder of how both sides of the river, once unified through trade, are today unified by Rutgers University–New Brunswick.

—ELIJAH REISS (SAS '17)

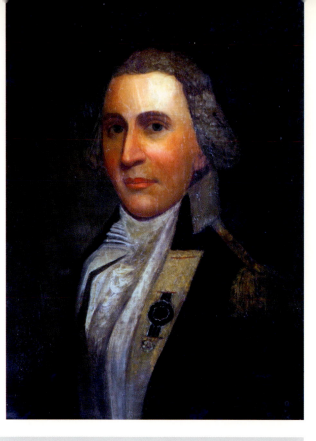

Frederick Frelinghuysen (1753–1804), a graduate of the College of New Jersey (now Princeton University) (1770), served as the first tutor of Queen's College in 1771.

Queen's College and Slavery

In a recent study of slavery and the rise of the American college, historian Craig Steven Wilder writes that "American colleges were not innocent or passive beneficiaries of conquest and colonial slavery…[but] stood beside church and state as the third pillar of a civilization built on bondage." That "third pillar" started with Harvard in the 17th century and extended throughout the 18th and into the 19th centuries with each institution having connections to slaveholding and the slave trade.

Yale, Columbia, Princeton, and Brown have all conducted extensive research projects to investigate their involvement with slavery before and after the American Revolution. While this type of focused research has not occurred at Rutgers, evidence in the historical record indicates that several trustees, faculty, and early graduates of Queen's College either owned slaves or were raised in slaveholding families. The Netherlands was deeply involved in the slave trade, and Dutch Reformed ministers in America accepted the views of the mother country on slavery. Likewise, successful merchants and businessmen who resided among the heavily Dutch populations in New York and New Jersey profited extensively from the slave trade, and many sent their sons to be educated at Queen's College. Prominent names such as Hardenbergh, Frelinghuysen, Livingston, Lott, De Witt, and Hasbrouck were associated with both Queen's College and slavery. Henry Rutgers, the university's namesake, was a slaveholder who stipulated in his will that it was his "desire…that my Negro Wench slave named Hannah being superannuated, be supported out of my estate."

By the outbreak of the Civil War, many of these slaveholding families had manumitted—released—their slaves. Some became involved with the American Colonization Society that advocated removing enslaved and free blacks to Africa; others became abolitionists and joined forces with a growing antislavery campaign. While the important story of Queen's-Rutgers and slavery has yet to be told, the very existence of this nefarious institution and its connection to Rutgers must be acknowledged.

or students, provision was made for the appointment of a professor of divinity.

The trustees next turned to selecting a site for Queen's College. The members were split on whether to locate the college in Hackensack or New Brunswick. The supporters of the latter locale reminded their colleagues that the Reverend John Leydt of New Brunswick had joined with Hardenbergh and other members of that community to establish a college-preparatory grammar school in 1768. When the trustees convened in May 1771, New Brunswick carried the vote 10 to seven.

By October 1771, the trustees were prepared to open Queen's College. They had purchased the "Sign of the Red Lion," a former tavern located on the corner of Albany and Neilson Streets in New Brunswick, to accommodate the students of the college and the grammar school and appointed Frederick Frelinghuysen, a Princeton graduate (Class of 1770), as the first tutor. Frelinghuysen, grandson of Theodorus Jacobus Frelinghuysen, son of John Frelinghuysen, and stepson of Jacob Hardenbergh, commenced instruction on November 12 "to cultivate Piety, Learning and Liberty" among the first students of the college.

The curriculum of Queen's College was modeled on that of Princeton, whose course of study mirrored that at Yale. The plan of education, first published in the *Rules and Regulations for the Government of Queen's College* (1787), informs us

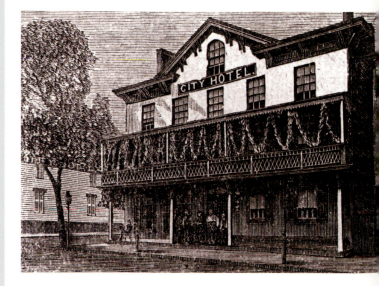

The Sign of the Red Lion, a former tavern on the corner of Albany and Neilson streets in New Brunswick. Previously owned by Brook Farmer in 1761, the tavern was purchased by Queen's College and instruction began in November 1771. The building was acquired by Jacob Hardenbergh, son of the first president of Queen's College, who ultimately sold the building in 1791. By 1807 the building was known as the Albany or City Hotel.

RULES

Jonas AND *Coe's*

REGULATIONS

FOR THE GOVERNMENT OF

QUEEN's COLLEGE,

IN NEW-JERSEY:

Enacted by a Board of the TRUSTEES of said COLLEGE, the 7th day of August, 1787.

NEW-BRUNSWICK: Printed by SHELLY ARNETT, 1788.

Front cover of *Rules and Regulations for the Government of Queen's College* (1787), the first pamphlet that provided admissions requirements, course of study, and regulations governing student conduct and behavior.

that prospective candidates for admission to the college were required to "render into English, Caesar's *Commentaries of the Gallick War*, some of Cicero's *Orations*, the *Eclogues* of Virgil…and at least one of the Gospels from the Greek." In their four years at Queen's, students were to master Latin and Greek, and become familiar with standard works in antiquities, logic, geography, rhetoric, arithmetic, algebra, elements of geometry, trigonometry, navigation and surveying, natural and moral philosophy, and English grammar and composition.

The college grew slowly over the next few years, and had only 20 students enrolled when it held its first commencement in October 1774. The Reverend Jacob Hardenbergh presided over the memorable event and conferred on behalf of the trustees the first and only degree of the day to Matthew Leydt, son of founder John Leydt of New Brunswick.

The American Revolution and the "Future Glory of America"

In his commencement address, Hardenbergh, an ardent patriot who was to play a significant role in the American Revolution, reminded his audience of the troubled times ahead: "O! May America never want [for] sons of consummate wisdom, intrepid resolution and true piety to defend her civil and religious liberties, and promote the public weal of the present and rising generation!"

As the war approached, the students of Queen's College voiced their staunch patriotism with increased frequency. There were very few, if any, loyalists among the students and faculty, and along with many students at other colonial colleges, Queen's students proved to be among the strongest supporters of resistance to Great Britain. Discussion on topics pertaining to the Revolutionary War took place at Queen's College during meetings of the Athenian Society, a student literary group established shortly after the opening of the college. The minutes of the society make frequent references to speeches on liberty, "the future Glory

The first two pages of Jacob Hardenbergh's commencement address delivered in October 1774 when he extolled "that men of Learning are of absolute necessity and extensive advantages to Society." In his address, Hardenbergh urged those who had assembled to continue their moral and financial support by sending their children to the college, reflecting on "how reasonable and necessary it is, that the Community should promote and Incourage [sic] the Seats of Learning…"

Laws and Regulations of the Athenian Society.

Transactions of the Athenian Society.

Delaware with General Washington at the Battle of Trenton, served as an officer in a battalion of Minutemen, captain of artillery, and colonel and aide-de-camp to General Philemon Dickinson in the Continental Army; John Taylor, who rose to the rank of colonel in the militia, led troops on battlegrounds from Trenton to Springfield; Simeon De Witt (Queen's College Class of 1776) became General Washington's chief geographer and conducted a survey of the road to Yorktown, where the final battle of the Revolutionary War took place.

Queen's College survived the war but struggled to find a leader. The trustees finally succeeded in securing the services of the faithful Jacob Hardenbergh, who accepted the presidency of the college and the pastorate of the church at New Brunswick in 1786. The college prospered during the next four years under Hardenbergh's leadership.

of America," readings on patriotic themes, and actual participation in the war.

When war broke out, the small college was swept up in the struggle, and classes were suspended on several occasions. In 1777, during the British occupation of New Brunswick, Queen's tutor John Taylor joined six students in an abandoned church in Somerset County to resume their studies. Called into active service in the Continental Army, Taylor was replaced by John Bogart, an alumnus of Queen's, who directed the college until Taylor returned in 1779. The college relocated to several locations in Millstone the following year, and finally was able to return to New Brunswick in the spring of 1781.

Queen's College trustee Jacob Hardenbergh became an outspoken proponent for American independence. He served as a delegate to the last Provincial Congress, which met in Burlington in June 1776 to ratify the Declaration of Independence and frame the constitution of the State of New Jersey. The British burned his Raritan church to the ground in 1779. The young tutor Frelinghuysen, who crossed the

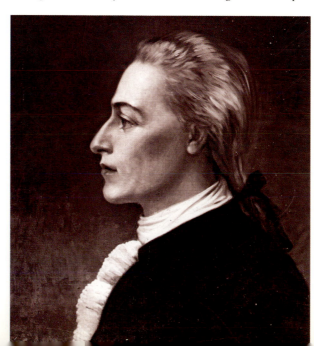

John Taylor (1751–1801), assisted his Princeton classmate Frederick Frelinghuysen at Queen's College in 1771 when he took charge of the Grammar School and became tutor of the college when Frelinghuysen left to study law. Taylor served on the faculty until 1790 and is credited with assembling the students for instruction in an abandoned church in North Branch and later in Hillsborough following the British occupation of New Brunswick in 1776. He also suggested the students organize the Athenian Society. In a letter written to John Bogart (Queen's College 1778), Taylor urges him to take charge of students while he served in the New Jersey militia, suggesting to Bogart what books and subjects to assign to each student.

Simeon De Witt

One of the most accomplished graduates of Queen's College, Simeon De Witt (1756–1834) became a pioneer in American cartography. He was born and raised in Ulster County, New York, and studied under the distinguished Dutch minister Dirck Romeyn before enrolling in Queen's College, from which he graduated as the only member of the class of 1776. With the war's outbreak, he enlisted in a volunteer battalion that participated in the American victory at Saratoga. In 1778, De Witt became an assistant to Robert Erskine, surveyor-general of the Continental Army—a position he assumed himself on Erskine's death two years later—and contributed to several significant surveys of the roads to Williamsburg and Yorktown. The resulting maps guided General Washington's army to its victory at Yorktown with the British surrender in 1781. Headquartered in Philadelphia following the war, De Witt urged Congress to publish the military road maps as a record of "the state of war in America," but his proposal was turned down. He resigned his post in 1784 to become surveyor-general of the State of New York, a position he held for the remainder of his life.

From his office in Albany, De Witt made lasting contributions to the development of American cartography, and was directly involved in numerous internal improvement projects that fostered settlement and economic growth. He helped determine the correct boundary between New York and Pennsylvania and assisted in establishing townships in New York to satisfy land claims for war veterans. In 1808, De Witt began directing a survey of land in western New York that led to the construction of the Erie Canal. He was also appointed as one of three commissioners to develop a plan for the future growth of New York City. The resulting Commissioners Plan of 1811, considered by historians as "the single most important document in New York City's development," served as the blueprint for John Randel Jr. to survey and develop the grid pattern of avenues and streets that defines Manhattan to this day.

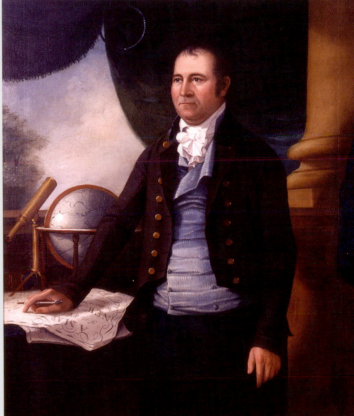

Above: Simeon De Witt (1756–1834), a 1776 graduate of Queen's College, served as Surveyor-General for the Continental Army during the Revolutionary War, assisting General George Washington's army in the final major battle and the surrender of the British at Yorktown. (*Portrait by Erza Ames, ca. 1806.*)

Left: Compass used by Simeon De Witt to conduct land surveys for map-making.

A "Plan of Union," formulated by a joint committee of trustees from Queen's and the College of New Jersey at Princeton in September 1793, called for the elimination of collegiate instruction in New Brunswick, to be replaced by a preparatory academy. Princeton would maintain a liberal arts college. The trustees of both colleges would request a new charter, to be issued by the State Legislature of New Jersey. Following a fierce debate, the Queen's trustees rejected the plan and soon closed the college following commencement in 1795.

With assistance from the trustees and local ministers, Hardenbergh campaigned for additional financial pledges to meet expenses and paved the way for attracting funds to erect a new home for the college on George Street, which was fully occupied by 1791. Enrollment climbed slowly; by 1789, the graduating class comprised 10 students. Hardenbergh cautioned the Dutch Church's leadership of the college's precarious financial situation with tutors going unpaid and salaries being owed even to him. But before the churches could act, Hardenbergh succumbed to tuberculosis and died on October 30, 1790.

With Hardenbergh's death, Queen's College fell on difficult times. The most controversial proposal to save the college was a merger with the College of New Jersey (known today as Princeton University).

This bold proposal created a stir among Queen's trustees and led to an acrimonious debate within their council. Even before the College of New Jersey had an opportunity to discuss the merger, the Queen's College trustees narrowly defeated the proposal, as well as another plan that would have transformed the college into an academy and theological seminary, both maintaining close ties with the College of New Jersey. When the local church body (known as the General Synod) of the Dutch Reformed Church learned about the negotiations with the College of New Jersey, it showed its displeasure with the trustees by withholding any financial support secured for the college. When that restriction was lifted, the Synod proposed moving the college closer to the large Dutch population in northern New Jersey and New York. Cognizant that this plan would mean an end to the college in New Brunswick, the trustees narrowly voted against such a move and, with meager resources and diminishing prospects, closed the college following the commencement exercises of 1795.

Though collegiate instruction ceased, the trustees continued the grammar school, which progressed in the early years of the 19th century under the watchful eye of the Reverend Ira Condict. A graduate of Princeton (1784), Condict received the appointment as professor of moral philosophy in Queen's College in 1794, and became its president *pro tempore* in 1795. With the college closed, the trustees did not meet again until 1800 and then infrequently thereafter until 1807, when interest in the college was renewed. Condict, along with Andrew Kirkpatrick, chief justice of New Jersey, urged the trustees to raise funds for a new college building and to "re-establish the College and its courses of instruction, and raise it to that pitch of publick utility which the present view of things seems to encourage…" Condict soon received more than $6,000 from patrons in and around New Brunswick for the building, and he assisted trustee Abraham Blauvelt in selecting a site and reviewing architectural plans. The family of former delegate to the Provincial Congress and East Jersey proprietor James Parker donated five acres bounding Somerset and George Streets, where John McComb's architectural plans for the Old Queens Building were realized in 1809.

The revival of Queen's College in 1807 was facilitated by the Dutch Reformed Church. The Articles of Union that had ended the controversy between the factions of the Dutch Church in 1772 had designated the theological professor as an office of the church, with the specific task of preparing students for the ministry. In 1784, following the delay caused by the American Revolution, the Synod chose

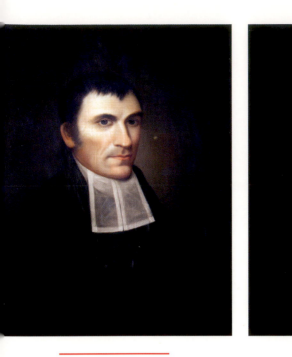

John Henry Livingston (1746–1825), the most influential minister in the Dutch Church and a member of one of the most prominent families in America. He served as the fourth president of Queen's College (1810–25) while instructing students in the theological seminary.

Ira Condict (1764–1811), professor of moral philosophy, became President *pro tempore* of Queen's College in 1795 and served in that capacity until 1810. Under his leadership, the college reopened in 1808 and soon occupied its first permanent building, "Old Queens." (*Portrait by Henry F. Darby.*)

John Henry Livingston as the first holder of this office. Though Livingston himself was a pastor in New York and after his election proceeded to teach students in his home there, it was assumed that this theological professorate would become the basis of an established seminary. But over the next 23 years, the church could not solicit the necessary funds to operate the seminary.

When the Queen's trustees resolved in 1807 to revive the college, they saw the theological professorate as key, and

they made a proposal attractive to the church, which led to a covenant between the two bodies. The trustees agreed to assist the church in raising funds for the theological professorate (known as the professorial fund), with the understanding that the professorate would be located at Queen's, and that the professor himself, who would also serve as president of the college, would be "nominated and chosen by the General Synod." Furthermore, the department of theological studies (as we might term it) that would thereby be created at Queen's would have its own board of superintendents, accountable to the Synod, rather than to the Queen's trustees. With this agreement, the trustees relinquished control of the "Theological Institution in Queen's College," as the price for bringing it to New Brunswick. But the trustees achieved their aim: money was raised, Livingston arrived in New Brunswick in 1810 and took up his duties as both professor and president, and the college, now including the theological institution, reopened.

On assuming his dual office in 1810, Livingston was assured by the trustees that he was only "to preside at

The Rutgers-Utrecht Connection

Right: Seal *Sol Iustitiae Et Occidentem Illustra.* Thin metal impression used with a stamper to create seals for the college from 1766–1892.

Utrecht University in the Netherlands had an early connection with the small colonial college that would become Rutgers University. Queen's College's fourth president, John Henry Livingston (1746-1825), studied theology at the University of Utrecht after having completed his undergraduate years at Yale. As the two institutions were so deeply rooted in the Dutch Reformed Church, Livingston suggested a motto and seal for Queen's College based on Utrecht's. Devised in the 1630s, Utrecht's motto *Sol Iustitiae Illustra Nos* ("May the Sun of Righteousness Enlighten Us") was adapted

and changed to *Sol Iustitiae Et Occidentem Illustra* ("Sun of Righteousness, Shine Upon the West Also"), demonstrating the connection between the two schools on each side of the Atlantic. Utrecht's seal featured a sunburst, a symbol of enlightenment, with a shield of the city of Utrecht at its center, while Queen's chose a sunburst surrounded by its new motto.

One of the earliest examples of the seal appears on Simeon De Witt's diploma. Both the diploma and the original plate of the seal reside in the Rutgers Special Collections and University Archives.

—Elijah Reiss (SAS '17)

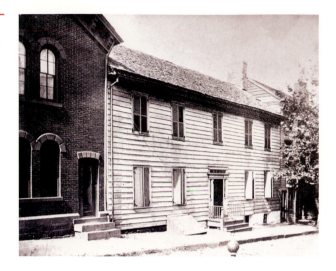

College Hall, near the current intersection of George Street and Livingston Avenue in New Brunswick, served as the second home to Queen's College, 1791 to 1811.

commencement and authenticate diplomatic documents and take general superintendence of the institution as far as… [his] time and health [would] admit." In his first year, he had only five theological students but the enrollment soon grew. Between 1812 and 1816, he instructed 32 students, who went on to the church for their ordination and for ministry in its parishes. Livingston was the sole professor in the seminary until 1815.

While the theological seminary showed great promise, the college once again faced an uncertain future. Severe financial shortages halted construction on Old Queens. An attempt by the trustees to raise funds by conducting a lottery proved to be an extremely complicated venture and fell short of its intended goal. Money promised for the professorial fund was not forthcoming, and obligations for Livingston's salary and house rent were not met. To make matters worse,

local banks were now demanding payment on the college's accumulating debt.

When the church leadership learned about the college's troubles, they responded with a plan to transform Queen's College into a theological seminary that would also provide instruction in classical subjects. While the trustees accepted much of the plan, problems arose over details and no agreement was reached. Operating at a financial loss, on May 29, 1816, the trustees voted to close the college for a second time.

Queen's College remained closed for nearly a decade. Unable to raise funds to complete repairs on the Old Queens Building, the trustees agreed to sell the building and the property to the church in 1823. Free of debt, they turned their attentions once again to devising a plan to revive the college, one that would place the institution on a stable and permanent foundation.

Broadside and tickets for the Queen's College Literature Lottery, 1812. Queen's College faced an uncertain future in the second decade of the 19th century. Severe financial shortages halted construction on its new building. An attempt by the trustees to raise funds by conducting a lottery proved to be an extremely complicated venture and fell short of its intended goal. In 1816, the college was closed for the second time. However, a more successful lottery conducted in 1824 brought the college an additional $20,000 that was used to endow a professor of mathematics and contributed to the reopening of the college.

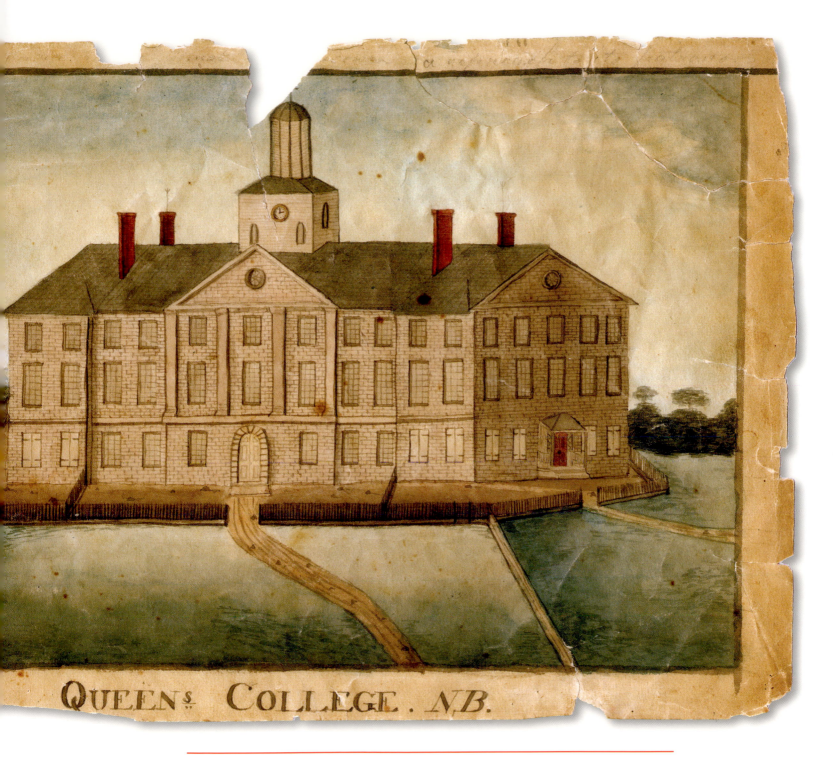

QUEENS COLLEGE. N.B.

Early rendering of Queen's College. Now home of administrative offices of Rutgers University, the building was originally known as the Queen's College building and today is called Old Queens. Designed in 1808–09 by the noted architect John McComb, who also designed City Hall in New York, the building is one of the finest examples of Federal architecture in the United States. When first occupied in 1811, Old Queens housed the academic work of the college, the New Brunswick Theological Seminary, and the Rutgers Preparatory School, then known as the Grammar School. Constructed of brownstone and adorned by colossal pilasters, the building included recitation rooms on the first floor, the Chapel and the library on the second floor, and wings on each side that served as living quarters for the faculty of the college. The building was finally completed in 1825 and included a cupola, the gift of Stephen Van Rensselaer, and a college bell, purchased by Colonel Henry Rutgers, that originally signaled the change of classes. In 1976 Old Queens was designated a historic landmark by the U.S. Department of the Interior.

Daguerreotype of Philip Milledoler (1775–1852), fifth president of Queen's College, who was instrumental in having Queen's renamed in honor of his friend Colonel Henry Rutgers.

From Queen's to Rutgers College

The sale of the Old Queens Building cleared the college of its financial obligations, and the church immediately expended funds to complete most of the building's interior rooms and perform much-needed alterations to the exterior and grounds. At the urging of the trustees, the church secured funds for an additional professorship in theology and established a committee to look into the possibility of revitalizing the college. Prompted by the success of a second lottery that yielded $20,000 in 1825, the trustees reached agreement with the Synod on a plan to commence instruction. But this new agreement essentially limited the authority of the trustees and, according to Richard P. McCormick, "placed the College under the complete control of the Synod."

The Covenant of 1825 dictated that the trustees were to name one of the theological professors as president. The agreement also required the trustees appoint the treasurer of the Synod as the college treasurer, while assuming responsibility for naming and supporting a professor of mathematics and a professor of languages. No other faculty appointments could be made without approval of the Synod. Most importantly, the Synod reserved the right

Henry Rutgers (1745–1830)

Henry Rutgers was a lifelong New Yorker. With only two exceptions—his service in the American army during the Revolutionary War and his tenure in the New York state legislature—Rutgers spent his entire life in the neighborhood that would later become the Lower East Side. At his birth in 1745 to Dutch-American parents whose wealth was based in brewing and landholding, New York was a colonial port town of approximately 12,000 people on the periphery of a global empire. By the time of his death in 1830, the city had burgeoned into a metropolis of over 200,000 that was the chief seaport of a dynamic new nation.

Rutgers graduated in 1766 from King's College (later Columbia University). He then commenced, at age 20, to manage his father's business. In 1775, he was appointed to his first public office as tax assessor in the Out Ward (later designated the Seventh Ward). When opposition to British imperial measures began, the Rutgers family supported the Whig, or patriot, cause. They had much to lose: the Rutgers family's property was worth more than £80,000—an enormous sum exceeding that of any other New York City patriot "in actual rebellion."

Henry was present at the battle of Long Island (or Brooklyn Heights) in late August 1776, where his brother Harman was among the first killed. When the American army abandoned New York, he fled in advance of the British entry into the city on September 15; enemy forces later used the buildings on the family farm as barracks, storehouses, and a hospital. Henry also fought at the battles of Harlem Heights and White Plains. For the remainder of the war, he served in an administrative capacity as a muster master and recruiter on both the state and Continental levels at various posts in the Hudson Valley. He eventually attained the rank of lieutenant colonel.

After the war, Colonel Rutgers (as he was usually known) returned to the Rutgers Farm and succeeded his

Above: New York State Dollar, signed by Henry Rutgers.

Below: Signature of Henry Rutgers from a manuscript letter written to Gerard De Peyster, August 30, 1776.

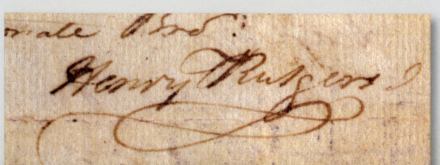

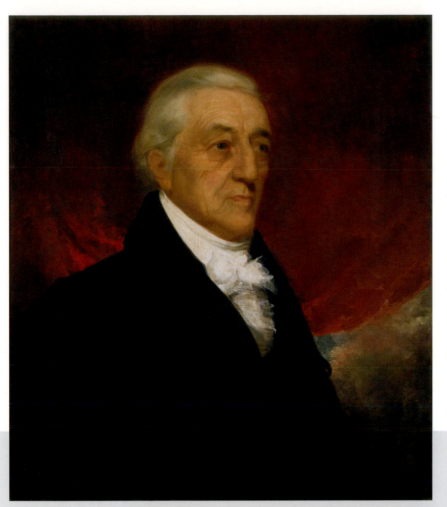

to sever its connection with the college if "it could not be sustained without impairing the funds devoted to the Theological Seminary."

By the time 30 students arrived for classical instruction on November 14, 1825, Queen's College had acquired a new president and was soon to have a new name. At a meeting in September 1825, the trustees elected as their new president the Reverend Philip Milledoler, a Queen's trustee since 1815 and professor of didactic theology. It was also at this meeting that Milledoler and fellow trustee Jacob Hardenbergh (son of the college's first president) suggested that Queen's College be named in honor of trustee Henry Rutgers. A devoted member of the Dutch Church, Henry Rutgers epitomized those Christian qualities held in high esteem by both the Synod and the trustees.

Above: Portrait of Colonel Henry Rutgers (1745–1830), which currently hangs in the Old Queens building at Rutgers. (*Portrait by Henry Inman.*)

Right: Artifacts belonging to Henry Rutgers donated or acquired by the Rutgers library, including a watch fob; a watch Inscribed on the back, *Henry Rutgers 1776*; a matchbook/matchstick cover; a silver tray engraved with initials "HR"; and a silver teapot.

father as family patriarch. The property had sustained substantial losses during the war. Henry did not revive the brewery business; instead, he now concentrated on being an entrepreneur, developer, and landlord who amassed most of his wealth from long-term leases and investments. He also exploited the strategic location of his property on the East River by establishing lumber yards and a wharf. He was a

militia officer and an influential leader of the Democratic-Republican (i.e., Jeffersonian) party in southern New York. Between 1800 and 1808, Rutgers was elected several times to the state assembly. On the local level, he remained active in the affairs of his hometown.

Henry Rutgers determined, it is said, to be his own executor before he died. Contemporaries regarded him as "the most benevolent man" in the city; among the philanthropic endeavors he was most passionate about were poor relief, religious institutions (especially Dutch Reformed and Presbyterian), and education. He was a trustee of the College of New Jersey in Princeton and of Queen's College in New Brunswick. In 1825 the latter institution was renamed Rutgers College, and the following year he donated the interest on a $5,000 bond and a bell to the eponymous school.

The defining influences of Henry Rutgers' long life were family, community, country, religion, and philanthropy. His last words were a tribute to the neighborhood he loved: "home … home."

—DAVID J. FOWLER (GSNB '79 '87)

Below: First commencement program (1827) following the reopening of Rutgers College. Note the order of the procession, led by the janitor of the Queen's building, followed by the students, faculty, and distinguished guests, including the Governor, Chief Justice, and Attorney General of New Jersey.

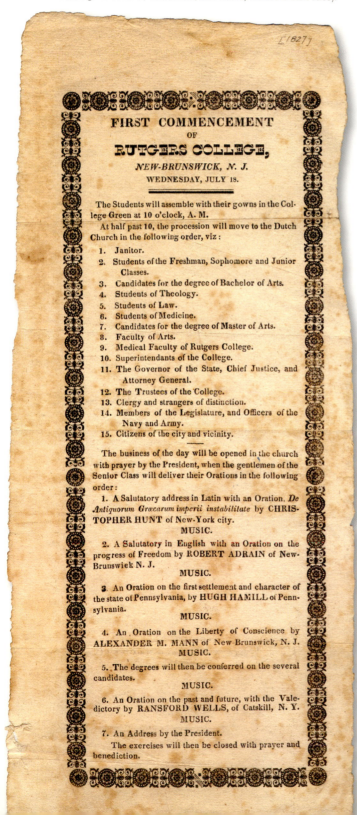

[1827]

FIRST COMMENCEMENT
OF
RUTGERS COLLEGE,
NEW-BRUNSWICK, N. J.
WEDNESDAY, JULY 18.

The Students will assemble with their gowns in the College Green at 10 o'clock, A. M.

At half past 10, the procession will move to the Dutch Church in the following order, viz :

1. Janitor.
2. Students of the Freshman, Sophomore and Junior Classes.
3. Candidates for the degree of Bachelor of Arts.
4. Students of Theology.
5. Students of Law.
6. Students of Medicine.
7. Candidates for the degree of Master of Arts.
8. Faculty of Arts.
9. Medical Faculty of Rutgers College.
10. Superintendants of the College.
11. The Governor of the State, Chief Justice, and Attorney General.
12. The Trustees of the College.
13. Clergy and strangers of distinction.
14. Members of the Legislature, and Officers of the Navy and Army.
15. Citizens of the city and vicinity.

The business of the day will be opened in the church with prayer by the President, when the gentlemen of the Senior Class will deliver their Orations in the following order :

1. A Salutatory address in Latin with an Oration, *De Antiquorum Græcarum imperii instabilitate* by CHRISTOPHER HUNT of New-York city.

MUSIC.

2. A Salutatory in English with an Oration on the progress of Freedom by ROBERT ADRAIN of New-Brunswick N. J.

MUSIC.

3. An Oration on the first settlement and character of the state of Pennsylvania, by HUGH HAMILL of Pennsylvania.

MUSIC.

4. An Oration on the Liberty of Conscience by ALEXANDER M. MANN of New-Brunswick, N. J.

MUSIC.

5. The degrees will then be conferred on the several candidates.

MUSIC.

6. An Oration on the past and future, with the Valedictory by RANSFORD WELLS, of Catskill, N. Y.

MUSIC.

7. An Address by the President.

The exercises will then be closed with prayer and benediction.

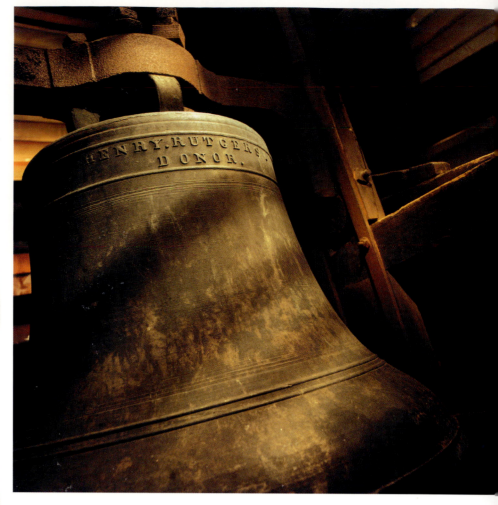

Bell donated by Henry Rutgers in 1826 and placed in the cupola of Old Queens. Originally used to signal the change of classes, the bell is now rung on special occasions such as commencement, anniversaries, and signature accomplishments in Rutgers athletics.

Colonel Rutgers had been elected a member of the Queen's College trustees in 1815. He and Milledoler had formed a close relationship in New York City. Rutgers became an elder in the Rutgers Street Presbyterian Church, where Milledoler served as pastor. Rutgers also served as president of the Board of Corporation of the Dutch Reformed Church, a post that placed him in an interesting position when discussions turned to the church's relationship with the trustees of Queen's College.

Colonel Rutgers' attendance at meetings in New Brunswick was infrequent. By 1821 his inability to attend meetings "by a variety of circumstances and because of Rheumatic affection" forced him to resign his position on the board. But his leadership in the church certainly kept him directly involved with the college. In March 1826, he presented a gift to Rutgers College of the interest on a $5,000 bond that he presented to the General Synod of the Dutch Reformed Church, to be paid semi-annually to the college trustees. If the college ceased to exist, the money would be directed to the Synod in support of a theological professorship. Colonel Rutgers made another donation to the college—$200 for the purchase of a bell to be hung in the cupola, which had been erected on Old Queens

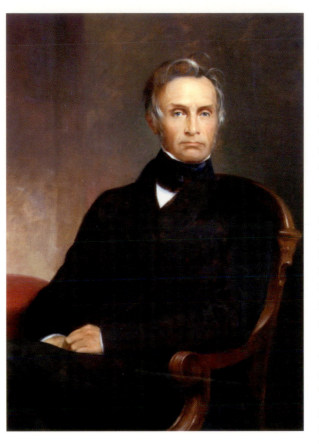

Theodore Frelinghuysen (1787–1862), lawyer, social reformer, and educator, was no stranger to Rutgers College when he arrived in New Brunswick in 1850 as Rutgers' seventh president. His father was Frederick Frelinghuysen, the first tutor in Queen's College and stepson of Jacob Hardenbergh, the college's first president. Frelinghuysen served New Jersey as attorney general, U.S. Senator, and mayor of Newark before becoming chancellor of New York University in 1839. In 1844 he made his last appearance in a political role as the unsuccessful vice presidential candidate of the Whig Party, headed by his friend Henry Clay. (*Portrait by Thomas Sully.*)

Enrollment in the college slowly increased from 30 students in 1825 to 85 in 1833. Students continued to come from Dutch families who resided in New Jersey and New York. Once in New Brunswick, they secured rooms in respectable boarding houses and became an integral part of the community. Students formed their own associations within the college. In 1825, they established two literary societies, Peithessophian and Philoclean, which became the center of social and intellectual life in the college during the 19th century.

The revival of Rutgers College commenced with enthusiastic optimism. The college had secured an able faculty, adequate facilities, and renewed leadership. A new building constructed on the corner of College Avenue and Somerset Street (today's Alexander Johnston Hall) opened in 1830 to accommodate the growing number of students in the grammar school and to separate the younger students from the undergraduates.

Milledoler found himself the source of dissension with the Dutch Reformed Church throughout the 1830s, specifically his opposition to the liberalization of the church. The leadership further complained that the theological professors had become overburdened with their teaching responsibilities within the "literary institution" (as the college was referred to in order to distinguish it from the seminary) and discussed proposals to remove the seminary from Rutgers College. By 1840, however, both parties had reached an agreement whereby the trustees were to elect a new president without approval from the church and to govern the college's affairs. The church guaranteed the trustees use of Old Queens for college instruction and tuition fees from those students supported by two beneficiary funds previously devoted to the support of deserving theological students. The theological professors would continue to provide instructional assistance in the college, when needed. In effect, this new agreement restored the authority of the trustees to govern the affairs of the college in order to "carry out the intention of those who first originated the plan of the College." This arrangement proved to be a significant step toward establishing the college's independence from the church.

through the generosity of Stephen Van Rensselaer. Rutgers' contributions to the college in New Brunswick, however, ended in 1826.

Rutgers College slowly progressed under Milledoler's leadership. Much of its early success was due to its ability to attract prominent scholars to the faculty. The faculty met twice a week to deliberate over the curriculum, examinations, grading, and student discipline. Rules and regulations governed student behavior within the halls of Old Queens and their conduct in the city of New Brunswick. The faculty, standing *in loco parentis* to the students, spent an enormous amount of time discussing such matters as tardiness, inattention in class, and absence without permission from chapel or recitations, and they handed out punishment accordingly.

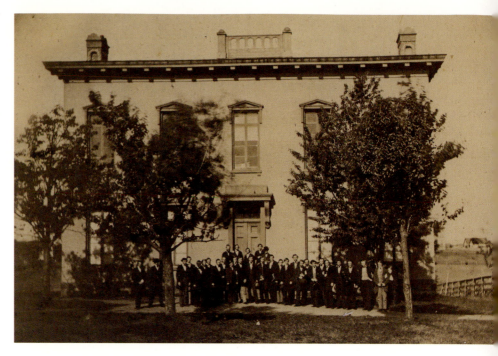

Abraham Bruyn Hasbrouck, chosen by the trustees in 1840 to succeed Milledoler, who had resigned the previous year, was the first layman to hold the office of president of Rutgers College. During his administration, Rutgers continued to suffer from a paucity of finances, but some progress was made. The number of faculty increased, and the curriculum expanded to include courses in modern languages and scientific instruction.

In 1841, the college erected a small house for the president and his family to the east of Old Queens on a plot of land leased from the church. Van Nest Hall, completed in 1848, became home to the two literary societies, the geological museum, and the chemical laboratory of Professor Lewis Beck. The literary societies flourished in the 1840s, but their supremacy was soon challenged by the

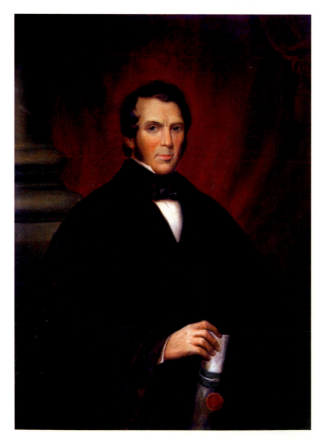

emergence of "secret societies," or Greek-lettered fraternities. Delta Phi, the first fraternity established at Rutgers in 1845, was soon followed by Zeta Psi in 1848, Delta Upsilon in 1858, and Delta Kappa Epsilon in 1861. The existence of these societies created animosity among alumni, whose loyalty remained with the literary societies and who sought to banish the fraternities from the college.

In the midst of this thriving collegiate life, the business end of the college struggled. Attendance steadily declined from 85 students in 1834–35 to 65 in 1849–50. President Hasbrouck resigned in 1849. The trustees had high hopes when they recruited his successor in 1850, former U.S. senator and vice presidential candidate Theodore Frelinghuysen—who also happened to be the great-grandson of Theodorus Jacobus Frelinghuysen, and the son of Frederick Frelinghuysen, the first tutor of Queen's College. Initially, the 63-year-old Frelinghuysen did not deliver. Enrollments and finances continued to decline. The trustees were forced to borrow from the principal of the college's endowment to meet construction costs for the president's house and Van Nest Hall and looked to innovative methods to raise the funds. They sold perpetual scholarships to individuals or groups (a common fundraiser in the 19th century). They hired agents to solicit subscriptions for the college in exchange for free tuition. Neither strategy sufficed, however. The public displayed great apathy toward the college, and the trustees placed the blame on the aging faculty. By 1859, the trustees replaced all of them with the

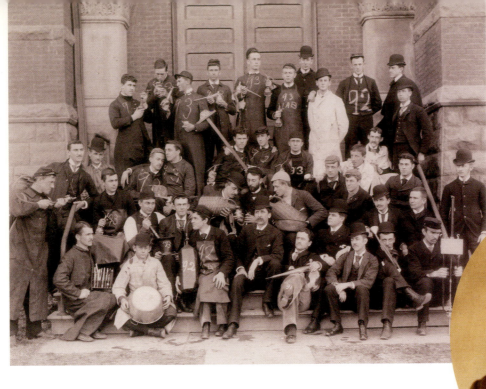

Members of the Laboratory Group assemble on the steps of New Jersey Hall, ca. 1891–92.

Composite of members of the Class of 1856. In the mid-19th century seniors would have their portraits taken and produced as cabinet cards by a local New Brunswick photographer, to be exchanged with their classmates. This tradition was soon replaced in 1871, when the first issue of the *Scarlet Letter*, the student yearbook, appeared.

Below: George H. Cook (1818–89) was Rutgers' first full-time professor of science; he also was made New Jersey's State Geologist in 1864.

exception of George H. Cook, who had joined the faculty in 1853 as professor of chemistry and natural sciences and would go on to have a major impact on Rutgers.

The number of students increased during the late 1850s—from 72 in 1850–51 to 124 in 1860–61. The latter arrived in a city that had become an industrial center with close ties to the commercial metropolis of New York. The growth in enrollment was due in part to a larger number of available scholarships, the national renown of President Frelinghuysen, and improved boarding facilities. But such a high number of students in both the college and the seminary created overcrowded conditions in Old Queens, prompting Professor William H. Campbell to admonish his students and fellow instructors to demand new facilities. The Synod obliged by acquiring a gift from Mrs. Anna Hertzog of Philadelphia to erect a spacious building one block north of the campus. In 1856 all seminary work was transferred to Theological Hall (later known as Hertzog Hall), signaling the physical separation of the college from the church.

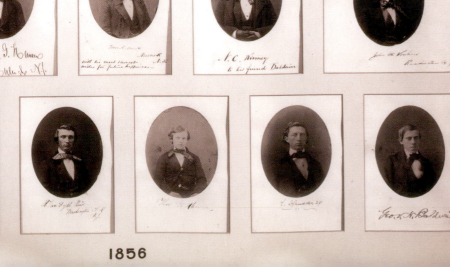

1856

Students gathered in 1862 for one of the earliest posed shots in front of Old Queens.

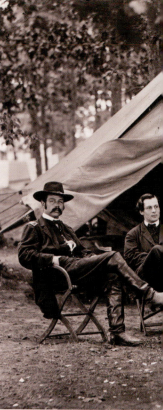

The Civil War ushered in a great transformation for higher education, and the war itself had a considerable impact on Rutgers. Not surprisingly, enrollments steadily decreased, reaching a low of 64 students in 1863–64. The decline temporarily disrupted collegiate life. The faculty and students demonstrated their allegiance to and support of the Union, though three students from the South left New Brunswick to join the forces of the Confederacy. Approximately 160 Rutgers alumni representing the college classes of 1827 through 1873 served in various capacities during the conflict, and 17 died during the war.

By the war's end, Rutgers College had completed another distinct era in its history. The Covenant of 1825 that had reopened the college with great optimism had also placed the institution under the direct control of the Dutch Reformed Church. But the trustees, perennially plagued with financial problems, "never waived the autonomy with which they were vested by the charter." Through a series of struggles and negotiations, they were able to regain control of the college and would soon reclaim ownership of Old Queens. In 1867, Rutgers College successfully severed its organizational ties to the church by separating from the seminary, though it remained Dutch Reformed in character. With one source of bitter contention removed, the college soon became entangled with another that would prove to be equally problematic and much longer term—its relationship with the State of New Jersey.

Above: Riverstede, one of several homes built and occupied in New Brunswick by George H. Cook. The building, located at 542 George Street on the corner of Seminary Place, has served multiple purposes and has had several names through the years, including Demarest House, named for William Henry Steele Demarest who lived in the house after serving as Rutgers president, 1906–24.

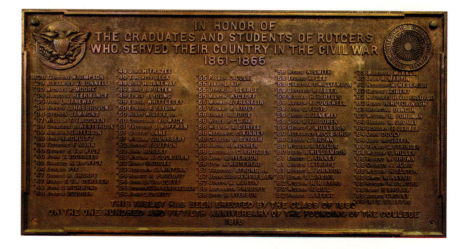

Above: Civil War plaque commemorating the alumni and students who served, 1861–65.

Right: Andrew Kirkpatrick Cogswell (1838–87) graduated from Rutgers in 1859 and served as a private in the 7th Regiment, New York Volunteers, during the Civil War. Cogswell earned a degree from Columbia Law School in 1863 and went on to a successful legal career as a lawyer and judge in the Court of Common Pleas in Middlesex County, N.J.

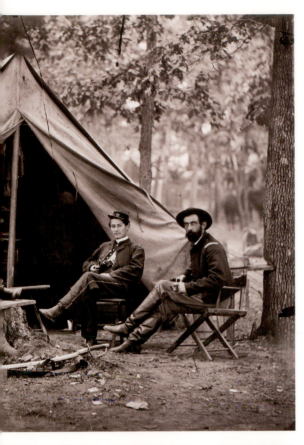

Left: Civil War camp, Brandy Station, Virginia, 1864. George Henry Sharpe is seated far left.

Below: Jacob J. Janeway (1840–1926) graduated from Rutgers in 1859 and served in the Union Army during the Civil War as a captain, major, lieutenant colonel, and brevet colonel in the 14th Regiment of the New Jersey Volunteers. Janeway went on to a successful manufacturing career with the Janeway & Carpender Wallpaper Company in New Brunswick.

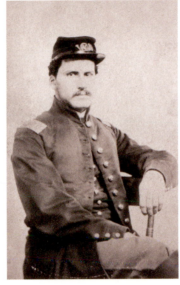

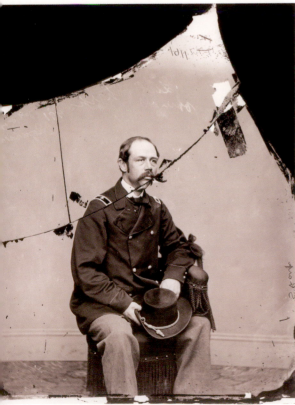

George Henry Sharpe (1828–1900), Rutgers College Class of 1847, is arguably the father of U.S. military intelligence. After receiving two degrees from Rutgers and a law degree from Yale, Sharpe worked as an attorney for several years. As the Civil War ravaged the nation, he raised a regiment, the 120th New York, and commanded it during fighting in the Fredericksburg, Virginia, area. In 1863, Major General Joseph Hooker was named by President Abraham Lincoln to lead the Union Army. Hooker was unhappy with the state of military intelligence and asked Sharpe to create a Bureau of Military Information. A few months later, the bureau accurately assessed General Robert E. Lee's order of battle just before the Battle of Chancellorsville. Sharpe's intelligence reports made additional vital contributions to the Union cause from the Battle of Gettysburg until the final siege at Petersburg. A U.S. Army study praised Sharpe's practice of "comparing intelligence from a number of sources and evaluating it before passing it along." Sharpe served as a U.S. Marshal from 1870 until 1873, and was instrumental in uncovering the Boss Tweed election fraud of 1868 in New York City. Sharpe served as a Rutgers College trustee from 1879 until his death in 1900.

The Multipurpose College

Between the Civil War and the turn of the 20th century, American society shifted from a primarily agricultural economy to an industrial one; from a vast stretch of Protestant small towns to a diverse, cosmopolitan nation with world-class cities. Millions of immigrants arrived during these decades, many of them from places unfamiliar to most Americans. Revolutions in transportation, communication, and other technologies created entire new industries and transformed old ones. Major corporations emerged (including the birth of Johnson & Johnson in New Brunswick in 1886), employing thousands of men and women, greatly expanding white collar and professional work, and creating a new class of the super-rich. Politically, the Civil War and Reconstruction not only freed enslaved people and gave them citizenship and educational institutions (which Jim Crow laws later perverted), but also greatly expanded the size and scope of government.

All these changes, and more, placed new demands on higher education and offered new opportunities for growth. Every aspect of American colleges changed—funding, administration, curriculum, student life, even the core purposes of institutions. Fueled by huge federal and private grants, the number and variety of institutions doubled between 1870 and 1900, as did the percentage of Americans aged 18–24 years old enrolled in some form of postsecondary education. New kinds of institutions proliferated—segregated colleges for African Americans; large, coeducational state universities; so-called "normal schools" to train teachers; and, beginning with Johns Hopkins, full-fledged research universities. Meanwhile, students demanded a curriculum that was more useful and scientific, and a social experience that was, for lack of better words, more fun. In this uncertain educational marketplace, old denominational colleges like Rutgers struggled to reconcile their traditional missions with major funding opportunities, the demands of students, and the changing times. Many became multipurpose institutions, reacting to rather than leading change. Despite this period of transformation and growth, as of the year 1900 only

Daniel S. Schanck Observatory

In 1865, architect Willard Smith started construction on a two-story, octagonal Greek Revival building on the corner of George Street and Hamilton Street that was to be Rutgers' first building devoted solely for scientific purposes. Modeled after the Tower of the Winds in Athens (ca. 100–50 BC), the Daniel S. Schanck Observatory was dedicated on June 18, 1866, following a year of construction. The project costs totaled $86,845, with $33,802 donated by New York City businessman Daniel S. Schanck.

Complete with telescopes, clocks, and a revolving roof, the observatory was highly advanced for its time. Most of its equipment was donated by the Peithessophian and Philoclean literary societies as well as individual donors. Unfortunately,

as time went by, New Brunswick light pollution and the building's proximity to growing trees made astronomical observations here nearly impossible. The facility was closed in the 1960s and suffered decades of vandalism and decay. Today, astronomical observation is made across the Raritan at the Robert A. Schommer Astronomical Observatory on the roof of the Serin Physics Lab on the Busch Campus.

In 1973, the Schanck Observatory was added to the National Register of Historic Places, and in 2012 its exterior was restored. The future of the observatory is currently unknown, but it stands as a marker to where Rutgers began its construction of facilities for scientific exploration.

—ELIJAH REISS (SAS '17)

Below: In 1888 the New Jersey Legislature passed a bill providing for state funds to construct an "Agricultural Hall" to accommodate the recently established State Experiment Station. Situated on land deeded to Rutgers by James Neilson, the building, which became known as New Jersey Hall, was completed in the spring of 1889. It originally housed the State Agricultural Experiment Station as well as the college's chemistry and biology departments, all of which had been previously located in Van Nest and Geological halls. Designed in the Richardsonian Romanesque style by George K. Parsell, New Jersey Hall was partially destroyed by fire in 1903 but was restored without essential changes to its original composition. The building was added to the National Register of Historic Places in 1975.

Above: Notarized document certifying the legislation (**left**), signed by Governor Joel Parker on April 4, 1864, designating Rutgers College as New Jersey's land-grant college.

2.3 percent of Americans aged 18–24 attended some form of higher education. College did not become all things to all people, but many things to a chosen few.

The single biggest change for Rutgers was the passage of the federal Morrill Act in 1862. The act promised grants of federal land, which through sale or rental would produce funds to support colleges that

> *without excluding other scientific and classical studies and including military tactics, …teach such branches of learning as are related to agriculture and the mechanic arts… in order to promote the liberal and practical education of the industrial classes in the several pursuits and professions in life.*

States across the North and Midwest (Confederate states were obviously excluded) selected or built colleges to receive the windfall. In an effort led by chemistry and natural sciences professor George H. Cook, Rutgers made a successful bid to be the State of New Jersey's land-grant college. As a result, Rutgers launched the Scientific School, designed to provide an academically oriented education in science for farmers and scholars alike, purchased a 100-acre farm on what is today the George H. Cook Campus of Rutgers, and thanks to a generous benefactor, constructed the Schanck Observatory, which still stands on George Street. The Scientific School offered two tracks: engineering and chemistry.

For the first decade, the effort was beset with problems. Despite the fact that Rutgers had agreed to offer up to 40 full scholarships, there were not enough qualified applicants. Indeed, there were too few students to support the two-track curriculum. Farmers—a key target population for the plan—did not flock to science classrooms. Socially, it took several years for the regular Rutgers College crowd to accept the "scientifs." In a colossal blunder, the college held a separate ceremony for the first graduating cohort of the science school, which the students resented and which was

Alumnus James Neilson (RC 1866) donated large tracts of land to Rutgers including the parcel between Hamilton Street and Seminary Place—now Voorhees Mall—as well as Neilson Field and his home and property on the current Cook/Douglass Campus where the Eagleton Institute of Politics is situated.

not repeated. The annual proceeds of New Jersey's federal land grant amounted to $5,800, well short of the costs of the school and the college farm. Rutgers adapted. Gradually, students filled the seats in the Scientific School and won an equal place in the life of Rutgers College.

If the Morrill Act of 1862 was a financial disappointment, the Hatch Act of 1887 and the Second Morrill Act of 1890 were a triumphant vindication of the decision to become New Jersey's land-grant college. The new Morrill Act, intended to extend the original act to former Confederate states, appropriated annual cash grants to each state's agricultural college of $15,000, rising $1,000 annually to $25,000. The Hatch Act, designed to support agricultural experiment stations—centers where modern modes of agriculture would be researched, developed, and shared with the public—provided another $15,000 annually and was integrated into the existing New Jersey Agricultural

Experiment Station created in 1880 by George Cook, to the direct benefit of Rutgers. By 1890, three-fifths of the Rutgers budget, not including the experiment station money, came from federal land grants. By 1900, scientifs outnumbered classical track students two to one.

Although Rutgers was not the only private institution to serve as its state's land-grant college, the period from 1860 to 1900 saw a development of a uniquely strained

Below: Situated between Old Queens and Van Nest Hall, Geological Hall was completed in 1872. Designed by Henry Janeway Hardenbergh, this Gothic brownstone structure was former home to the departments of geology, physics, and military science. On the second floor resides the Rutgers Geology Museum, nationally recognized for its outstanding collection of minerals, fossils, Indian relics, and modern shells. A 10,000-year-old mastodon (**opposite**) has dominated the museum for over a century. Also on display is an Egyptian sarcophagus, replete with mummy, jewels, and relics.

Henry Janeway Hardenbergh, Architect of Geological Hall and Kirkpatrick Chapel

Situated on each side of Old Queens, Geological Hall and Kirkpatrick Chapel appeared on the Rutgers College campus in the early 1870s. The architect for these two structures was Henry Janeway Hardenbergh (1847–1918), a young protégé of the German architect Detlef Lienau. Hardenbergh's ties to Rutgers were substantial. His great-great-grandfather was Jacob Rutsen Hardenbergh, the first president of Queen's College; his maternal grandfather was the Reverend Jacob Janeway, who served as a vice president; and his maternal uncle was Henry Janeway (RC 1844), who, as a college trustee, assisted the young architect in securing his first commission—a two-story addition to Alexander Johnston Hall. So pleased were the trustees with Hardenbergh's "substantial" design, they selected him for their next two projects. In 1872, Geological Hall appeared in response to the federal legislation that established Rutgers as New Jersey's land-grant institution. The building was one of the nation's first devoted to instruction in agriculture, the mechanic arts, and military tactics. Hardenbergh soon followed with a design for a chapel that

Kirkpatrick Chapel, a Gothic Revival church designed by Henry Janeway Hardenbergh, was built in 1873. The chapel is named for Mrs. Sophia Astley Kirkpatrick of New Brunswick, who donated $65,000 to Rutgers. In addition to religious services, the chapel housed the college library on the second floor until 1903, when Voorhees Hall was completed. The chapel contains a collection of portraits of prominent officers and benefactors of Rutgers. Kirkpatrick Chapel is a striking combination of 14th-century German and English architecture.

relationship between the state and the college. Rutgers and other colleges of the day did not survive on tuition, which was quite modest by today's standards. Support had to come from elsewhere. Even if Rutgers was the state's land-grant college, however, many state officials were wary of too much entanglement with the private college. The state legislature offered no direct support for Rutgers. Indirect efforts were mixed. In 1888, the state agreed to build an agricultural building, which came to be known as New Jersey Hall, on a plot of land donated by Rutgers trustee James Neilson (RC 1866). Although owned by the state, ostensibly for running its agricultural experiment station, the building housed classrooms for chemistry and biology for the Scientific School. In another instance, the state legislature agreed to remunerate Rutgers for an expanded scholarship program, but the state comptroller balked at making the payments after the first year and the matter died. Ironically,

the federal government and private donors kept the land-grant college of New Jersey afloat until the 20th century.

The late 19th century brought Rutgers a number of active and charismatic presidents. The most important of these men—perhaps the most effective president in his century—was a former pastor and academy principal, the Reverend Dr. William H. Campbell. From 1862 to 1882, President Campbell oversaw a major transformation of the college from a small, sectarian, struggling institution to a substantial, academically oriented, increasingly secular, financially secure, multipurpose college. Even before securing the federal land grants, Campbell initiated an ambitious fundraising campaign to raise $100,000 from private donors, which he achieved within a year. He then broke the direct connection between the college and the church, reaching an amicable settlement

Left: One of Hardenbergh's bills for work on Kirkpatrick Chapel, 1873.

was privately funded by Sophia Kirkpatrick. The completion of Kirkpatrick Chapel (1873) prompted a lengthy story in *Architectural Digest*, which described the building as "a creditable piece of work" and launched Hardenbergh's career. Following his commission in New Brunswick, Hardenbergh moved to New York City.

Family connections and a growing reputation led to his being entrusted with very substantial undertakings. In 1880 he completed work on the Dakota Apartments, which, according to architectural historian John Tauranac, "changed the city's social structure" by anchoring a desirable new uptown neighborhood. (In the recent past, the Dakota has been home to such luminaries as John Lennon and Yoko Ono, Lauren Bacall, Leonard Bernstein, Roberta Flack, Rudolf Nureyev, and others.) In the early 1890s, the Astor family hired Hardenbergh to design the original Waldorf-Astoria. Between 1901 and 1912, he designed several hotels outside Manhattan, including the Raleigh and Willard in Washington, D.C., the Windsor in Montreal, and the Copley

Plaza in Boston. His crowning achievement, however, was the New York Plaza Hotel, which opened in 1907.

As the country's most influential luxury hotel architect, Hardenbergh never forgot the institution that launched his career. He assisted the Rutgers trustees in selecting architects for other campus buildings and lent his design experience to an interior renovation of Kirkpatrick Chapel. He and his brother William donated to the chapel a stained-glass window, *Jesus, the Teacher of the Ages*. Upon his death in 1918, *Architectural Record* called Hardenbergh "one of the most august and inspiring figures that American architecture has produced."

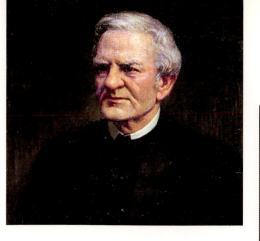

The Reverend William Henry Campbell (1808–90), eighth president of Rutgers and its most influential leader during the 19th century. He began his career in New Brunswick as professor of Oriental languages in the theological seminary and, concurrently, professor of *belles lettres* in Rutgers College.

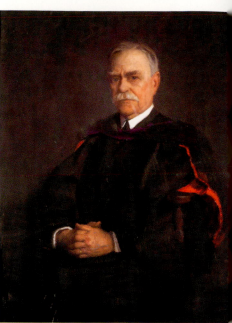

that bought back the Old Queens Building and other campus property and fully separated the seminary from the college.

Campbell's leadership in the pursuit of land grants and the construction of the Scientific School and other facilities transformed the college. He made additional changes to teaching and learning as well. Most significantly, he hired a number of highly regarded and capable faculty members noted more for their scholarly credentials than their religious commitments, and substantially increased faculty salaries to keep them. Under his leadership, the faculty enjoyed a large degree of authority and responsibility for the operation of the college. History became a regular subject. Modern languages returned to the curriculum, while Latin and Greek became optional after sophomore year to allow juniors and seniors to take an elective course—a reform that was sweeping higher education at the time. Another notable change was the decision to offer graduate-level courses—approved by the trustees in 1876. Not all decisions were forward looking: even as he broke formal ties with the church, Campbell initiated

a compulsory bible study class. In a similar vein, while higher educational institutions—particularly land-grant institutions—increasingly opened up to women, the Board of Trustees shot down a similar proposal by the faculty in 1881. Nevertheless, under Campbell's leadership, the college grew from 79 undergraduate students in 1862 to 194 in 1872. Moreover, his leadership on the issue of federal land grants bore substantial fruit long after his departure.

Subsequent presidents built on Campbell's legacy. Merrill Edward Gates (1882–90) embarked on an aggressive campaign to raise academic standards and improve student discipline. Only 34 years old, Gates was ambitious, energetic, and opinionated. His vision of the college was a traditional one: looking after the moral development of each student in a distinctly Christian environment. Conservative in academic matters, he also attempted to regulate students' personal lives,

Above: An eminent and influential teacher, Austin Scott (1848–1922) was professor of history, political economy, and constitutional law in Rutgers College when the trustees elected him to succeed Merrill Gates as Rutgers' 10th president in 1891.

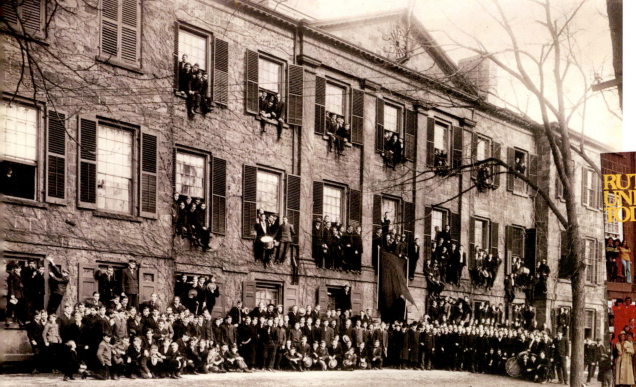

Left: Students gathered at Old Queens in 1906 on the occasion of the inauguration of William H.S. Demarest as president. The student body at that time was around 250 and the younger boys in the photograph were probably from the Grammar School.

Below: Taken in 1979 for a university publication, the photo recreates the 1906 image.

Winants Hall, designed by New York City architect Van Campen Taylor (Class of 1867), was Rutgers' first dormitory, constructed in 1890. It is named for Garret E. Winants, a wealthy philanthropist from Bayonne who in 1889 joined the Board of Trustees and a year later presented a sketch of a proposed dormitory building and a gift of $75,000 to pay for its construction. Winants Hall served as the sole dormitory for Rutgers until 1915, when John Ford Hall was constructed. In the late 1940s the building was converted for use by departments and administrative offices of the university. On November 9, 1990, a century after its construction, Winants Hall was rededicated following a two-year, $9.4 million restoration.

interviewing each one about his spiritual beliefs, tightening the regulations of student associations, and requiring a weekly gym class. He shook up the faculty as well, curtailing their authority and responsibilities and recruiting stellar young scholars. Despite some resistance, Gates succeeded in raising the academic standing of the college. He was less successful at fundraising—with one exception. With the help of an unsolicited gift from Garret E. Winants, he oversaw the creation of the first dormitory on campus to further his vision of an ideal community (Winants Hall, 1890).

Gates's successor was Austin Scott (1891–1906), an energetic and hot-tempered Rutgers professor of history and constitutional law. While Scott labored to take the college in a

new direction (abolishing mandatory bible study, for example, and reinvigorating faculty governance), he spent much of his presidency playing defense. His greatest challenge was the relationship to the state, a problem compounded by what was at that point the worst economic depression in American history, which lasted from 1893 to 1897. Enrollments dropped nearly 30 percent. By law, Rutgers provided nearly all the Scientific School students with full scholarships—for which, also by law, it was supposed to be compensated by the state, but wasn't. After a series of legal maneuvers, the college finally won recognition as a public university (though not in terms of oversight) in the highest court in the state, and the state legislature began compensating the college for what became state scholarships in 1905.

During Scott's presidency, Rutgers had become, by national standards, a small scientific college with a tiny classical program. By 1906, William H.S. Demarest (RC 1883), Scott's successor, saw Rutgers enroll 235 students, making it half the size of peer institutions and a fifth the size of rival Princeton. The state legislature was committed to a small but steady stream of financial support, as was the federal government. Private donations and the college endowment did not approach the hopes of the school's leaders.

Despite the struggles of Rutgers leadership, student life flourished, replete with fraternities, intercollegiate athletics, a YMCA, debating contests, and new secret honorary societies such as Cap and Skull (1900), Casque and Dagger (1901), and Theta Nu Epsilon (1892). Students experimented for the first time with self-government and formed a committee to regulate student conduct and discipline. Physical training received a boost in the 1890s when Robert F. Ballantine, a wealthy brewer in Newark and college trustee, bequeathed funding to build a gymnasium on a site now occupied by the Zimmerli Art Museum. A private gift from Mrs. Ralph Voorhees provided funds for the construction of a new library, now Voorhees Hall, in 1904. Rutgers emerged in the new century as a small but otherwise typical American college: a place where the male upper middle class went to study, make connections, form friendships, and learn the habits necessary to solidify their place in the new American industrial economy.

The campus community surveys the damage to Ballantine Gym following a devastating fire in 1930. The current Zimmerli Art Museum and Voorhees Hall are built around the Ballantine's remnants.

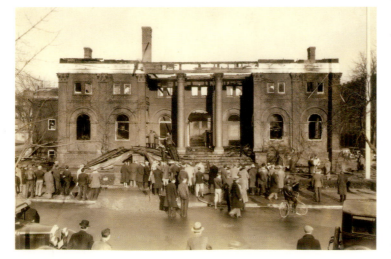

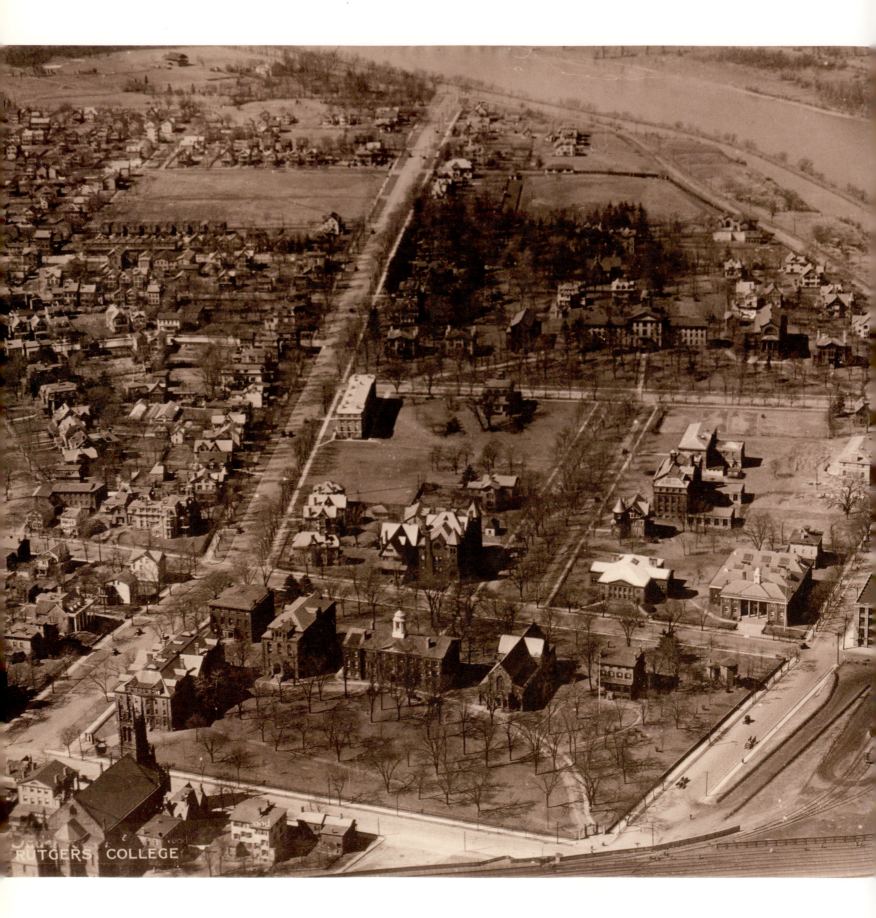

RUTGERS COLLEGE

Left: Aerial view of Rutgers College showing the College Avenue campus in 1923.

Right: William Henry Steele Demarest (RC 1883), the first alumnus to become president of Rutgers College, envisioned a dual role for the institution. One would be that of a state-supported university; the other, the small private college the school had been throughout its history. Of Demarest, Richard P. McCormick notes, "No son of Rutgers had ever been privileged to serve his alma mater with such loyalty and distinction."

Toward a Modern University

The Progressive Era marked a great reordering of social institutions in the United States into the patterns that would remain in place for the next 100 years. Social efficiency was the watchword. Business leaders and social reformers believed in expanding and improving government, increasing educational opportunity, and applying modern science to social problems. Public high school enrollment more than doubled between 1890 and 1900, and then doubled again each decade until 1930—a change from 200,000 to 4.4 million students; growth peaked at 6.6 million in 1942.

Progressive reform profoundly reshaped America's colleges, which in particular reaped the benefits of mass enrollments in public high schools. At the end of the 19th century, Rutgers and most other colleges were not selective, and rarely turned away minimally qualified applicants. Supply outweighed demand. The explosion of high school graduates, however, created a vast new class of consumers of higher education, transforming the higher education marketplace. From 1890 to 1930, the percentage of Americans enrolling in higher education degree programs rose from 1.8 percent of 18- to 24-year-olds to 7.2 percent. In raw numbers, this meant a jump from 157,000 to 1.1 million students. Higher education became a national marketplace, and colleges and high schools exerted influence on each other—aligning curricula and admissions standards and creating accrediting and accounting mechanisms to make the system more efficient.

For Rutgers, the first three decades of the 20th century saw several major changes associated with these broader social shifts: a final break with its sectarian roots and renegotiation of its relationship to the state, a major reorganization and expansion of the curriculum, the expansion of the student body, and transformation into a full-fledged university. The Great Depression then put all of these issues on the back burner as the university sought to manage the economic catastrophe, but ultimately, it was the entry of the United States into the Second World War that marked the end of a unique era in higher education.

At the start of President Demarest's administration (1906–24), the State of New Jersey had agreed to reimburse the college for student scholarships, formally (if tepidly) accepting responsibility for Rutgers as the state college. Over the next four decades, that relationship proved to be a challenging and unique one, as the state haltingly increased its financial support while fighting unsuccessfully to wrest control from the private Board of Trustees. Throughout the period, outside entities consistently cited this curious relationship as a source of dysfunction—state lawmakers

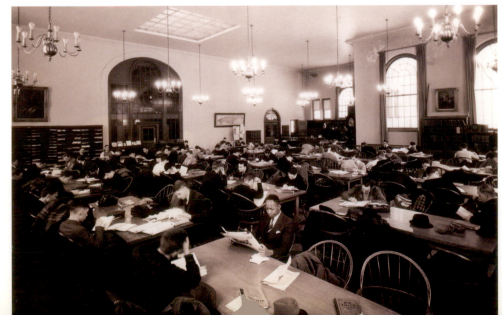

Students studying in the Voorhees Library, 1934. Completed in 1904, Voorhees Library replaced the over-crowded library on the second floor of Kirkpatrick Chapel. This new library served the students of Rutgers College through most of the 20th century. In 1956 the Alexander Library opened and Voorhees became home to the art history department.

were wary of committing too much public money to a private, denominationally oriented institution without public oversight in return; private associations and donors were wary of the college's precarious relationship to the state and the financial insecurity that resulted. For their part, the trustees refused to compromise the core values and traditions of Rutgers enshrined in its charter.

In 1920, the Board of Trustees removed all religious references from the charter, including the requirement that the president and a percentage of the board be members of the Dutch Reformed Church. Rutgers was now, legally speaking, a secular institution. To prove its ecumenical intentions, the board elected its first Roman Catholic member in 1922. Meanwhile, over the course of President Demarest's tenure, the annual state appropriation grew by a factor of 15, with most of this money going toward scientific and technical programs.

Nevertheless, these numbers must be put in perspective. In 1927, President Demarest's successor, John Martin Thomas (1925–30), solicited the U.S. Bureau of Education to sponsor a study of higher education in New Jersey. The conclusions were scathing. Despite the growth of the university, nearly 80 percent of New Jersey students left the state to go to college, and another 13 percent attended colleges in New Jersey other than Rutgers. Only 7 percent of New Jersey students enrolled in college were attending Rutgers, ostensibly the state university! This was a lower rate by far than any other state.

Rutgers added new colleges, schools, and programs, and took the university in a more progressive direction. The first of these new units was for women. With the exception of one small women's college, the only viable paths to a higher education for most New Jersey women were to attend a teacher training or "normal" school, or leave the state. The New Jersey Federation of Women's Clubs first raised the problem in 1911, and Mabel Smith Douglass took the lead. A talented politician and energetic leader, she doggedly developed a statewide network of people interested in bringing women to Rutgers. Although the conservative President Demarest refused to have women at Rutgers College, he supported the idea of a separate, affiliated institution for women. By 1918, the Board of Trustees

announced the establishment of "a Women's College as a department of the State University of New Jersey maintained by the trustees" and Douglass took the post of dean. The New Jersey College for Women enjoyed rapid growth in enrollments and reputation until, by the early 1930s, it was on parity with the men's college. Indeed, so fiercely did the women's college assert its independence from Rutgers that the board had to formally reassert its authority in 1932, agreeing in return to include five women among its ranks.

The transition from college to university involved the creation of other semi-independent units as well. In 1914, Congress passed another grant program, the Smith-Lever Act, to support extension programs in agricultural and other fields. As a result, the college farm more than doubled in size. In 1917, seeking to clarify its position, the Board of Trustees managed to get the state legislature to designate

Above: Dean Mabel Smith Douglass and President William Demarest lead the academic procession at the 1924 New Jersey College for Women commencement.

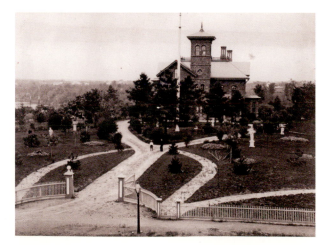

Left: College Hall on the Douglass Campus, formerly the Carpender House, served as the only building when the New Jersey College for Women opened in 1918.

Opposite: The building currently houses the offices of the dean of Douglass Residential College.

Below: Botany laboratory of New Jersey College for Women (NJC) in the early 1920s. The instructor (standing) is Jessie G. Fiske, one of the earliest female faculty members at NJC in biological sciences who began as a laboratory assistant in botany in 1918 and progressed to professor and chair of her department.

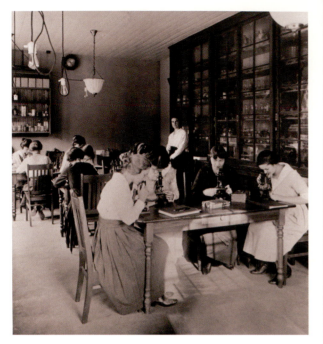

the Rutgers Scientific School, also called the State College of Agriculture, as the "State University of New Jersey, maintained by the Trustees of Rutgers College." Thus the state university was within Rutgers College, but it remained unclear where one began and the other ended.

In 1921, the trustees and the state reorganized the College of Agriculture (later renamed Cook College) as a semi-independent unit within Rutgers, along the same lines as the College for Women. By 1924, Rutgers College had become Rutgers University. The following year, the board reorganized the remnants of the old classical program into the College of Arts and Sciences, while the parts of the Scientific School not in the College of Agriculture became the College of Engineering. The university added yet another unit in 1927 with the addition of the New Jersey College of Pharmacy in Newark.

The field of education saw even more growth. Rutgers had offered classes to seniors on the art of teaching since the late 19th century. Thanks to the popularity of both the professors and the subject, more faculty and more types of courses were added that focused on education, which became its own department, and then, in 1923, a full-fledged School of Education. By 1929, the School of Education offered the largest program at Rutgers, including

Below: Paul Leroy Robeson (1898–1976) is one of the most well-known graduates of Rutgers. A future singer, actor, orator, and civil rights activist, Robeson excelled both as a scholar and athlete during his four years "on the banks." This image of Robeson appears as his senior portrait in the 1919 *Scarlet Letter* yearbook.

nearly 2,900 students enrolled in summer session on campus and another 2,500 taking extension courses off campus at 28 different sites in New Jersey and one at the Metropolitan Museum of Art in New York City.

All this rapid growth led to major changes in the organization and curriculum of the university, which became more comprehensive, vocationally oriented, and compartmentalized. In addition, a handful of graduate students could earn master's and doctoral degrees. Across the university, professional administrators and staff took over jobs once performed by faculty. The faculty became increasingly specialized and research oriented.

The student body changed as well. While still a bastion of the upper middle class and elites, Rutgers boasted students from over a dozen states, and a greater variety of walks of life. In 1900, most Rutgers students had gone to private high schools. By 1930, the majority had attended public ones. New groups came to college campuses in numbers never seen before, leading many institutions, including Rutgers, to develop mechanisms for marginalizing certain groups as a way to protect privilege—of religion, gender, class, and race. Even within the notably separate New Jersey College for Women, no African-American woman graduated until 1938.

In general, just a few remarkable African-American students were able to overcome the racism and discrimination at Rutgers—and throughout the nation—to successfully reach graduation. The first at Rutgers, James Dickson Carr (RC 1892), went on to Columbia Law School and became one of New York City's first African-American judges. The third, Paul Robeson (RC '19), was an all-American athlete, debating champion, member of Phi Beta Kappa and the elite Cap and Skull, student speaker at commencement, and future world-famous actor, singer, and civil rights leader. Like most public and private educational institutions, Rutgers failed to publicly acknowledge the ways in which it promoted white privilege, while at the same time actively engaging in racist policies that excluded or marginalized African-American students. Not until the civil rights movement forced the issue did the university seriously consider the problem of race and accept social justice as part of its mission.

Jews fared better, although they too had to fight for fair treatment. Only a trickle of Jewish students had attended Rutgers in the 19th century. But their numbers greatly increased in the early 20th, as more Jewish immigrants

settled in the Garden State and attended public high schools. Between 1920 and 1930, Jewish enrollment grew from 5 to 20 percent of the Rutgers student body. Moreover, Jewish students achieved much academic distinction, earning nearly one-half of state scholarships by the end of the decade, and the envy and resentment of some of their peers.

Even though Rutgers claimed to be a secular state university after 1920, in reality the trustees sought to maintain the tradition of Christian, especially Protestant, culture. In their study of anti-Semitism at Rutgers during the 1920s and 1930s, historians Michael Greenberg and Seymour Zenchelsky found that the student government and the Board of Trustees colluded to prevent the formation of Jewish student groups. The New Jersey College for Women tried to prevent Jewish women from entering its teacher education program. The men's college changed its admissions policy from accepting anyone who met a minimum standard to having a "selective" admissions process. The result was a student body with lower test scores and fewer Jews. Rutgers was not alone: anti-Semitism became widespread across American higher education during the 1920s and 1930s.

Jewish leaders and outraged students took the matter to the state, leading to an official investigation into the actions of the Board of Trustees and the administration. The board insisted that Rutgers, as a private institution, had the right to discriminate in its admissions process, and even defended the institution's anti-Semitism. Not until after the Second World War did the board change its position.

For over 150 years, Rutgers students had organized extracurricular life on their own. In the 1930s, the faculty began assessing a general fee for extracurricular activities and funding and regulating formerly independent activities. On the whole, the students gained from this new arrangement with better-organized sports, improved fraternity life, an expansion of literary publications, and the formation of academic clubs such as the History and Politics Club and the Spanish Club, among others.

The Great Depression hit the university hard. The state cut support by over 30 percent between 1930 and 1933—

from $1.1 million to $664,360—while enrollments in the colleges declined 16 percent; the university cut salaries until the state budget and enrollments returned to normal. Adding insult to injury, the Ballantine Gymnasium was destroyed by fire in January 1930, requiring an outlay of hundreds of thousands of dollars for a replacement. The university got by. New Deal programs provided employment

Below: When Lienhard Bergel (left), an instructor in the German department of the New Jersey College for Women, was let go in 1935 he claimed his failure to share the pro-Nazi views of department chair Frederick J. Hauptmann (right) as the reason behind his termination. A trustee investigation into the matter disagreed, citing "budgetary issues and declining enrollments." Fifty years later, a panel concluded that political differences did play a role in the dismissal.

DEDICATION
OF THE
RUTGERS STADIUM
1938

NOVEMBER 5 · 1938

50 CENTS

RUTGERS 1869 PRINCETON
FIRST INTERCOLLEGIATE FOOTBALL GAME · ·

Left: A significant Works Progress Administration (WPA) project in the 1930s was the construction of Rutgers Stadium on the newly acquired University Heights (now Busch) Campus. The stadium was completed in 1938 and witnessed in the dedication game a Rutgers victory over Princeton, the first since the historic intercollegiate football game in 1869.

Below: The log cabin, now in Rutgers Gardens, was built in 1935 as a Works Progress Administration project during the Depression.

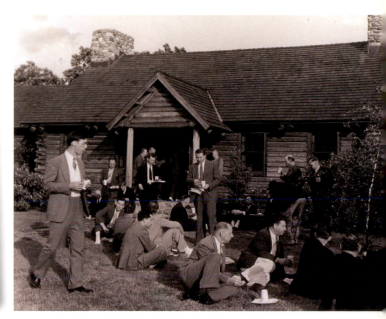

and services: the Civilian Conservation Corps (CCC) and the Works Progress Administration (WPA) did extensive work on campus, including building the now-famous Log Cabin and the original Rutgers Stadium. And the trustees responded to changing student demand. During the 1930s, enrollment in the College of Arts and Sciences remained stagnant, but more than doubled in the College of Agriculture, Schools of Education and Chemistry, and Department of Ceramics. In 1935, the university added a School of Banking to its campus. The Extension Division expanded its enrollments, too. But the biggest change was the creation of University College in Newark, a school geared toward part-time and evening students. By the end of the 1930s, enrollments and state support had rebounded to new highs.

The coming of World War II further revolutionized higher education. America's participation in the First World War had been mercifully brief; and while Rutgers participated fully in the effort, the experience did not deeply change life at the college. Initially, the declaration of war in April 1917 had led nearly half the student body to drop out, though most students engaged in agricultural occupations and only four faculty members and 63 students joined the military. Altogether over 800 alumni and students served in the war, half as commissioned officers. Twenty-one died in service, and another 21 were wounded. The effect on daily operations was relatively minor.

Not so with the Second World War, which profoundly affected the university in both the short and long term. Once again, enrollment in the men's programs fell by 50 percent. In total over 1,700 undergrads dropped out of Rutgers from 1941 to 1945 to fight, and historian Richard P. McCormick estimated that one-third of all living alumni at the time served in the armed forces. Nearly 200 Rutgers women (alumnae and students) served too. By the end of the war, two women and 234 men had died in service, including the son of President Robert Clothier (1932–51).

The war effort touched every aspect of the university and profoundly reshaped daily operations. Plummeting civilian enrollments among men forced the university to streamline its regular curriculum, while the addition of the Army Specialized Training Program (ASTP) and Army Specialized Training Reserve Program (ASTRP) brought thousands of new students for training in civil affairs, engineering, and area and foreign language studies. Many of these courses were offered in partnership with neighboring Camp Kilmer, which served as the main embarkation facility for soldiers bound for the European theater. The war effort required the addition of new courses and the adaptation of old ones. The chaotic enrollment status of undergraduate men, combined with the military's demands for rapid training and deployment of its ASTP students, kept faculty scrambling to teach whatever and whenever required. Nonmilitary research languished, while courses in the humanities struggled for survival. Applied sciences thrived. By 1943, nearly all student organizations had disbanded, most fraternities had closed, and a few frat houses were borrowed by the military to house soldiers. Even the student newspaper, the *Targum*, suspended operations in 1944. Athletics limped along at a reduced schedule.

After the war, Rutgers and the State of New Jersey tried to resolve their differences. The state abolished the Board of Regents, declared all parts of Rutgers to be The State University of New Jersey, and acknowledged that the university was an "instrumentality" of the state responsible for the provision of public higher education. The Board of Trustees agreed to allow key state officials to serve as ex officio members of the board and to admit five public trustees appointed by the governor. Now the State Board of Education would have the power to advise the trustees and to investigate and make recommendations to the governor

and state legislature. The legislature agreed to take financial responsibility for supporting the university, and employees became state employees, entitled to the state's retirement system. The Board of Trustees remained largely private.

Above: Members of the Student Army Training Corps (SATC) perform field drills during World War I.

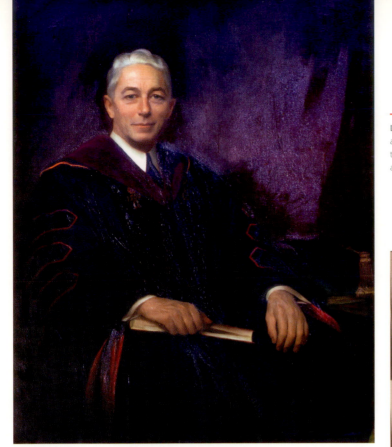

Left: Robert Clothier (1885–1970), served as Rutgers' 14th president during the tumultuous years of the Great Depression and World War II, 1932 to 1951.

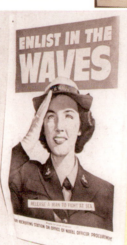

War Comes to Campus.

Left: Rifle drill outside Old Queens; **Above:** an NJC student considering her options; **Top right:** Army Specialized Training Program (ASTP) students studying weaponry; **Right:** cover of a brochure on Camp Kilmer.

Veterans flocked to Rutgers following World War II and took advantage of the educational benefits of the G.I. Bill, the single most important piece of legislation affecting higher education in the 20th century. More than 9,000 students entered the university in the immediate post-war era, many of whom were married and had young children, such as the family appearing in this photograph.

Cold War University

For the American university, the Cold War (ca. 1945–90) was a period of unprecedented growth and prosperity. Enrollments exploded, fueled by the G.I. Bill, a baby boom, and the rise of federal student loan programs. Federal and private support for research grew to unprecedented heights. Meanwhile, groups previously excluded or marginalized in higher education fought for and won spaces in the classroom and on the faculty, and issues of race and social justice entered the curriculum. This growth was not even, nor was the fight for civil rights fully won. Nevertheless, in retrospect, the degree of transformation was impressive.

These remarkable transformations could not have been predicted at The State University of New Jersey during the decade or so after the Second World War. The 1944 Servicemen's Readjustment Act, known as the G.I. Bill, brought a deluge of veterans to Rutgers during the late 1940s. By 1948, universitywide enrollment reached 16,000 students, more than double what it had been before the war. Enrollment in the men's college, for example, grew from 750 in 1945 to 4,200 in 1947. The number of faculty grew apace. But the rate of change was so rapid that the university had to resort to temporary facilities and hastily created programs and courses to accommodate the students. Enrollments sagged after the veterans departed: overall undergraduate enrollments dropped 25 percent between 1948 and 1951. Students and faculty alike expressed frustration, and morale was low.

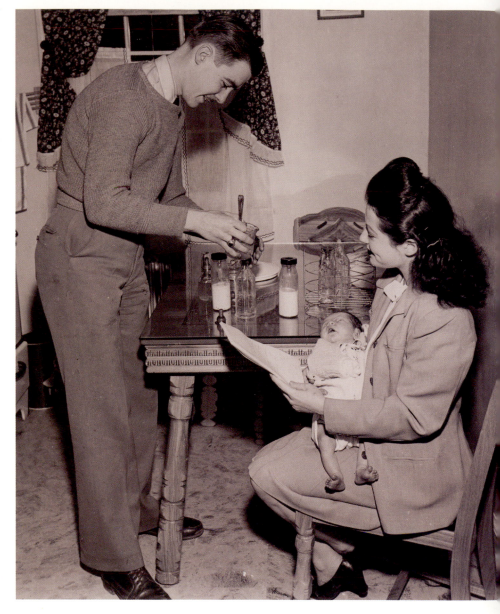

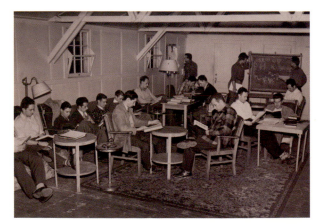

Perhaps the most damaging Cold War effect on the university was the anticommunist hysteria instigated by U.S. Senator Joseph McCarthy. During the early 1950s, three Rutgers professors were dismissed or forced to resign after invoking the Fifth Amendment in refusing to answer questions concerning their possible Communist Party connections. Simon W. Heimlich and Moses I. Finley were called to testify before the Senate Subcommittee on Internal Security. Abraham Glasser was called to testify before the House of Representatives Committee on Un-American Activities. The three refused to testify for a variety of reasons: fear of perjury conviction, an unwillingness to incriminate others, and opposition to what they believed was a grave invasion of privacy.

Left: Veterans studying in 1949.

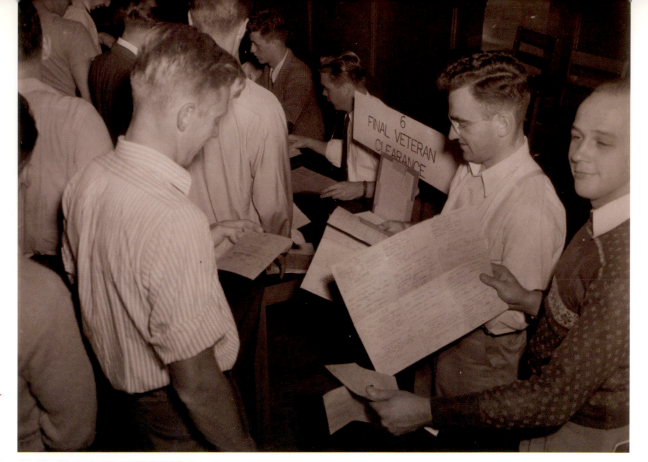

Right: The influx of veterans on campus required a more streamlined system for students to register for classes.

Housing became an issue with the return of veterans after the war. Rutgers responded by creating temporary facilities such as the development of the Hillside campus for married students and the conversion of the barracks at Raritan Arsenal.

The early years of the 1950s were overshadowed by the Cold War and its subsequent restriction on academic freedom. In 1952 three professors at Rutgers—Abraham Glasser (left), Moses Finley (center), and Simon Heimlich (right)—were dismissed or forced to resign after invoking the Fifth Amendment in refusing to answer questions before Congressional committees concerning their possible Communist Party membership or affiliation.

At the time, Rutgers, like most colleges and universities across the country, lacked a clear mechanism for handling a case of this nature. President Lewis Webster Jones (1951–58) and the university as a whole were under a great deal of pressure, particularly in the conservative climate of the times, to prevent any communist infiltration of academia, whether real or supposed. Although an appointed faculty committee cleared the men of charges, the president questioned their fitness and the Board of Trustees issued a resolution: any faculty or staff invoking their Fifth Amendment right to silence while under investigation could be dismissed. When Heimlich and Finley refused to comply, they were fired; Glasser was suspended, and he eventually resigned. In 1956, the American Association of University Professors (AAUP) censured Rutgers for its treatment of the three men. When a newly created Board of Governors revised the university policies on academic freedom in 1958, the AAUP lifted its censure.

Not all news was bad. In 1952, Rutgers professor Selman Waksman (RC '15, '16) won the Nobel Prize for research leading to his discovery, with his research assistant Albert Schatz (AG '42, '45), of streptomycin, the first effective antibiotic against tuberculosis and other deadly diseases. Rutgers athletics in the late 1940s and early 1950s enjoyed great success in football, baseball, crew, and other sports. Student clubs and extracurricular

Below: In 1943 Albert Schatz (left) and Selman Waksman, doctoral student and professor in the Department of Soil Microbiology, respectively, discovered the soil microorganism that produced streptomycin, the first antibiotic effective against tuberculosis. The "wonder drug" streptomycin was patented and the resultant royalties helped establish the Waksman Institute of Microbiology at Rutgers. Waksman received the 1952 Nobel Prize in Physiology or Medicine for research leading to its discovery.

The American Chemical Society designated the Waksman Institute of Microbiology a National Historic Chemical Landmark in 2005. Martin Hall on Cook Campus, where Waksman and his students did much of their research, also received the landmark designation that year.

A C S

NATIONAL HISTORIC CHEMICAL LANDMARK

SELMAN WAKSMAN AND ANTIBIOTICS

Waksman Institute of Microbiology
Rutgers University
Piscataway, New Jersey

This institute is named after Selman A. Waksman, who with his students isolated antibiotics produced by actinomycetes, most notably streptomycin, the first effective pharmaceutical treatment for tuberculosis, cholera, and typhoid fever. They also isolated neomycin, used as a topical antibacterial agent. These discoveries emerged from Waksman's research program, which developed novel screening protocols for detecting antimicrobial agents in the soil. Waksman received a Nobel Prize in 1952 for "ingenious, systematic and successful studies of the soil microbes" that led to the discovery of streptomycin.

American Chemical Society May 24, 2005

Left: Groundbreaking ceremony for the Archibald S. Alexander Library on College Avenue. Included among the dignitaries were (left to right) Student Council President Norman Driscoll (RC '54), Rutgers President Lewis Webster Jones, University Librarian Donald Cameron (with shovel), Roy F. Nichols (RC '18), Governor Alfred E. Driscoll, President Emeritus Robert C. Clothier, and members of the ROTC in the background.

Below: Members of the Board of Governors collectively take a loyalty oath during their first meeting in 1956. The Board of Governors was established by legislative act as the principal governing body of the university, now known as Rutgers, The State University of New Jersey.

activities experienced a renaissance, and the university administration made its first concerted effort to reduce discrimination in the fraternity system.

Of most far-reaching consequence in this decade, however, were the ongoing efforts of the Board of Trustees and Presidents Clothier and Jones to expand the university. In 1946, the legislature approved a merger of Rutgers and the University of Newark, which included a law school, a business school, and a college of arts and sciences, giving rise to Rutgers University–Newark. Four years later, the legislature added a third campus at Camden by having the university take over the floundering College of South Jersey, which

included the unaccredited South Jersey Law School. Thus was born Rutgers University–Camden. In 1948, the electorate delivered a crushing financial blow to the university when it turned down a vital $50 million bond issue. While the university managed significant construction projects on all three campuses, it could not adequately meet its present or future needs. The problem, once again, was political: the ambiguous status of Rutgers as a public university under private control in a state that treasured low taxes.

In 1956, the state and the university reached a new agreement that seemed to satisfy both parties. After nearly a century of resistance to state oversight, the Board of Trustees ceded its authority to a new Board of Governors, a body composed of 11 voting members—five from the Board of Trustees and six appointed by the governor. The Board of Trustees would continue to exist but would now function

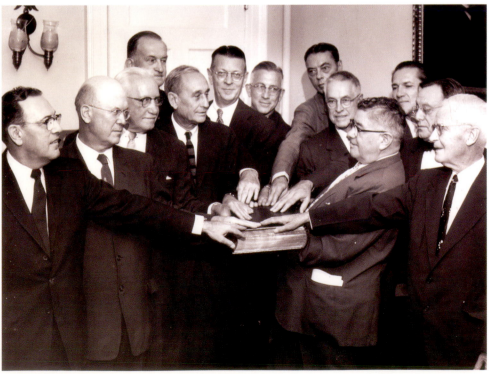

Rutgers University–Newark

Newark is an old city—among major American cities, only New York and Boston were established before Newark's founding in 1666. Military Park, a 17th-century training ground for the colonial militia, is one of the oldest public spaces in the United States. That means Newark was a developing urban area while New Brunswick was still a backwater known as Prigmore's Swamp.

Unlike most of the colonial colleges, founded in rural areas with spacious buildings on vast lawns, Rutgers–Newark grew up in the heart of a busy city. By the late 19th century, when the first higher education institutions in the city were opening, Newark was an immigrants' and migrants' city, with a primarily working-class population—as it remains today, though the populations have changed with the times.

The colonial colleges were built for the children of the gentry, and for much of their history they catered only to the leisured classes. Not so in Newark. As the dean of Dana College said to the institution's very first graduates, "It is sometimes said that students go to college for no particular reason or for lack of anything else to do. In the case of the members of the class of 1933, however, it is self-evident that they will be receiving their baccalaureate degrees… because of intense desire on their part to complete their liberal arts course."

That spirit has been part of Rutgers–Newark's character ever since. Its mostly working-class students aren't the children of the privileged attending "for lack of anything else to do," and they have never taken a college education for granted. Every graduating class has fought hard for what it achieved, and that "intense desire" is just as clear today as it was in the 1930s. Back then University of Newark president Frank Kingdon described the typical Newark student:

He is city conditioned, and must be prepared for membership in a city community. He is intellectually keen, certainly intellectually hungry for he is making some effort of his own to go forward with his education. He is actually aware of social problems, particularly of their pressure upon under-privileged groups. Altogether he is promising educational and social material…

Apart from the old-fashioned male-only language—Rutgers–Newark today graduates as many women as men—the description could describe the present just as well as the past.

—Jack Lynch, Professor of English,
Rutgers–Newark

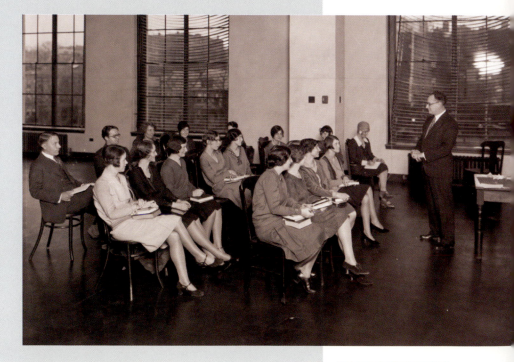

University Extension Division class conducted in the Mutual Benefit Life Insurance Company building in Newark, 1928.

in an advisory capacity, with control over certain funds and properties. This rapprochement notwithstanding, the state legislature slashed aid to the university.

The crisis soon passed. By the end of the 1950s, two outside factors combined to usher in a golden age of American higher education. The first was conceived, ironically enough, in the Soviet Union. In 1957, the Russians launched the first manmade satellite. While only the size of a beach ball and having the life span of a butterfly, Sputnik created a political uproar in the United States that launched a new space race and focused federal and state attention squarely on the quality of American educational institutions. The National Defense Education Act alone, for example, injected hundreds of millions of dollars into the educational sector, primarily in the form of student loans for future teachers. Other programs provided funds for new construction, while federal demand for research in scientific and military fields soared.

Rutgers–Newark students walking across park, ca. 1950s.

Right: Georgia Mallick at commencement ceremonies at Camden in 1966.

Below: The library at Camden—the first structure built on the campus. The library was subsequently renamed the Paul Robeson Library in honor of the singer, actor, civil rights activist, and later resident of Philadelphia before his death in 1976.

Rutgers University–Camden

Rutgers–Camden, now a thriving urban research campus, began with an idea that has never lost its salience—that higher education belongs to everyone, not just to the sons and daughters of the prosperous. Founded in 1926 as an independent law school in what was then a flourishing industrial city, it later added a junior college for local residents. In 1950 it became a part of Rutgers University: "The State University's extension of educational service to South Jersey has been a part of its long-range planning for some years," Provost Mason Welch Gross explained when the merger plan was first announced. "Only by the establishment of facilities within easy reach of that portion of the State can it meet its obligations in that area." From these roots, the campus has grown into a nearly 7,000-student university, offering degrees from the bachelor's to the doctorate. It attracts students and faculty from around the world. Rutgers–Camden has withstood challenges brought on by the Great Depression, World War II, the urban decline of the 1960s, and, more recently, a plan to sever its ties with Rutgers. It remains a vibrant, ever-growing campus.

—Michael Sepanic, Associate Chancellor for External Relations, Rutgers–Camden

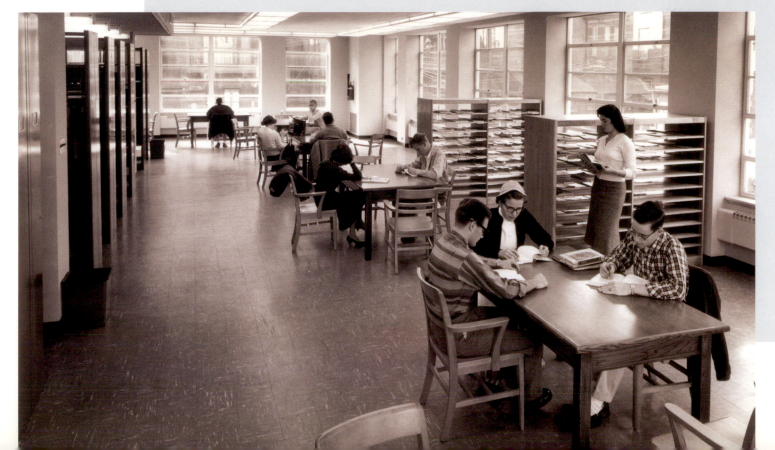

The second factor was conceived in the United States—indeed, all over the United States—by the return of servicemen from the war: a boom in babies. The rash of American births from the late 1940s to early 1960s created a demographic bubble that reshaped American education at all levels. Politicians embraced the issue of educational advancement, and the American public grew increasingly favorable to the idea of paying taxes to support postsecondary education as a matter of domestic improvement and national security.

Rutgers reaped the windfall. When long-time university provost Mason Welch Gross became president (1959–71), the university had already begun laying plans for the baby boomers. Gross's natural leadership skills and deep personal commitment to the university aided relations with the state legislature and the public. A series of big bond issues signaled new public support for Rutgers: $30 million in 1959, $19 million in 1964, and $68 million in 1968. The Gross administration created a federated system of five separate undergraduate colleges in New Brunswick: Douglass College, the College of Agriculture, Rutgers College, University College, and the newly opened Livingston College (1969). Coeducational Livingston College was oriented

toward social service, equal opportunity, and—through unique programming and admissions policies—increasing the enrollment of racial and ethnic groups that had been underrepresented in the undergraduate population.

As expected, the students came. Undergraduate enrollment doubled from 1959 to 1964, and doubled again by the early 1970s. The mission of the university evolved too, with a more explicit focus on research and graduate education. Admissions became more selective. Graduate and professional school enrollments soared from 3,300 to 6,600 over the 1960s. Course offerings and programs expanded. The university developed a national reputation and an "A" ranking by the American Association of University Professors.

Above: The Camden Campus of Rutgers in the 1970s.

Below: Aerial view of Rutgers–Newark in the 1960s.

The golden age of the university also exposed the ugly side of American higher education—its racism, sexism, and other antidemocratic traditions. To their great credit, Rutgers students themselves forced the university to reconsider its role in American society and include social justice as part of its mission. In the context of the unpopular war in Vietnam and a civil rights movement at home, college students across the United States put their education to work in ways not foreseen by Cold War promoters of education for national defense. Many faculty members joined them. As the war escalated, Rutgers campuses polarized around the question of the university's role in it. Students rallied for and against the campus's Army Reserve Officer Training Corps (ROTC), while faculty offered controversial "teach-ins" to educate students about the conflict.

The most historically significant and long-standing problem, however, was the university's poor record on race. Like most predominantly white colleges and universities, Rutgers did not keep track of racial data; and like most, it admitted far too few students of color and offered little in the way of coursework, programming, or extracurricular activities that addressed their experiences or concerns. Thanks to increases in enrollment, federal antidiscrimination laws, and federal student loan programs, however, Rutgers and other colleges saw the entry of a significant—if relatively small—number of African-American students during the mid-1960s. The migration of African Americans from the South to work in New Jersey's industrial cities greatly increased the state's black population. Historian Richard P. McCormick estimates that only 200 of 24,000 students earning their bachelor's degree at Rutgers between 1952 and 1967 were black. But in the late 1960s, the number of African-American students rose sharply, from 100 undergraduates in 1965 to 400 in 1968—roughly 3 percent of the undergraduate student body.

The growth in black students had been planned for. Inspired by the broader civil rights movement, and in particular in the jailing of popular Rutgers alumnus Donald Harris (RC '63) in 1963 for civil rights work in Georgia, the faculty and administration had initiated several modest initiatives to recruit black students and faculty. But what Rutgers had not planned for were the ways in which the black student body would identify glaring examples of institutional racism and privilege that were woven into the fabric of the university. Nor could black students anticipate the intrusion of outside events, climaxing with the assassination of the

Below: Students lining up to board buses to Trenton to demonstrate in support of a Bond Issue for Higher Education, 1959.

Below right: Rutgers–Newark students outside Hill Hall, 1973.

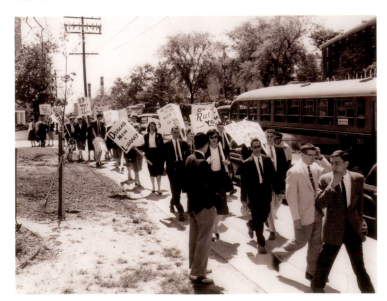

Reverend Martin Luther King Jr. in April 1968. Admitting more blacks to the same old institution was not enough, these students argued: Rutgers itself had to change.

The tipping point came in spring of 1969, when black student organizations enacted a series of protests to force the hand of the university in admissions, hiring, community relations, and curricular and programmatic reform. Students at Rutgers–Newark occupied Conklin Hall, chained the doors, and did not leave until, after 72 hours, the university agreed to at least some of their demands. In New Brunswick, students staged mass food dumpings in the main dining halls of Rutgers and Douglass Colleges and organized meetings with faculty and the Board of Governors. At Rutgers–Camden, students disrupted a Student Council meeting and later barricaded themselves inside the College Center. For two days, classes were canceled universitywide.

While many white students and the general public responded with anger or confusion at the black students' methods and demands, the great majority of the faculty was supportive, as was the administration. President Gross

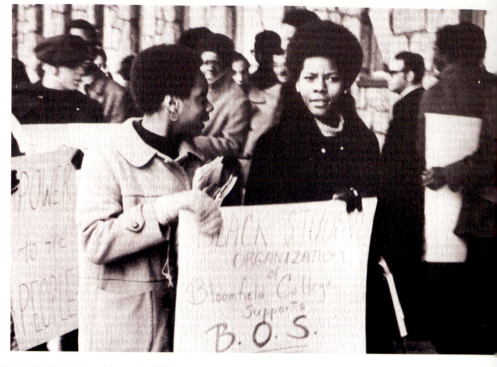

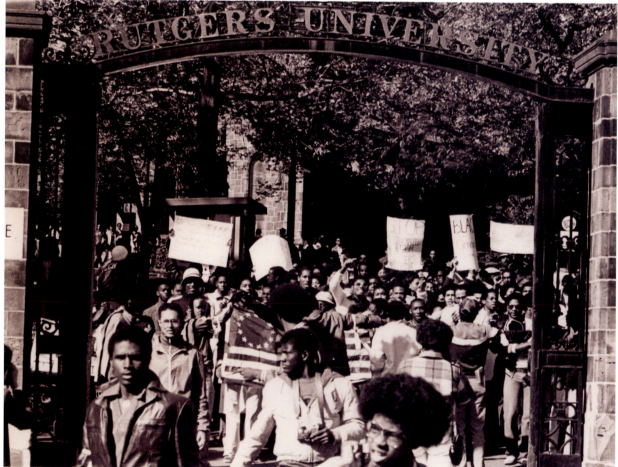

Above: Bloomfield College students show their support for the Rutgers Black Organization of Students (BOS) takeover of Conklin Hall at Rutgers–Newark in 1969. This pivotal event led to demonstrations on all campuses, demands presented by the BOS leadership at a meeting held in the College Avenue Gymnasium, and continued protests throughout the 1970s and 1980s, such as the one held on the Old Queens Campus in New Brunswick (**left**) in 1979.

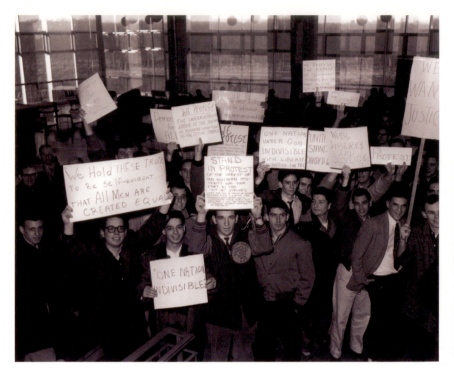

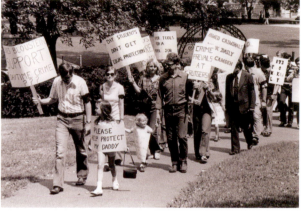

Left: Rutgers College students at "The Ledge" protesting segregation, ca. 1960. The Ledge (built in 1956) provided a much-needed space for student activity and social life. Both on College Avenue and across town at Douglass, students were becoming aware of social injustice. These early protests at The Ledge marked the beginnings of a radical consciousness amongst Rutgers students.

Below: Students with family members in tow demonstrate for the need to expand the Campus Patrol at the university for day-time students, 1974.

Many maintain that Rutgers reached a "Golden Age" under President Edward Bloustein. His tenure (1971–89) began in the midst of student protests over Vietnam and ended with protests over proposed tuition increases, but the intervening years saw the university expand its research facilities, attract internationally known scholars, and join the prestigious Association of American Universities.

refused to take a hard line, neither expelling the students nor involving the police unless absolutely necessary. Instead, he led the university in a significant effort to address the students' concerns. The university expanded recruitment efforts in urban high schools; created an African studies program; offered a number of new courses in other departments; and expanded extracurricular activities, campus resources, and cultural events of interest to African Americans in particular, but also to other traditionally excluded groups. While these changes did not eliminate the problems of institutional or societal racism, they were major developments. Gross's conciliatory approach with student and faculty activists kept the university from slipping into the bitter disputes and violence that characterized those institutions that took a harder line, but it cost him politically and took a toll on his physical health. He retired in 1971.

From 1971 to 1989, Edward Bloustein led the university and presided over what is arguably the most important period in its modern history. In an inaugural speech to the New Jersey State Legislature, Bloustein acknowledged that the university had to work harder to serve all the people of New Jersey—suburbanites and city dwellers, minorities as well as whites, women as well as men, the working class as well as elites. Over the two decades of his leadership, he enjoyed significant progress on this and other issues, including expanding the size and scope of the university, raising the status of intercollegiate athletics, and solidifying Rutgers' reputation as one of the nation's leading public research universities.

Bloustein inherited the challenge of dismantling the legacies of institutional racism at Rutgers, and together with the Board of Governors and the State Department of Education, responded seriously to the issues of black student admissions, support, and intellectual and cultural life. Their signal achievement was the Educational Opportunity Fund, which created state scholarships for economically disadvantaged students to enter Rutgers with the assistance of remedial courses and other academic supports. Within five years of the protests of 1969, slightly more than 10 percent of full-time undergraduate students at Rutgers were African American, as was approximately 5 percent of the full-time faculty—a rapid and significant change. The university had made other changes as well, not the least of

Right: Dean John Bettenbender speaking at the dedication ceremony for the Mason Gross School of the Arts on January 18, 1979. Although the first MFA program at Rutgers was offered in 1960, formal planning for the establishment of a school for the arts wouldn't begin until 1973. The school opened as the School for Creative and Performing Arts in 1976 and was renamed to honor the late Rutgers president Mason Gross. Keynote speaker at the event was Joan Mondale, second from right, wife of then-Vice President Walter Mondale and a fervent advocate for the arts.

Below: Douglass students, 1970s.

which was the decision to acknowledge and begin to address institutional sexism. Over loud protests from Douglass College, Rutgers College became coeducational in 1972, nearly a century after faculty had first requested such a change.

The second major development of the Bloustein administration was continuing expansion and modernization across all three campuses. At an extraordinarily fortuitous moment in the history of university–New Jersey relations, Bloustein worked in partnership with Thomas Kean, a governor for whom the necessity of state support for its university was never in question. Bloustein oversaw the expansion of a number of centers and programs; the building of more and better residence halls, gyms, and student centers; and the proliferation of student services. He challenged those areas that he saw as preventing the formation of a first-rate public university, especially the secondary role of graduate education and the convoluted nature of the federated college system in New Brunswick. By 1981, the separate faculties in the liberal arts colleges in New Brunswick had been combined

into campuswide departments, and graduate programs had begun that would earn nationwide distinction—especially in philosophy, women's history, English and American literature, food science, physics and astronomy, mathematics, and chemistry. Bloustein also oversaw the creation of the Graduate School of Applied and Professional Psychology, the Mason Gross School of the Arts, and the Newark-based School of Criminal Justice, among many new initiatives. He promoted the campus as a safe space for gay and lesbian students, and urged new programs in this area; and he supported vigorously the establishment of women's studies programs. He encouraged service learning, connecting courses to the needs of the communities in New Jersey; in short, he emphasized the "public" in public university.

The Bloustein years produced remarkable changes in graduate education and research, but had no equal impact on undergraduates. Bloustein himself urged that the proliferation of knowledge demanded that students be educated in "ways of knowing," but his challenge did not provoke lasting change. Most students remained involved in a menu approach to undergraduate education. In response, in the late 1980s, the president asked the provosts on each campus to establish committees to address the issues related to undergraduate education in the context of a research university. The provosts' reports, impressive in their concerns and recommendations, appeared just as new president Francis L. Lawrence (1990–2002) took office after Bloustein's untimely death in 1989.

Right: The *Rutgers Focus* headline announcing Rutgers receiving an invitation to join the prestigious Association of American Universities (AAU). An overjoyed President Edward J. Bloustein delivers the news at a special press conference.

Below: Frank Burns (RC '49), who served as head football coach during the transition to "bigger time" athletics at Rutgers, leads the team for a contest at Rutgers Stadium, his final game as coach, 1983.

Rutgers selected to join top university group

By Harvey Trabb
Rutgers News Service

Rutgers has been invited to join the prestigious Association of American Universities (AAU), a body of the 58 leading universities in the United States and Canada.

"With membership in this organization, Rutgers is recognized as among the most distinguished American universities. We now stand with the finest company in American higher education," said Rutgers President Edward J. Bloustein at a news conference Monday, Feb. 6.

"This recognition of Rutgers' status is in large measure due to the strong and significant support the State University of New Jersey has received in recent years from the governor, the legislature and the citizens of this state," he said. "On behalf of Rutgers, I thank them for that support."

Princeton is the only other New Jersey university belonging to AAU, whose members also include Harvard, Yale and the Universities of Michigan and Wisconsin.

Rutgers and the State University of New York at Buffalo were notified late Thursday, Feb. 2, of their selection as new members, bringing the number of universities and institutes in the distinguished organization to 58.

Membership in the organization is highly selective, Dr. Bloustein said, pointing out that only 17 universities have been invited to join over the last 25 years. Admission of new institutions is considered by the AAU approximately every three years, and requires the assent of three-quarters of the association's membership. The last new

RUTGERS JOINS ELITE — President Edward J. Bloustein announces Rutgers' acceptance into the American Association of Universities (AAU), a body of 58 leading universities in the United States and Canada. "The AAU is the most prestigious association of universities in the United States and the most influential by far," Bloustein said.

members were selected in 1985.

In addition to being the only two institutions offered admission this year, Rutgers and SUNY at Buffalo are the first and only two public research universities in New Jersey, New York and New England to join the AAU ranks.

The AAU is the "most prestigious association of universities in the United States and the most influential by far," Bloustein said.

"Association members play an extraordinary role in determining the future of education and research in America," he said.

Bloustein also noted Rutgers' relative youth as a major institution compared to most of the other AAU universities. While Rutgers traces it roots back to 1766, the year it was chartered, the institution has been a full-fledged state university for only 33 years.

"Rutgers is the youngest of the major public universities in the United States," Bloustein said. "Many of the other AAU universities have been public research institutions for a cen-

tury or more. Our selection — by them to join them — is another indication of Rutgers' rapid growth in quality."

Bloustein was joined by several other university administrators in discussing the AAU membership at the news conference.

Commenting on the importance of AAU membership for graduate education, Dr. Catharine R. Stimpson, dean of the Graduate School–New Brunswick, explained that membership in the organization includes participation in AAU's Association of Graduate Schools.

"There we will be able both to give and take a number of ideas about the training of the next generation of people who will create knowledge and who will transmit knowledge," she said.

"There are about 3,000 institutions of higher education in the United States. To be one of only 58 of them asked to join the AAU is a singular distinction. For graduate education, joining the AAU also means that our hopes and standards have been recognized. It is a confirmation of our quest for excellence, and a sense that ideas matter and that the strength of our ideas matters."

Dr. David Mechanic, director of Rutgers' Institute for Health, Health Care Policy and Aging Research, cautioned against complacency in light of Rutgers' membership in AAU and urged the university to continue developing its infrastructure of buildings, laboratories and research capacities, as well as the quality of teaching programs.

"Our joining the AAU is an indicator of the extraordinary progress

Continued on back page

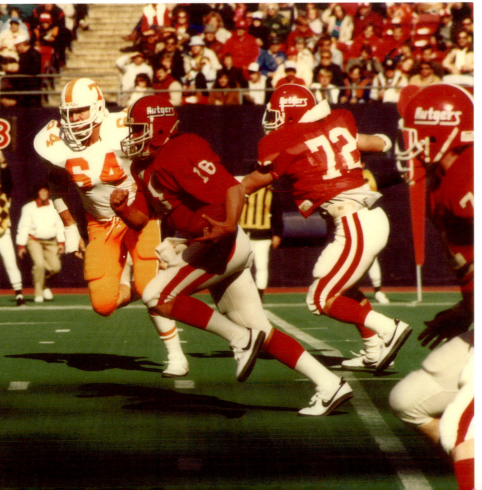

Under pressure from the Board of Trustees, the Bloustein administration also committed to creating a first-rate athletic program. Recognizing men's football as the intercollegiate sport of record, he replaced both the athletic director and the football coach. In response to the passage of Title IX in 1972, which banned discrimination by gender in education, Rutgers made earnest efforts to expand women's athletics as well. By the 1980s, Rutgers athletics enjoyed a large following in the state.

President Bloustein had led the university to an unprecedented period of growth in size and reputation. In February 1989, Rutgers was invited to join the Association of American Universities (AAU), a group whose members at the time represented 58 of North America's leading research universities.

But troubling trends still existed. Despite the considerable accomplishments of the university regarding

The move to big-time football required an enhancement in competition, such as Rutgers hosting the University of Tennessee at Giants Stadium in the Meadowlands in 1983.

In the autumn of 1969, gay liberation found a place at Rutgers with the establishment of the Student Homophile League (SHL). Lionel Cuffie (RC '71) was a Rutgers College sophomore, black activist, and Yippie, when he founded the Student Homophile League, the oldest college group formed as a result of the Stonewall uprising. Cuffie hoped that the SHL "would ultimately aid in the breakdown of social and political persecution and discrimination directed against minority groups."

admissions and hiring practices, students and faculty continued to push the administration to do a better job with the more subtle forms of institutional prejudice—the lack of minorities in senior positions and the disproportional dropout and failure rates of students of color, among others. As had been the case for over a century, it was primarily due to the courageous activism of Rutgers students and faculty that the university moved forward on these issues.

Some factors were beyond the administration's control. A bad economy in the 1970s, followed by the rise of the conservative movement in the 1980s, saw a decline in political enthusiasm for public institutions and a binge in borrowing. One result was a considerable increase in tuition.

Historian Paul Clemens has found that Rutgers tuition had remained astonishingly flat and relatively inexpensive, for much of the post-World War II era—roughly $400 a semester from the 1950s to early 1970s. It then began to climb steadily. Federally funded student loan programs, created in the 1960s and 1970s as a way to provide college access to a wider range of Americans, made up for much of the difference. Certainly students got more for their money—better facilities, more and higher-quality extracurricular activities, more extensive libraries and other research facilities, and higher-status degrees thanks to the development of a first-rate faculty. As long as the economic future looked promising, the rising debt for the typical student appeared worth the investment.

From 1971 to 1975, the Student Homophile League organized five successful, well-attended conferences on Gay Liberation and Culture, attracting some of the day's best-known lesbian and gay activists.

TACTICS FOR CHANGE

results of a conference on Gay Liberation April 30 - May 2, 1971

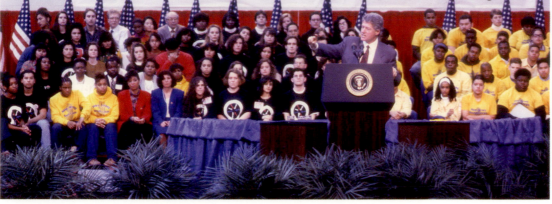

Learning To Serve – Serving To Learn
Rutgers Civic Education & Community Service Program

During the 1990s, more than 7,000 students had participated in Rutgers' nationally acclaimed Citizen and Service Education Program (CASE), which provided countless hours of community service. Such impressive results brought President Bill Clinton to the Rutgers campus in 1993 to deliver a major policy address where he announced the start of a national service organization, AmeriCorps. Clinton praised "the spirit" behind the CASE program and congratulated Rutgers for demonstrating how community service "enriches education."

Below: In 1995, reports surfaced that President Francis Lawrence, at a faculty senate meeting in Camden, said: "The average SATs for African Americans is 750. Do we set standards in the future so we don't admit anybody? Or do we deal with a disadvantaged population that doesn't have that genetic, hereditary background to have a higher average?" Lawrence, who claimed to have committed a verbal "slip," was pilloried for what was perceived by many as a blatantly racist remark, and the incident led to impassioned, bitter debate at Rutgers. Though expressing outrage at his remarks, the Rutgers Board of Governors and many faculty supported Lawrence because of his strong commitment to diversity and multicultural initiatives.

Becoming a Comprehensive Research University

Rutgers University entered the last decade of the 20th century at a crossroads. One of the nation's oldest institutions of higher education had become one of its youngest public research universities. Rutgers, the flagship state university in New Jersey, was now associated with such elite institutions as Harvard, Princeton, Stanford, and Yale. Just as important, Rutgers University's peers included the prestigious public AAU institutions in California, Illinois, and Michigan. Throughout the 1990s and in the ensuing years of the new century, the university would keep its focus on elevating its status within this elite company. Yet as the 1990s unfolded, higher education in general and Rutgers in particular faced significant challenges that required leadership, vision, and in many cases sacrifice. Could Rutgers be elite and public in an era of declining state support and increasing diversity? In his 1991 inaugural address President Lawrence argued that it could. Noting census data showing that the nation had become "less white, more Asian, Hispanic, and African American,"

Lawrence called for a new vision of the university that would respond to the needs of a more diverse student body; Rutgers needed to be "a people's university" and find "a new way of conceptualizing higher education."

Lawrence immediately faced a budget crisis, the result of a nationwide recession that had surfaced in the late 1980s. The impact on New Jersey was severe, and Rutgers endured massive cuts in state funding. It responded by mounting an intensive campaign to win public and political support, even attracting President Bill Clinton in 1993 to deliver a major policy address where he announced the start of a national service organization, AmeriCorps, while praising Rutgers for demonstrating how community service "enriches education."

The state's fiscal climate nonetheless remained precarious. Tuition increases became a yearly occurrence, provoking student anger and protests. Contract negotiations between the administration and faculty and staff were

DEADLY DISEASES
After a 25-year study which used Black men as guinea pigs, many believe agencies such as the Centers of Disease Control cannot be trusted. Health & Science

THE DAILY Targum
SERVING THE RUTGERS COMMUNITY SINCE 1869

SCORCHING PERFORMANCE
Alicia Sheeler and the Lady Knight basketball team wreaked havoc upon the lowly Temple Lady Owls last night in Philly's McGonigle Hall, winning 95-71. Back Page

WEDNESDAY, FEBRUARY 1, 1995 10 CENTS
VOL. 126, No. 81 ©1995 TARGUM PUBLISHING CO.

Lawrence's words elicit furor

EDITORIAL
A call for resignation

"GENETIC HEREDITARY BACKGROUND." These words have been called badly articulated, but the statement made by University President Francis L. Lawrence is much, much more than that — those words have made it impossible for him to function adequately as a spokesperson, figurehead and leader of New Jersey's largest and most diverse learning institution.

With those three words, the president of our University became a symbol of racism that can no longer represent the diversity and progressiveness of Rutgers. Yesterday, administrators stood behind the president, claiming his progressive record negates his comments, and the faculty union asked only for an apology; therefore, it will be left up to students to ...

President defends remarks on role of genetics, SAT

By Carrie Budoff and Jeannine DeFoe
TARGUM STAFF WRITERS

Flanked by more than a dozen members of the University community, President Francis L. Lawrence said yesterday he regrets having stated that disadvantaged minority students may not have the "genetic hereditary background" to do well on standardized tests, but did not go as far as to offer an apology for those remarks.

For additional coverage, please see page 4

During a special press conference yesterday in Winants Hall on the College Avenue campus, he insisted the comments, which date from a Nov. 11 meeting with faculty, do not reflect his personal opinions, but were instead a misstatement on his part.

Lawrence's quotes, part of an address to 30 faculty members at Rutgers-Camden, were made public by the Star-Ledger of Newark in a front-page article yesterday after that newspaper obtained a tape of the meeting from the Rutgers Council of the American Association of University Professors.

... In spite of the fact that I did use those words, they are ...

Above: President Francis Lawrence, who began his presidency in 1990, is welcomed into the Alumni Association at homecoming that year.

prolonged and contentious. Rutgers' "meteoric rise" in the 1980s had received praise and recognition from many quarters, but there was a perception among members of the university community that it came at the expense of undergraduate education. To provide support and direction, the president created two high-level vice president positions devoted exclusively to undergraduate education and student affairs. In 1992, the university created Learning Resource Centers on all three campuses to provide students with training in effective study and learning skills, as well as tutoring and supplementary instruction in specific disciplines. The administration added Teaching Excellence Centers in Camden, Newark, and New Brunswick to assist faculty in teaching techniques, including the integration of new technology into classroom instruction.

In 1995, Rutgers developed and implemented its first-ever strategic plan—a divisive cultural shift that some hailed as increasing efficiency while others found dispiriting and alienating. The Lawrence administration developed individual campus plans for Camden, Newark, and New Brunswick and an integrated, universitywide plan. Programs that did not meet target goals would have to compete for their funds.

Attracting external funding became all the more necessary for Rutgers to maintain its trajectory toward becoming a top-tier public research university without sacrificing its public mission. The university's federal funding during Lawrence's tenure rose dramatically—from $46 million in 1990 to more than $107 million in 2000. During this 10-year time period, corporate giving increased from $10.5 million to $14.9 million, and foundation support grew from $13.4 million to $37.2 million. In addition, license and patent revenues derived from faculty research discoveries increased substantially—from 17 licenses in 1991 that generated $1.7 million to 172 licenses that garnered $4.7 million in 1998. Adding $6.5 million from royalties derived from research discoveries, more than $350 million secured by the Rutgers University Foundation, and a substantial increase in tuition revenue, Rutgers prospered in the midst of dwindling state support throughout the decade. Most significantly, the growth in external funding contributed to

its enhanced status among public AAU institutions as well as among all research universities nationally.

In 1998, the Board of Governors approved the RUNet 2000 initiative, a five-year, $100 million project to install an advanced universitywide data, video, and voice network. With funding from state, federal, and private sources and the introduction of a student computer fee, the university built one of the largest higher education data networks in the country. The RUNet project had an enormous effect on all

Below: Typical library computer lab from 2001.

Left: Strolling across the Ravine Bridge on Douglass Campus in 1997.

Below: A beautiful fall day near Bishop Beach in 1996.

Above: Students exiting Murray Hall after class in 1993.

Below: The RUNet 2000 initiative wired the entire university.

RUNET 2000

university operations and altered instruction, research, and communication at all three campuses. By 2003, a majority of academic buildings, residence halls, and libraries in Camden, Newark, and New Brunswick were wired.

Throughout the 1990s and into the 21st century, Rutgers strove to maintain its commitment to providing educational opportunity to the state's diverse student population. Nationwide, demographic changes, coupled with the increased demand for higher education, marked a significant shift in the student population of colleges and universities during this period. In 1973, for example, only 47 percent of high school graduates went on to higher education; by 2000, that number had increased to 65 percent. In addition to an increase in the enrollment of traditional students, colleges and universities witnessed a substantial growth in the number of older students attending part time while holding full-time jobs. Professional and technical education soon accounted for nearly 60 percent of degrees awarded nationally in 1995.

Between 1989 and 1999, enrollment of first-year students at Rutgers increased by 14 percent to 6,517 students. The university made an extensive effort to curtail the exodus of the state's better students, utilizing a state-sponsored Outstanding Scholars Recruitment Program that provided financial assistance based on merit, along with a challenging honors program in New Brunswick, and new honors colleges in Camden and Newark. Impressively, first-year minority enrollment grew 40 percent over the decade, from 1,797 to 2,517, including many Latino and Asian students. By 1999, 35 percent of baccalaureate degrees were awarded to minority students. A point of particular pride came in 1997 when Rutgers–Newark was named the most diverse university campus in the nation by *U.S. News & World Report*—a distinction it has held ever since.

Another source of pride for many at the university, but a significant source of contention too, was the rise of college athletics. President Lawrence took a keen interest in developing the athletic program; he strongly believed that a highly competitive and successful program would enhance the university's stature within the state and among its peer state universities. During the early years of his presidency, Rutgers had joined the prestigious Big East Conference, first with football in 1991 and then all sports competing in 1995. Membership in the Big East provided enhanced visibility but also necessitated increased costs. In 1994, an expanded and renovated Rutgers Stadium was completed through a $28 million appropriation from the state legislature. Rutgers

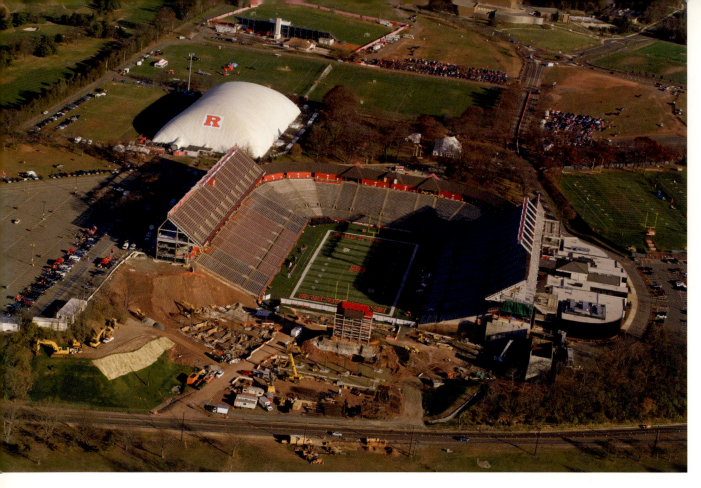

Left: The 2008 expansion of Rutgers Stadium.

Below: Rutgers' 19th President Richard L. McCormick (right) with his parents, celebrated Rutgers professor and historian Richard P. McCormick and longtime Rutgers administrator, Katheryne Levis McCormick.

continued its path to big-time athletics by securing C. Vivian Stringer, one of the most successful women's basketball coaches in the nation, in 1995, and by naming 34-year-old Greg Schiano as the new football coach in 2000. Both Stringer and Schiano would bring excitement and success to Rutgers athletics in the ensuing years, but, as critics observed, not without cost. Even as the university cut academic program budgets, athletics ran multimillion-dollar deficits and high-profile coaches became the highest paid state employees in New Jersey, with salaries dwarfing those of the university's top faculty.

Coming Home: The McCormick Era

Taking over the helm of New Jersey's flagship university in December 2002, Richard L. McCormick (2002–12) knew Rutgers well. His mother, Katheryne Levis McCormick, taught chemistry at the women's college and then became a long-time university administrator. His father, Richard P. McCormick (RC '38, GSNB '40), was a distinguished professor of history, a college dean, and author of *Rutgers, A Bicentennial History* (1966). In 1976, the younger McCormick joined his father on the faculty of the history department, and became department chair in 1987. Two years later, he was named acting dean and then appointed dean of the Faculty of Arts and Sciences at Rutgers–New Brunswick. McCormick left Rutgers in 1992 to become provost at the University of North Carolina, Chapel Hill;

he then moved to Seattle in 1995 to serve as president of the University of Washington. With extensive knowledge of state universities and years of experience in higher education administration, he returned home to confront issues and concerns that would define the future of New Jersey's premier public research university.

Below: In 2008, all alumni groups came under the umbrella of the Rutgers University Alumni Association with enhanced benefits; the fall 2008 issue of *Rutgers Magazine* marked the reorganization.

Bottom: Students gather for class on the lawn on Voorhees Mall.

The new School of Arts and Sciences gonfalon debuts at the 2007 University Commencement.

Many of the problems Rutgers and McCormick faced were not new. The most persistent were the lack of state funding for higher education and the State of New Jersey's persistent plans for restructuring higher education.

A signature accomplishment of the McCormick presidency was the successful transformation of undergraduate education in New Brunswick. As a former Rutgers faculty member, McCormick was cognizant of the shortcomings associated with the academic reorganization that had occurred in the early 1980s on the New Brunswick campus. He summed it up in his 2005 presidential address:

There is the patchwork quilt of undergraduate colleges…each without a faculty, but each of which nonetheless has its own admissions, core educational requirements, honors programs, academic discipline, graduation standards, and much more. And then there is the Faculty of Arts and Sciences, whose members take responsibility for undergraduates once they have declared their majors but who have no obligation or authority

in regard to their admission, their general education, or their graduation. So we have degree-granting colleges without faculties and an arts and sciences faculty without students. This has got to be the weirdest academic set-up in America.

In 2007, the university unified the four liberal arts colleges in New Brunswick (Douglass, Livingston, Rutgers, and University), establishing a single School of Arts and Sciences. The new school was responsible for setting admissions criteria, general education requirements, student advising, scholastic standing expectations, honors programs, and degree certification for all arts and sciences students in New Brunswick. Cook College, which had successfully fulfilled the university's role as New Jersey's land-grant institution, continued as a distinct professional school but was renamed the School of Environmental and Biological Sciences. Douglass College retained much of its distinctive mission by becoming a residential college.

Above: Professor Barry Qualls who with President McCormick led the Transformation of Undergraduate Education in New Brunswick, resulting in the creation of the School of Arts and Sciences.

Right: *Education Is an Open Book* by Melvin Edwards is a focal point of the updated Livingston Campus, now affectionately known as "Livi."

Below: The dynamic *Signal* sculpture by Ralph Helmick graces the entryway of the Biomedical Engineering building on the Busch Campus.

The consolidation addressed other issues as well. The Livingston Campus received long-overdue attention to its facilities, including an expansion of the student center, construction of a new dining hall, and the addition of three residence hall apartment complexes—complete with retail establishments. To enhance its academic significance, the McCormick administration made plans to make Livingston Campus home to the professional schools of business, management and labor relations, social work, and education. A $10 million gift paved the way for a new academic building for business on Livingston that opened in fall 2013. Livingston was transformed into an attractive and highly desired campus for students, faculty, and staff.

Rutgers achieved several other milestones during the first decade of the 21st century. Though proud of its efforts in attracting a student population that reflected the state's diversity, the Rutgers student body was mainly suburban, with too few students coming from the state's cities and especially too few disadvantaged minority students. In 2008, the Rutgers Future Scholars Program was launched, which identified 200 academically promising seventh grade students annually from schools located in Rutgers' host cities of Camden, Newark, New Brunswick, and Piscataway, and provided resources to prepare them for eventual college admission. For those who succeeded and gained admission to Rutgers, their tuition would be free. The program's success attracted national attention when the first group of students who graduated from their high schools and selected Rutgers as their college choice entered the university in the fall of 2013.

Much like his predecessor, McCormick supported Rutgers' intercollegiate athletics, and enjoyed the university's continued rise in reputation. Following a stunning 2006 football season, culminating in a climactic victory over the undefeated and highly ranked University of Louisville (and televised nationally by ESPN), Rutgers became the talk of college football. The impact of that particular game and that successful season, along with the continued success of the women's basketball program, furthered Rutgers' commitment to big-time athletics. But the athletics program continued to be controversial for its financial losses,

particularly in light of continuous budget reductions in other areas. The costs of further expanding Rutgers Stadium, compensation issues relating to the football coach, and the decision to eliminate six Olympic sports because of budget cuts led to several formal reviews and revisions of athletics operations and governance.

During the first decade of the new century, the university faced tough decisions and internal tensions. The worst came during the economic crisis of 2008. Significant cuts in state funding resulted in staff layoffs, a hiring freeze, and curtailment of salary increases for faculty and staff. Contract negotiations with the AAUP and other unions representing Rutgers employees became highly contentious. The university continued to raise tuition each year and expand its efforts to attract external funds to make up the loss in state support. A new tagline, "Jersey Roots, Global Reach," appeared throughout New Jersey and beyond, capturing the importance of academic and research successes achieved by faculty and students. McCormick established the first Rutgers Day in

Right: President McCormick enjoys a moment with the inaugural class of Rutgers Future Scholars.

Below: An adoring crowd hoists Jeremy Ito whose field goal sealed the Scarlet Knights' victory over the Louisville Cardinals in 2006. Fans rushed the field and the night would be dubbed "Pandemonium in Piscataway."

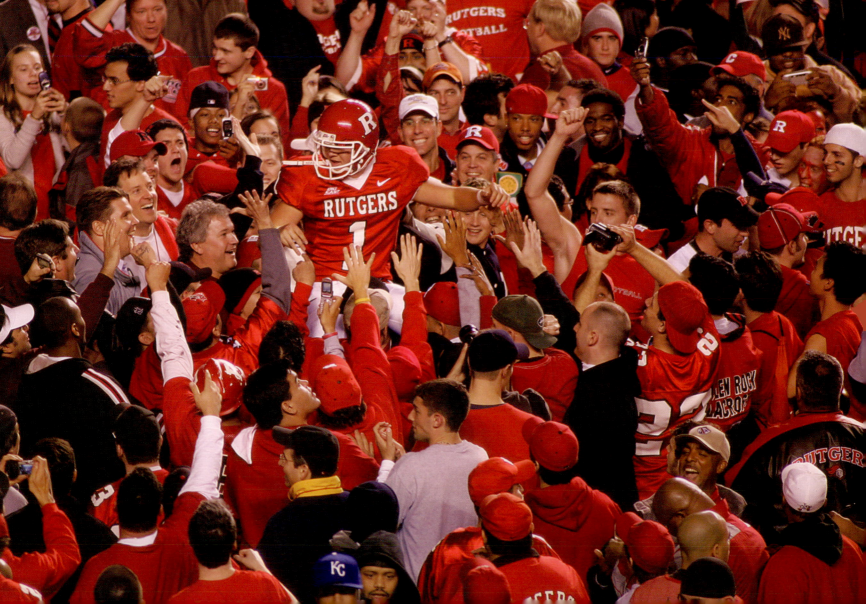

Thousands flock to Rutgers on the last Saturday in April to enjoy the annual Rutgers Day, Ag Field Day, and New Jersey Folk Festival.

2009, an annual event that has attracted more than 75,000 people to the New Brunswick campuses for a daylong event showcasing the university's academic, research, cultural, and recreational programs. In 2010, the president publicly launched a new fundraising campaign, "Our Rutgers, Our Future," with a $1 billion goal. By the campaign's close at the end of 2014, it had surpassed its goal—raising $1.037 billion and advancing Rutgers into the ranks of the nation's most prestigious public research institutions.

In May 2011, McCormick announced that he would step down as president at the end of the following academic year. He had begun his term with specific goals for the university— to transform undergraduate education, explore ways that would make the university self-sufficient and its campuses more attractive, establish closer ties to the state, and ultimately bring a medical school back to Rutgers. This last goal turned

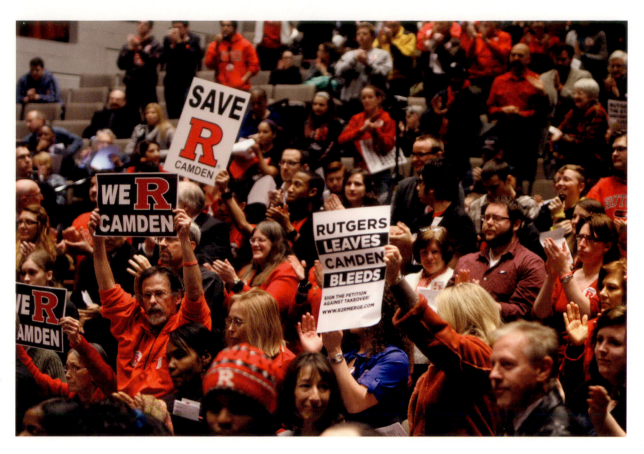

Rutgers–Camden spearheaded the drive to save the campus from a merger with Rowan University.

The Rutgers name replaces UMDNJ on building signs in Newark in advance of the July 2013 integration of the two universities.

out to be one of the most important, and one that would alter the future of New Jersey's flagship institution.

In May 2010, Governor Chris Christie appointed the New Jersey Higher Education Task Force to develop recommendations for improving higher education in the state. The most significant feature of the task force report and of the Governor's Committee to Study the University of Medicine and Dentistry of New Jersey (UMDNJ) was a recommendation to integrate Robert Wood Johnson Medical School and a few other UMDNJ units into Rutgers University to enhance its competitiveness for distinguished faculty, top students, and federal research funding. The

most controversial feature that emerged was a proposal to eliminate Rutgers–Camden by merging it into Rowan University. The Rutgers faculty and students in Camden, joined by their loyal alumni and supporters in New Brunswick and Newark, challenged the governor and organized a widespread protest against the loss of their school. The Save Rutgers–Camden Campaign altered public opinion in favor of keeping Rutgers' presence in Camden. In a definitive move, the Rutgers Board of Trustees, whose vote was required to approve the change, formally resolved to save Rutgers–Camden.

When the governor signed the final legislation in August 2012, Rutgers acquired two medical schools and much more. In addition to the UMDNJ units in New Brunswick, the university integrated all the units of UMDNJ in Newark, except University Hospital. Moreover, the legislation provided greater autonomy for Rutgers' regional campuses by establishing a Campus Advisory Board in Newark and a Board of Directors in Camden. In November 2012, voters approved a $750 million bond issue to support facilities construction and maintenance on the campuses of New Jersey's public colleges and universities. The integration of UMDNJ transformed Rutgers into a truly comprehensive research university.

Day One of the Rutgers-UMDNJ integration was marked by celebrations across the university on July 1, 2013.

The Board of Governors selected McCormick's successor, Robert Barchi, based on his promising abilities to oversee the merger. A respected neuroscientist and medical neurologist, Barchi had been a top-level administrator at the University of Pennsylvania and president of Thomas Jefferson University in Philadelphia. His first year in office proved to be one of important accomplishments but also witnessed unexpected events that proved challenging.

One of the first steps in the integration process was the establishment of the Rutgers Biomedical and Health Sciences division to serve as the umbrella organization for nine health-related schools and numerous institutes, clinics, and centers across New Jersey. To guide this integration and inform ambitious plans to reimagine the entire university, President Barchi initiated a massive strategic planning process—the first since 1995—which took over a year to complete. During this period, the president announced another major development: Rutgers–New Brunswick would join the Big Ten intercollegiate athletics conference. In addition to giving the Scarlet Knights the chance to compete in one of the most prestigious of American conferences, Big Ten membership also resulted in Rutgers–New Brunswick becoming a member of the Committee on Institutional Cooperation, a consortium of world-class research universities dedicated to advancing their academic missions. In his announcement, President Barchi concluded by reaffirming the university's commitment to a "strong focus on academic as well as athletic success… and to running a program of unquestioned integrity." That integrity was later questioned, however, as a scandal erupted in the Rutgers athletic program over videotapes showing the alleged mistreatment of players. The incident resulted in the termination of the head basketball coach and the resignation of the athletic director, but the Barchi administration weathered the storm.

Indeed, the university was in a strong position overall. With the integration of medical and health science programs and a budget exceeding $3 billion, Rutgers had grown to include 65,000 students, 9,000 faculty, and 15,000 staff. Its alumni numbered 450,000, with about two-thirds residing in New Jersey. Besides significant growth in academic programs, student and faculty accomplishments, and the diversity of the university community, there were other tangible signs of progress. Adding to new capital projects completed in Newark and Camden, construction had begun

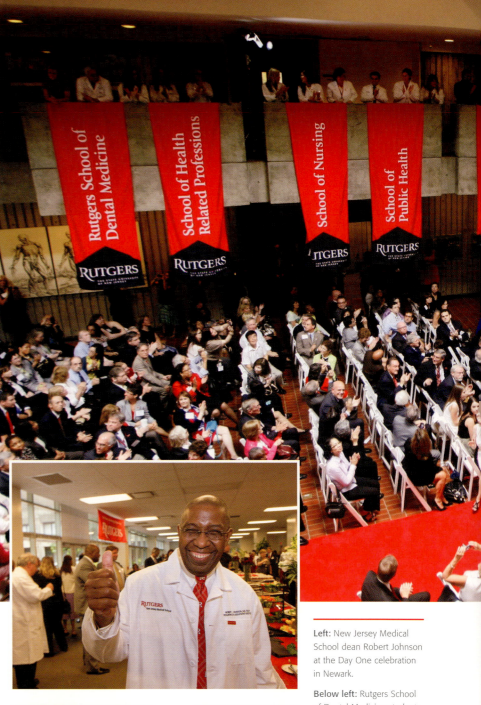

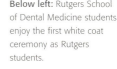

Left: New Jersey Medical School dean Robert Johnson at the Day One celebration in Newark.

Below left: Rutgers School of Dental Medicine students enjoy the first white coat ceremony as Rutgers students.

students. The plans also included a new student apartment complex, complete with green space and retail space, to be located on the corner of College Avenue and Hamilton Street on a former parking lot that had served as home to the famous Grease Trucks, fast-food restaurants on wheels parked semi-permanently across the street from Scott Hall. As part of the redevelopment initiative, the seminary would take ownership of a new building constructed on the corner of College Avenue and Seminary Place, while Rutgers Hillel would enjoy a new facility across College Avenue.

From Seminary of Learning to Public Research University: Rutgers at 250

In reaching its 250th anniversary, Rutgers remains the only institution of higher learning that has been a colonial college, a land-grant institution, and a state university—a unique history mirroring the development of higher education in the United States. It has faced challenges that other colleges and universities have confronted, but it also has had its share of problems that are unique to New Jersey. In its continuing quest to be a top-tier public research institution, Rutgers has established impressive goals for the future. It is certainly a very different place than the one envisioned by Theodore Frelinghuysen and Jacob Hardenbergh in the 18th century. What began as a "seminary of learning" has become a large, influential, and respected public research university—one that gives pride to the students, faculty, staff, and alumni who make up the university community. Its hopes and aspirations for the future rest with those who work on its campuses and with the citizens of New Jersey.

Below: At groundbreaking ceremonies for the largest College Avenue Campus construction project in 50 years, Rutgers President Robert Barchi addresses the crowd as New Jersey Governor Chris Christie (middle) and DEVCO President Christopher Paladino (RC '82, CLAW '85) look on.

on a major transformation of the College Avenue campus in New Brunswick.

The plan was ambitious. Rutgers redeveloped five acres of land, formerly the property of the non-Rutgers-affiliated New Brunswick Theological Seminary—and once the 1800s home of the Rutgers-connected seminary—to construct a new academic facility and Residential Honors College to attract the world's most academically gifted and talented

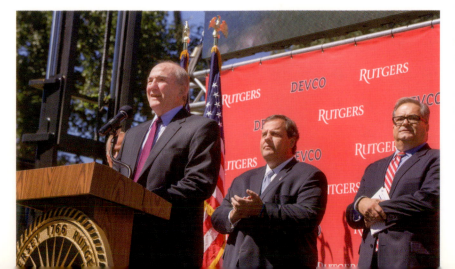

PART 2

ACADEMICS

BARRY V. QUALLS

Rutgers University–New Brunswick

"… the college discourages four years of aimless wandering and assumes that a young man by the age of eighteen should be sufficiently mature to recognize at least the general directions of his vocation."

—RUTGERS COLLEGE CATALOG, 1929

"[Colleges must not turn out] dangerously skilled barbarians [but provide] an education which deliberately sets out to teach students that civilization is their responsibility."

—RUTGERS PRESIDENT LEWIS W. JONES,
1952 INAUGURAL ADDRESS

"[Rutgers must] learn to serve the cities and suburbs of this day as effectively as it served the farms of yesteryear."

—RUTGERS PRESIDENT EDWARD J. BLOUSTEIN,
1971 ADDRESS TO THE STATE LEGISLATURE

The Seminary for God's Prophets

These comments from the 1929 Rutgers catalog and presidential addresses mark the ways that Rutgers has grappled with the very nature of education well-nigh since its founding. From the outset, the college repeatedly confronted debates about what its curriculum should be and who should control that curriculum: was the college to be the Reverend Theodore Frelinghuysen's envisioned "school of the prophets in which children of God may be prepared to enter upon the sacred ministerial office"? Or was it, as the 1770 charter declared, to be an institution providing the "Learned Languages" and the "Liberal and Useful Arts and Sciences"? The charter, significantly for the college's future, provided for the appointment of a divinity professor and "at least one professor or teacher well versed in the English language." Of course in the 1700s, a liberal education was a classical education. But the "useful" was then, and has remained through the present day, a vexing and contentious question. The 1787 list of requirements certainly hints at the useful; in addition to Latin, Greek, and some forms of mathematics, it notes navigation and surveying, and English grammar and composition.

With the revival of the institution as Rutgers College in 1825 (after a series of financial crises), the traditional "classical" courses retained their place in the curriculum; political economy, geology, mineralogy, and chemistry soon joined them. Significantly, a course in moral philosophy was developed to bring the varied curricular offerings together by "relating all subjects to higher general laws of nature." By 1840, a 10-person faculty—including three theological professors—provided instruction in moral philosophy, mental philosophy, evidences of Christianity, logic, modern languages (German and French), and expanded scientific instruction. The next year, a scientific or commercial course was introduced to accommodate students desiring specialized training, reflecting the debate simmering between traditionalists and those who wanted a preprofessional curriculum. Although President Theodore Frelinghuysen in his 1850 inaugural address offered a vigorous defense of traditional academic values at the college, noting that "The mind must be subdued to self control… [and] pass through the healthful discipline of mental and moral culture—and regular, systematic, and severe study," an 1861 trustees committee report noted that the education students were receiving "had imperfectly fitted them" for success in their chosen professions.

Times were changing. In 1856, a grand building, Hertzog Hall (now demolished), was erected for theology students between Seminary Place and Bishop Place, facing Old Queens—indicating the increasing separation of the seminary from the college, and the

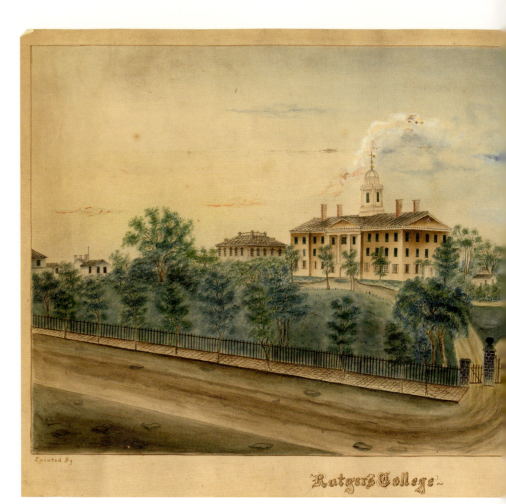

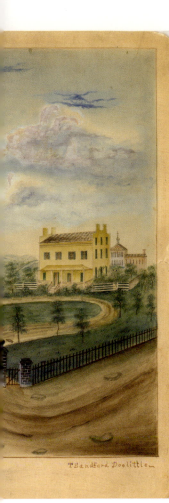

Right: Hertzog Hall, completed in 1856 to accommodate instruction for theological students, marked the physical separation of the collegiate students from the seminarians. This early photograph shows the building's location on what was affectionately called "Holy Hill."

increasing move away from religious, "classical" instruction toward a modern secular education. By 1864, history and English literature became fields of study; by 1882, half the faculty taught in the fields of science and mathematics. Still, in this same year, incoming president Merrill Edward Gates declared that the American college was "designed to give a liberal education, not to train specialists in any one department of knowledge." He went on to enjoin:

A system of education which substitutes for all the disciplinary work of the college course, a seductive and discursive field of elective studies, where a youth at eighteen is told to wander, selecting all at his own sweet will…is utterly subversive of all self-discipline, and will not develop manly fibre, or give tone and symmetry to intellect or character.

Above: Watercolor of Rutgers College by T. Sandford Doolittle (RC 1859).

Right: Student's progress, 1887: Victorious ones climb the Phi Beta Kappa flagpole.

Opposite: Page from *A Compend of Algebra*, assembled by John Taylor, Queen's College tutor, 1773–90.

Gates emphasized academic rigor, developed the first honors program in New Brunswick, and appointed distinguished faculty—not one of which was from the clergy. He also tackled the sparse library collection, which at the time had only 10,000 volumes.

Rutgers College blossomed academically; in 1869, the first chapter of Phi Beta Kappa in New Jersey (the 20th chapter in the nation) was established here. But new attention to both the importance of vocational training and the application of scientific knowledge to real-life problems brought about an even greater change in the essential idea of the nature of a college education. In 1864, in the wake of the Morrill Act, the state legislature designated the Rutgers Scientific School as the state's land-grant college—the beginning of what would become first the College of Agriculture, Cook College, and then the School of Environmental and Biological Sciences as well as the College of Engineering. Here students would find instruction in chemical engineering, mechanics, chemistry, and agriculture—the useful arts indeed.

The conjunction of the separation of the divinity school from the college and the creation of the Rutgers Scientific School marks the beginning of Rutgers' move toward becoming The State University of New Jersey. The Scientific School offered a focus on scientifically based useful knowledge to support New Jersey farmers. The state's role in this transition indicated increasing state involvement in the college's affairs—including the funding of new buildings and scholarships—and presaging more controversial intrusions into the institution.

The Statewide State University for a Diverse New Jersey

Certainly the most important development for Rutgers in the early 20th century was the founding of the New Jersey College for Women (NJC) in 1918. From the outset, NJC was a marked success, with a student body of 54 in its first year and 238 by its fourth. By 1922, when its first class graduated, it had a Phi Beta Kappa

Below: Industrial engineering students in the 1890s.

Right: A group of men and women visit the greenhouse on the College Farm, 1900.

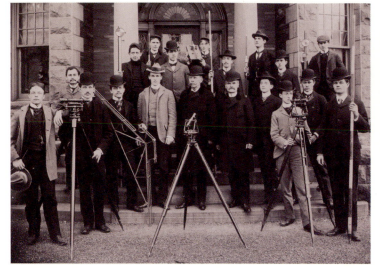

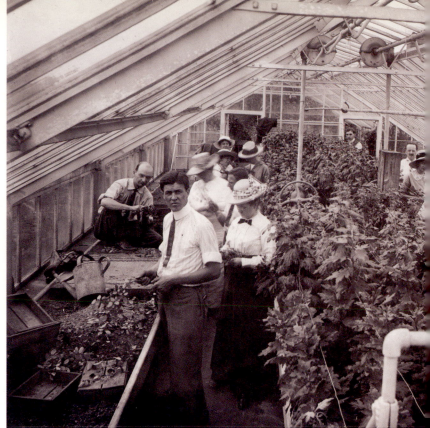

chapter. NJC's curricular emphasis differed from that of the men's college; not surprisingly, given the prevailing culture, home economics, education, music, and art predominated. A science emphasis was not to come until the 1980s, with the launching of the Douglass Project for women in science, technology, engineering, and mathematics (STEM) disciplines.

Thus by 1930, Rutgers consisted of seven colleges: Arts and Sciences, Engineering, Agriculture, Education, Pharmacy (originally located in Newark, this college moved to New Brunswick in 1971), Chemistry, and NJC. It had departments of history, economics, education, sociology, political science, music, modern languages, and English. The requirement of both Latin and Greek was dropped; one classical language would suffice. The course on the evidences of Christianity had disappeared in 1917, replaced by a course on the Bible and ethics, which had in turn disappeared by 1926. The secularization of the Rutgers curriculum was complete.

As the 1929 catalog declared, there was to be "no more aimless wandering." The "Useful Arts and Sciences"

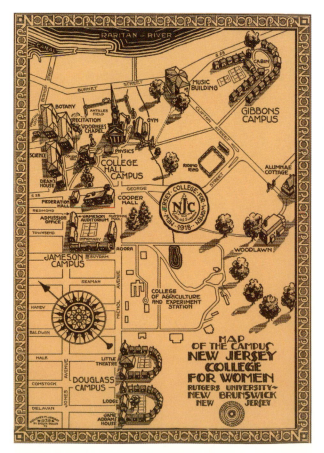

Left: Map of the New Jersey College for Women campus, ca. 1930s.

NJC, renamed Douglass College in 1955 in honor of its first dean, and renamed Douglass Residential College in 2006 following a major redesign of undergraduate education in New Brunswick, has continued to thrive, even as the number of women's colleges in the nation has dropped below 60. Its science programs that support women and its women's leadership programs, along with the Department of Women's and Gender Studies that grew out of Douglass programs, have become national models. As then-dean Carmen Twillie Ambar noted at the time of the proposed reorganization, "Women's colleges still have a role to play in helping women achieve at the highest levels, and Douglass College is still here to do that."

Residents of the Spanish House at New Jersey College for Women in the 1930s.

Wayne Vesey (Dean), lower left, poses with the first graduating class of the Graduate School of Social Work, ca. 1959. The first students were admitted in 1955.

envisioned in the Queen's College charter had become the useful knowledge of the Scientific School—and of the pragmatic culture that has defined so much of the intellectual energies of American life.

Curricular issues were hardly the chief concern during the years of the Depression and World War II. A graduate school was initiated in 1932; and University College began in 1934 as the evening division of the college, focusing mostly on adults and nontraditional students. Most important in these difficult years were the university president and faculty's growing concerns about the anticipated numbers of veterans who would seek a college education at war's end.

The G.I. Bill of 1944 is arguably the most crucial legislation after the Morrill Act in democratizing higher education in the United States. This democratization was expedited as the G.I.s came to all campuses, and in great numbers. Not surprisingly, this new group of students changed the nature of a Rutgers education, especially in terms of an emphasis on new professional programs and graduate education and research. The 1950s saw the establishment of the Graduate Schools of Social Work and Library Service. There

were also programs in labor relations and management (later to become a school), urban studies (later to become part of the Edward J. Bloustein School of Planning and Public Policy), and alcohol studies. The number of doctoral programs, 29 at the beginning of the decade, reached more than 50, propelled by increased federal grants for the sciences. The university's focus, and coming distinction, in the sciences was anticipated by the work of Professor Selman Waksman (RC '15, '16), who led the team of graduate students including research assistant Albert Schatz (AG '42, '45) that discovered streptomycin in 1943, the first cure for tuberculosis. Waksman would win the 1952 Nobel Prize in Physiology or Medicine for his lifelong research work leading to the discovery.

The university's presidents during the 1950s and 1960s continued to address the role of the liberal arts at the increasingly research-based, science-focused campus. Notably, President Lewis Webster Jones championed the education of men and women of all races and all religions as the way forward amid the pressures of individualism and professionalism.

Left: Soldiers studying at Rutgers during World War II, when the university offered many courses designed specifically for them. They were housed in barracks buildings on what is now the Livingston Campus.

Pioneering journalism and urban communications professor Jerome Aumente (NCAS '59), left, and a student in a photo from the *This Is Livingston College* 1974–75 catalog.

in: the urban, racially and ethnically diverse world that characterizes so much of New Jersey. Its curriculum focused on issues that challenged the contemporary world; thus it became the home of urban studies, African-American studies, computer science, and other interdisciplinary programs new to the university; it was also the home of the only business curriculum in New Brunswick. At its best, Livingston would champion the embeddedness of academic study in the wider cultural, political, and economic world where students actually lived. Alas, because of its flexible

admissions policies, it also acquired a reputation as somehow a place of second-rate education, a reputation it never entirely lost (especially among high school guidance counselors) in spite of all evidence to the contrary. This reputation was not helped by the inattention to its campus, which became the dreariest in New Brunswick—until the first decade of the 21st century, when the run-down infrastructure was replaced by architecturally interesting new buildings, the renewal of many existing buildings, new classroom space, and landscaping worthy of Rutgers. And of course a Starbucks.

Above: The P.J. Young Department Store served as one of several early locations for the Mason Gross School of the Arts before moving to a new complex at Civic Square, which also houses the Edward J. Bloustein School of Planning and Public Policy.

Right: A student looks over the new campus of Livingston College in 1970.

Left: The fountain between Tillett Hall and Lucy Stone Hall was among the first new additions on the Livingston Campus in the 2000s, a harbinger of delightful new improvements to come.

Below: Rutgers' early foray into telerehabilitation technology was just one byproduct of major investments in research in the 1990s. Professor Grigore Burdea's virtual-reality glove allows a physical therapist to interact with and monitor patients remotely and in real time.

The Research University

Rutgers' new president, Edward Bloustein, took as a signal goal the reinvention of the New Brunswick Campus as the flagship of the state's research university, a goal that led to Rutgers' entrance into the prestigious Association of American Universities in 1989. Bloustein noted in his inaugural address that contemporary universities were infected with "uncertainty of purpose and the failure of nerve." He lacked neither. His initiatives to make the university a magnet for graduate education and research were transformative. A committee report in the late 1970s had found graduate education "'fragmented, and subordinated to undergraduate needs'; professional schools often ignored; research 'handicapped'; and governance too complicated." Graduate school dean Kenneth Wolfson declared that graduate students at Rutgers were second-class citizens.

All this changed. The rise of research and graduate education at Rutgers marks the administration of Edward Bloustein and the enthusiasm of Governor Thomas Kean for a "new" Rutgers conceived on the scale of Michigan and Berkeley. Of course faculty had been doing research at Rutgers since the establishment of the Rutgers Scientific School; and the work of Selman Waksman from the 1930s into the 1950s

Chemist Kathryn Uhrich leads a Rutgers laboratory that designs biocompatible and biodegradable polymers for medical, dental, and personal care applications.

glider project. And chemistry professor Kathryn Uhrich had undergraduates working alongside graduate students in her lab studying biodegradable polymers that can be adapted to the care of wounds through stints used in surgery.

The Bloustein years triggered the remarkable changes in graduate education and research that continue to this day. At the same time, President Bloustein urged faculty to find ways to ensure that the pursuit of new knowledge did not eclipse the education of undergraduates. This concern—an issue for research universities across the country—was taken up in earnest by Bloustein's successor, Francis L. Lawrence. In his 1991 report on "Undergraduate Education at Rutgers: An Agenda for the Nineties," he noted

> that faculty members' responsibilities have shifted away from undergraduate instruction to graduate instruction or no instruction at all, that teaching is no longer valued or rewarded, that the number of publications is really all that matters when considering a faculty member's promotion, and that undergraduate class sizes have escalated.

Lawrence appointed a committee to examine the issues. The resulting report updated the long-standing debate about what distinguishes a Rutgers education. It championed a "curriculum emphasizing critical awareness"; it articulated students' need for "an understanding of the historical and cultural forces which have created the wide range of

specialized disciplines"; and it planned a curriculum that not only focused on the "basic literacies that modern life requires," including new technologies, but on the diversity of the state and university "as an occasion for cross-cultural exchange and enrichment."

This was clearly a vision of a comprehensive curriculum that grew out of the cultural studies discussions of the 1980s and early 1990s. But few colleges wanted to give up their rights to determine their curricula. Most faculty members, not to mention deans, saw a single universitywide curriculum as unnecessary and probably impossible.

But curricular and structural change that would alter the way Rutgers undergraduates were admitted, educated, and graduated was on its way. In 2004, new Rutgers president Richard L. McCormick convened a Task Force on Undergraduate Education. His premise was that the 1981 reorganization, when faculties of the liberal arts colleges were moved into the New Brunswick department structure, had left the colleges in charge of admission, curriculum, and graduate requirements. Students and faculty were caught in a maze of contradictory rules about which courses counted at which college—and even about rules on cheating.

Cartoon from the *Star-Ledger* focusing on the debate at Rutgers in 2005–6 over reorganization of the undergraduate colleges in New Brunswick.

"I WANTED TO COMPLAIN ABOUT THE CONSOLIDATION PLAN, BUT I DON'T KNOW WHERE TO GO."

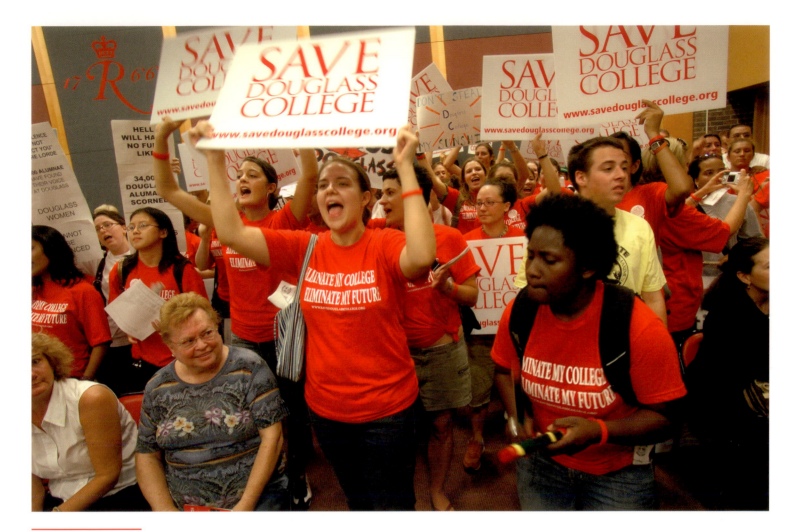

Douglass College students protesting the 2005 recommendations for reorganization of the New Brunswick liberal arts undergraduate colleges into one unit, the School of Arts and Sciences.

The task force report appeared in July 2005, and controversy erupted immediately—not about the discussion of the curriculum or learning communities, undergraduate research, admissions and recruitment, classroom design, or the myriad other issues covered. Instead, the focus of the controversy was on the recommendation that the liberal arts colleges (Rutgers, Douglass, Livingston, and University Colleges) be abolished and merged into a School of Arts and Sciences. In particular, Douglass deans, alumnae, and students protested that this plan was a backtracking from the university's proud history of support for women's education. In the end, Douglass became Douglass Residential College, losing its degree-granting status but retaining its cocurricular programs, adding new ones for incoming women, and even extending its reach onto the Busch Campus through housing for women in engineering and other STEM fields.

Few presidents have accomplished such bold action amid so much dissension. But this report, unlike previous ones, involved the New Brunswick faculty, students, and staff who would implement it; and it was championed by a president determined that undergraduate education was central to his vision of Rutgers as a research university. Once the Board of Governors supported the president's recommendation—including the establishment of Douglass Residential College and the name change of Cook College to the School of Environmental and Biological Sciences—McCormick immediately challenged the schools to plan implementation within a year so that the class of 2011 would operate under the new organization. And he called on the dean and faculty of the School of Arts and Sciences to begin work on a curriculum that would truly define a Rutgers education and end the cafeteria menu of course selection.

Chief among McCormick's initiatives was his emphasis that students be exposed to Rutgers as a research university from their first introduction to the campus, during the recruitment process, and in their first-year courses, notably the Byrne Family Seminars taught by faculty.

FIGS

One of the most enjoyable experiences I have had at Rutgers is creating and teaching my own course through the First-Year Interest Group Seminars (FIGS) Program, which sets out to expose new students to what goes on in various majors. I had the opportunity to create my own course, "Exploring Mathematics," and help students navigate through their first semester at Rutgers University while introducing them to some math. This experience affirmed my desire to become a middle or high school math teacher. It also allowed me to learn more about the resources that this great university offers while interacting with people with diverse academic and personal interests. Moving forward, the FIGS Program will benefit Rutgers tremendously. It will allow upper-class students to mentor first-year students and improve their skills, including communication and public speaking. Furthermore, it will allow first-year students to become comfortable at Rutgers and gain a sense of Rutgers pride, which will increase retention and graduation rates for many years to come.

—Angelo Monaco (SAS '15, GSE '16)

He also mandated and funded the Office of Distinguished Fellowships, charged with supporting Rutgers undergraduates in the competition for major national fellowships like the Rhodes, Gates, Fulbright, Goldwater, Truman, Marshall, and Churchill. The numbers of Rutgers students now applying for, and winning, these fellowships have multiplied tenfold.

Arpita Shah conducts research in a pharmacy laboratory. After earning her undergraduate degree she went on to participate in Rutgers Pharmaceutical Industry Fellowship Program.

The results of the discussions about what would become the Core Curriculum of the School of Arts and Sciences—the general education program of nearly all entering students in New Brunswick—reflect the nature of a 21st-century undergraduate education. Core courses do not present "coverage" of various areas in the disciplines as their focus; instead, they push students outside their goals for majors or careers so that they begin to develop wider perspectives on knowledge and the societies that produce it. The most widely discussed part of the core has been the section on 21st-century challenges, which urges students to think from various disciplinary perspectives about real-world issues such as food shortages, climate change, poverty, and geopolitical conflicts. A superb example of a course in this area is the one required of all women choosing Douglass Residential College, "Knowledge and Power," which asks students to understand how gender issues are embedded in the cultural, political, and economic assumptions we make about the roles of women.

The findings of researchers in the NJAES Marucci Center for Blueberry and Cranberry Research are essential to cranberry growers in New Jersey.

Above: Philosophy professor Andy Egan teaching an undergraduate Signature Course on food and the ethics of food choices.

Above: Robert Goodman, dean of the School of Environmental and Biological Sciences, celebrating the opening of a Rutgers farmers market.

Right: George H. Cook, namesake of Cook Campus, was instrumental in advancing Rutgers as a research institution.

Perhaps the core's most exciting component is the signature courses. These courses speak to issues that confront students now and once they leave the university—for example, "Extinction," taught by Rob Scott of anthropology and focusing on dying species, dying languages, and much else; "Eating Right: The Ethics of Food Choices and Food Policy," taught by Andy Egan of philosophy; and "Sea Change: The Rise and Fall of Sea Level and the Jersey Shore," taught by Kenneth Miller of earth and planetary sciences. These courses, like the curriculum they inform, do not try to balance traditional liberal arts and the newer, science-connected and professional fields. They are an ambitious turning away from single disciplinary areas to establish a common basis for intellectual exchange.

So we come full circle in the discussion and formation—really reformation—of the Rutgers curriculum, and in the work of defining a genuinely Rutgers education. That work has not ceased with the development of a core curriculum, any more than it ceased with the classical education proposed for Dutch Reformed ministers at the end of the 18th century or with the remarkable research energy that characterizes the contemporary Rutgers. Clearly the entrance of a multitude of scientific courses and of professional schools into the university, all begun with the formation of the Rutgers Scientific School, complicates any discussion of what constitutes the liberal arts. So does the redefinition of a university education as preparation for global citizenship. Still, Mason Gross's profound belief that a college education produces in its students "a sense of tremendous excitement and joy" remains a reality. Knowledge is not just power; it is also joy.

Rutgers Roots as New Jersey's Land-Grant Institution: Past, Present, and Future

ROBERT M. GOODMAN, EXECUTIVE DEAN OF THE SCHOOL OF ENVIRONMENTAL AND BIOLOGICAL SCIENCES

I have had the privilege of leading two units—Cook College (which today is the Rutgers School of Environmental and Biological Sciences), and also the New Jersey Agricultural Experiment Station (NJAES). Both have their origin in the Rutgers Scientific School created in 1864 when the New Jersey legislature made Rutgers the state's land-grant college. George H. Cook, who had led the campaign for land-grant status against a counterproposal from Princeton, was named the school's first dean and professor of agriculture. The teaching of chemistry, engineering, geology, and agriculture are among his legacies. So too is agricultural research; he convinced the state legislature to create and fund the NJAES in 1880, seven years before the U.S. Congress passed legislation creating a nationwide system of such stations.

The role of the NJAES was broadened by the 1914 passage of the federal Smith-Lever Act, which created and funded the beginnings of the Rutgers Cooperative Extension, whose mission was to bring the results of scientific research and best practices to New Jersey farms and homes. NJAES was a pioneer in creating short courses on topics of use to practicing farmers, leading to the construction of the Short Course Building (now Waller Hall) in 1906. With both classrooms and lodgings, this was the first academic building on what is now Rutgers' George H. Cook Campus.

In 1917 the New Jersey legislature designated the State College of Agriculture as The State University of New Jersey. After some organizational controversy and confusion, that led to the creation of the College of Agriculture in June 1921.

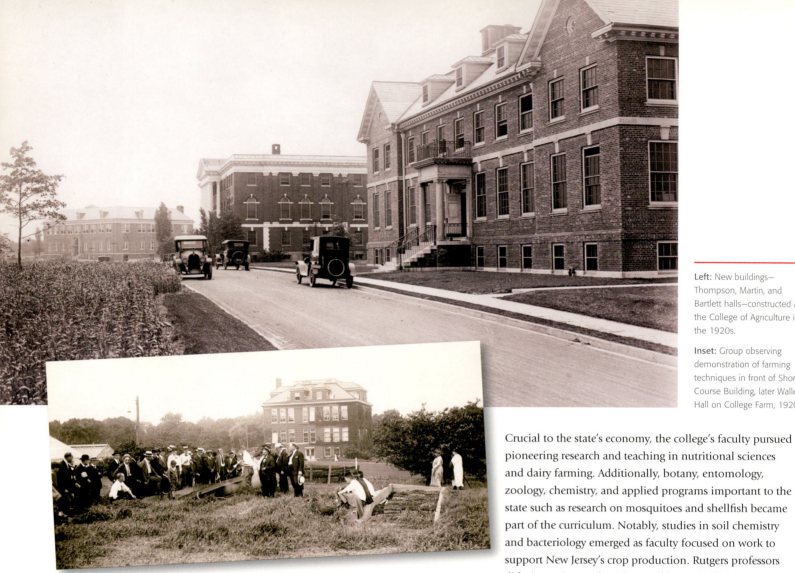

Crucial to the state's economy, the college's faculty pursued pioneering research and teaching in nutritional sciences and dairy farming. Additionally, botany, entomology, zoology, chemistry, and applied programs important to the state such as research on mosquitoes and shellfish became part of the curriculum. Notably, studies in soil chemistry and bacteriology emerged as faculty focused on work to support New Jersey's crop production. Rutgers professors did pioneering work on how soil bacteria "fix" nitrogen, making it available as an essential nutrient for plants. This idea that the soil was a bacterial goldmine led to the discovery by Selman Waksman and his students of antibiotics such as streptomycin from soil bacteria. Meanwhile, in poultry research, Fred Beaudette pioneered advances in the

Below right: Selman Waksman, left, with Randolph Major, center (research director, Merck and Co.), and Alexander Fleming (Nobel Laureate, penicillin) discuss antibiotic screening techniques in Waksman's laboratory, 1940s. In 1952 Waksman received the Nobel Prize in Physiology or Medicine for his life-long research leading in 1943 to the discovery by him and his research team of streptomycin, the antibiotic most effective in combating tuberculosis.

Below: Meteorology student presentation, 1949.

Filming a short course in agricultural economics.

Below right: Nobel Prize citation to Selman Abraham Waksman, 1952.

Below: J.A. Stackhouse with two horsehoe crabs. Under the New Jersey Agricultural Experiment Station, Stackhouse became county superintendent of farm demonstration for Cape May County in 1917.

identification and prevention of disease, particularly those caused by viruses; later, Hans Fisher (AG '50) pioneered studies in poultry nutrition. Fisher would go on to lead the transformation of the Department of Poultry Science into the first Department of Nutritional Sciences in the United States. Also, the animal science faculty, through their research on the endocrine system and the biology of mammary glands and breast cancer, showed the value of animal models to address important aspects of human medicine.

The period after World War II brought unprecedented investment by the federal government in research. These investments have driven, directly and indirectly, much of Rutgers' research agenda for the past six decades.

The Rutgers Antibiotics

The 1901 founding of the nation's first Department of Soil Microbiology subsequently led to dramatic changes in world medicine through the discovery of the "Rutgers antibiotics" in the 1940s at the New Jersey Agricultural Experiment Station. The study of dirt—usually anathema to medicine—by Selman Waksman's group yielded over 20 antibiotics. The best known of these, streptomycin, was the first effective agent against tuberculosis, then the world's greatest killer. These studies resulted in international screening of soils for microbes that produced antibiotics. Selman Waksman was awarded the 1952 Nobel Prize in Physiology or Medicine for his methodologies—the only Nobel Prize awarded to a Rutgers faculty member.

—Douglas Eveleigh,
Distinguished Professor Emeritus,
Department of Biochemistry and Microbiology

Below: Researchers examine juvenile oysters at an NJAES Haskin Shellfish Research Laboratory field station. Haskin scientists are key players in a Rutgers, New Jersey Department of Environmental Protection, and oyster industry collaboration largely credited with restoring the Delaware Bay's oyster population, decimated over the past 30 years by disease and overharvesting.

Right: Fieldwork involving taking an air sample from a small smokestack for a College of Agriculture and Environmental Science course on air pollution, 1971.

In the early 1960s, the College of Agriculture at Rutgers, significantly and not without controversy, added the word "environmental" to its name, becoming the Rutgers College of Agricultural and Environmental Sciences (CAES). This was the era of pesticides and inorganic fertilizers, and the industrialization of agriculture was in full swing. New Jersey, while proportionally not a heavy user of these products on its small family farms, was a major supplier, and we are still dealing with the resulting legacy of pollution of groundwater and estuaries and of serious heavy metal contamination a half-century later. Academic departments found in today's School of Environmental and Biological Sciences—for example, environmental sciences, ecology, natural resources, and human ecology—and work priorities of the NJAES trace their origins to this time.

CAES in 1973 became Cook College, a separate, affiliated college within the university, focusing on agriculture and the environment and committed to undergraduate teaching. It occupied its own bucolic campus, also named for Cook, and spent the next 30-plus years struggling for recognition and identity (there was at one point talk of secession).

During these years, there was a major reorganization of the life sciences at Rutgers, which led to a partition of disciplines. Those in the emergent molecular sciences remained on the Busch Campus, while those dealing with food, water, atmosphere, and the like moved across the river to Cook—forming the core of today's School of Environmental and Biological Sciences.

My arrival as executive dean of Cook College and executive director of the NJAES in mid-2005 allowed me to play a central role in the reorganization of undergraduate education under President Richard L. McCormick. Cook College, while unchanged in its academic role and autonomy, would become a school: ultimately, after much discussion and not a little controversy, the School of Environmental and Biological Sciences.

The faculty quickly coalesced around three high-level guiding themes: food, nutrition, and health; climate and energy; and international education. To advance our work,

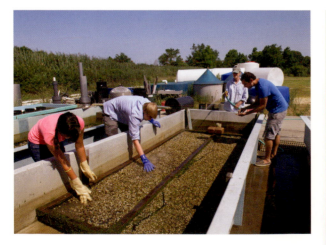

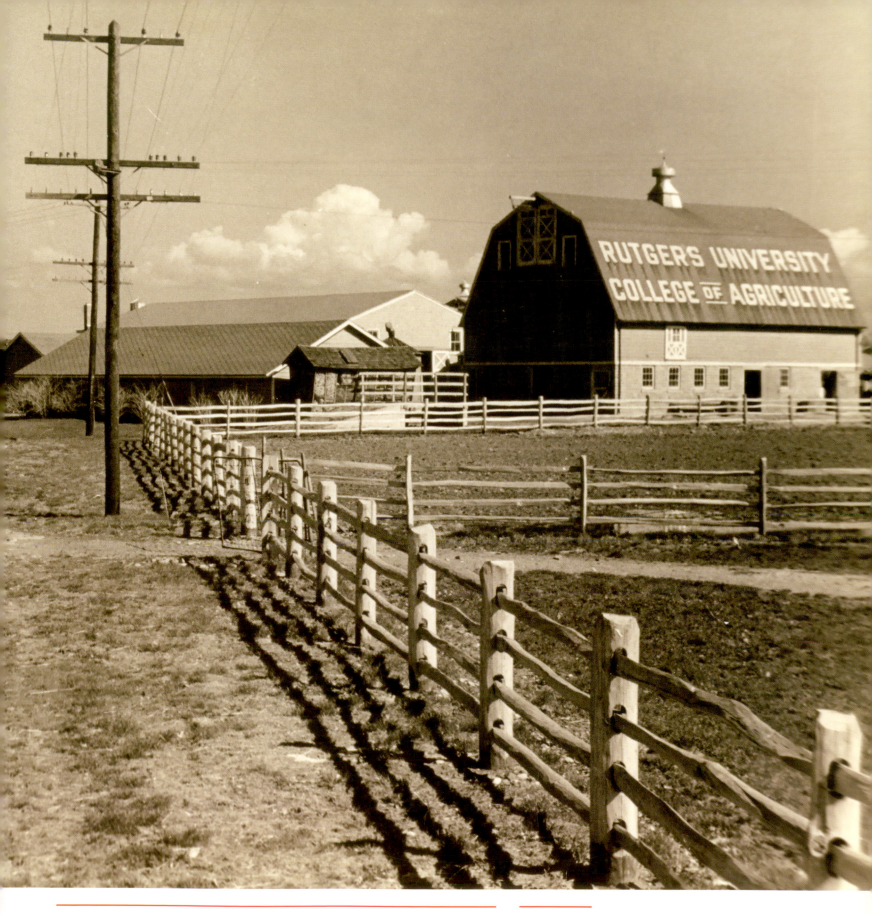

Opposite: Arctic, Freedom Peppermint, Silverstar Red, Sonora Jingle, and Premium Polar are among the many poinsettia cultivars on display during the Poinsettia Open House at the Floriculture Greenhouse on G.H. Cook Campus. The annual event lets growers and sellers learn more about handling and marketing this popular crop.

Above: A view of a barn along College Farm Road.

Doc Locandro

When I think of being a Rutgers University student, Roger "Doc" Locandro is always part of it. I can't help but smile as I remember him saying, "Eat together, learn together." Doc was a real teacher. He did not teach by standing in front of a room of students seated at desks. If we were seated, he usually was as well, but we were not lined up in rows, but more than likely in a circle all around him. Or we'd all be standing, huddled around Doc so we didn't miss a word. Either way, you'd often find yourself eating or drinking while he was sneaking some new knowledge into your head. It was communal … a true sharing of experience. I believe that is why I have never forgotten his lessons. And to this day, he still quizzes me, either to remind me of all that I have learned over the years or perhaps to see how good a teacher he really was.

I can remember studying very hard before our final exam in "Interesting and Edible Plants." I was paying particular attention to the spelling of genus and species and the differences between edible and poisonous varieties of mushrooms. It seemed like a lot of intensity for a 1-credit course, but the final was going to be down in the Pine Barrens, and we really didn't know what to expect. When we arrived, we all gathered around Doc for instructions. He told us to meet back at this spot in an hour or so, with lunch! We took off in different directions to use all that he had taught us in order to find edible food. When I returned with my hat full of "lunch," Doc simply had us all explain what we had found and how we were able to identify it. After we had all shared, someone asked Doc how we would be graded. I think he just said, "Oh yeah, you all get A's."

Roger Locandro (AG '60, GSNB '67, '73), above, was renowned for his epic "Field Ecology" classes that took students to Alaska, Newfoundland, and Puerto Rico, as well as exploring the nature and culture of New Jersey. The photos, at right and bottom left, are from two of those trips. In a journal she kept during a trip to Alaska (see sample entries below), ecologist Jamie Morgan (RC '02) noted: "… these three weeks have been the best learning experience I've ever had. Not only did I learn about ecology, but geology, native life, art, land management, recreation, mining, cultures, lifestyles, happiness, and love. The class was a combined bonding experience with people and nature, and I guess that's what learning ecology is all about anyway!"

Not when I initially applied to Rutgers CAES, or while drinking dandelion wine and eating Swedish moose meatballs and moose tongue *pâté* with classmates (both the result of a recent student trip to Newfoundland), or even when I graduated in the first four-year class of Cook College did it ever cross my mind that someday I would be working at Rutgers University. During my 25-plus years here, I have always remembered the lessons Roger taught me, and done my best to give students my time and attention, in an effort to sneak some lessons into their heads the same way Doc did to me.

—Joseph Charette, Executive Director, Rutgers Dining Services and Student Affairs Retail Operations (CC '73)

Above: The Rutgers Food Development and Manufacturing Center improves the quality and variety of food for the U.S. armed forces. Rieks Bruins uses the center's nondestructive seal tester.

Right: Rutgers tomato breeds are coveted for their hardiness and distinctive flavor.

Below: The Center for Advanced Food Technology is a model for industry, government, and academic collaboration that addresses food quality, safety, and healthfulness.

we created the New Jersey Institute for Food, Nutrition, and Health. The Rutgers Energy Institute focuses on alternative energy, with scope from catalysis, biomass conversion, economics, natural energy (wind, wave) conversion, and atomic (nuclear) energy. The Rutgers Climate Institute grew from successful faculty collaborations in the physical, chemical, biological, and social sciences. The Department of Marine and Coastal Sciences has become an internationally recognized center of excellence in oceanography and marine biology. It claims international leadership in deep-sea biogeochemistry, robotic technologies for coastal and ocean observation, benthic and pelagic marine biology, coastal and near-coastal ocean fisheries, and coastal processes related to global climate change.

To prepare ourselves for the future, I have made reinvestment in faculty a major focus, including the hiring of more than 80 new faculty members between 2007 and 2013, half of them women.

Public, comprehensive research universities that emerged from the land-grant movement of the 19th century and prospered—and helped the nation to prosper—in the latter half of the 20th century are today struggling to define their future roles. With federal and state investments no longer certain, some question whether such universities can—or should—survive.

I believe there remains an overarching role for these large, complicated, and expensive institutions. Human

civilization faces major issues: one generation from now, there will be 9 billion people on Earth; there is undeniable evidence of human-caused environmental degradation and forcing of climate change that compete with our needs for the resources to feed, clothe, house, and provide ecosystem services to sustain civilization.

All human progress in science, in technology, and in the arts and humanities depends on people with different knowledge and experiences coming together in places and institutions where ideas are shared, problems are solved, the next generation can learn, and societal needs including governance can be advanced. No other institution of human invention is more suited to addressing these issues than the large, comprehensive public university. The School of Environmental and Biological Sciences, with its rich history and its future obligations, will play its part in seeing that Rutgers invests its resources and focuses its values on addressing humanity's major needs.

Women at Rutgers and the Women's Revolution of the 1970s

MARY HARTMAN, UNIVERSITY PROFESSOR OF HISTORY, FOUNDING DIRECTOR OF THE INSTITUTE FOR WOMEN'S LEADERSHIP, AND FORMER DEAN OF DOUGLASS COLLEGE

When I arrived on the banks in 1968 to teach history at Douglass, I learned that Rutgers was the only state university that had evolved from a small, private colonial school to a major public research institution. I was also reminded that Rutgers College was still all male.

By the turn of the 20th century, most colleges and universities admitted women, but only one did so in New Jersey: the College of St. Elizabeth. Like most colonial colleges, Rutgers had persistently rejected pleas for coeducation, prompting the New Jersey State Federation of Women's Clubs to launch in 1911 a statewide campaign for an alternative—an affiliated college for women. To lead the effort, the group named Mabel Smith Douglass head of its Jersey City Club.

In 1915, after 58 percent of the all-male electorate rejected women's suffrage in a state referendum, the federation president urged members to keep championing the women's college—and to avoid taking sides on the suffrage issue! Still, the effort stalled until the Smith-Hughes Act in 1917 gave federal funding for home economics classes at land-grant institutions. Rutgers trustees then took a three-year lease on the Carpender estate near the agricultural school, with an option to buy. The new New Jersey College for Women now had a campus and one building: a mansion soon to be called College Hall that was at once offices, classrooms, a library, a dean's residence, and a dormitory. In the fall of 1918, Dean Douglass welcomed Rutgers' first 54 female students.

When the dean resigned in 1933, her thriving college had its own faculty and over 1,000 students. Renamed for its founding dean in 1955, by the 1980s, Douglass was the largest women's college in the country, with over 3,000 students.

The first landmark moment for the impact of feminism at Rutgers was thus a long struggle for the admission of women. The next such moment was the stormy era from 1968 to 1971 when Rutgers College—then the last public, nonmilitary men's school in the land—was again wrestling with coeducation. By fall 1968, its faculty, students, and dean, Arnold Grobman, all wanted coeducation, but the alumni

Ravine Bridge, also know as the "Kissing Bridge," on Douglass Campus, 1948.

At Rutgers College, Foster argued, "coeds" would be discriminated against, with only four tenured women on a faculty of over 300, and few services. The athletics director later admitted there were no plans to add women's sports, and the head of health services said that he would not be hiring a gynecologist. He reportedly said that if girls had health problems they should talk to their mothers. So the dean turned the focus to saving Douglass. To lead the campaign, she chose a part-time instructor in English, future feminist literary critic Elaine Showalter.

At Douglass, Showalter was already pioneering one of the country's first women's studies programs, recruiting from among her colleagues, including myself, in departments housed in the then-new Hickman Hall—English, history, philosophy, and political science. With coauthor Mary Howard, a sociologist, Elaine got the dean's attention with a kind of manifesto—"The Future of Douglass College: Women and Education"—arguing that instead of giving in to coeducation as Vassar had done, Douglass should try "a bold experiment in feminist education" that aimed "to provide students and faculty with a genuine sense of identity and leadership." Further, she told Dean Foster about Barnard

Below: Aerial view of Douglass, 2000.

Below right: The Nereids, Douglass College's synchronized swimming team, 1956.

and Rutgers Board of Governors still rejected it. Meanwhile, the new dean at Douglass, Margery Somers Foster, was being pressured by Rutgers College to endorse coeducation for Douglass as well as Rutgers College. An economist with a Wellesley BA and a Radcliffe PhD, plus a wartime stint in the WAVES, Dean Foster was having none of it.

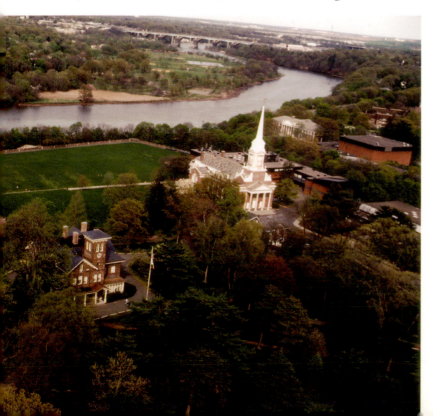

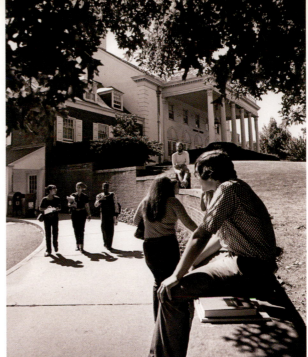

Students gathering on Douglass College campus, 1974.

instructor Kate Millett's 1968 pamphlet, "Token Learning," which alleged that even the best women's colleges had since the '50s traded in a mission of opening opportunities to women for a "tacit feminist mystique of gentility and service." The upshot was that the then-unknown Millett was invited as the Founders Day speaker on April 14, 1970—the day before the Douglass faculty was slated to vote on coeducation.

Nearly a quarter-century later in 1993, as dean of Douglass, I invited Elaine Showalter, then Princeton's Avalon Professor of Humanities, to be the Founders Day speaker at Douglass's 75th anniversary. She recalled Millett's visit in 1970, when she had shocked many, but not Dean Foster, with examples of the second-class status of women in education and society. She saw coeducation as the way things were headed, but argued that women's colleges should be "centers of hope…and encouragement of excellence in women." The next day, voting 90 to 32, the faculty adopted a resolution based on Showalter and Howard's pamphlet, committing "to undertake to educate women for full partnership and active participation in society." A resolution declaring that if Rutgers College went coed, Douglass should do so as well was defeated by a two to one vote.

Dean Foster invited the two young women to head a committee on what was needed, as the dean put it, "to do right by women's education." In Showalter's words:

We called for the development of courses dealing with women's history, status, and achievements; for a day-care center; for programs for women in the community; for an emphasis on women artists and writers; for improved career counseling; for the sponsorship of research on women; for sexual counseling; and for the abolition of inequities between male and female student life at Rutgers.

In fall 1970, the Board of Governors considered a new recommendation proposing coeducation for the men's college, while (grudgingly) guarding Douglass's single-sex status. Although the board affirmed its single-sex stance for both schools one more time, this position was reversed within a year after a federal court decided that the formerly all-male, publicly funded University of Virginia was moving too slowly in admitting women. Asked by the Rutgers administration to comment, Ruth Bader Ginsburg, then on the Rutgers School of Law–Newark faculty, replied

Elaine Showalter, professor of English and one of the founders of Women's Studies at Rutgers, wrote the landmark study *A Literature of Their Own: British Women Novelists from Brontë to Lessing.*

that the decision "renders Rutgers College vulnerable" to legal action if it decides not to admit women. As to whether Douglass might also be ordered to go coed, she noted that the Supreme Court and Congress had upheld the constitutionality of women's colleges as a remedy for inequities women still confronted in educational and professional pursuits. She added dryly, "If America were now a matriarchy (as some paranoid men seem to fear it becoming), we would regard women's colleges as a menace." Douglass remained single sex; and in fall 1972, Rutgers College admitted its first 600 women.

Faculty leaders of Douglass College: Mary S. Hartman, historian and dean of Douglass College, and Cheryl Wall and Carol Smith, professors of English.

Although most of us did not realize it then, the board's decision to keep the college for women in 1971 was the landmark moment for the long-term impact of feminism and women's studies, both at Douglass and in the wider university. That same year the Eagleton Institute of Politics, located at Douglass, launched its soon-to-be-renowned Center for American Women and Politics. Douglass proceeded to forge links with women-focused studies in other Rutgers divisions, and ultimately to promote a consortium, the Institute for Women's Leadership, dedicated to understanding and advancing women's lives. In 2014, the institute, along with the School of Communication and Information and the School of Arts and Sciences' Department of Women's and Gender Studies, launched a campaign to endow a chair in media, culture, and women's studies to be named for feminist icon Gloria Steinem.

It is hard after all these years to convey the bizarre experience of entering Rutgers–New Brunswick in 1968 as a junior faculty woman at Douglass. Here was a place of multiple undergraduate cultures, where the colleges for women and men—a mile or so apart—felt like different planets. Ongoing "coeducation wars" had hardened pro- and anti-factions on both sides of the river. By the early 1970s, Rutgers University had 27 percent female faculty—typical for universities then, with women clustering in the humanities, education, nursing, and social work. What set Rutgers apart was not just being one of a few (now the only) state universities with a women's college, but having a full 43 percent of its entire female faculty located at that college— even though most Douglass departments were still about two-thirds male. Having attended "single culture," coed schools, and having been taught by just two women in college and none in graduate school, I was thrilled to be in a place with so many female faculty who were both visible and valued.

For me, the 1970s went by in the panic and elation of turning myself from a political historian into a women's historian before my tenure clock ran out. My book on Victorian murderesses was accepted just under the wire, so I made it. A Rutgers College colleague told me later that he had voted against me because all the time I had spent on organizing

Women's studies leadership course with Charlotte Bunch, founding director of the Center for Women's Global Leadership and author of important studies focusing on women's global rights.

Jewel Plummer Cobb, Douglass College's sixth dean (1975–81) and an eminent cell biologist.

the first Berkshire Conference on women's history—a field he labeled a "fad"—signaled to him that I was not serious about doing what he called "real history." By then I knew women's history was real history, and that I was serious about it. For this, I have Douglass to thank.

When Jewel Plummer Cobb, a noted cell biologist and the first African-American dean of Douglass, left in 1981 to become president of California State at Fullerton, I accepted New Brunswick provost Ken Wheeler's request to serve as acting dean of the college, ultimately becoming dean in 1982. In a move I fully supported, the separate college departments were being combined into a single arts and sciences faculty. I found more space for the New Brunswick-wide women's studies program, then assigned to two small offices in the basement of the Spanish building, in four offices plus meeting space in another basement—that of Voorhees Chapel. That basement, in fact, soon became home to more Douglass-led ventures, including the Institute for Research on Women; the Douglass Project for Rutgers Women in Math, Science, and Engineering; the first state-funded Chair in Women's Studies, and the Center for Women's Global Leadership. All thrive to this day, many now—significantly—above ground.

Meanwhile, the restructuring plans of the early 1980s entailed moving Douglass's math and science departments to the Busch Campus, raising our fears of losing the many Douglass women majoring in these fields. We decided on better options for women in STEM fields. We converted a large Douglass residence hall into a math-science dorm, which

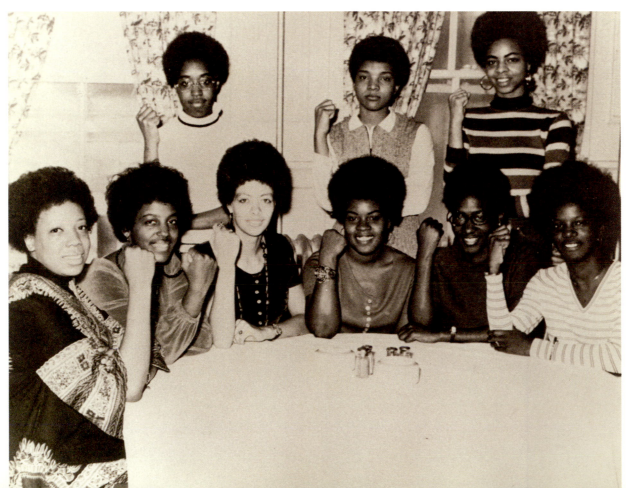

Left: Douglass College Afro-American House members pictured in the 1970 *Quair* yearbook. Located in the Gibbons residences, the Afro-American house was opened in 1969–70 as a living-learning option for students. Together with the newly formed majors in African and Afro-American Studies, it "acted as a center for the study of the cultural heritage of the African and Afro-American peoples."

became the first such residence in the country. We housed 100 Rutgers undergraduate women majoring in STEM fields and 10 graduate student mentors for them, dedicating the Bunting-Cobb residence, named for our two scientist deans, Mary I. (Polly) Bunting-Smith and Jewel Cobb, in 1989. (Douglass now has a presence for women in floors of the engineering residence hall on the Busch Campus.) The other new initiative was the Douglass Project for Rutgers Women in Math, Science, and Engineering, which offers special mentoring to STEM women and a research stipend allowing them to pursue special projects. In a White House ceremony in 1999, President Bill Clinton gave this program the National Science Foundation's award for excellence in mentoring.

There is much more. But my take on how feminism and women's studies played out at Rutgers underscores the backdrop of excitement around diversity issues in the 1970s. To the lively civil rights and women's rights dramas on the national stage, Rutgers–New Brunswick added dramas of its own. A comment attributed to Gloria Steinem well expresses the shift many of us experienced there in our mindsets about gender: "What we have learned to call 'sexism,' we used to call 'life.'"

Zimmerli Art Museum

As Rutgers celebrates its 250th birthday, the Jane Voorhees Zimmerli Art Museum has double reason to mark 2016 as it celebrates its own 50th birthday. Established in 1966 in a small room off the art history department office, the Zimmerli has become Rutgers' university art museum. Today, the museum occupies a 40,000-square-foot facility that houses a collection of 60,000 objects, and is one of the 10 largest university art museums in the United States.

The collections have particular strengths in 19th-century French art, particularly prints and rare books; Russian and Soviet Nonconformist Art; and American art—especially prints. But as a teaching museum, the Zimmerli owns, and greatly values, smaller groups of holdings in many other areas including European old masters, American painting, Pre-Columbian works, and Art Nouveau objects.

The Zimmerli is well known internationally for its Norton and Nancy Dodge Collection of Nonconformist Art from the Soviet Union. The Zimmerli owns the best, largest collection of this artwork that illustrates the determination of creative people to express themselves even under the most repressive regimes.

A place for the integration of the creative arts into the social and intellectual life of our academic community, the museum is intent on establishing Rutgers as an international leader in the study and practice of creative expression and its place in the human experience. We work with all departments to supplement formal instruction by being a path to new worlds, new ideas, and new insights for students in the arts, humanities, and STEM subjects. Admission to the Zimmerli is free to all, a meaningful symbol of Rutgers' determination to connect with local, regional, and national communities beyond the university itself. The museum is a laboratory for learning and for experience, and a place of peace, quiet, contemplation, and enjoyment for the students, faculty, and staff of Rutgers and our New Jersey neighbors.

New Brunswick

Lloyd Gardner: The History of the History Department
PROFESSOR EMERITUS OF HISTORY

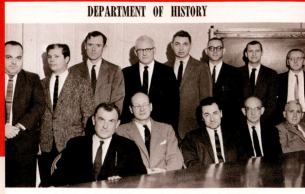

DEPARTMENT OF HISTORY

Sitting: R. Schlatter, S. Ratner, H. Winkler (chairman), L. E. Ellis, P. Charanis. Standing: W. Susman, T. Stoianovich, J. Lenaghan, W. Hardaugh, D. Weinstein, R. Vecoli, R. Brown, E. McDonnell.

Rutgers College History Department pictured in the 1962 *Scarlet Letter*.

I arrived at Rutgers in the fall of 1963, fresh out of the Air Force. The students were all male—with perhaps one or two exceptions—in a class of about 60. The history department was already known for attention to teaching. Teaching assistants did not teach the basic survey courses; our best lecturers did. In American history, that honor belonged to Richard P. McCormick and Warren I. Susman.

The department was on the verge of a rapid expansion. The year I came, there were three other hires, added to the 16 members who could sit around one table in Bishop House, my "home" for the next 20 years—until history moved to Van Dyck. By then, the department had over 50 full-time members, as the Douglass and Livingston College departments were all combined under one "super-chair."

The first new hires were in what some older skeptics called "exotic fields"—a full-time person in Latin American history, followed by positions in Chinese history, Southeast Asian history, Japanese history, etc. As a specialist in American foreign relations, I welcomed these additions and the ones to follow—the result of a growing sense that the history department needed to rethink its rationale along the lines of what was happening across the country. The 1960s, of course, will be most remembered for a number of "movements" that became permanent changes for the better. There was a symbiotic connection, I believe, between the impact of the Vietnam War "teach-ins" (largely led by the history department) and the long-term implications of the civil rights protests and the women's movement; to our credit, we hired a historian of Native Americans as well. Rutgers had always had great strength in the women faculty members of Douglass College, of course, and that was a springboard to the creation of what has become the outstanding undergraduate and graduate programs Rutgers boasts.

Faculty additions thus became part of the broadening national awareness of the need to become more inclusive of groups and issues previously left out of history courses. The department went through a serious reconsideration of the way the major should be

Above: Lloyd Gardner.

Below left: Students studying in Dana Library in Newark.

Libraries

There may have been some books around for students when Queen's College was first established, but not in any organized manner nor in their own space. One of the earliest gifts to the college was books for a library donated by the Reverend Peter Leydt (QC 1782) who was the brother of Matthew Leydt, the first graduate of Queen's College in 1774. But the trustees did not appoint the first college librarian until 1814. From this humble beginning to the mid-1930s, the library grew to nearly 300,000 volumes and over 1,200 users a day from students and faculty.

Like all of Rutgers following World War II, the library expanded rapidly. As of 2014, it provides services on a 24/7 basis through an amazing panoply of electronic resources accessed via computers and mobile devices. With over 27 libraries, over 5 million volumes, thousands of digital resources, and more than 3.1 million users every year, our libraries rank among the top research libraries in the nation. But even after this growth and change, the Rutgers libraries are in the midst of an even greater period of reinvention today. Most critically, this reinvention involves the building of a comprehensive technological infrastructure that will allow our libraries to leverage partnerships with other research centers and also with faculty across all of our disciplines. And yes: The libraries will always remain places for reading books!

—MARIANNE GAUNT, VICE PRESIDENT FOR INFORMATION SERVICES AND UNIVERSITY LIBRARIAN 1997–2014

construed to include not simply basic political courses, but also social history, black history, and women's history. The great danger of these changes, of course, was overspecialization, and I am not sure we have completely found the proper balance between the old requirements and the new demands. Probably it is impossible to do so, and the result will always be that the history major leads to a degree that is a subjective creation.

When I started teaching, the normal load for faculty was three courses each semester. I taught both "Recent U.S. History Since 1900" and "American Foreign Relations"; my third course was a graduate or undergraduate seminar. Within a couple of years, however, I took on the basic survey course in Scott Hall with its huge enrollments—and delighted in the experience, because it was a chance to experiment with ideas about areas I had not really

thought about, such as the nationalizing impact of the sewing machine or the typewriter, or the tragic efforts of Native Americans to recreate the past with the Ghost Dance.

Throughout the 1960s, whether it was curriculum reform, emphasis on good teaching, or university leadership, the history department was always a leader. We hired carefully and built from the inside out. When President Edward Bloustein made it his mission to put Rutgers among the first rank of the nation's universities, the department had already achieved prominence in a number of areas.

History majors reached a high point in the 1960s. Students were searching for what the past could tell them about the dramatic changes in America and the world. And I like to think that the department understood the challenge and did its best to meet their needs.

Below: Warren Susman, left, and Richard P. McCormick frequently co-taught the introductory U.S. history course, "Development of the United States." Here in spring 1982, to mark Professor McCormick's last lecture before retiring, Professor Susman presents McCormick with a U.S. atlas, a gift from his colleagues in the history department.

Puerto Rican Studies

The U.S. civil rights movement, the struggles for decolonization in various parts of the planet, and the multiple mobilizations that were inspired by them in the United States generated not only new laws and values, but also new areas of study. Rutgers University is one of the sites where these new areas emerged. These are 20th-century fields with a 21st-century vision that seek to establish better knowledge for a better world. Puerto Rican studies (now Latino and Hispanic Caribbean studies) is one of those areas.

In 1969, 16 Livingston Educational Opportunity Fund students of first-generation Puerto Rican background made vociferous and uncompromising demands to end exclusion and recruit Puerto Rican staff and faculty at Rutgers University. They further challenged Rutgers to establish interdisciplinary academic spaces for Puerto Rican studies in which to develop an educational, research, and community agenda. These incursions into academia were

also driven by a critique of a Euro-centric and class-based social science and humanities theory and methods that legitimized the neo-colonial relationships of the United States with Puerto Rico, and of the conditions of Caribbean and Latin American communities in the United States.

From its beginnings, three goals characterized Puerto Rican studies: historical reconstruction, cultural affirmation, and interdisciplinarity. The academic purposes were to help students understand the complexities of the conditions and dynamics that set their very demands and upheaval into motion, to learn about their cultural and political history and how these translated into their daily lives, and to develop the bases for substantive research and scholarship linked to action on the issues faced by the mostly poor Puerto Rican communities.

The first milestone was reached in the 1972–73 academic year, with a 32-credit concentration in Puerto Rican studies. The second milestone was the unanimous approval in 1973 by the Livingston faculty chamber to establish a department of Puerto Rican studies. In this way, Puerto Rican studies proponents defined new terrain for the university.

Responding to evolving migration trends, the department was renamed Puerto Rican and Hispanic Caribbean studies in the mid-1980s, and Latino and Hispanic Caribbean studies in 2005–06. Today, the department includes specialists in various linguistic and geopolitical regions of the Caribbean and Latina/o communities in the United States.

—María Josefa Canino, Founding Chair, Department of
Puerto Rican Studies, and Professor Emerita,
Public Administration, Rutgers–Newark

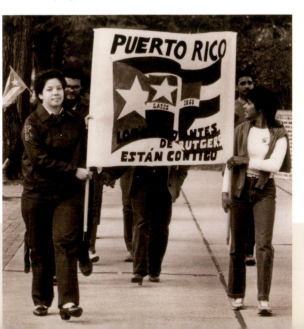

Susan Lawrence.

Susan Lawrence: The New Brunswick Core Curriculum

SAS Dean for the Core Curriculum and Educational Initiatives, Associate Professor of Political Science

When I joined the political science department in 1985, the faculties of the several liberal arts colleges at Rutgers–New Brunswick had recently been joined in a single faculty of arts and sciences, but the individual colleges still set student curricular requirements and academic policies. It was a baffling maze for any faculty member, new or veteran, who ever hoped to advise students as she signed their paper registration slips. And, charged with teaching one of the department's large introductory courses, I had little opportunity or incentive to think about how my course fit into students' general education requirements.

That opportunity came on a grand scale in 2005 when I joined the Dean's Office of the School of Arts and Sciences (SAS). The university's president had called for a complete review of undergraduate education, stressing that the institution that had emerged in the 1980s and 1990s as a top-flight Association of American Universities public research university needed to ensure that it was providing an undergraduate education worthy of Rutgers. Key to the transformation of undergraduate education was the development of a distinctive 21st-century liberal arts and sciences core curriculum that would distinguish, and unite, the New Brunswick Campus.

In working with undergraduates, it troubled me that they often had little sense of the purpose of requirements that forced them to take courses outside their major. Furthermore, in choosing any course in a required discipline from among the broad range of specialized courses characteristic of a research university, students had little guidance in integrating the requirements into a meaningful whole, and faculty had little incentive to think of their teaching as part of a liberal arts educational mission.

In the spring of 2007, a broadly representative faculty committee embarked on a deep consideration of the purposes and structure of a distinctive Rutgers–New Brunswick core curriculum. In May 2008, the faculty voted to approve the

committee's work, and I began putting together procedures for implementation of our new core.

The core curriculum makes the purposes of general education transparent to students by defining the requirements as learning goals met by taking courses from defined lists. Each core goal represents a particular aspect or mode of critical thinking or problem solving and describes for students how our general education requirements correspond to the skills and intellectual capacities they need in their majors, to pursue graduate study, and to navigate an era of rapidly changing careers. The core nurtures intellectual curiosity by incorporating students into Rutgers' research mission and challenges them to develop their individual values, talents, and passions.

The process of adopting and implementing a new core, along with ongoing assessment of student learning, reinvigorated faculty engagement with undergraduate education. An important aspect of this new energy is the Signature Course initiative I launched in 2009. Signature courses, designed around core goals, engage nearly 3,000 students each year in the types of transdisciplinary and enduring liberal arts and sciences questions that are sometimes orphaned by a world-class research faculty

Signature Courses, foundational undergraduate courses, cover topics of grand intellectual sweep and enduring importance. They are designed and taught by renowned scholars and scientists who are not only recognized for their specialized research but are also eloquent and demanding award-winning teachers.

RUTGERS
School of Arts and Sciences

Signature Courses
Fall 2014

deeply engaged in specific questions within their disciplines. The initiative turns the necessity of large classes into an asset by showcasing leading scholar-teachers who have a particular mastery of the large interactive lecture format and creating a shared academic experience. Signature courses have become a defining feature of SAS undergraduate education. Students rave about them, and faculty call them their best teaching experience in careers that span decades.

For me, the core curriculum embodies our belief in and aspirations for our diverse and growing student body and reflects Rutgers' mission as a comprehensive public research university. Preparing our students for reflective lives and meaningful careers, I take a very special pride in the core and the contributions I have made to undergraduate education at Rutgers.

Kenneth Miller: A Flagship Research University
Professor of Geology in the Department of Earth and Planetary Sciences (RC '78)

Arriving at Rutgers College in 1975 as a transfer student after stints at the U.S. Naval Academy and Rutgers–Camden, I saw science being taught in an unusual way. "General Biology" was taught by videotape. When I began "General Physics," the 300-person classroom was filled, and though physicists are entertaining, the experience was less than fulfilling. Despite these initial disappointments, I came through Rutgers with a top-notch education in science.

Flexibility and research opportunities are the two great strengths of Rutgers sciences. How does Rutgers–New Brunswick deal with educating more than 34,000 undergraduates, many of whom are fearful of science? When confronted with the large lecture class in physics, I was offered a "self-paced" approach that I found rewarding, with a caring and helpful teaching assistant. Today, we are beginning to offer introductory sciences as online hybrid courses—the modern equivalent of self-paced courses. Though many faculty and administrators are concerned about online education, I have found it productive for students. I teach "Sea Change," a signature class that endeavors to reinvent the large lecture class. We bring the impact of climate change to the classroom by integrating video

Right: Kenneth Miller (RC '78), center, and colleagues in the Department of Earth and Planetary Sciences.

Left: The SAS core curriculum graphic represents the core's three primary areas of emphasis. Core courses are designed to nurture curiosity and prepare students for future challenges in a rapidly changing world.

MAJOR · MINOR · ELECTIVES

21st Century Challenges

Areas of Inquiry

Cognitive Skills & Processes

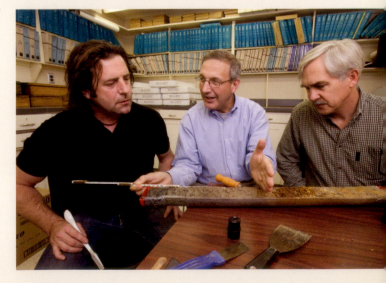

Other Science and Engineering Voices

In 1977, I joined what was then the College of Engineering as the first woman professor. At the time, ceramic engineering was the first department to hire a woman to a tenure-track position. It took many years for the other departments to hire women faculty members. In fact, it took 33 years before the department of ceramic engineering hired its second woman professor. By then, the department had been renamed the Department of Materials Science and Engineering. The history of women students and faculty in the School of Engineering is an interesting one. Today, each of the departments has at least one woman on its faculty, and the percentage of women undergraduates hovers around 20 percent.

—Lisa C. Klein, Distinguished Professor of Materials Science and Engineering

I came to Rutgers in 1971 at the encouragement of my wife, Professor Mary Jean (Yonone) Lioy (CAES '72, GSNB '86), one of the original women graduating from the ag school. At the time, environmental science was an emerging field, and Rutgers had one of the first programs. Our research labs were located in the former dye factory on Georges Road in New Brunswick. Four of us PhD candidates shared the same lab, and we had to use creative positioning to allow each to work. The atmosphere was very collegial, and I remember the many hours we spent during lunch playing bridge. Since leaving Rutgers, I have had a very interesting career in science, which now includes being a member of the faculty because Robert Wood Johnson Medical School merged with Rutgers in 2013. Our son, Jason, received his master's in human resources from Rutgers in 1999. And in 2008, I received the Rutgers Distinguished Alumni Award for Mathematics, Physical Science, and Engineering.

—Paul Lioy (GSNB '75), Professor and Vice Chair, Department of Environmental and Occupational Medicine, Robert Wood Johnson Medical School

and recitations with hands-on exercises and student presentations on the scientific basis, ethics, and legal and political aspects of climate change. I also teach "Environmental Geology" online. Students love learning online, and I am convinced that hybrid courses are the wave of the future. We will need to "flip" our classrooms, with lectures posted on video and classroom time spent mentoring. This is not a shade of GenBio 1975, but an evolution in science teaching that allows more hands-on exercises and engenders true learning.

I advised two sons through sciences at Rutgers, one as a geological science minor and one as a major. I could see the 21st-century student experience through their eyes. It was a generally excellent one. The real undergraduate opportunities in the sciences are experiences with research. Rutgers is a flagship research university; research opportunities here are the same as they are at the top private universities. Current undergraduate and graduate students are working on sea level change in our department and at the Department of Marine and Coastal Sciences.

Research opportunities at Rutgers have grown dramatically over the past 25 years. Entering Rutgers, I bemoaned the fact that we did not have an oceanography major. We do now, and our Department of Marine and Coastal Sciences is ranked fourth in the world as an oceanographic institution. Rutgers has grown from $50 million per year in external research funding in 1988 to over $700 million now. What this means is that our science majors are involved with some of the top research projects in the country. Rutgers' vibrant research in the sciences spans countless cutting-edge topics: string theory, nanotechnology, polymers, the next generation of photovoltaics, understanding climate change, and understanding the past, present, and future of our planet.

The opportunities for undergraduates, as well as graduate students, in the sciences at Rutgers are vast, and these opportunities yield jobs and advanced degrees. Because of their strength in research work, our science graduates continue to be placed in the top graduate programs in the country. Our science majors get great jobs; my son started as a geological technologist for Chevron after graduation.

I am thankful to Rutgers for preparing me as a scientist, and am happy I have given back as a professor, administrator, and parent of Rutgers students.

With its photovoltaic solar energy installations on Livingston Campus, Rutgers in 2014 ranked second in the nation for university solar energy capacity. Its solar systems have the potential to provide 63 percent of the electrical demand of the Livingston Campus.

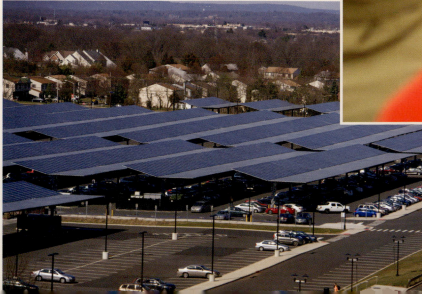

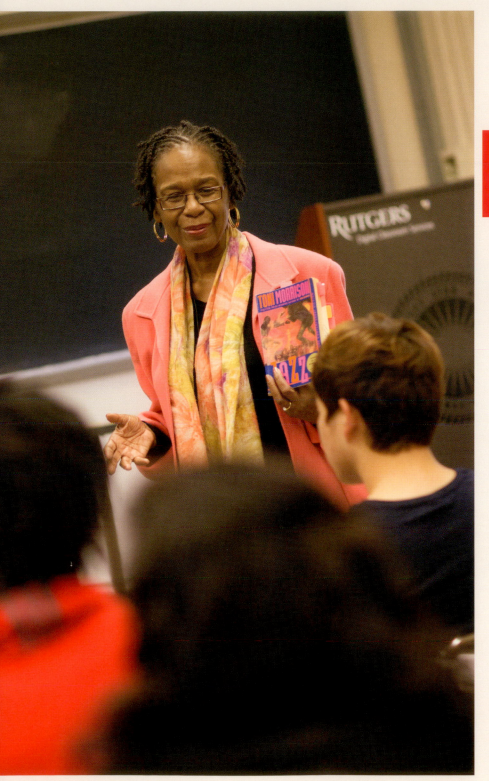

Above: Cheryl Wall.

Cheryl A. Wall: Exploring the Unimaginable

BOARD OF GOVERNORS ZORA NEALE HURSTON PROFESSOR OF ENGLISH

When I began my career as an assistant instructor at Douglass College, I found a full complement of African-American courses on the books. The jazz scholar A. B. Spellman had invented a course called "Black Music and Literature" that became my maiden voyage as a teacher. On the Livingston Campus, Toni Cade Bambara, Nikki Giovanni, and Sonia Sanchez, writers whom I had admired from my undergraduate days, had left, but their imprint on the curriculum remained. By the time the college departments were centralized on the New Brunswick campus in 1981, Rutgers boasted offerings in the field that were unmatched by any of its peers. Even more unexpectedly, it had a cohort of scholars—Aijaz Ahmad, Wesley Brown, Abena Busia, Donald Gibson, and me—larger than any outside of historically black colleges and universities. Over the next three decades, Rutgers would award more than a score of doctorates to scholars specializing in the field.

Of course, that future could not be foretold in 1972, the year I stood in Hickman Hall and attempted to share what I knew about black music and literature. I was in flight from my own graduate program at Harvard, an experience that rendered me invisible. I needed to find out whether I wanted an academic career. It was pure luck that brought me to Rutgers, and I was both surprised and relieved when my advisor wrote me that "Rutgers was a very good place." It was definitely that for me, as scholars at Douglass were busy inventing what would become the field of women's studies. Elaine Showalter in English and Mary Hartman and Martha Howell in history were asking new questions, recuperating stories of forgotten women, and, yes, inventing new courses. The second course I taught was "The Educated Woman in Literature," which Professor Showalter had created a few years before.

My time at Harvard had made me a feminist before I heard the word. I soon learned a style of pedagogy that, I hoped, would make all of my students visible. We arranged our desks in a circle, the students kept journals, and I happily ceded authority

that I had not yet earned. It now seems inevitable that my scholarship turned to writing by black women. I was fascinated by the women of the Harlem Renaissance, and as a result of the literature I was teaching and the criticism I was reading, I was able to develop a context in which to analyze writing by Jessie Fauset, Nella Larsen, and, especially, Zora Neale Hurston. Subsequently, I have written extensively on fiction by Toni Morrison, Alice Walker, and Toni Cade Bambara, the teacher and author who preceded me at Rutgers.

And I was hardly alone. From 1970 forward, black women writers had begun to transform the nation's literary landscape. Critics soon responded with shelves of articles and books. This criticism existed uneasily with the turn toward theory that began to transform literary study in the 1980s. In 1987 I organized a conference, "Changing Our Own Words: Criticism, Theory, and Writing by Black Women," that put these two movements into conversation. Speakers included the leading African-Americanist scholars—Houston Baker Jr., Hazel Carby, Barbara Christian, Mae Henderson, Akasha Gloria Hull, Deborah McDowell, Valerie Smith, Claudia Tate, Mary Helen Washington, Susan Willis, and my colleague Abena Busia. The novelist Paule Marshall gave a reading, and more than 100 scholars and graduate students from across the country attended. The conference marked a new chapter in African-American literary study at Rutgers.

Students asked that a graduate course on black women's writing be offered, and I was asked to teach it. Rutgers began to develop a reputation as "a good place" to study African-American literature. Our graduates are tenured on the faculties of the College of New Jersey, Dartmouth, Georgetown, Montclair State, Northwestern, and elsewhere. In 2008, Rutgers established postdoctoral fellowships in African-American and African Diaspora for young scholars, five of whom have published books. My current colleagues—Busia, Olabode Ibironke, Douglas Jones, Ryan Kernan, Stéphane Robolin, Evie Shockley, and Michelle Stephens—explore topics in African, African-American, and Caribbean literature and culture that were unimaginable in 1972. Together we have established the Rutgers English Diversity Institute to encourage undergraduates from underrepresented groups to pursue graduate study. I know the future is in good hands.

Students take a break, ca. 1970. Notice the many posters behind them promoting various events.

Below: Abena Busia, right, and student Chinwe Oriji.

Right: Livingston students and their new campus. Note the mattresses being delivered on move-in day at the opening of Livingston College, 1969.

Below: Members of the Livingston Social Justice Learning Community.

Abena P.A. Busia: Transforming Communities and Changing the World at Livingston College

CHAIR OF WOMEN'S AND GENDER STUDIES AND ASSOCIATE PROFESSOR, DEPARTMENT OF ENGLISH

Today, Livingston is the most majestic of campuses: the green of the ecological preserve remains but it is now surrounded by wide avenues, high-tech architecture, the smartest of smart classrooms, the most magnificent of dining rooms, and its own cinema. What a change.

I first came to Livingston College to discuss a one-year visiting lectureship in fall 1980. In spring 1981, I interviewed for a tenure-track position and arrived on campus in September with one chapter of an unfinished Oxford doctorate in hand and 18 months to finish it before the tenure clock started ticking. Born in Ghana and raised in Holland, Mexico, and England, New Brunswick, New Jersey, was not where I imagined I would spend my adult life—yet, over 30 years later, here I am still. What a journey.

Arriving just before the first reorganization when the collegiate faculty lost their autonomy and united to form New Brunswick-wide departments, I was hired to help develop Livingston's first-ever Honors Program—a program I stayed with for almost 20 years and ended up directing.

The decision to have an Honors Program, I learned quickly, was a radical one. This was, after all, the egalitarian, experimental college. The first coeducational liberal arts residential college in New Brunswick, dedicated to the education of minorities and inner-city working-class students, a mission of social justice was always at its core. I realized later that I was replacing Barbara Masekela, who had left that year to continue the struggle against apartheid full time, working for the African National Congress.

Looking back on it today, many of the things that are taken for granted as the bedrock of a good American liberal arts education were

Above: Students walking on central pedestrian path on Livingston Campus, ca. 2012.

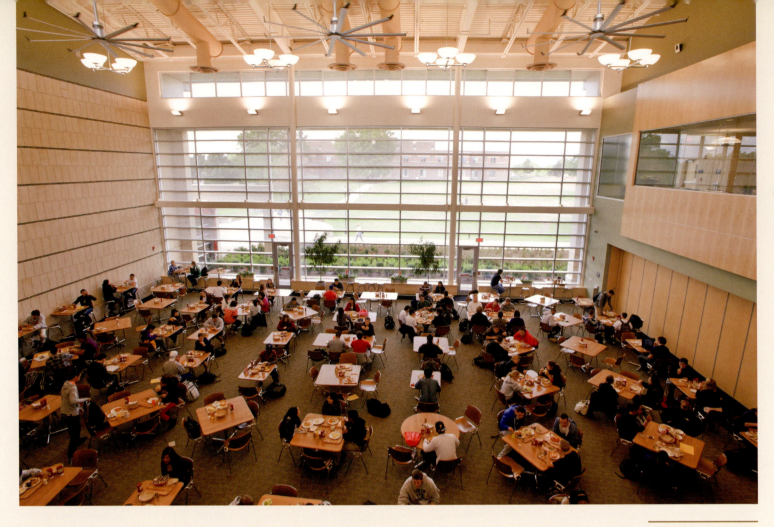

fought for at Livingston College. For example, Livingston was the only college that had, among other things, mandatory requirements on ethical leadership and diversity—both intended to foster awareness of the changing worlds of New Jersey, the United States, and the wide world in which we all live. We believed fiercely in the power of collective action, clung to a vision of social justice, and insisted that educational institutions could be ethical and answerable to the communities that supported them. Livingston became a vital home.

Perhaps ironically, it was also the only place you could study business, which is why to this day the business school is located on that campus. Of course, over the last 30 years, business degrees have acquired a cachet they did not then have. When Livingston started offering the degree, to the high-minded such a degree was just one step above "the trades." Today those who enter business are considered among the most ambitious and academically distinguished.

This change in attitude is reflected in the change in the physical plant of the campus. Thirty years ago we almost had to bribe students to live on Livingston, so it was with a great deal of amusement that I learned from today's deans of admissions that they have started receiving calls of anger and abuse from parents whose children are *not* assigned to the Livingston Campus. New, majestic campus notwithstanding, it is our hope that what inspired Livingston College and what meant so much to me on arrival—the sense of a vision of

social justice and the idea that education could not only change us as individuals, but could transform communities and change the world—still lives on, despite the utilitarian ideas that seem to dominate higher education.

The mission of Livingston exists still in certain universitywide programs like the minor in social justice; it survives in the existence of university centers still located on the campus, like the Center for African Studies; and its missions are still served in universitywide offices such as those for diverse community affairs and perhaps the best-named committee ever dreamed up, the Committee to Advance Our Common Purposes.

Above: With its enormous variety of food, everything from sushi to a cereal bar, the "Livi" Dining Commons is by far the favorite dining hall at Rutgers–New Brunswick.

Below: The Rutgers Cinema at the Plaza at Livingston Campus offers first-run films at discount prices.

Students walking over footbridge near Hickman Hall on the
Douglass Campus, home of the Department of Political Science.

Lisa L. Miller: On the Necessity of Cross-Disciplinary Study
ASSOCIATE PROFESSOR OF POLITICAL SCIENCE

I came to the Department of Political Science in 2004 after four
years in an interdisciplinary department at another university.
It was refreshing to be among political scientists again. Since I
started graduate school in the early 1990s, the social sciences
had become more specialized and, having been the sole
political scientist in a multidisciplinary program, I was eager for
colleagues with whom I shared a foundational literature and set of
methodological tools.

And yet, as my research and teaching developed through
dynamic engagement with the first-rate Rutgers faculty and vibrant,
engaged student body, I found myself once again working in cross-
disciplinary spaces.

Right: Professor Lisa Miller continues a discussion with fellow panelists after an event at
the Jewish Center in Princeton titled "Race, Justice, and Mass Incarceration in America."

FACULTY VOICES

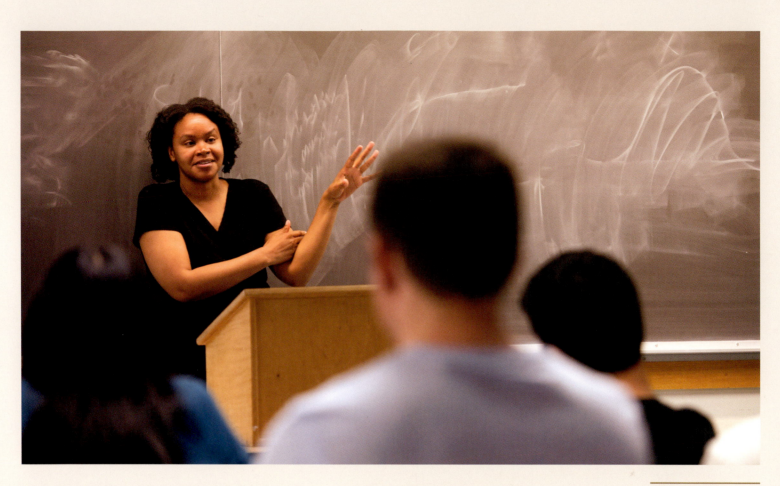

Political science professor Shatema Threadcraft teaches a class in Hickman Hall.

While specialization is important, knowledge production also requires generalists—scholars who think across disciplinary boundaries, who can move between the depth of scholarship from one field into the depths of another, drawing out the key insights on timely and important issues. Just as specialists seek clarity and replication in order to provide precise causal explanations, generalists ask questions that may otherwise be overlooked, provoking reconsideration of standard assumptions and causal mechanisms. Moreover, subspecialties within disciplines can sometimes become ossified, requiring a fresh perspective that cross-subfield and cross-disciplinary work can provide.

Several experiences at Rutgers further solidified my generalist sensibilities. In 2009–10, I served as acting director of the Center for Race and Ethnicity, where I worked with faculty and graduate students from across campuses and disciplines to bring together scholars with shared research interests. Frequently, the silos of academic research isolate scholars with similar concerns; a core strength of the center is to facilitate dialogue and collaboration between researchers who may not be aware of other scholars at Rutgers working on topics similar to their own. I observed a range of excellent scholarship asking big questions about race and ethnic

politics, policy, culture, language, inequalities, and advancement in New Jersey, the country, and the world.

In the spring of 2010, I taught a Byrne first-year seminar entitled "Race, Politics, and Crime in HBO's *The Wire*." My seminar provided an opportunity to engage students with a timely, popular television program while providing them with a framework for understanding how scholars think about, study, and analyze problems of urban racial inequality. Byrne seminars are an extraordinary opportunity for undergraduates; they also allow faculty to highlight how research questions can be applied to real-world concerns. This seminar provided me with the opportunity to show students how different social science and historical perspectives can help us understand the devastating realities of urban violence.

Political science—like most of the social sciences—continues to move toward greater specialization, offering crucial opportunities for more precise and reliable understanding of the causes and consequences of political, economic, and social issues. I am well settled in my generalist role, however, which keeps the focus on big questions of importance to the lives of ordinary people. And I am delighted to work in an institutional context in which so many faculty, staff, and students continue to ask challenging and complex questions about the modern world.



Julia Ritter: Mason Gross School—Laboratory for Creative Research, Home for Artist-Scholars

PROFESSOR OF DANCE, MASON GROSS SCHOOL OF THE ARTS



Art is tethered to the past from which it emerges, to the present in which it exists, and to the future where its impact is manifested. The artistic lineage of Rutgers reveals pioneers whose work explored the cultural, sociopolitical, and aesthetic concerns of their time and generated questions through creative experimentation. Accomplished innovators linked to Rutgers include students such as actor, singer, and political activist Paul Robeson (RC '19); faculty members such as Don Redlich, esteemed choreographer and protégé of dancer, choreographer, and musician Hanya Holm (one of the "Big Four" founders of American modern dance); and the Rutgers-affiliated Fluxus artists Allan Kaprow, Geoff Hendricks, and Roy Lichtenstein. These experimentalists helped establish Rutgers as an incubator of artistic invention and discovery that continues to attract international attention. As an alumna of Mason Gross School of the Arts (MGSA '92) and now artistic director of the dance program, I have been shaped by the opportunities Rutgers afforded me. I continue to refine my artistry and scholarship within the fellowship of a community whose renown has been secured through rigorous and dedicated creative research.

The Mason Gross School has served for nearly four decades as a laboratory for creative research and as a home for artist-scholars. As an artist-scholar, my research includes the creation of choreographic works through both participatory arts practices and theorizing the roles of performers and audiences in immersive performance—which is loosely defined as live events designed to include audience members in processes that contribute to the creation and/or alteration of the performance. Individuals of all ages increasingly act as their own curators, synthesizing the abundance of choice that exists in the media, in live performance, and online to forge their own learning, cultural experiences, and entertainment.

During my time as chair, the dance department has expanded frameworks for education beyond the university setting by sponsoring residencies with renowned artists and scholars from Africa, Austria, China, Israel, Taiwan, Turkey, and the United Kingdom. These opportunities allow students, faculty, and staff to experience dance while gaining a greater sense of the international communities of artists that shape our cultural worlds. Undergraduate dance majors at Rutgers currently study in London's Trinity Laban Conservatoire of Music and Dance and the Dance Jerusalem program of Hebrew University; they will soon train at the National Taiwan University of the Arts through a new partnership. As an artist-scholar devoted to accessibility and inclusivity, I have also established online dance studies courses that enable students from across all Rutgers campuses to interact and study with dance scholars and choreographers working within and teaching from their communities in Ghana, Istanbul, and elsewhere. With Rutgers now a member of the Committee on Institutional Cooperation, the dance department is well situated to engage in teaching and research collaborations by harnessing available technologies.

Students and faculty across Rutgers are engaged in creative research that links math and visual art, oral history and dance,

Julia Ritter (MGSA '92) and two of her students.

Robert E. Mortensen, Rutgers graduate (RC '63) and donor, in Mortensen Hall, which opened in 2013, providing additional rehearsal and performance spaces for Mason Gross music, dance, and theater students.

Kurt Spellmeyer: The Whys and Hows of Expos
PROFESSOR OF ENGLISH AND DIRECTOR OF WRITING PROGRAM, NEW BRUNSWICK

About a year ago, one of the teachers in the Writing Program here at Rutgers told me about a former student of hers who had interviewed in Manhattan for an internship at Sesame Workshop, the nonprofit group behind *Sesame Street*. The interview did not turn out to be the perfunctory exercise she had gone through for other jobs. Instead she found herself engaged in a serious, wide-ranging conversation about the media as a force for social change. "Somewhere in the conversation," she recalled, "something the interviewer said reminded me of the Malcolm Gladwell essay I had read in my 'Expository Writing' class. This knowledge helped me to hold my own in a discussion that went on for 40 minutes." Two weeks later she got the good news: she'd been offered the internship. "Finally," she wrote her former teacher, "I understand why we were reading all those strange articles in Expos."

Almost by tradition, writing courses have relied on readings shorter and less difficult than the material students are assigned in their other classes, but the course that Rutgers students call "Expos" assigns them articles and book chapters by some of the most important thinkers of our time, academics and public intellectuals wrestling with the big questions: the economic consequences of globalization, the ethics of genetic technology, the looming climate emergency, the consequences of the nation's widening income gap. The readings come from journals of public

Above: *The New Humanities Reader* is the core text for "Expository Writing."

Below: Neurologist and best-selling author Oliver Sacks speaking to students after his address in the Writers at Rutgers Reading Series in New Brunswick, 2008.

puppetry and the politics of Cambodia, music and robotics, and much else. These endeavors provide students opportunities to develop critical thinking skills, conceptual acumen, and applied techniques. Experience and knowledge gained through cross-disciplinary, interdisciplinary, and transdisciplinary research help students build foundations for career pathways in the arts, the humanities, business, education, sciences, and technology. I believe that the study of dance is essential knowledge for all students, whether they wish to pursue professional dance careers, want to augment their learning in other fields of study with embodied knowledge, and/or wish to be more informed and skillful cultural consumers and global citizens. It is my charge as an artist-scholar in dance to guide each student I encounter toward understanding the embodied nature of intelligence.

"To be a good citizen and a good thinker one must first develop a healthy skepticism towards those with power. This wise principle, which I learned on my first day of my first class at Rutgers College, has served me magnificently every day since."—Junot Díaz, an English major at Rutgers who graduated in 1992 and won the Pulitzer Prize in 2008 for his novel *The Brief Wondrous Life of Oscar Wao*.

opinion like the *Atlantic* and *Harper's*, as well as from the foremost university presses. Among the writers taught in Expos over the years are anthropologist Clifford Geertz, sociologist Richard Sennett, poet and feminist Adrienne Rich, neurologist Oliver Sacks, architect and educator Juhani Pallasmaa, philosopher Martha Nussbaum, economist Joseph Stiglitz, and theorist of democracy Benjamin Barber. One important fact about our English 101 is that the teachers are opposed on principle to the practice of lecturing: the point is not to tell students what a text means but to give them the ability to make sense of complex information on their own.

If Expos teaches reading by helping students to think for themselves, it teaches writing by emphasizing the social dimension of knowledge. None of us write primarily for ourselves: like all communication, writing is fundamentally social. One key assumption behind Expos is that real-world writing always takes place in the context of a conversation with others, whether the subject happens to be the starting price of an IPO or the structure of the brain. Expos assumes as well that conversations form around a common question that all participants help to clarify through the give-and-take of dialogue. Writing instruction has been designed to approximate the stages in a conversation, asking students to work with one article for the first paper they complete, and then, for the second paper,

assigning them to make an argument that connects two different reading selections. Even though the two texts might come from different fields and deal with different subjects, students learn that new insights are produced through the process of synthesizing arguments that might seem incompatible at first. Generally, the third assignment will expect students to make an independent argument that connects all three of the readings within a new encompassing framework. Of course, students learn to craft effective thesis statements, start their paragraphs with topic sentences, and pay close attention to transitions. But they learn something more. They learn that contradictions often hold the key to a larger, undiscovered way of seeing: they learn the secret, in other words, to creativity.

And that's a lesson many students never forget. When the Pulitzer Prize-winning novelist Junot Díaz (RC '92) spoke at Rutgers, his alma mater, in the spring of 2008, one person in the audience asked him to comment on his experience of English 101, which he had completed in 1988. "I took Expos," he answered. "Guys, Expos is tough, man!" But then he added, "You cannot learn to write without reading—and reading a lot. Expos alerted me to issues." For Díaz, active citizens are thinking citizens, and that means reading, thinking, writing. Expos is tough, for a reason.

Below: An "Expository Writing" paper by first-year student Elijah Reiss.

Below right: In addition to serving as director of the Rutgers Writing Program in New Brunswick, Kurt Spellmeyer (at right in blue shirt), teaches classes in Zazen meditation.

Reiss 1

Elijah Reiss

Essay Grade: B
Course Grade: B

Expository Writing GA

Nevius

Final Draft P5

The Search for the Self

When looking into a mirror, what do you see? Do you see the body of someone else, or merely a reflection of yourself? Chances are you see yourself. Are you tall, short, fat, or skinny? Are you the same person you remember seeing when you last looked at yourself in a mirror? Once you have answered these questions, you have discovered who you are, but only from a physical standpoint. Yet who you are physically is irrelevant to who you are on the inside. The search and discovery for an inner-self cannot simply be achieved by looking into a mirror. It takes years of experiencing and thinking to find out who we are. Self-discovery is often dependent on outside forces: Forces that make us think deeply about our own existence and place

FACULTY VOICES

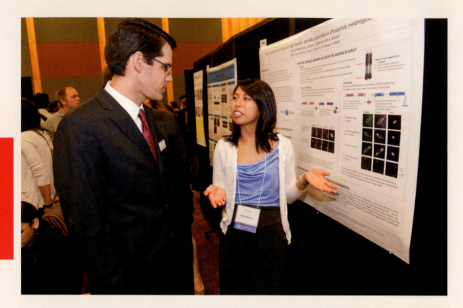

Charles Keeton: Rutgers, Research, and the Spirit of Engagement

ASSOCIATE PROFESSOR, DEPARTMENT OF PHYSICS & ASTRONOMY; FACULTY DIRECTOR, ARESTY RESEARCH CENTER

This time of celebration for Rutgers comes at a time of change for higher education. Technology is transforming how we teach, and online education seems to challenge the very existence of the bricks-and-mortar university. *New York Times* columnist Thomas Friedman has celebrated the broad access online courses provide. Yet he remains cautiously optimistic about the physical academy, writing: "There is still huge value in the residential college experience and the teacher-student and student-student interactions it facilitates. But to thrive, universities will have to nurture even more of those unique experiences."

In my view, this spirit of engagement lies at the heart of Rutgers' mission as a research university. But what exactly is a research university? In this context, "research" refers to scholarship and knowledge creation, while "university" refers to education and

knowledge transmission. Do those activities really fit under the same roof? Why should students choose to attend such a place?

People often say a research university is a place where professors bring research into the classroom. That is absolutely true; in my own field of astrophysics, it gives me great pleasure to explain how exciting discoveries and beautiful pictures from the Hubble Space Telescope and other observatories relate to topics we cover in class. I know colleagues feel the same way about their fields.

That is only part of the story. Another vital part is when professors and students take education outside the classroom. The longer I spend at Rutgers, the more I appreciate the broad view of learning that fills the air here. From the lab and library to the studio and rehearsal hall, students find myriad opportunities to move from passive consumption to active creation of knowledge. There are more programs than I can list here, but two with which I am most familiar are the Byrne seminars and the Aresty Research Center. These programs continue to grow thanks to a surge of interest from students who want to learn what the research university is all about and faculty who are keen to show them.

What is driving this surge? No doubt there are as many reasons as people, but I see a couple of common themes. One motivation is sheer curiosity about the world we live in. A second comes from contemplating the intellectual skills needed to prosper in the 21st century. In the age of Google, what matters is not how much you know but how well you can learn and think. As professors and students work side by side in Byrne seminars and Aresty research projects to answer their questions, they discover that there is something ineffable about inquiry: it can only be taught through direct interaction and learned by practice. In other words, the faculty-student interactions that Tom Friedman promotes—and Rutgers

Charles Keeton at the annual Undergraduate Research Symposium sponsored by the Aresty Research Center.

Left: Undergraduates Ankit Shah, left, and Muhammad Shahid, right, work with assistant research professor Patricia Buckendahl in the Center of Alcohol Studies.

Aresty scholars (left to right): Olivia Rubion-Finn (SAS '14), Vincent Luo (SAS '14), Michael A. Boemo (SAS '14), and Nicole Heath (SAS '14). The Aresty Research Center, founded in 2004, is instrumental in engaging undergraduates in research with Rutgers scholars and scientists.

nurtures—make learning an action and a skill that will lead students to success throughout their coming careers.

Faculty-student interactions are not a one-way street. My first Aresty research assistant, Jennifer van Saders (RC '09) is now finishing a doctorate in astrophysics at Ohio State University and has been offered a prestigious postdoctoral research position. As Jennifer first learned about research, her excitement was palpable. She'd say, "This is so cool!" Her enthusiasm was so genuine I could not help feeling invigorated myself. It is truly special when an undergraduate can teach a professor about the excitement of learning. But that's what happens when both share in the best of the unique experiences a great research university can offer.

Rutgers University–Newark

JACK LYNCH, PROFESSOR OF ENGLISH,
RUTGERS–NEWARK

The New Jersey Law School

Rutgers–Newark usually traces its history to 1908, though we can look back even further. The New Jersey College of Pharmacy was founded on High Street (now Dr. Martin Luther King Jr. Boulevard) in 1892. It was the first Newark institution to become part of Rutgers when it was incorporated into the university in 1927; later in the century, it moved to Rutgers–New Brunswick. But it was the opening of the New Jersey Law School, a private, for-profit institution, on October 5, 1908, that traditionally marks the birth of the Rutgers–Newark we know today. That's when President Richard D. Currier, a New York attorney, opened the school to 30 students who had saved up the necessary tuition and fees: $283 a year.

The institution thrived in its early days. Just a few months after the school opened, in May 1909, New Jersey's Board of Bar Examiners gave it official recognition as a school of "established reputation." Although World War I caused enrollments to decline, things turned around quickly in the 1920s, and students returned in ever-greater numbers. By 1922, the New Jersey Law School had grown to 401; by 1927, enrollment reached 2,335 students—at that time, the second-highest enrollment in any law school in the United States.

Growth was exciting, but posed challenges. Its Victorian townhouse at 33 East Park Street, now the site of Public Service Plaza, was soon too small, and the administration was looking for a new home. The answer was found at 40 Rector Street, not a conventional college building by any stretch of the imagination. In 1927, Newark moved its classes into Malt House No. 3 of the old Ballantine & Sons Ale Brewery, built in 1860 and still smelling strongly of beer. Classes began there in September 1928, and the 75,000 square feet of floor space was enough for 10 classrooms of 50 students each, which in those days felt like more space than they could use.

Birds-eye view print of Newark east of Mulberry Street, 1820–25.

Addressing the Liberal Arts

From the very beginning, President Currier's plans had called for more than a law school. He was keen to establish a University of Newark, with both professional and liberal arts schools. In the early days practical difficulties intervened, and he managed to open only the law school. By the late 1920s, though, the school was doing well enough to think about branching out.

The New Jersey Law School was already offering some undergraduate liberal arts classes as part of a prelegal program beginning in 1926, but changes in the nature of the profession and in state law forced a rethinking of the curriculum. When the law school was founded in 1908, the only requirement for admission was that applicants be at least 18 years old and "of good moral character." But as law became more professional across the United States, admission requirements became more stringent. In 1914, the law school began requiring a high school diploma for admission. In 1927, applicants needed at least one year of undergraduate college work before they'd be considered; that was increased to two years in 1929.

The New Jersey Law School decided to address those needs by offering the undergraduate classes themselves, and it established a prelaw department in 1926. The two-year program offered English, government, history, psychology, and science in the first year; and economics, English, government, history, and philosophy in the second. In this prelaw department, we see the seeds of the Newark College of Arts and Sciences.

John Cotton Dana, "The First Citizen of Newark"

John Cotton Dana was a man with a mission: he believed in art and literature as a fundamental support for American democracy. Culture was not a highbrow enterprise to be locked away from the masses: it should be open to everyone, and accessible to people of every background and every class. It was Dana who first called for open-stack libraries in America, where patrons could take books off the shelves for themselves rather than relying on a librarian to do it; it was Dana who believed libraries should be community centers; it was Dana who opened the country's first children's reading room in a library. A public librarian for 40 years, he worked in the Newark Public Library from 1902 until his death in 1929, advocating for foreign language collections for immigrant communities and building the collection of business books. In 1909, he founded the Newark Museum, today the largest art museum in the state.

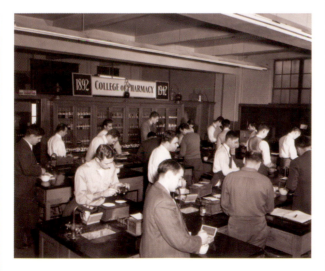

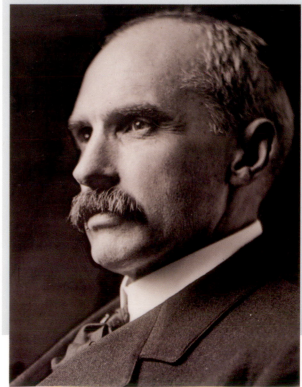

Left: Newark today.

Above: Rutgers College of Pharmacy in Newark, 1942.

Right: John Cotton Dana.

However, just a year after its founding, the prelegal faculty had decided that "Pre-Legal was not a suitable name for this Department." Concurrently, President Currier was calling for a liberal arts college as part of a university in Newark. The two issues were resolved by settling on a stand-alone arts and sciences college, named after one of Newark's most distinguished residents. Public librarian John Cotton Dana had led a crusade to make cultural institutions open to everyone. He seemed the perfect presiding spirit over a college to serve the largely working-class population of Newark.

Currier envisioned "a Newark University with Dana as its nucleus." The need was real: Newark in the 1920s was a bustling city, densely populated, with more than half a million residents. But, as Currier noted, "There is no area anywhere in the United States with the population of Newark and the surrounding towns which has not at least one college or university." He strove to provide Newark with a university "suitable to its size and importance."

Dana College admitted its first students in fall 1930, relying on the faculty who had been part of the prelaw department; the next year, the college added departments of language, biology, and sociology. Within a few years, Dana had become a liberal arts college with a full range of academic subjects, and the faculty began offering public lectures for locals and radio addresses for the nation at large.

The Seth Boyden School of Business Administration

Even before Dana College was properly established, Currier and his colleagues were thinking about other professional offerings. The faculty and administration recognized that "Business, like law and medicine, has reached the professional level where the broadest possible education is essential to success." The state agreed: beginning in 1929, the State Board of Education allowed the New Jersey Law School to offer a bachelor of science degree in business administration.

The result was the Seth Boyden School of Business Administration, named for the man Thomas Edison hailed as "one of America's greatest inventors." Over the course of a long life (1788–1870), much of it spent in Newark, Boyden worked as a watchmaker, invented new methods

Above: Students in the Dana College library, 1937.

Above right: A Rutgers University Extension Division class in Newark, 1930.

Opposite: Statue of Seth Boyden, Washington Park, Newark.

for producing patent leather and silver plating, created malleable iron, built the most powerful locomotives of his day, pioneered photographic processes, worked with Samuel Morse on the telegraph, and even cultivated a hybrid strawberry. He was just the sort of wide-ranging but eminently practical thinker that the new business school wanted to claim as a guiding light.

The first class at Seth Boyden consisted of 76 men and 36 women, split into morning and evening divisions. Classes were concerned mostly with business, including accounting and economics, but the school also made history, psychology, and English classes from the prelaw department available to round out their students' education.

Those students arrived with high hopes, but the timing was bad: just three weeks after the first class arrived in September 1929, the stock market crashed and sparked the Great Depression. It was a challenge just to keep the school open, and harder still to justify its course of study when the whole structure of American business had collapsed so spectacularly. The first Seth Boyden class graduated in 1933—in President Currier's words, "a time when business is at its lowest ebb," when "the capitalistic system as we know it is on trial for its very existence." The school's dean, Herbert C. Hunsaker, therefore, addressed the graduates and

urged them to be forward-looking, freed from the prejudices of the past. He called for business graduates who would be "versatile in technique, socially responsible in outlook, and solidly grounded in the basic essentials of knowledge."

Bringing the Pieces Together

By the early 1930s, there were five institutions of higher education in Newark working more or less together. The New Jersey Law School had spun off the Seth Boyden School of Business Administration and Dana College. There was also the Newark Institute of Arts and Sciences, founded in 1906. There, New York University faculty offered history, literature, science, art, and business classes at the Newark Public Library. Most of the early students were Newark schoolteachers eager to continue their own educations. Finally, there was the Mercer Beasley School of Law founded in 1926 as a nonprofit institute and named for a former chief justice of the New Jersey Supreme Court. All five Newark institutions had been sharing space and resources.

Realizing that the whole was stronger than the parts, the Dana College Board of Trustees voted in 1933 to assume responsibility for New Jersey Law School and the Seth Boyden School of Business, resulting in a new joint institution that was now "a university in fact." The schools

Right: Welcome sign for Engelhard Hall, Rutgers—Newark.

Below: Basketball at Newark, 1937.

officially came together in 1935, merging to establish the University of Newark. Things moved quickly. The business school received accreditation and grew from 112 students in the first class to 556. Dana, too, was expanding, taking on new subjects and admitting more students.

The University of Newark was now a much larger institution than it had been before, but small compared to the two oldest and most established colleges in New Jersey, Rutgers and Princeton. Rutgers, in fact, was watching the developments in Newark with interest. The Rutgers trustees believed they needed a law school to stay in the first rank of American universities, and thought the quickest route was to make Newark's law school part of Rutgers. As early as Christmas 1932, there was talk of a Rutgers takeover of the Newark colleges.

Newark's mayor, Jerome Congleton, was a skeptic: "In my mind," he wrote, "it smacks too much of the chain store system." The Newark faculty shared his skepticism and wrote to President Currier:

It is the sense of the faculty that ideally the interests of higher education in Newark and vicinity can best be served by an entirely independent non-tax-supported institution, controlling its own policies, free to meet the needs of the community according to the community's interpretation of those needs.

Students, too, protested the proposal in large numbers, fearful that Newark would become "the tail end of the Rutgers kite."

Rutgers responded by opening University College in Newark in 1934, its first venture into evening education. For more than a decade, the University of Newark and Rutgers coexisted in the city before coming together under the Rutgers banner.

The University of Newark had rejected a Rutgers takeover, but life as a small, independent university was not easy. The Great Depression hit the institution hard, and students dropped out in large numbers. In 1933, the president called for a 10 percent cut in faculty salaries. Over the course of the 1930s, enrollments began creeping up again after a disastrous drop, but resources were in short supply. In December 1937, preparing the faculty and staff for cutbacks, President Currier declared, "We are at a crisis in the life of the University of Newark."

Another crisis was right around the corner. With the start of World War II, enrollments once again plummeted. During the war, the University of Newark maintained a barracks and ran a pilot training station in Essex Fells.

Studying in the Law Library, Newark, ca. 1940.

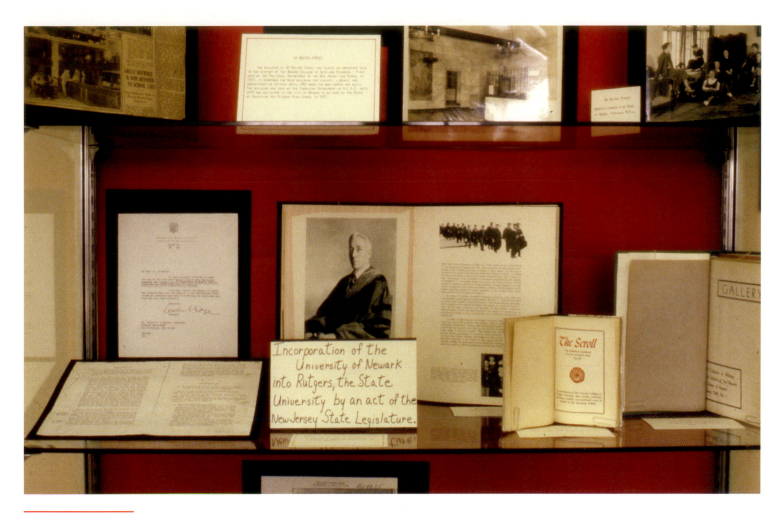

A 1981 exhibit at Dana Library of the history of Newark shows documents from the period when the University of Newark was incorporated into Rutgers.

Rutgers–Newark Is Born

The University of Newark barely made it through the war: in 1945, nine students graduated, taught by 13 faculty members. But the end of the war marked a turning point, as it did at colleges across the country. The G.I. Bill filled the classrooms: in 1946–47, more than four out of five students in Newark were veterans.

Right after the war, Rutgers once again approached the University of Newark. It still felt the need for a law school, and the fact that the business school in Newark was accredited made it that much more desirable. Rutgers was in the process of becoming The State University of New Jersey, and was more interested than ever in having a significant presence in the state's largest city. As Rutgers dean of administration Albert Meder put it in 1946, "I see in the Newark Colleges the great possibility of becoming a leading urban center of education, equal to, indeed, surpassing, any other such center in the country."

This time Rutgers' courtship of Newark was more successful. As the dean of Dana College explained to his faculty in September 1945, "Rutgers University proposes a kind of consolidation with the University of Newark, in which we are to retain our name, our set-up, our staff, and our rank." The talk of "takeover" had thus given way to "consolidation," and the terms were much more promising. And Rutgers President Robert Clothier spoke enthusiastically of the benefits "that will be passed on to the student bodies of both institutions." The Newark campus could take its place as a research university, with Newark having access to the Rutgers libraries. The negotiations succeeded, and Rutgers–Newark was born.

It became official on April 30, 1946, when the New Jersey legislature passed an act making the University of Newark part of Rutgers, which had recently been designated a public university.

Three new schools were added to Rutgers, effective July 1, 1946: Dana College was now the Newark College of Arts and Sciences, the Seth Boyden School of Business became the School of Business Administration, and the New Jersey Law School was now the Rutgers School of Law.

Newark students in the Norman Samuels Plaza, just as popular today as a meeting spot (**right**) as it was in the 1970s (**below**). It was named in honor of long-time provost Samuels under whose watch Rutgers–Newark emerged as one of the nation's leading urban universities.

The pace of change only accelerated once Newark was part of Rutgers. The business school started its first MBA program in 1950, followed by the nation's first master's degree in professional accounting in 1954. Accounting had always been an undergraduate subject at American business schools, but Rutgers achieved national recognition for introducing an accounting program of unprecedented rigor. The University of Newark had offered courses in nursing since the 1940s; the Rutgers College of Nursing was established in 1956. The School of Criminal Justice was established by an act of the New Jersey state legislature in 1972; it opened to students in 1974. The development of Newark colleges continues to the present: one of the newest academic units in the city is the School of Public Affairs and Administration, founded in 2006 from the graduate department of public administration.

One of the most significant dates in Rutgers–Newark's history is one of the least noticed: the opening of the Graduate School–Newark as a separate division, with its own degree-granting authority, in 1975.

Toward Academic Excellence…

The Newark colleges had been established strictly as teaching institutions, and the early figures in Rutgers–Newark's history were pioneering educators. They served a population that was neglected by most other institutions of higher education, and they provided liberal arts and professional degrees. But you'll find few groundbreaking works of scholarship by those early faculty members, few scientific discoveries, few revolutionary theories.

That began to change in the 1960s, as the faculty became more ambitious and worked to turn the institution into a center of research activity. The foundation of the graduate school and the arrival of doctoral students in many disciplines affirmed Rutgers–Newark's identity as a research university. The campus was no longer concerned only with teaching what others had discovered—now it would also work on producing knowledge. The effect was clear across the Newark colleges: the Rutgers Business School, for instance, opened a doctorate program in 1978, which has

Institute of Jazz Studies

Institute of Jazz Studies (IJS) founder Marshall Stearns, a professor of English at Hunter College and author of the 1956 *Story of Jazz*, was a serious jazz scholar well before the subject was accepted in academic circles. His original collection was housed in his Greenwich Village apartment, which he opened to researchers once a week. By the mid-1960s, he began to seek out an institutional home. Rutgers president Mason Gross was receptive, and in 1967, the collection was moved to the Rutgers–Newark campus. Stearns, who died in December 1966, did not live to see the transfer. Housed in the Dana Library, the institute's first administrator was sociology professor Charles Nanry; he was succeeded by bassist Chris White.

In 1976, Dan Morgenstern became director, a position he held until his 2012 retirement. Morgenstern, a respected jazz writer/historian and winner of multiple Grammys for his album notes, oversaw a period of tremendous growth in the institute's collections and activities. In addition to over 100,000 recordings, a 6,000-book library, and archival collections, IJS has the saxophones of Lester Young, Ben Webster, and Don Byas, a handwritten memoir of Louis Armstrong, Billie Holiday's jewelry, and Ella Fitzgerald's gown and wig.

IJS undertook many outreach activities, including a monthly Jazz Research Roundtable, a yearly concert series, and numerous performance events, conferences, and exhibits—all free and open to the public. In 1973, it launched the *Journal of Jazz Studies*, a now peer-reviewed, online open-access publication. In 1979, it began a weekly radio program, *Jazz from the Archives*, heard on Newark's WBGO-FM. Its Studies in Jazz series of over 60 titles was begun in 1982. The institute has obtained grant support for major projects ranging from performance to cataloging and preservation, digitization, and oral history. IJS supports students and faculty in a unique master's program in jazz history and research, founded by Professor Lewis Porter in 1994. The world's leading jazz archive, IJS serves scholars, students at all levels, musicians, the media, arts organizations, and members of the general public.

—EDWARD BERGER, FORMER ASSOCIATE DIRECTOR, INSTITUTE OF JAZZ STUDIES, RUTGERS UNIVERSITY LIBRARIES

Dan Morgenstern (left), Ed Berger, and Vincent Pelote of the Institute of Jazz Studies.

since grown to be one of the largest doctoral management programs in the country. Taking advantage of its proximity to New York City, Rutgers–Newark began attracting high-profile academics in a range of fields.

The result has been academic excellence across the schools and departments, including many firsts in the nation. The *Rutgers Computer and Technology Law Journal*, published by the School of Law, was America's first law review focusing on emerging technologies. The very first law reform clinic in an American law school, the Constitutional Rights Clinic, was founded in 1970; the first public interest law center devoted to representing parents and students, the Education Law Center, followed in 1973. Meanwhile, George Walker, professor of music from 1969 to 1992,

became the first African-American composer to win the Pulitzer Prize for music.

Rutgers–Newark also offered the world's first master of arts in jazz history and research. Jazz has long been one of Rutgers–Newark's strengths. Marshall Stearns founded the Institute of Jazz Studies in New York in 1952, but negotiated a transfer of the materials to Rutgers in 1967 "to foster an understanding and appreciation of the nature and significance of jazz in our society."

Today Rutgers–Newark has strengths across many disciplines, including chemistry, creative writing, criminal justice, jazz studies, mathematics, neuroscience and brain imaging, oral history, public affairs, public interest law, quantitative finance, supply-chain management, and urban history.

...With a Focus on the Real World

It's only fitting that a campus born out of professional schools should have a practical bent, and through all the advances in scholarship, the attention at Newark has always been on the real world. This comes through in the curriculum, which has been designed with working students in mind. For example, Rutgers–Newark started an accounting internship program in the 1950s, giving senior accounting majors the chance to work for top firms for two months at a time; an executive MBA program established in 1980 allowed middle managers to combine full-time work with full-time study.

Making the curriculum accessible to, and useful for, students living busy lives outside college has been at the heart of the Rutgers–Newark story—and when the administration hasn't provided a relevant curriculum, the students have demanded it. In March 1971, the arts and sciences faculty approved what they called a "curriculum for all time," which did away with some old requirements, including Western civilization, literary masterpieces, physical education, and foreign language courses. In their place came much more flexibility: students had to take two years of courses in each of the humanities, social sciences, and natural sciences outside of their major, along with separate requirements for the lab sciences. New interdisciplinary programs were rolled out, some in established areas—such as Hebraic, Eastern European, urban, and environmental studies—and others in areas developed by the students themselves. Rutgers–Newark was on the cutting edge of curricular development.

The "real world," though, has sometimes intruded on campus life in momentous ways. Newark was the site of some of the country's bloodiest and most costly urban violence of the 1960s. The Newark riots of July 1967 were devastating, with 26 residents killed, more than 700 injured, and more than $10 million in property destroyed. Tensions between the races and social classes were as bad as they had ever been. Those tensions came to campus in February 1969, when a group of students took over Conklin Hall and presented a list of demands to the administration, calling for increased minority presence among the students and faculty and more engagement with the local community.

So many student actions of the 1960s ended badly, but the protests in Newark ended up producing real benefits for everyone. After some prompting from its most courageous campus leaders, Rutgers–Newark came to see not threat but opportunity in its setting. Rather than withdrawing from the city, it became more engaged than ever. Rutgers–Newark had always been an urban campus, but for a long time that meant only that it was located in a city and served the neighboring students. Now it took on a specifically urban focus in its teaching and research as well. In the wake of the riots and the Conklin Hall occupation, Rutgers began strengthening its historic ties to the city of Newark, and became one of the leading urban universities in the country, especially under the 20-year leadership of Provost Norman Samuels.

Just a few months after the riots, for example, the Rutgers Minority Business Program was established, offering weekly seminars to "help ensure that minority groups had an opportunity to participate in the mainstream of American economic life." The program worked on raising grant money from the Ford Foundation, DuPont Corporation, and General Electric Company to help start 40 new minority-owned businesses. In 1969, there followed the Rutgers Minority Investment Company. Other initiatives, like the Educational Opportunity Fund and the Academic Foundations Department, also started up, alongside new recruitment policies aimed at increased student and faculty diversity.

The School of Law expanded its mission of outreach and service to the urban community. It became a pioneer in affirmative action, working to bring minorities and nontraditional students into the profession, including through the Minority Student Program of 1968. It established a series of legal clinics to serve the community,

Front page headlines on the riots appearing in the *Newark Sunday News*, July 16, 1967.

Nursing department staff, ca. 1955.

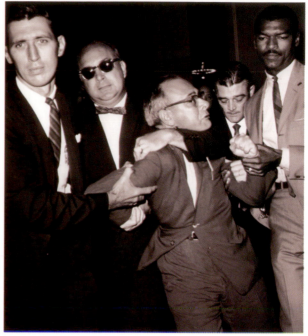

Below: Arthur Kinoy, professor of law at Rutgers–Newark and founder of the Center for Constitutional Rights, was a premier champion of civil liberties who argued before the U.S. Supreme Court, including 1965's landmark *Dombrowski v. Pfister* free speech case. Kinoy is pictured here being ejected from the House Un-American Activities Committee hearing room in Washington, D.C., 1966.

Known widely for his encyclopedic knowledge of and tireless advocacy for the city of Newark, Distinguished Professor Clement Price (GSNB '75) died unexpectedly in 2014. His final major project was one in which he joined with historians Spencer R. Crew (GSNB '73, '79) and Lonnie G. Bunch III to edit *Slave Culture: A Documentary Collection of the Slave Narratives from the Federal Writers' Project*, a collection of reminiscences by the last generation of enslaved Americans.

including one of America's first women's rights law clinics and an early environmental law clinic.

The College of Arts and Sciences made urban engagement one of its central areas of concentration, leading to a three-day scholarly conference on urban literature in 1980. The meeting attracted attention across the country by bringing James Baldwin, Joyce Carol Oates, and Saul Bellow to campus, while Amiri Baraka demonstrated to allow nonregistrants to attend for free. A host of research initiatives—including the Center for Migration and the Global City, the Institute on Education Law and Policy, and the Institute on Ethnicity, Culture, and the Modern Experience founded by history professor Clement Price (GSNB '75)—confirmed Rutgers–Newark's commitment to the city.

Activism has long been a hallmark of the campus, which has believed in putting scholarship into practice and ensuring that the life of the mind has effects in the larger world. The law school faculty has been especially committed to social action. Arthur Kinoy joined the law faculty in 1964 and worked full time until 1991 and part time as a professor emeritus until his death in 2003. Before coming to Rutgers, he had achieved notoriety by defending Ethel and Julius Rosenberg in the early 1950s; after he arrived on campus, he won a Supreme Court case against Richard M. Nixon for wiretapping domestic organizations.

In the early 1970s, a number of women faculty in Newark—including future Supreme Court Justice Ruth Bader Ginsburg, who was a professor at the law school between 1963 and 1972—filed a class-action suit against Rutgers for pay discrimination. They discovered that male employees at nearly every level were earning more than equally qualified women, and brought one of the first legal actions on behalf of women's rights at a university campus in America. Their victory brought about greater pay equity at Rutgers and led to the creation of one of the first women's studies programs in the nation.

The Newark faculty has been just as committed to the campus's famous diversity. The first African-American faculty member began teaching in the School of Law in 1955. Although it took until 1962 for the school to hire its first woman faculty member, in 1977—just a year after alumna Elizabeth Warren, now a U.S. senator from Massachusetts, earned her law degree here—Rutgers became the first law school in the country to enroll more women than men. And Calvin McClelland, one of the earliest professors in the school, was a pioneer for the disabled: a preacher turned lawyer, he began at the New Jersey Law School in 1915, after losing his sight in 1911 and his right leg in 1914.

So what's next? America's most diverse urban university and Rutgers' most politically active campus are inextricably bound to the city of their origin. How that relationship continues to develop and how Rutgers–Newark develops as a crucial part of The State University of New Jersey is an ongoing story of opportunity and vision.

Newark

Frank Jordan: Rutgers Chemistry at Newark, a Sentimental Recollection

RUTGERS BOARD OF GOVERNORS PROFESSOR OF CHEMISTRY, RUTGERS–NEWARK

The Rutgers Department of Chemistry in Newark began after World War II as an undergraduate program. By the 1950s, it offered a doctoral program, with examinations administered jointly with the much larger New Brunswick department. In the early 1970s, the Newark chemistry department became autonomous, offering its own doctoral qualifying exams, and setting its own requirements for the baccalaureate and doctorate. This autonomy was not without its own problems; there was the real danger that the department would always be underfunded, both in terms of infrastructure and faculty support, while the much larger "flagship" department in New Brunswick (with more than 40 faculty members after the merger of the college faculties) would enjoy a sizable critical mass in the nationwide competition for talented faculty and grant money.

When I arrived in 1970, the department was housed at 40 Rector Street, east of Broad Street, in the old Ballantine Brewery building, with some talented young faculty relegated to the shabby building across the street. It is of historical note that at the time, chemistry faculty could smoke in their offices, which often also served as their laboratories.

What made the job offer appealing to me was the promise of a new building for housing the department in its own quarters among the newer construction west of Broad Street at 73 Warren Street. Indeed, the new building—Olson Hall Laboratories, named after the first professor of chemistry, Carl A. Olson—opened its doors by the fall semester of 1973. As was the (very smart) custom of the day, in addition to the construction costs, there was 15 percent allotted for "movable equipment," providing a shot in the arm with new instrumentation, and enabling faculty to undertake experiments in X-ray crystallography and vibrational spectroscopy at a competitive level. Other than that, most research was carried out in the synthetic and biological chemistry areas, with rather conventional laboratory equipment. It took an additional 30 years to add to the research space. Now there are adequate and modern research facilities for 11–12 groups. In 2013, a New Jersey bond issue provided funds for extension to the Life Sciences Building.

In 1970, there were 13 tenure-track faculty positions in the department; by 2014, this had been increased to 15 tenure-track positions. From a very minimalistic approach to faculty start-up funds before the mid-1980s, a quantum jump occurred during the years of the Edward Bloustein–Alexander Pond administration, which recognized that in order for Rutgers to become competitive in the sciences, there must be adequate funds to kick-start the independent careers of the newly hired faculty. This change led not only to more competitive offers for assistant professors, but also to higher success rates in research funding from external sources. Where about four of 13 faculty members were funded in the 1970s, as many as eight of 15 were funded by the 2000s.

By any measure, the chemistry department is in fine shape and thriving; assuming reasonable continuing state and federal research support, it has a bright future ahead.

Above: Chemistry laboratory on Rector Street, Newark, 1948.

Opposite: Opened in 2006, the Life Sciences Center at Rutgers–Newark added much-needed space, including academic laboratories, a media seminar room, research labs, and support space.

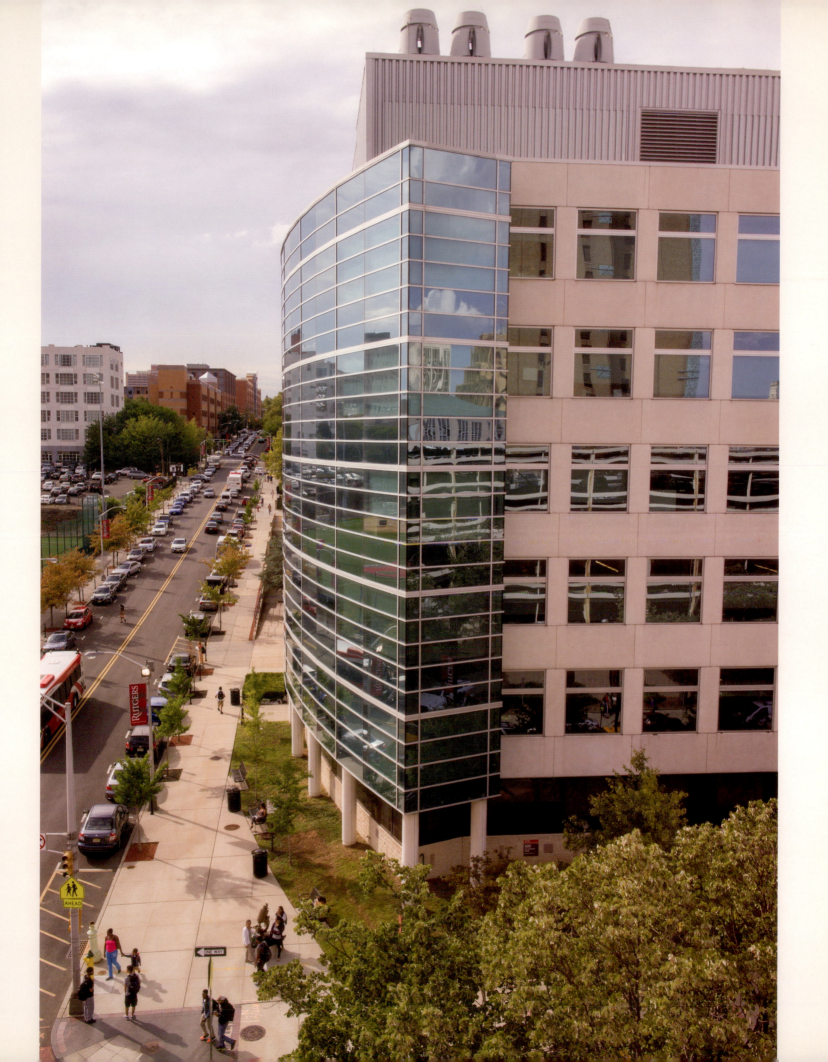

FACULTY VOICES

Through creative and interactive theater, the UNITY Theater engages student audiences by provoking dialogue about health issues. The UNITY cast receives training on leadership, theater skills, facilitation, and health and social justice topics such as racism, sex, alcohol and other drugs, homophobia, mental health issues, and many more.

Rachel Hadas: Literature Is by, for, and about People

BOARD OF GOVERNORS PROFESSOR OF ENGLISH, RUTGERS–NEWARK

I began teaching in the English Department at Rutgers–Newark College of Arts and Sciences (NCAS) at short notice and under irregular circumstances. Still some months away from defending my comparative literature dissertation at Princeton, I'd been sending out my bio to all the schools in the tri-state area, Rutgers among them. An elderly professor at NCAS had died suddenly over the summer, a prompt replacement was needed, there was no time for a national search, and my CV must have been at the top of the pile. So it was that in 1981 I stumbled into a truly remarkable college.

More than 30 years later, it's hard to remember that first semester, but I think I was teaching two sections (could it have been three?) of freshman composition and one section of a course called "Literary Masterpieces": epic, tragedy, Plato. Even then I understood the relaxed, laissez-faire spirit in which faculty were allowed to approach these courses. I also grasped how different my NCAS students were from the students I'd encountered as a teaching assistant at Johns Hopkins and then at Princeton. Those students had been intimidatingly well prepared; I'd felt like an impostor leading a class discussion whether on Shakespeare or Thomas Pynchon. NCAS students, on the other hand, didn't know everything already. They were very varied in age, ethnicity, background. One of my first comp students was a woman in her late 30s; another had escaped from Vietnam on a boat. Most of my students had jobs, many had families, all commuted to campus, and all seemed to be at NCAS because they wanted to be. College was something worth struggling for. I knew more than they did about some things, and they knew more than I did about many things. During those early years at Rutgers–Newark, I was completely absorbed in the dialectic of the classroom, a rhythm that still not only allows enough time for my own writing but also nourishes it.

Now, early in 2014, I can't remember when I last taught "Literary Masterpieces." But I remember clearly that my students had wanted to read a richly diverse group of authors, including dead white males. From the start, Rutgers–Newark students never made me feel either apologetic or intimidated. I never assumed they had read anything in particular; I never assumed they were English majors. It didn't matter. Literature is by, for, and about people.

I get bored hearing myself talk; I lecture for maybe 10 minutes at a time and then break the class into groups. We may read less, but we talk and analyze more. None of these trends is unique in academia to Rutgers or to me. My father, Moses Hadas, wrote many years ago in the context of Columbia University's Colloquium about the temptations of teaching facts about the text versus actually teaching the text.

Below: The Paul Robeson Galleries are a focal point for a wide variety of programming throughout the year. Recent exhibits included Empire of Dirt, Healing through the Arts, and a Nelson Mandela Tribute Mural.

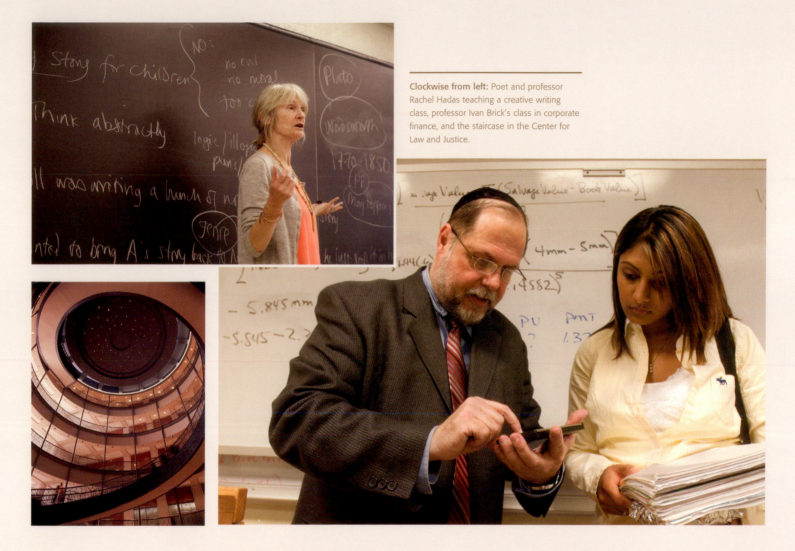

Clockwise from left: Poet and professor Rachel Hadas teaching a creative writing class, professor Ivan Brick's class in corporate finance, and the staircase in the Center for Law and Justice.

But what is special about Rutgers–Newark is its justly famed diversity. In a class of 40, students may well speak 15 different languages at home. And language difference is the least of it. What does diversity in the classroom actually mean? What puts a human face on diversity is human exchanges: group work, writing, responding, arguing, understanding that an interpretation of a fairy tale or myth, or a response to an illness, is not an *ex cathedra* edict but rather is inflected both by one's own unique experience and by the culture in which one grew up.

For several years now, I've asked my students to write a final memoir instead of a term paper. A native speaker of Malayalam wrote heartrendingly of the stories her grandfather told her. A student from Macedonia wrote a passionate response to the Iphigenia myth. A student from Nigeria wrote about her annual bout of malaria when she visited a lake every summer. Last month, 40 students from all over the world sat in a circle as we read the first chapter of *Charlotte's Web* out loud, pausing every sentence or so for questions and comments. What is close reading if not

this? Just such a mix of far-flung geography and human encounters is typical of what Rutgers–Newark has always been like.

In 2007, Rutgers–Newark inaugurated its master of fine arts program. I enjoy teaching poetry workshops in this program, whose students are (no surprise) far more diverse than most MFA students. I also teach literature courses in our master's program in English, where some of the best students are high school teachers from all over New Jersey. But if I had to choose (luckily I don't), I'd vote to teach only the undergraduates. They have so much to read and to learn, and their time with me (though it may seem long to them) is so short. The future they face is complex and demanding. They need at least one course that affords them the necessary luxury of engaging with literature, which requires engaging with each other and with their lucky teacher. They come from Albania, Korea, Egypt, Pakistan, Vietnam, Ecuador, Cuba, Haiti, Portugal, the Philippines, Macedonia, the Dominican Republic, Colombia, Greece, Bulgaria, Russia, Turkey, India, Iran, and many other places. They also all come from New Jersey.

Rutgers University–Camden

MICHAEL SEPANIC, ASSOCIATE CHANCELLOR FOR EXTERNAL RELATIONS, RUTGERS–CAMDEN

Modest Beginnings

Classes at what would become Rutgers University–Camden began, rather inauspiciously, in 1926 on the third floor of an office building on Market Street. Elmer G. Van Name, a Camden native with an active law practice in the city, and Arthur E. Armitage Sr., a lawyer who went on to become a longtime mayor of Collingswood, saw the need for a law school in southern New Jersey because of their involvement with the Young Men's Christian Association of Camden, where Van Name was teaching a law class. The founders had vision and enthusiasm, and were supported by strong local social and political connections. Armitage, in particular, the son of a working-class North Jersey family, was indefatigable in seeking education for the lower income population. By September of that year, the first class of 53 students, including four women, had matriculated. Van Name became dean of the new school and ran the admissions office out of his law practice. The faculty was composed principally of practicing attorneys.

At the time of the school's founding, admission to law school required no more than a high school degree. As was the case with many law schools opening at the time, many of the students, coming from backgrounds similar to Armitage's, worked during the day and attended classes at

Below: 329 Cooper Street, Camden, ca. 1950s, today known as the Artis Building.

Left: Opened in 2012, the 330 Cooper residence hall for graduate students features modern apartments, a business center, study spaces, and gathering spots such as a rooftop deck with sweeping views of the Delaware River, Philadelphia, and Camden.

Below: Renovated with painstaking attention to historical detail during 2003 and 2004, 303 Cooper Street houses the offices of the chancellor.

night. But emerging shifts in legal education at the national level placed a roadblock in the young institution's way. During the 1920s, the American Bar Association (ABA), fearing a growing legal profession that lacked standards, raised qualifications and prerequisites in legal education. The New Jersey Board of Education responded by requiring two years of college education before students could begin law school in New Jersey.

Rather than being daunted by these new requirements, the founders saw opportunity and created an evening prelaw curriculum. Called the "college department," it opened in September 1927. Charles L. Maurer was named its first dean, and part-time faculty members were recruited from other area colleges. In that year, the South Jersey Law School and its college department had a collective enrollment of 175 students. In 1930, the law school graduated its inaugural class, including Mary Walsh Kobus, who went on to become a prominent politician in Camden, later serving as the city's director of public safety.

In 1932, a day college was established, which offered courses in English, algebra, world history, sociology, ecology,

geology, and German. This college department was the forerunner of the College of South Jersey; the law school, still an evening program, was its only postgraduate department.

The Great Depression had a serious impact on the college. In a time of great economic hardship, when it was difficult for many to meet their basic needs for food and shelter, higher education became an unaffordable luxury. And when the country slowly recovered from its devastating economic decline, World War II brought new enrollment challenges, as both schools saw many of their male students leave to fight overseas. Nevertheless, the school continued to operate during the war years. By 1943, the lease on the Federal Street property that had housed the law school since 1930 had expired, so the schools purchased property on Cooper Street for their operations.

Postwar Growth and Merger

With the war's end and passage of the G.I. Bill, the College of South Jersey had in 1947 twice as many veterans in the sophomore class as nonveterans; in the first-year class, nearly 75 percent were veterans. That year, the college graduated

33 students. But enrollments were on the upswing: two years later, 128 students graduated.

To accommodate the rapid rise in enrollment, the college purchased the former estate of advertising magnate Francis Wayland Ayer, located at 406 Penn Street, which became the classroom space for the College of South Jersey. And because of an ABA requirement that accredited law schools must be housed in facilities separate from undergraduate programs, a two-story brick building was erected behind it. Next to the Ayer house, a science hall was constructed, and a three-story building on Cooper Street was converted to classroom use.

While the college was growing, the law school was facing new challenges. In 1949, it failed to receive ABA accreditation, primarily because it was not affiliated with an established university. Armitage sought help from the governor, Alfred E. Driscoll. Their solution was to have Rutgers acquire the campus, a proposal supported by both administrators and students. Both the school and the college would be placed under Rutgers' control, and title to all the Camden properties would be turned over to the university.

Rutgers had recently incorporated the University of Newark in a similar manner. The state legislature voted unanimously to make the merger official on July 1, 1950.

When the merger took place, the College of South Jersey offered 14 different courses to 251 students enrolled in its two-year program. It employed 27 faculty members and administrative staff, most of them part time. Becoming part of Rutgers, however, made it possible for the campus to become more ambitious. It immediately began to increase both the scope and quality of undergraduate education. As a first step, the junior college was expanded to three years; it became a four-year college by 1952. The number of course

Below and below left: Students studying and strolling on campus. Stately 406 Penn Street is home to the Office of Admissions.

Left: Camden Campus library staff unpacking books, ca. 1960s.

Below: Students studying and conversing on the Rutgers University–Camden quad facing the Library in the 1970s.

Bottom: Planning for College Campus Center, ca. 1960s.

offerings grew from 31 in 1952 to 162 by the end of the decade. W. Layton Hall, an associate professor of marketing at the Rutgers–Newark School of Business Administration, was named full-time dean. An evening program, called University College, was added. Enrollment continued to climb, totaling 1,900 in 1959.

Expanding and Changing Campus

It was becoming increasingly difficult to fit all those students into the existing campus infrastructure. The required first-year physical education classes took place blocks away from campus at the YM and YWCAs, classes were held in old row houses, and city streets bisected the campus. The only new building was the library, which had opened in 1957 and had a capacity of 110,000 volumes. In 1959, the library's collection had more than 25,000 volumes, up from just about 5,000 at the time of the merger with Rutgers.

To accommodate the increasing numbers of students attracted to this newest member of the Rutgers family, physical expansion was essential. Passage of a 1959 college bond issue provided $2.6 million for new construction on the Camden campus. The decade that followed was a time of demolition, land acquisition, and a much-needed building program. The first new structures opened in fall 1964: a Campus Center and a Science Building. More relief from overcrowding came in December 1965 when Victor Hall at Point and Pearl Streets was obtained from RCA. Known

to generations of students as "the annex," the seven-story building made up in utility what it lacked in architectural charm and grace. The passage of another bond issue in 1964 prompted the construction of Armitage Hall, a classroom and office building that opened in fall 1968. In that same year, an addition to the library more than doubled its size.

The success of the campus came against a backdrop of urban decline. The city of Camden, after holding its own into the early 1960s as one of the nation's most productive manufacturing centers, witnessed plant closings and the departure of both the white middle class and the commercial businesses that had supported their needs. Losing its long-

The February 19, 1969, issue of the Rutgers–Camden student newspaper, *The Gleaner*, covered the administration's response to protests and demands initiated by the Black Student Unity Movement at the campus.

held position as the economic heart of the region, the city struggled to meet growing social needs with declining revenues. Riots in the summers of 1969 and 1971, brought on by what community members saw as police brutality against minorities, exacerbated tensions on campus.

In the 1968–69 academic year, these tensions boiled over as a group of black students took over the Campus Center and presented demands. The campus newspaper, the *Gleaner*, records student anger over the small numbers of minority students as well as a lack of attention to issues of race on campus and in the surrounding community.

In retrospect, this year marked the campus's transition from an old-fashioned college where first-year students wore "dinks" and sang the alma mater whenever asked to do so by an upperclass student to a socially aware and politically active student body. The change was reflected in the choice of the book to be read by incoming first-year students in the fall of 1969. It was Nat Hentoff's *The New Equality*, a book that directly addressed the problems of racism and economic disparities in America.

The end of the 1960s brought another change as well. After several years of discussion, Rutgers College of South Jersey officially became Rutgers University–Camden College of Arts and Sciences, with the Board of Governors approving the change on April 10, 1970. By then, the campus had grown both in size and stature and was large enough to make it possible for the nearly 250 members of the Class of 1970 to be the first to have commencement exercises on campus, instead of attending graduation in New Brunswick. By the time that first on-campus ceremony

Above: Camden's Armitage Hall, ca. early 1970s.

Right: Camden Campus Center, mid-1960s.

Left: Students on Camden Campus near North 3rd Street, 2005.

Below: Students talking near the parking lot on Camden Campus, looking toward Ben Franklin Bridge, ca. 1974.

took place, construction had begun on a new law school building—and, thanks to the passage of a 1968 bond issue, two more major undergraduate/graduate buildings were on the drawing board.

Emphasis on Academics

Rutgers–Camden was flourishing, aided by strong support from the university. In the fall of 1970, 1,787 undergraduates were enrolled, more than triple the number of students registered 10 years before. The new gymnasium opened in fall 1973; its 55,280 square feet offered a pool, basketball court, showers, locker rooms, weight rooms, teaching stations, and offices.

In July 1974, Walter K. Gordon, a member of the Rutgers–Camden English Department, replaced outgoing dean James Young, first as acting dean, then as dean. He later became provost of the campus, serving until his retirement

in January 1997. One of his major goals was the recruitment of stellar faculty. He also focused on the arts, chairing the planning committee for a new 65,000-square-foot Fine Arts Building that became a centerpiece of the campus, with classrooms, a theater, and a campus art gallery.

The building changed the nature of the campus dramatically, making it possible for Rutgers–Camden to attract high-caliber faculty who appreciated the varied possibilities of the new space. Today, the gallery offers exhibitions of national and regional artists—including our own faculty—drawing audiences from throughout the metro Philadelphia area. The theater, in addition to providing an attractive venue for productions of the Fine Arts Department, is home to the acclaimed regional orchestra, Symphony in C.

By the 1970s, the political activism that had characterized the late 1960s was less in evidence. About 20 percent of the students were majoring in business or economics in 1973, up 42 percent over a two-year period. The nursing program, established in 1973, enrolled 52 students in its first year and 172 the next. As the war in Vietnam wound down, the veterans returned to campus, and other nontraditional students joined them, including women

inspired by the feminist movement to begin or complete their college degrees and others who simply wanted the opportunity to attain a bachelor's. They were attracted to Rutgers–Camden both by its reputation for excellence and its accessibility. These older students brought "adult" concerns with them, such as a need for job counseling and day-care facilities. The campus also worked to increase the number of minority students in order to become a more diverse place.

At the beginning of the 1980s, Rutgers–Camden further broadened its scope and began offering its first master's degree programs, in biology, English, and business administration. It also started its pioneering Learning Abroad program, which allows students to integrate specific courses with a brief period of travel abroad. Designed for students unable to take advantage of traditional semester abroad programs, this program has been emulated widely. To date, it has taken over 10,000 students all over the world—to Brazil, China, Japan, Namibia, Russia, South Africa, and more. Most students had never previously left the United States; some had never traveled beyond the mid-Atlantic states.

As in the past, academic growth led to more building on campus. In 1982, the university's Board of Governors approved a two-phase student housing program, which the campus had long wanted. The $6.5 million building opened in late August 1986, bringing students to Rutgers–Camden

from 14 states and from such countries as Canada, Greece, Taiwan, Indonesia, and Japan. The campus portfolio of facilities further increased when it acquired the Johnson Library from the City of Camden in 1986. The impressive Greek revival building extended the campus for a full block along Cooper Street. It became the home of the Walt Whitman International Poetry Center.

In 1988, the growing demand for business offerings led to the founding of the School of Business–Camden, the first business school in southern New Jersey to earn accreditation from the Association to Advance Collegiate Schools of Business International. At that time, it offered undergraduate degrees in accounting and management, and a master's in business administration. In fall 1990, a $9 million Business and Science Building opened. The four-story structure, with its distinctive chevron-shaped glass front, provided a much-needed home for the new school and for the Computer Science and Physics Departments. Rick Elam had been named the founding dean of the School of Business in 1988. His successor, Milton Leontiades, took on the position in 1991. Under his tenure, the school added undergraduate programs in marketing, finance, and hospitality management, as well as offering MBA courses in Atlantic County, and aggressively engaged with the regional business community.

The steps of the Paul Robeson Library have long been a favorite place to hang out between classes and to gather to voice opinions, as in the photo above.

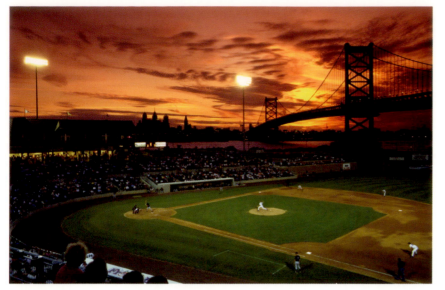

Campbell's Field on the Camden Campus below the Benjamin Franklin Bridge.

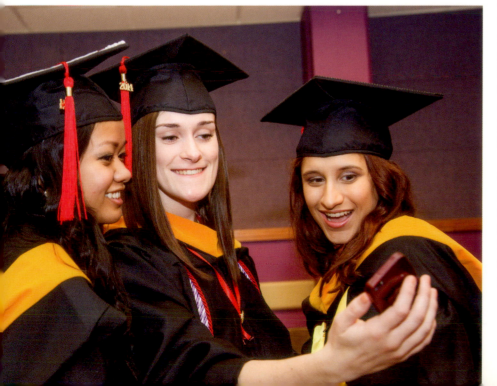

School of Nursing–Camden graduates take a "selfie" after the 2014 ceremony.

Accelerating Impressive Growth

Roger J. Dennis became provost of Rutgers–Camden in 1997. Rayman Solomon succeeded him as the school's dean in 1998. That same year, Margaret Marsh (CCAS '67) returned to her alma mater as dean of the Faculty of Arts and Sciences. Working closely with the deans, Dennis sought to ensure that Rutgers–Camden continued to grow in stature as a first-rate academic institution. He encouraged the development of interdisciplinary programs and supported cross-campus collaborations. He worked to develop meaningful opportunities to leverage Rutgers expertise to address city, regional, and statewide issues.

Dennis also recognized the importance of creating an attractive environment, embarking on a series of initiatives

not only to expand the size of the campus but also to enhance its aesthetic appeal. In 1999, the site of the former Victor Hall became part of the 5.5 acres making up the Rutgers–Camden Community Park, positioned beside the Benjamin Franklin Bridge, which brought soccer and softball fields to the campus for the first time in its history.

Dean Marsh had been hired to expand and strengthen the arts and sciences in Camden. Working closely with the faculty and the associate deans, she launched several research centers and initiatives, including the Center for Children and Childhood Studies and the Mid-Atlantic Regional Center for the Humanities (MARCH). The creation of a strong graduate school was a priority. During her tenure, graduate enrollments grew by more than 43 percent and the number of programs doubled.

Marsh recognized that with its relatively small faculty who were both able and willing to collaborate across departments, the campus was in the perfect position to create innovative, interdisciplinary doctoral programs. Both the provost and the central administration agreed. The first of these programs, in childhood studies, was approved in 2006. Other terminal degree programs created included a doctoral program in physical therapy; an MFA in creative writing; a PhD program in computational and integrative biology, a critical growth area in the biosciences; and a PhD in public affairs with an emphasis on community development. The rise of these terminal degree programs extended Rutgers–Camden's burgeoning reputation as a center for research and scholarly accomplishment, and began to attract faculty and students from around the world.

Similar activity was under way at the Rutgers School of Business–Camden, where the traditionally upper-division undergraduate program evolved into a fully realized four-year school in 2008, allowing the business school to achieve greater levels of success. Overall, a renewed focus on adult learners, coupled with a commitment to extending access to a Rutgers degree across the state, led to the establishment of partnerships with every county college in southern New Jersey, including degree-granting Rutgers–Camden programs held at some of those institutions.

Undergraduate research—the ability for students to generate their own original knowledge by working in partnership with their research faculty—emerged as, and remains, a distinguishing characteristic of Rutgers–Camden, leading to the launch of a Celebration of Undergraduate Research and Creative Activity that continued into the second decade of the 21st century. Many of those students published their work in academic journals and presented

The artist Larry Kirkland's sculpture *Emerge*, located on the campus of Rutgers School of Law–Camden, is considered a tribute to the city's industrial roots as well as the opportunities promised by higher education.

their posters at top scholarly conferences. The growth of the Honors College additionally cemented Rutgers–Camden's attraction for top students. Created as an honors program in 1997, the Honors College has grown into a community of 400 students drawn from the three undergraduate schools on campus. Its distinctive focus on learning communities, including an emphasis on civic engagement, distinguishes the Rutgers–Camden Honors College from its counterparts on other Rutgers campuses.

Upon Dennis's departure in 2007 to become founding dean of the Drexel Law School, Dean Marsh became interim provost and then interim chancellor, serving for more than two years in this position.

Into the Future

In the early 21st century, the campus continued to expand. Its most ambitious project was Law School East, an attractive four-story facility that allows Rutgers' law clinics and pro bono programs to better deliver more than 30,000 hours of free legal service annually. Under Dean Solomon's leadership, the law school has become a thriving center of legal education, strengthened by exceptional faculty who are widely recognized in fields including international law, health law, intellectual property, family and women's rights law, and state constitutional law. Members of the faculty engage in a wide range of public service, testifying before committees of the U.S. Congress; appearing before The Hague and the U.S. Supreme Court; and offering their expertise to state supreme courts, law firms, and various organizations across the nation and the world. Its alumni are equally impressive—leading members of the bar in public and private settings throughout the nation, including the U.S. Army's first female judge advocate general. Solomon also placed a priority on enhancing lawyering programs that provided students with critical skills for legal practice.

The physical evolution of the campus was not limited to the new law school facility. The installation of the Gateway, an impressive, donor-supported corridor of illuminated glass artwork, brought new energy to the university. An ambitious restoration project reanimated Johnson Park and its historic

statuary and reflecting pools for the enjoyment of both the campus and city communities; a related project renovated the former Carnegie library at 101 Cooper Street into a grand and welcoming facility for Rutgers classrooms and community enjoyment.

In 2009, the Athletic and Fitness Center at Rutgers–Camden reopened after undergoing a dramatic renovation. The $12 million project resulted in a state-of-the-art fitness center for the campus community, as well as appropriate space to serve Rutgers–Camden's increasingly competitive NCAA Division III intercollegiate teams and its intramural

The Business and Science Building houses South Jersey's first nationally accredited business school, the School of Business–Camden, as well as several student computing and science labs.

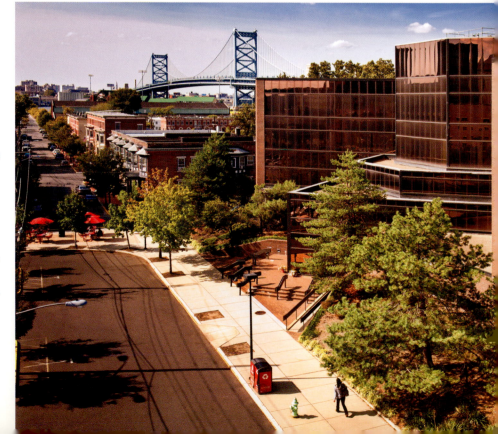

Cradle-to-College Education Pipeline at Rutgers–Camden

A transformative initiative on the Camden Campus is changing the lives of thousands of children and youth by fostering a cradle-to-college educational pipeline that is producing both high school and college graduates. The efforts to develop its signature project—the Rutgers Community Leadership Center and LEAP (Leadership, Education, and Partnership) Academy—began in 1993. The school opened in 1997 and today serves 1,500 K–12 students.

Rutgers University is deeply engaged with the school and has established Rutgers/LEAP Centers of Excellence to channel university resources to it. These include the Health and Human Services Center, for primary health and social work services to families and children; the Early Childhood Program, for preschool services; the Professional Development Institute, for training and coaching teachers and staff; the Parents' Academy, for programs to strengthen families' skills; and the Pre-College/Advanced Placement Office for assisting with college placement.

This work has received many awards for its success in transforming public education in Camden and serves as a model for efforts in similar cities across the country. With a dual focus on closing the achievement gap and ensuring college preparation and completion among African-American and Latino students who are poor and mostly first-generation college students, LEAP has maintained a record 100 percent high school graduation and college placement rate since 2005.

The Rutgers/LEAP Partnership is not only providing educational alternatives for at-risk youth and families, but is also spurring economic growth and urban renewal. Abandoned blocks in downtown Camden's Cooper Street have become vibrant educational places. In fact, Cooper Street may be the only street in a distressed city where a child can begin an education at infancy and attend school all the way through graduate studies along a few contiguous blocks. This visionary approach is producing much-needed positive results as poor cities and academic institutions struggle to address the widening achievement gap that keeps minority students outside the higher education pathway.

—Gloria Bonilla-Santiago, Board of Governors Distinguished Service Professor, Rutgers–Camden; founder of the Leap Academy University Charter School

programs. Other recent upgrades include a comprehensive reimagining of the Paul Robeson Library into a model research center for the 21st century, incorporating a branch of the Camden County Library on the lower level and a wireless student study space on the top level. Similarly, the dining hall received a thorough facelift that brightened the space into a popular gathering space for the campus.

Rutgers–Camden offers a wide range of unique opportunities and resources that focus Rutgers assets to advance many areas of scholarly and public interest. These include the Senator Walter Rand Institute for Public Affairs, the Center for State Constitutional Studies, the Center for Computational and Integrative Biology, the Community Leadership Center, and affiliation with the LEAP charter schools. At the Center for Urban Research and Education, top scholars and staff focus on issues of urban redevelopment, community development,

immigration, international development, public health, entrepreneurship, and urban education.

Combining two of Rutgers' most distinctive academic strengths—the law school in Camden and the philosophy department in New Brunswick—Rutgers Institute for Law and Philosophy has become a magnet for these complementary scholarly disciplines. At the School of Business–Camden, the Executive Education unit delivers tailored skills training programs for top-level organizations across the country.

The School of Nursing became the newest academic unit at Rutgers–Camden in 2011, with Joanne Robinson named the inaugural dean of this important institution. The school introduced a curriculum that, in the first year of study, integrates nursing courses with natural and social sciences; the school also has affiliations with top hospitals and health care agencies. The nursing school quickly established new

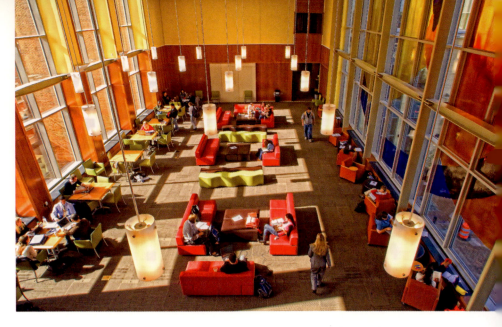

programs, including a doctor of nursing practice (DNP) degree program. In July 2014, the School of Nursing–Camden welcomed the students, faculty, and staff from the legacy UMDNJ nursing program that had been located at Stratford, New Jersey. The influx of these students, professors, and programs catapulted the growth of the Camden nursing school, which will become a primary tenant of a new Nursing and Science Building in Camden under construction at the time of the publication of this book.

In 2009, Wendell E. Pritchett became the campus's first permanent chancellor. The author of two books and numerous articles on topics related to urban history and policy, Pritchett chaired the Urban Policy Task Force for Barack Obama's second presidential campaign. Under his leadership, Dean Marsh has said that "the campus emerged as a true urban university, with civic engagement not only embedded in the campus's center and institutes but also highlighted in the curricula of all its schools and colleges."

Pritchett embraced Rutgers–Camden's history of community service and developed civic engagement into a signature characteristic of the campus. He created an Office of Civic Engagement to provide focus for Rutgers–Camden's existing programs, and to develop a thoughtful way to integrate civic engagement into the institution's academic curriculum. During the 2013–14 academic year, approximately 45 percent of all Rutgers–Camden students engaged in more than 300,000 hours of community service. During that same period, 1,065 students delivered service as part of a credit-bearing academic experience, which included 93 academic courses developed with specific civic engagement components.

Rutgers–Camden's many service-oriented initiatives include the North Camden Schools Partnership, which connects Rutgers students with Camden children for after-school enrichment activities; a wide array of pro bono and clinical legal programs offered through the Rutgers School of Law–Camden; empowerment workshops delivered by the Community Leadership Center; and research-driven analysis developed by the Center for Urban Research and Education.

In 2010, Pritchett named Jaishankar Ganesh, a noted business education innovator and international marketing

scholar, as fourth dean of the Rutgers–Camden business school. At the time of his arrival, the school had grown to 679 undergraduate and 276 graduate students attending classes in Camden, Atlantic City, and Mount Laurel. Ganesh launched the graduate programs Professional MBA and Professional Master of Accounting at diverse locations across the state, as well as a new bachelor of arts in business administration. Under his leadership, an endowment was established to support the Daniel Ragone Center for Accounting Excellence.

In 2011, Kriste Lindenmeyer, a noted scholar in the areas of childhood, public policy, and social entrepreneurship, was named dean of the Faculty of Arts and Sciences at Rutgers–Camden. Her vision for the growth of arts and sciences led to the creation of a Digital Studies Center, which now serves as a focal point for Rutgers–Camden scholarship and pedagogy in this new discipline, as well as the creation of new programs in such areas as the health sciences and a renewed emphasis on experiential learning opportunities for all students.

In recent decades, the Camden campus has been a signally important part of discussions about the structure of New Jersey's state higher education system. In 2012, a committee appointed by Governor Chris Christie proposed taking the campus away from Rutgers and merging it into Glassboro-based Rowan University, which had opened a new medical school in Camden, where it had long had a small campus. Rutgers–Camden students, faculty, alumni, and administrators vigorously protested the proposal, demanding that the state keep

The interior (**above**) and exterior (**below**) of the Rutgers School of Law–Camden.

its flagship university in southern New Jersey. They prevailed. Lawmakers and the governor ultimately agreed to a different vision for the campus: it would remain part of Rutgers, be granted greater autonomy from the central administration in New Brunswick, and work with Rowan in health science fields. Those changes became effective in July 2013.

In the summer of 2014, Phoebe A. Haddon became the newest chancellor to take leadership of Rutgers University–Camden. She immediately set to work with virtually every constituency related to the campus to develop a collaborative and comprehensive Rutgers University–Camden Strategic Plan, which set forth ambitious yet realistic goals for a five-year period. Haddon also recognized civic engagement as a distinguishing strength of Rutgers–Camden, especially in its ability to deliver exceptional experiential learning opportunities for its students while advancing its host city and region. In January 2015, Rutgers–Camden earned the highly selective Community Engagement Classification from the Carnegie Foundation for the Advancement of Teaching, a signature honor for universities committed to civic engagement. Haddon also articulated clear goals to strengthen access and student success at Rutgers–Camden.

What's ahead for Camden? Its history promises growth—and it suggests surprises. But its energies will remain focused on its commitment to its students, its research faculty, and its city and region.

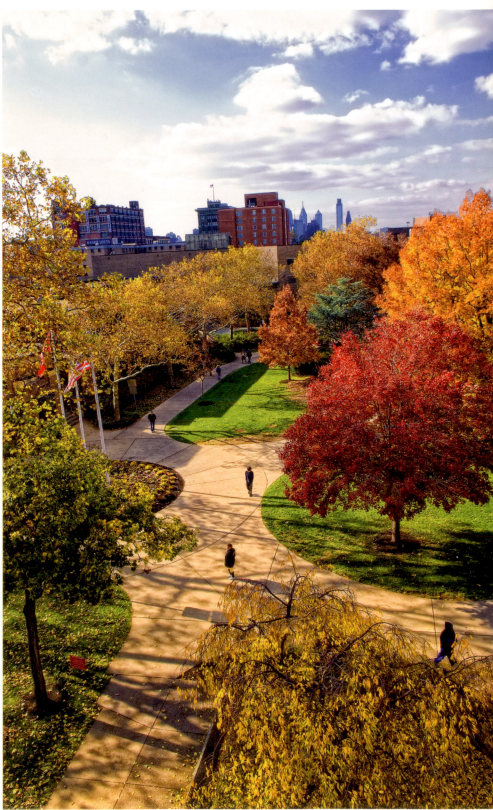

Above: The campus on a glorious fall day.

Camden

Margaret Marsh: Rutgers–Camden Meets the 21st Century: A Personal View

DISTINGUISHED PROFESSOR OF HISTORY AND UNIVERSITY PROFESSOR, FORMER EXECUTIVE DEAN OF THE FACULTY OF ARTS AND SCIENCES AT RUTGERS–CAMDEN, AND FORMER INTERIM CHANCELLOR OF THE CAMDEN CAMPUS

In 1998, when Rutgers–Camden was searching for a new dean of arts and sciences and the graduate school, a member of the search committee who recalled that I had been an undergraduate on the campus called to ask me to apply. At first I demurred. But Camden had been the foundation of my career as a scholar. How could I resist? A few months later, here I was, and for the next 13 years I served first as dean, then as interim chancellor and executive dean. I couldn't have chosen a more exciting time to be at Rutgers.

When I arrived, the campus had just under 4,600 students across undergraduate programs in arts and sciences and business, a thriving law school, an emerging graduate school, and an MBA program. Within the next decade, the law school's national profile rose, attracting students from across the country. The business school developed a vibrant four-year program. In arts and sciences, a host of new and expanded programs—including a very successful Honors College—flourished. The most transformative changes of the decade, which affected the entire campus and altered its trajectory, were, first, its embrace—in education, research, and service—of its urban environment; and second, the decision to make Rutgers–Camden a doctoral university.

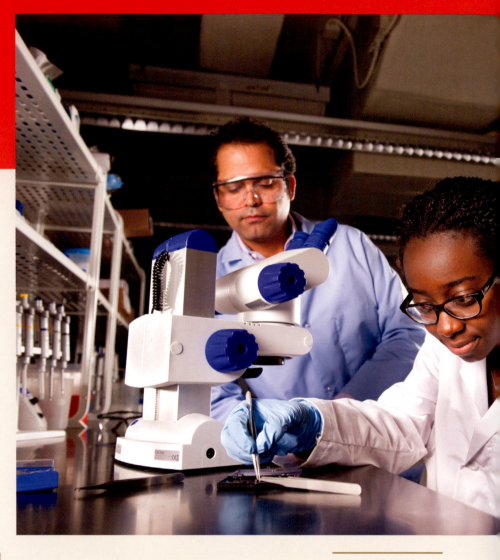

As provost, Roger Dennis was committed to making the campus a force for change in the city of Camden, and he led an effort by faculty and administrators to create new projects, centers, and institutes that offered research-based service and outreach in the city and region. And when he retired from Rutgers in 2007, his legacy continued. As interim chancellor, I added a new focus on civic engagement in the undergraduate curriculum. And under the leadership of the distinguished urbanist Wendell Pritchett, who became chancellor in 2009, this emphasis continued and grew.

Alongside community engagement, the other hallmark of Rutgers–Camden in the early 21st century was the decision to transform the campus into a doctoral institution—a determination that had the power to engender fundamental long-term change to its mission. We intended our first group of doctoral programs to focus on the intellectual challenges facing the new century, to be innovative interdisciplinary programs that both addressed new areas of inquiry and capitalized on existing and potential collaborations among the

Above: Scientists at work.

Left: Margaret Marsh (CCAS '67, GSNB '69, '74) stands in front of *The Gateway*, a glass wall sculpture by artist Clyde Lynds on the Camden Campus.

Opposite: Undergraduate Kimberly Donat (CCAS '10) spent a summer studying fungus at the Rutgers Pinelands Field Station, which is led by Camden professor John Dighton.

faculty. A doctorate in the emerging field of childhood studies, arising out of the campus's strength in research on children, seemed a natural first step. This new field, we believed—rightly, as it turned out—had the potential to transform research and scholarship on children in much the same way that women's studies and African-American studies had restructured the study of gender and race in the late 20th century. Rutgers–Camden became the first campus in the nation to offer this program, attracting outstanding faculty and students. Since its debut in 2007, the program has earned international plaudits as a model in the field. Doctoral programs in computational and integrative biology and public affairs followed in 2010. Others are in the pipeline. These programs became part of a greatly expanded graduate school, which doubled its program offerings in these years, also adding a doctorate in physical therapy and an MFA in creative writing.

By the end of the first decade of the 21st century, enrollment had grown by 37 percent to more than 6,300 students. At the undergraduate level, student research, civic engagement, experiential learning, and international study had become hallmarks of programs across all our schools; the law school enjoyed national prominence in multiple fields; and a nursing school would be formally created in 2011. It was an eventful, and fruitful, start to the new century.

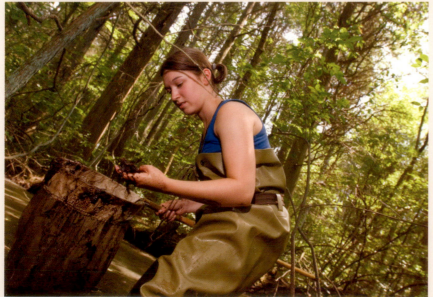

Lauren Grodstein: Creating with Camden Students
ASSOCIATE PROFESSOR OF ENGLISH, FACULTY OF ARTS AND SCIENCES, RUTGERS–CAMDEN

One evening in early September 2008, I sat down to preside over the Rutgers–Camden master of fine arts program's inaugural fiction workshop. Since my appointment three years earlier, I had been working toward this moment: writing proposals, designing websites, begging for money. I had also moved to New Jersey, written a novel, and had a baby.

I suspect I seemed a little feverish that evening: my son was a month and a half old, I hadn't been sleeping much, and I was so keyed up I was probably talking a mile a minute. But my students were young and eager and looked well rested, and they were smiling. I remember pausing before introductions, taking a deep breath: Who are you? Where are you from? What are you writing? Someone was from England, someone else from Philadelphia. A young man from Florida was going to write a comic novel. Another young man was going to write a suite of stories about Camden. A student who had led wilderness hikes in Colorado was going to write about nature's intersections with urban life.

Well, there's nothing like a group of eager young writers to make an exhausted novelist come back to life. I welcomed them all. I told them that during the next several semesters, we would try to build a literary community that would support them for the rest of their writing careers (which is to say, if they were lucky, for the rest of their lives). By reading each other's work and giving it our most careful attention, and by offering, to the workshop, the best material we could write, we would solidify a connection to one another that would be particular, intimate, and unique.

I'll never forget the way, under the buzzy fluorescent lights of that seminar room, all memory of the previous three years' effort evaporated—replaced instantly by the feeling of joy that permeates the best writing workshops.

We writers seek MFA degrees for a variety of reasons. Some of us need the regular deadlines a workshop provides, some want to connect to literary agents or publishers, some plan to finish a novel or a poetry manuscript. The writers who have studied with us since

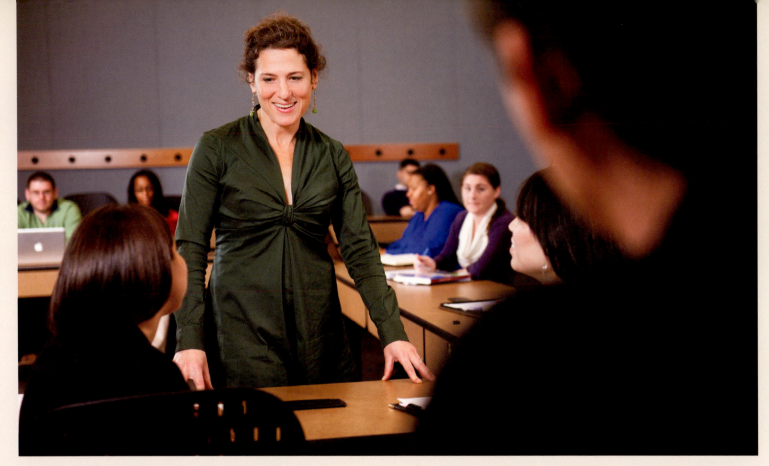

our founding six years ago have done all these things—and they've also interned at the *New Yorker*, studied travel writing in Bangkok and Prague, won national literary prizes, and published in some of the country's top magazines. They've collaborated on a nationally recognized literary journal, *StoryQuarterly*, and taught poetry and fiction writing in middle schools. The most impressive thing they've done in our relatively short history is create a close, welcoming, and supportive community. Our students genuinely like each other, root for each other, and celebrate each other's successes. The stereotypically competitive creative writing program might exist at other schools, or in the movies, but at Rutgers–Camden writers find a group of fellows who understand that creativity is not a

zero-sum game. It is, instead, a lifetime project of challenge and dedication and heartache and delight.

That first class has graduated and gone on to all sorts of interesting things: fellowships and doctoral programs and work at small presses. I see several of them every so often for lunch or coffee, and am glad to hear of their successes. But what makes me even happier is the fact that they still rely on one another for criticism and encouragement.

Soon enough it will be another September, and we'll be welcoming a new class of MFA students to campus. We will train them to read critically and try new things with their poetry and prose. We will introduce them to visiting writers and put them in touch with publishers and agents. Like all writing professors, I'll give them the best of my attention and knowledge. But after years of working with Rutgers–Camden MFA students, I know this: the best thing our program will give them is one another.

Professor Ellen Goodman, an attorney with a focus in information policy law, teaches students at Rutgers School of Law–Camden.

Lauren Grodstein, professor in the Master of Fine Arts in Creative Writing program.



Myra Bluebond-Langner: My Work in Childhood Studies

BOARD OF GOVERNORS PROFESSOR OF ANTHROPOLOGY, FACULTY OF ARTS AND SCIENCES, RUTGERS–CAMDEN; PROFESSOR AND TRUE COLOURS CHAIR IN PALLIATIVE CARE FOR CHILDREN AND YOUNG PEOPLE, LOUIS DUNDAS CENTRE FOR CHILDREN'S PALLIATIVE CARE, UNIVERSITY COLLEGE LONDON-INSTITUTE OF CHILD HEALTH



My research career has focused on children with chronic and life-limiting illnesses and their families. *The Private Worlds of Dying Children* explored how children came to know that they were dying when no one told them and how they communicated that awareness. The research for the book shattered the myth that children didn't or couldn't know they were dying.

Working alone in an area that few wanted to talk about and without graduate students to move it forward, my work could have ended there. But it didn't. Through Rutgers' sabbatical program and the way in which the university funded faculty who secured competitive fellowships, I was able to pursue my research. From a campus perspective, this work has led to the establishment of the Rutgers Center for Children and Childhood Studies and the Rutgers University Press series in Childhood Studies.

The center was founded in 2000 to support intellectual inquiry into the lives of children in Camden, the United States, and abroad; and, among much else, to develop and evaluate service and outreach programs for children. With the establishment of the Department of Childhood Studies in 2005, many of these activities were transferred to that department, enhancing what would be available to new graduate students as well as to the burgeoning population of undergraduates.

The academic portfolio of the center and the department are enhanced through the book series that Marlie Wasserman, editor-in-chief of Rutgers University Press, and I launched in 2003. With 35 books in print and more on the way, the series is an important contribution to the field of childhood studies.

In 2010, I was granted a leave of absence to take up the first academic chair in the first academic department in Paediatric Palliative Care in the world, at University College London's Institute of Child Health. It is Rutgers' vision, its commitment to global academic and clinical collaboration, and its support of its faculty that made such a move possible. I look forward to our continuing relationship in the years ahead.

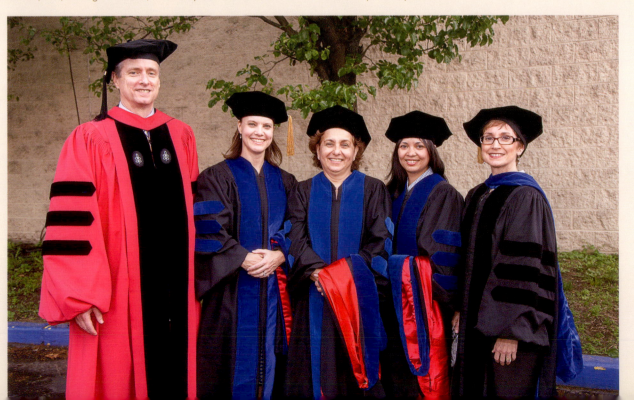

The first three graduates of the Childhood Studies program at Rutgers University–Camden; Deborah Valentine, Marla DeMesquita Wander, and Lara Saguisag with distinguished professor of psychology and childhood studies Daniel Hart (left), and professor of childhood studies Lynne Vallone (right), May 23, 2013.

Medical geneticist Jay Tischfield heads RUCDR Infinite Biologics, a world leader in supporting research on the genetic causes of common, complex diseases. RUCDR manages more than 350 projects globally, has established more than 200,000 cell lines, and has extracted and distributed more than 1,000,000 biosamples.

Mathematics, Engineering, and Technology

Rutgers' innovative plastic resin sorter got America recycling on a grand scale. Just five years after its introduction in 1985, the nation went from recycling zero pounds of plastic to recycling over 500 million pounds a year.

First developed by engineer Tom Nosker (GSNB '83, '88) and his team in 1988, Rutgers lumber made from recycled plastic keeps tons of plastic bottles and waste from ending up in oceans and landfills.

WINLAB's MobilityFirst project, launched in 2010 and led by electrical engineer Dipankar Raychaudhuri, is advancing the world's shift to a ubiquitous wireless internet.

Endre Szemerédi, professor of computer science, received the 2012 Abel Prize—described as the mathematician's Nobel Prize—for revolutionizing discrete mathematics.

The brainchild of engineer Nenad Gucunski, the Center for Advanced Infrastructure and Transportation's award-winning RABIT bridge deck robot is transforming today's road safety by assessing bridge conditions—inside and out.

Life Sciences

Since 1985, the Center for Advanced Biotechnology and Medicine has been working to improve human health. Breakthroughs include uncovering an autism-susceptibility gene; developing new medicines to treat AIDS; and finding a protein that could lead to a vaccine against deadly hepatitis C.

Plant biologist Ilya Raskin's trailblazing use of metal-accumulating mustard plants to absorb dangerous toxins from soil following the 1986 Chernobyl nuclear disaster introduced "phytoremediation"—using plants to clean soil—to the science lexicon.

Neuroscientist Paula Tallal's research unlocked the neurological basis of language-based learning disabilities. Award-winning software she and her team developed has been helping children worldwide improve language and learning skills since 1996.

The New Jersey Center for Biomaterials, founded in 1997 and led by chemical biologist Joachim Kohn, develops groundbreaking tissue replacement technologies, such as surgical meshes, cardiovascular stents, and bone

regeneration scaffolds, that are found today in the bodies of more than 35,000 people.

Founded in 1998 and directed by medical geneticist Jay Tischfield, RUCDR Infinite Biologics, the world's largest university-based cell and DNA biorepository, is an essential international resource for studying genetics and mental health, drug abuse, alcoholism, diabetes, and digestive and kidney diseases.

The Research Collaboratory for Structural Bioinformatics Protein Data Bank, led by chemist Helen Berman and headquartered at Rutgers since 1998, is a free, online library of 3-D protein structures used by scientists around the world to study and share molecular information as they hunt for new medical and drug therapies.

Since 1999, the W.M. Keck Center for Collaborative Neuroscience under the leadership of its world-renowned founding director, neuroscientist Wise Young, has focused on finding a cure for spinal cord injuries.

Waksman Institute of Microbiology director Joachim Messing won the world's top agricultural research award—the Wolf Prize—in 2013 for developing genetic engineering techniques that produce disease-resistant crops, helping to alleviate hunger and conserve the environment.

Natural and Earth Sciences

Marine scientist Richard Lutz's 1970s codiscovery of species in the ocean's deepest, harshest environments, where there is no sun infiltration to create traditional forms of life, revolutionized ideas about where and how life exists.

After the 2009 transatlantic journey of the Scarlet Knight glider demonstrated to the world the viability of robotic sensors for exploring the ocean's depths, Department

Two of the more than 100,000 3-D biomacromolecule images in the Protein Data Bank.

A medical breakthrough hailed by the World Health Organization, David Alland's test cuts from weeks to hours the time it takes to confirm a tuberculosis diagnosis.

of Marine and Coastal Sciences scientists were tapped to spearhead the Challenger Glider Mission, an initiative to simultaneously pilot 16 ocean-faring robots around all the world's ocean basins.

After developing a theory to explain that the ocean bottom consists of interconnected environments, each with unique organisms, marine scientist Fred Grassle led the 10-year, 80-nation Census of Marine Life project, completed in 2010, to catalog everything living in the ocean.

Medicine and Health Care

Pathologist Oscar Auerbach found the first evidence in human lung tissue of a link between cancer and smoking. His findings, published in the 1960s, laid the groundwork for the now well-known label on cigarette packages warning that smoking can be harmful to health.

In 1981, pediatrician James Oleske (NJMS '71) was one of two physicians who shocked the world with the discovery that children can get AIDS.

Neuroscientist Stuart Cook and his team were the first, in 1988, to demonstrate that high doses of steroids can alleviate early symptoms of multiple sclerosis and that lymph node irradiation can slow down deterioration in patients with progressive forms of the disease.

Neurologists Roger Duvoisin and Lawrence Golbe discovered in 1997 the first gene mutation linked to Parkinson's disease and later found that the malfunction of a protein called alpha-synuclein is a fundamental step

in the disease process. Their findings changed the direction of Parkinson's research.

Paul Lioy (GSNB '71, '75) from the Environmental and Occupational Health Sciences Institute was called to Ground Zero immediately after the attacks of September 11, 2001, by the Port Authority of New York and New Jersey and the National Institutes of Health to take samples of—and analyze—the more than 1 million tons of dust created by the collapse of the World Trade Center towers. Lioy wrote the book *Dust* to tell the story of the investigation.

In 2001, biochemist and geneticist Sidney Pestka won the National Medal of Technology for his work that led to the first recombinant interferons for treating cancers, viral diseases such as hepatitis B and C, and multiple sclerosis.

In 2004, neuroscientist James Millonig and geneticist Linda Brzustowicz pinpointed two small areas on the chromosome ENGRAILED 2, which are inherited far more frequently by individuals with autism than those exhibiting no symptoms.

In 2005, molecular biologist Jeffrey Kaplan discovered a previously unknown enzyme that he named dispersinB, which has the unique ability to disperse bacteria from surfaces where they stick, particularly on medical equipment such as intravascular catheters and cardiac pacemakers. DispersinB is a major player in the battle against catheter-related bloodstream infections in hospitals.

In 2010, infectious disease specialist David Alland adapted molecular beacon technology to create a new rapid diagnostic test for tuberculosis, hailed by the World Health Organization as "the first major breakthrough in tuberculosis diagnostics [in] more than 100 years." In 2014, Alland received a major National Institutes of Health grant to develop a rapid test to diagnose Ebola, enabling health care workers to quickly identify Ebola patients in small, remote villages where the disease's spread is especially rampant.

Led by cellular and molecular pharmacologist Hatem Sabaawy, investigators at the Cancer Institute of New Jersey's zebrafish laboratory use models of the fish to map common genetic defects in cancer, identify new small molecules for targeted treatment, and predict each cancer patient's response to therapy in precision medicine trials.

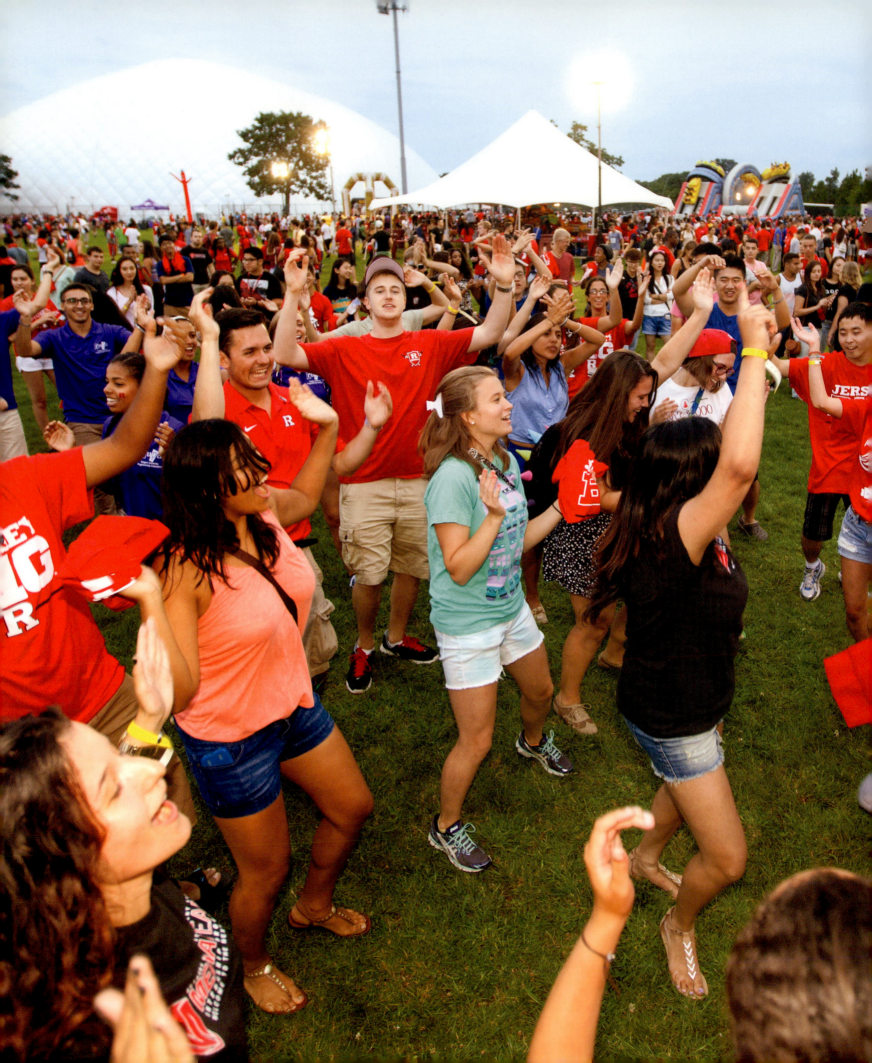

CAMPUS LIFE

Marie Logue

Extracurricular Rutgers: The Half You Have Not Told

"Say you a college is where we study books? The half you have not told."

—*Scarlet Letter*, 1873 preface

The extracurricular life of Rutgers students may very well add up to at least half of what it means to be of Rutgers. From the earliest accounts of Rutgers student life to the present day, the time outside the classroom has been cherished and robust: highly original, deadly serious when not unabashedly zany, and deeply committed to solidarity—variously defined as brotherhood or sisterhood or community or Scarlet Nation.

In the Beginning…

Before the students of Rutgers formed their first fraternity (Delta Phi in 1845), played that first football game (1869), or started a newspaper (the monthly *Rutgers College Quarterly* 1858 and the *Targum* in 1869) or a choir (the Rutgers University Glee Club in 1872), the daily routine of students

Right: New Jersey College for Women first-year students wear green dinks on their heads and signs with their names and dorm assignments around their necks in 1950.

Below: The Class of 1890 with their canes.

was restricted to twice-daily prayer, classroom instruction that was largely defined by rote memorization, and prescribed hours of study that in 1827 were listed as 9 a.m. to noon, 2 to 5 p.m., and 7 to 10 p.m. If students were not in a lecture or recitation during those hours, they were expected to be in their rooms studying. Moreover, students were forbidden to frequent taverns, play cards or dice, have liquor in their rooms, or get into any fights. The 1787 code of conduct noted that students should stay out of taverns and "houses of ill repute" or "be guilty of cursing, screaming, or any unbecoming language." The Laws of Queen's College 1810 forbade students from keeping the company of ladies. The dress code required the wearing of black gowns for chapel services and Sunday worship, and students were required to remove their hats when they met the president or their tutors.

Standards are one thing, reality another. The lighting of firecrackers indoors and out was a popular prank, and a disliked professor could expect to have pistols discharged outside his door. The clapper of the Old Queens bell was stolen in 1851, and the college latrine was blown up in 1868. While the administration sought to inculcate piety and discipline in the students, brandy punch and "seegars" figured strongly in student celebrations in New Brunswick barrooms. And the Calliathumpian Serenade, or Cali-thump, which involved bands of students roaming the campus and nearby streets making as much noise as possible and tearing down fences, was popular for decades in the middle of the 19th century. Drunkenness was often cited as a factor in the mischief.

Perhaps with the goal of harnessing some of that youthful energy and coercing older students into serving as a model for their younger peers, the college adopted the English university practice of organizing the students into classes: freshmen, sophomores, juniors, and seniors. The practice of lowerclassmen running errands for upperclassmen in a system of class-based servitude made the journey across the pond as well. By the late 1850s, the servitude system was replaced by hazing, which involved more pranks, initiation rituals, and contests.

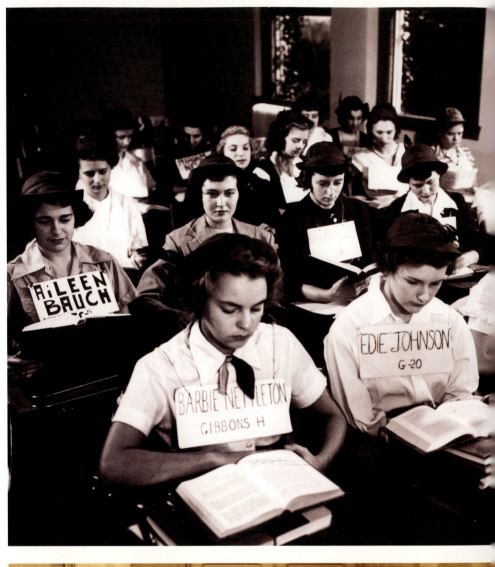

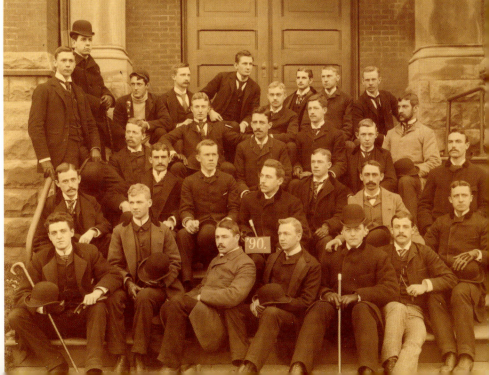

Left: First-year men and women in the 1950s, wearing their dinks, gather at the *Sundial* sculpture by Paul Rudin on Douglass Campus. Today, the original astrolabe on top of the sculpture's kneeling figure is missing.

Below: Shakespeare's "ages of man" are reimagined as the four ages of the college student in an 1886 yearbook: freshman infant, ne'er-do-well sophomore, rakish junior, and worldly senior.

The college authorities adopted the class system primarily to identify a fixed course of study unique to students at each level, but they no doubt also encouraged the identity with one's class in order to strengthen bonds of friendship and a sense of loyalty to others. Members of each class wore identifying badges on their gowns and were seated in chapel by class, with seniors in front and freshmen bringing up the rear. The bonds formed within the classes ultimately led to class rivalries and the first intramurals: athletic contests like foot races and baseball games and cane rushes. Remnants of some of these customs continued until well into the 20th century: freshmen wore silly little hats called "dinks" and could be asked by an upperclassman to sing the alma mater on the spot. In the 1950s New Jersey College for Women, first-year students couldn't wear the color red, wore green dinks, and had to answer the door and the phone in the campus residences. For many years,

fraternity pledges were required to run errands for the brothers. But students soon became more creative about ways to build pride, discipline, and esprit de corps.

In the mid-19th century, it was fashionable for Rutgers upperclassmen to carry canes and for freshmen to refrain from carrying canes. Thus the gauntlet was thrown down to the freshmen: overpower the upperclassmen and take their canes, thereby earning the right to carry canes on campus. Drawings from the era show students in pitched hand-to-hand combat on the college lawn in what looks a little like rugby—but with the canes making rugby look tame by comparison. One of the most intense "cane rushes" occurred on September 22, 1869—a pushing and pulling match that resulted in much torn clothing and well-muddied undergraduates.

Right: The "cane rushes" of the 1800s pitched upperclassmen against freshmen in a battle for supremacy.

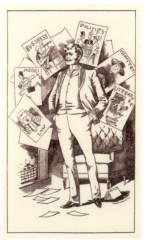

Members of the 1923–24 Peithessophian Society, a literary and debating society that endured for more than 100 years. Peithessophian, derived from the Ancient Greek, means "persuasiveness of wisdom."

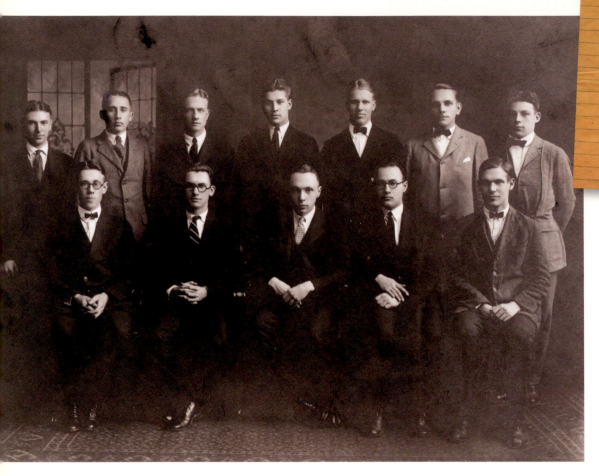

'94 JUNIOR HOP.

COMMITTEE:

P. G. THOMAS, CHAIRMAN,

H. V. M. DENNIS, JR.,

W. H. STILSON.

The First Organizations: Meeting Unmet Needs

Life of the Mind

In virtually every early American college, students organized themselves in societies to meet the intellectual and social needs that the colleges ignored. At Rutgers, students formed two literary secret societies (i.e., fraternities), Peithessophian and Philoclean, which became the center of social and intellectual life in the college during the 19th century. Members engaged in competitive orations, essays, prose and poetry selections, reported on current affairs, and debated significant topics of concern. Members met weekly to debate a topic chosen in advance and to witness student performances in declamation and composition. Every member participated at least once a month, and student judges evaluated the performances and the debates. The debates allowed students to sharpen their oratorical skills by drawing on knowledge acquired from classroom recitations and their own independent reading. Because the college library was filled with classical Greek and Latin texts and open only a limited number of hours, students purchased and circulated among themselves books in English on history, philosophy, economics, and politics. Many of the books were current works of literature, biography, and travel, which were not part of the classical curriculum at all. Before long, the societies' libraries were larger than the college library.

The societies were secret but not exclusive, and nearly every undergraduate was elected to one or the other.

Junior Hop program, 1894.

Left: Dance card from the 1948 Junior Prom.

The Class
of
Nineteen Hundred Forty-nine
of
Rutgers University
presents
CHRIS CROSS
at the
JUNIOR PROM
Fairuary Twentieth
Nineteen Hundred and Forty-eight
Rutgers Gymnasium

Peithessophian Society badge of Abraham Van Nest Jr. (RC 1841).

Below: The Philoclean Society was a Rutgers College student literary society that, along with the competing Peithessophian Society, was founded in 1825. It established one of the first lending libraries at the college.

Below right: The Rutgers Boating Association, the first organized student athletic club at Rutgers. Photo taken in 1864. The team was formally established in 1867.

Members of the faculty were also elected to membership, but only the college president could belong to both. Faculty, alumni, and trustees supported the literary societies, for they saw the opportunities for education, skills development, and leadership to be had there.

From 1826 to 1923, one of the most popular events of the academic year was a competition sponsored by Peitho and Philo the evening before commencement. Four junior orators from each organization competed in a local church, and the intense rivalry and excitement surrounding this Junior Exhibition has been compared to athletic competitions. The seriousness of the occasion was, it seems, not wholly incompatible with heckling and pranks in the capacity crowds. During commencement week, the societies took turns securing a speaker to deliver an address under their joint sponsorship. These activities today do not look all that "extra" curricular, but they are in essence the precursors of the extraordinary range, number, and ambitiousness of major events sponsored by present-day debate teams, performing arts organizations, cultural organizations, and social action, political, and religious groups at Rutgers—even if Senior Week in many memories was decidedly less serious.

As time passed, faculty prohibitions against leisure activities, and specifically ball playing, ended. In parallel, "campus life"—that is, a student culture distinct from the pursuits of adults in the world outside the college gates—became more prominent as students formed fraternal organizations and organized their leisure activities into athletic clubs with constitutions, officers, captains, by-laws, committees, and of course, schedules of fines and dues, in much the same way as they had organized the literary societies. The *Targum* in February 1874 included a dictionary of 80 student slang terms—a sure sign that Rutgers men were creating a student culture of their own.

The Sporting Life

Compulsory physical education was introduced in 1886 for first- and second-year students, and the student body embraced the sporting life. The Rutgers Boating Association was the first official athletic club, founded in 1867; every monthly publication of the early *Targum* included numerous articles on this new Rutgers Crew Club. Baseball, which had

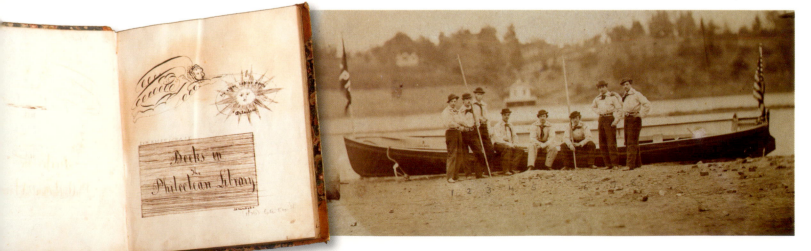

been played informally on campus for decades, became an organized entity soon after crew. By 1870, the *Targum* reported that the baseball team had "neat and serviceable suits" to play in. By the mid-1890s the football team played 13 games each year; this, combined with the fact that the Rutgers Glee Club sang in 20 concerts each year, prompted the faculty to begin to regulate the number of excused absences from class and the eligibility of the students who could participate. Lacrosse was introduced in 1887, track and field and fencing in 1889, boxing in 1890, gymnastics in 1902, and cross country in 1919. The 1920s brought rifle shooting (1920), wrestling (1927), and water polo (1929); soccer was introduced the following year. It was not until 1932 that student participation in the management of athletics ended, with the trustees assuming responsibility for the financial management that until then had been largely student and alumni controlled.

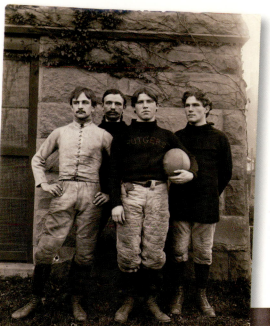

Left: Members of the football team from 1895.

Below: The 1881 Rutgers football team photographed in a studio.

Cap and Skull, a secret society founded in 1900, endures to this day. Twenty-one buildings at Rutgers are named for alumni of the group.

"Traditions like Cap and Skull are what separate Rutgers from modern universities like Maryland, Delaware, and Penn State. We have a proud history. We grew up with the Ivy League, and are older than some of them (and certainly better than some, too)," as noted in the *Daily Targum* on February 10, 1994.

General Liveliness

It is a wonder that students had time for classes in the late 19th century. In the 1880s roller-skating became all the rage, and the New Brunswick roller rink was the most popular gathering place for students. There were skating contests and even a polo team on roller skates. Formal dances were held throughout the academic year: the Sophomore Hop and the Junior Promenade. The seniors put on farcical plays for the student body. In 1908, the Dramatic Association was formed; in 1914, the Queens' Players. The College Band started up in 1916. There were elaborate class banquets. Intercollegiate debating began in 1899. As the 20th century began, secret societies proliferated: Cap and Skull was organized in 1900 for the senior elite. The juniors had Casque and Dagger (1901) and the sophomores Theta Nu Epsilon (1892). Not to be outdone, the freshmen founded Serpent and Coffin (1903). In 1906, another organization, Chain and Bones, was founded for sophomores.

20th-Century Organizations: Changing with the Times

Every succeeding decade saw the birth of new organizations that reflected the changing student body. The Menorah Society was organized in 1913 by a small group of Jewish students. By the end of the 20th century, Rutgers students had formed more than 40 student organizations dedicated to religious and religious-cultural interests. Compulsory bible class ended at Rutgers in 1893, and attendance at chapel service was made voluntary in 1946, but with more than 25 recognized campus ministries serving students' spiritual needs today, the Buddhist, Christian, Jewish, Muslim, Quaker, and other faiths and traditions are thriving at Rutgers. Interfaith meditation rooms can be found on the College Avenue, Douglass, and Busch Campuses, providing students, faculty, and staff with quiet spaces for prayer and contemplation. And none of it is required.

Sophomore Hop and Junior Prom posters from the 1930s. Isham Jones led one of the most popular dance bands of the era, writing the standard, "It Had to Be You."

The Rutgers "Cocurriculum"

Today, as in the past, the greatest number of student organizations are those most directly linked to the curriculum. Among the earliest were voluntary student clubs for French, Spanish, German, history and politics, economics, and student publications like the *Chanticleer*, a humor magazine founded in 1923, and the *Anthologist*, a creative writing journal founded in 1927 and still published today. Rutgers College alumnus Robert Pinsky, American's poet laureate from 1997 to 2000, was an *Anthologist* editor.

Today over 80 academic clubs in New Brunswick reflect the range of current majors and subspecialties. The English, Biology, and Chemistry Clubs of just a generation ago have spawned the Cell Biology and Neuroscience Society, the Behavioral Neuroscience Society, the Cognitive Science Club, the Association of Undergraduate Geneticists, and the Information Technology and Informatics Council, among others. And just as the earliest student organizations sought practical knowledge and skills development absent in the curriculum, myriad student organizations exist today to ensure that the Rutgers experience will prepare them well for life after graduation: the Actuarial Club, the Advanced Manufacturing Organization, the Allied Health Professions Club of Rutgers University, the Association for Women in Communications, the Future Teachers Association, the Management Consulting Association, the Future Healthcare Administrators, the Pre-Law Society, the Pre-Dental Society, the Pre-Optometry Professions Society, and the American Medical Student Association are but a few of these clubs. It is no surprise that many, especially student affairs professionals, describe this as the cocurriculum, not the extra-curriculum.

And too, there were the organizations and activities created in response to, or in defiance of, events occurring in the outside world. The Students' Army Training Corps was established on campus in 1918 and demobilized in 1919 after the armistice. One of the first political action organizations, the Rutgers Forum was founded in 1930 to discuss topics like censorship, socialism, and conscription. The Liberal Club was founded in 1931, followed by the League for Independent Action. There were clubs for the League for Industrial Democracy, the Socialist Party, and the Rutgers Christian Association. The 1960s and 1970s saw a flowering of antiwar and pro-civil rights organizations as students responded to the turbulent events of the era. In the late 1980s, student groups calling for divestiture of university financial support for companies doing business with apartheid South Africa were prominent on campus. More recently, student organizations calling for immigration reform and a stop to human trafficking have come to the forefront. And every spring students pitch Tent State University on Voorhees Mall to call for greater financial support for higher education.

CHANTICLEER

Junior Prom Number

THEY'RE OFF!

Above: Farewell dance, 1944.

Below: Bryan Adams (SBC '12), left, and William Brown (UCC '10, CLAW '14) advocate for veterans services at Rutgers while attending a 2008 University Senate meeting.

The Effects of War and Its Aftermath

The only break in the expansive growth of the organized campus life of Rutgers occurred in 1943 when, at the height of World War II, student organizations were disbanded. Even the *Targum*, which had been published continuously since 1869, stopped. Several fraternity houses were taken over as accommodations for Army trainees. The gym became a mess hall. Athletic competitions were scaled back, and only games with nearby colleges were played. Many civilian students worked part time in local war industries or volunteer services. But by June 1946, most student organizations had been revived. The Student Council, *Targum*, Cap and Skull, Glee Club, *Scarlet Letter*, the academic clubs, and the Sophomore Hop and Junior Prom were all back. The fraternities reestablished themselves as well—with a vengeance. In September 1945, only six houses had been in operation; by 1948, there were 17 houses and two other chapters were active.

The veterans were welcomed by the faculty for the more mature, philosophical approach they brought to the classroom and for their more tolerant attitudes. Efforts to form a student veterans' organization were resisted by the majority of veterans because they were afraid that this would "prolong the 'veteran feeling,' which most wished to forget." Interestingly, military veterans of the wars in Iraq and Afghanistan almost 60 years later felt very differently. Starting with Bryan Adams (SBC '12)

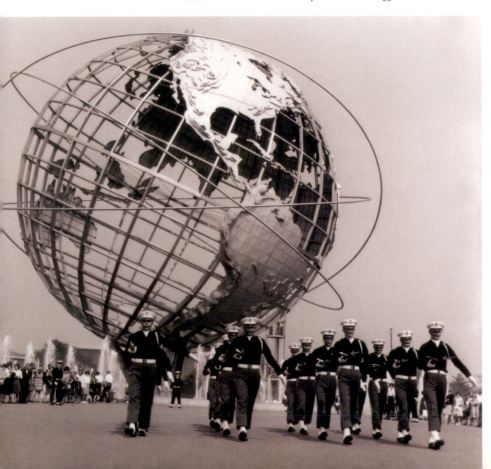

The Queens Guard of Rutgers University performs at the Unisphere in Flushing Meadows–Corona Park during the 1964 World's Fair in New York City. The routine took a mere eight minutes to perform, but it's a memory that has lasted a lifetime for Bill Dettmer (RC '66) (first row, second from left).

Fraternity for All: Gamma Sigma

The founding of Gamma Sigma fraternity is a story that reflects the egalitarian spirit, initiative, and irreverence that is a familiar part of the Rutgers student culture. Bernard Eskin (RC '47, GSNB '49), one of the founders, shared the story of the founding for the Rutgers Oral History Archives. Eskin was a member of the Class of 1947 who decided with George Harbaugh (RC '48) and a few other fellow military veterans to found their own fraternity that would be like none other: it would accept everyone. All races and religions. The fraternity would have no pledging rituals or initiation rites. They called it the Geronimo Society after Harbaugh, who was a paratrooper given to using that expression. They later changed the name to the Georgian Society, perhaps because it sounded more distinguished,

and later still settled on Gamma Sigma since fraternities were expected to have Greek letter names. They admitted African-American students to membership in 1949, and socially conscious students gravitated to the group. The organization was written up in the *New York Times*. This fraternity with no national affiliation later admitted women to membership and thus lost any chance of linking up with a national organization. Their house on Union Street has been there since 1950 but, ever the iconoclasts, Gamma Sigma is not formally recognized by Rutgers—and the students seem comfortable with that.

and William Brown (UCC '10, CLAW '14) at Rutgers–Camden, they would begin welcoming veterans in a new student organization they founded: RU SERVS. They also welcomed the opening of the Rutgers Veterans House and the availability of full-time staff dedicated to integrating veterans into campus life while providing opportunities for them to share experiences with other veterans. Rutgers ranks in the top 10 in the nation among the most "vet-friendly" colleges and universities and second among top research universities. Then and now veterans report that Rutgers provided them with what they needed to get an education and meet their life goals.

It is generally believed that it was the influence of the returning veterans after World War II that led

the Student Council to send a report to the trustees in March 1949 denouncing discriminatory practices in fraternities. Half of the 22 fraternities placed restrictions on membership based on race or religion. The trustees commended the Student Council, supported the right of fraternities to select their members, and decided to give them time to work toward more inclusive membership. Progress was recorded every year, and in 1957 the university ordered the remaining three fraternities with restrictive clauses to get rid of them by September 1, 1959. The one house that failed to comply was suspended. New fraternities were established and thrived. In the late 1950s, 50 percent of the students in the men's colleges were fraternity members.

Into the Age of Student Advocacy

The 1950s and early 1960s saw the revival of the trappings of old school spirit in the wearing of special hats, neckties, or buttons by new students. Interclass athletic competitions returned. Attendance at football and basketball games, homecoming events, and concerts soared. As the 1960s gave way to the 1970s and students nationally rebelled against the principle of *in loco parentis*, the dress codes and parietal regulations in residence halls fell away. The Rutgers campus culture increasingly reflected a nationwide trend toward students' involvement in advocacy: for greater financial support from the State of New Jersey, for an end to the war in Vietnam, for an end of support for campus ROTC, for divestiture of university investments in companies that conducted business with apartheid South Africa, for fair wages for the people all over the world who sew university logo sportswear. Today, multiple advocacy groups seek social justice for the poor and disenfranchised, better solutions for our nation's problems, and improvements for Rutgers' own students whether that be lowering the cost of college textbooks or putting in place interdisciplinary studies in Asian-American culture, history, and literature.

In the 21st century, the fastest-growing area of organized student life is in service and philanthropy. In 2014, the Rutgers University Dance Marathon raised $622,533.98 for the Embrace Kids Foundation and had to move from the College

Advocates from the Start

That voice for student welfare figures prominently in the first college yearbook published by the fraternities. Rutgers students had been petitioning for a residence hall since the 1850s and now they learned that Geological Hall was about to be built:

> …*new buildings will soon arise in stately grandeur on Rutgers Campus. We wait and hope. We hope, above all, for a dormitory—not the proposed Geological dormitory, in which to stow mummies, mastodons, and other inanimate bodies—but a dormitory in which the real life of the College can live and sleep…*
>
> —SCARLET LETTER, PREFACE, 1871

The next year, students had Geological Hall, but had to wait another 18 years for that dormitory. Winants Hall opened in 1890 to house 100 men. The dorm was much appreciated by its residents, one of whom wrote a poem in its honor in the 1893 yearbook, calling it a "jolly good home," offering "a feast and a fireside," "stories and pranks," "ingenious excuses," and "occult cerebration." Successful advocacy is measured in years, sometimes decades—another key element of any Rutgers story.

Student pursuits in the late 1800s: Another clue as to how Rutgers students spent their free time and money is found in the roster of yearbook advertisers from the 1894 yearbook.

emPOWERing Self, Community—and Beyond

I was dissatisfied. My undergraduate studies in biomedical engineering exposed me only to the narrow realm of classrooms and research labs. Following a rote path to a career that seemed divorced from the personal growth I desired and the grand schemes youthful idealism instills, I yearned for more.

I sought out students who felt the same way I did, and happened upon one of the greatest student-run organizations Rutgers University has to offer: Engineers Without Borders. It completely changed the way I think about engineering and service. The group married our technical skills and knowledge with meaningful humanitarian service. Soon after, we teamed up with a group of amazing engineers from Rutgers and Princeton Universities to form an organization called em[POWER] Energy Group.

Shortly thereafter, the Clinton Global Initiative University (CGI U) invited our team to participate in and feature our work at its conferences. Founded by former

president Bill Clinton, CGI U's mission is to foster viable solutions from bright student leaders to address today's most urgent global challenges.

Prior to 2012, em[POWER] Energy Group was the sole representative to CGI U from Rutgers University. But beginning in the 2012–13 academic year, Rutgers University Centers for Global Advancement and International Affairs (GAIA) began funding other students to participate—and hopefully to inspire future students as it had for me.

Later, as a graduate student at Rutgers, I continued to remain committed to the projects and goals of em[POWER]. We are currently collaborating with Warm Heart—an organization led by former Rutgers University faculty member Michael Shafer—to provide sustained and preventative health care to patients in Phrao, Thailand. And my work with CGI U also continues, as I was invited to speak at its eighth annual meeting in Miami.

—Nasir Uddin (ENG '10, GSNB '13)

Avenue Gym to the Rutgers Athletic Center to accommodate the larger crowd. And the Student Volunteer Council is devoted entirely to helping clubs and individuals make connections with community groups and not-for-profit organizations looking for help. Alternative winter and spring break programs involve students in semester-long exploration of a culture and history different from their own and a travel experience to a volunteer opportunity away from campus. Rutgers students went to New Orleans after Hurricane Katrina and all over New Jersey after Superstorm Sandy. The earthquake in Haiti sparked fundraising efforts on every campus. Spring break trips to underserved parts of Appalachia have opened New Jersey students' eyes to the challenges of rural poverty and communities far from many essential services.

Giving back is part of the student culture at Rutgers. Civic engagement forums, Days of Service, and student entrepreneurs forming their own community microlending organization, the Intersect Fund, prove the breadth, scale, and scope of student philanthropy. It's not just about bake sales anymore—although on any given day, someone is selling cupcakes for charity on the Brower Commons steps or the study area at the Allison Road Classroom building on Busch.

The growth in the number of student organizations formed to help people the world over shows the global reach of Rutgers student advocacy. Engineers Without Borders

students travel to Thailand, Guatemala, and Kenya to build wells they have designed themselves. The students in the Rutgers chapter of the Foundation for the International Medical Relief of Children raise funds and travel to the Dominican Republic, El Salvador, Nicaragua, and Peru to assist medical professionals in clinics serving the poor. The Rutgers chapter of Global Brigades has sent students to various locations in Latin America to help research, design, and construct sustainable solutions to problems in the developing world. This is experiential learning at its best: when it is in service to others.

Students celebrate another successful Dance Marathon, raising funds for the Embrace Kids Foundation.

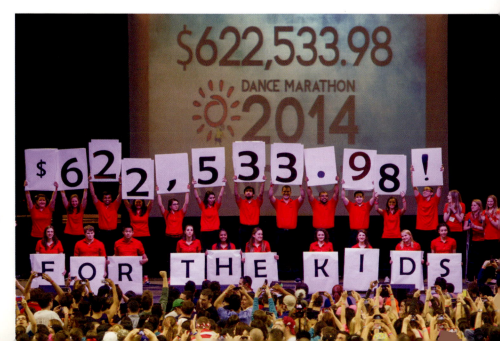

Demarest Hall

In the late 1940s, the Rutgers student population was rising, and housing was a must for those who did not want to commute. Named after former Rutgers president William H.S. Demarest, Demarest Hall was to be the solution. It advertised itself as the dorm for "the Young and the Green"—the first-year students—of Rutgers College, and its wood-furnished grand lounge became a popular spot for post-football-game social life in the 1950s. Compared to the more monolithic-looking dorms that came later on Bishop Beach like Mettler and Brett, Demarest has been heralded as an aesthetically pleasing gem on campus. After envious protest from upperclassmen, Demarest was opened to all students in the 1960s. In the mid-1960s, honors students in the dorm decided to form special-interest sections where ideas would be discussed and students would learn from one another. Early sections consisted of arts and crafts, foreign languages, and natural history. In the late 1970s, Demarest became an official special-interest dorm with funding from the Office of the Dean of Students and Residence Life. Today, it houses sections such as cinema studies; religion and spirituality; and sex, sexuality, and gender. An open-minded, friendly community, its various drag shows, dances, and other events attract students to the action.

—ELIJAH REISS (SAS '17)

Left: First-year student Elijah Reiss arriving at Demarest Hall on move-in day 2013.

Below: A Demarest Hall coffeehouse show from 1990.

Campus Life Today

There are currently over 400 student organizations in New Brunswick, over 100 in Newark, and 75 in Camden. The students of the Rutgers School of Law–Camden have formed 20 of their own organizations. There are over 80 fraternities and sororities in New Brunswick, 20 in Newark, and 15 in Camden. And intercollegiate athletics has grown from the Boating Association, the Base Ball Club, and the Football Association mentioned in the 1873 *Scarlet Letter* to 18 Division III Scarlet Raptors teams in Camden, 14 Division III Scarlet Raiders teams in Newark, and 22 Division I Scarlet Knights' teams in New Brunswick for both women and men. Sports clubs thrive on campuses, increasing the number of students who can participate in athletic competitions that range from soccer, rugby, volleyball, and dodgeball to judo, cricket, ballroom dancing, ice hockey, table tennis, and just recently, competitive intercollegiate bass fishing, among others.

Thousands of Rutgers students cheer for Rutgers athletes from the stands, and thousands more are on the field or floor participating in sports competitions themselves.

Housing

Today, students living on campus enjoy amenities earlier generations couldn't have dreamed of. Triples are the stuff of legend; students enjoy single rooms in the newest apartments, and all resident students consider their cable television and fiber optic Internet as commonplace as electricity. The Livingston Campus has achieved prominence on any comparative measure of amenities: students proudly note that "Livi" has the best dining hall, the most attractive apartments, the coolest radio station, and the only on-campus movie theater, 24-hour diner, and full-service grocery store. Not to mention the fountain.

Rutgers University provides more on-campus housing opportunities for students than any other college or university

in America. Over 16,000 students in 140 buildings on five campuses in New Brunswick and Piscataway, 640 students on the Camden campus, and 1,280 on the Newark campus live and work, study and play, right on campus. Thousands more choose close-by off-campus housing and contribute to the vitality (and noise level) of their host communities.

Student government was born in Winants Hall where an elected student senate was charged with maintaining order in the building. They did a good enough job that the faculty decided in 1894 to give students positions of responsibility in the adjudication of disciplinary cases. They were sometimes too lenient, but students were forever after partners with the faculty in their own governance. Residence halls today remain one of the best opportunities for students to develop leadership skills and partner with professional staff to maintain order and enrich the out-of-classroom learning experience.

The Constants

Many of the student organizations so critically important over the 250 years of our history continue to thrive by adapting to the needs and tastes of the day—and, more importantly, by remaining true to their founding commitment to excellence and service. The best among them win national awards and create some of the best leaders in all of Rutgers student life history.

The *Targum*, for example, founded as a student monthly in 1869, is today a daily newspaper published Monday through Friday when classes are in session. It has a circulation of 18,000 and a strong daily digital edition. It is staffed by full-time student writers and editors. In 1980, it went independent and formed the Targum Publishing Company so as to maintain journalistic objectivity free from

any university influence, real or perceived. The *Targum* won the prestigious Columbia Scholastic Press Association Gold Crown Award three times: in 1988, 1989, and 1990; these awards are the highest recognition given by the association to a student print or digital medium for overall excellence. *Targum* journalists won this award four times in the 1980s, six times in the 1990s, and three times in the first decade of the 21st century. The *Targum* has collected multiple awards from the New Jersey Press Association along the way as well.

The Rutgers University Glee Club, founded in 1872, is one of the most distinguished men's choruses in the United States. The club has always been strongly linked to the history of the university because so much of its early repertoire was dominated by songs of school spirit and the emerging collegiate sport of football. Today, many major events from football games to award receptions and from the opening convocation to university commencement feature the RU Glee Club singing "The Bells Must Ring" or "On the Banks of the Old Raritan," the alma mater. But this accomplished group sings classical repertoire as well. They have been conducted by Erich Leinsdorf, Leonard Bernstein, Eugene Ormandy, and more recently, Sir Simon Rattle and Valery Gergiev as well as the legendary Howard McKinney, F. Austin ("Soup") Walter (RC '32), and—since 1993—Patrick Gardner. From their first concert in Metuchen in 1873, the Glee Club has traveled to significant venues in Europe, singing masses in Notre Dame Cathedral in Paris and St. Peter's Basilica in Vatican City. And they still sing joint concerts with Mount Holyoke College

Above left: Members of the NJC Class of 1923, housed temporarily in "Packing Box" gymnasium in 1920.

Above: Today's housing options offer students many more amenities than in the past. Tatyana Crespo (ENG '16) enjoys wifi in her dorm.

Below: An 1895 cover and inside advertisements from the *Targum*.

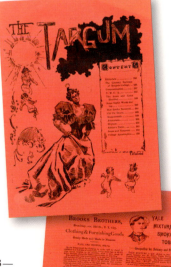

Above: "Soup" Walter, director of the Glee Club and founder of University Choir.

Below: Pat Gardner directs the Glee Club at Rutgers University Commencement, 2007.

"The President Has Been Shot"

I was in my last class of the week, Sociology 101. As class ended and we walked out into the hallway, it was clear that something had happened because the usual chatter and laughter had been replaced by tears streaming down faces and audible sobs. Someone said, "The president has been shot." We headed for the student center, which had a TV—there were only a few on campus at that time—and arrived there just as Walter Cronkite was announcing that the president had died. We were numb and in shock, trying to wrap our minds and hearts around such an unimaginable and devastating event. We had all grown up in the idyllic '50s; reality had intruded very little except maybe when Elvis was drafted. Unlike our parents and grandparents, we had not experienced the Great Depression and World War II, so we had no frame of reference for something of this magnitude.

I was a member of the Rutgers University Choir, and we were in the midst of singing Brahms's *A German Requiem* with Eugene Ormandy and the Philadelphia Orchestra in several concerts, including one at Carnegie Hall. We heard at dinner that we would be taking a bus to Philadelphia on Saturday to tape a performance to be aired nationwide that evening on CBS. This time the context was very different because this requiem was for a person who had brought youth, vigor, and charisma to the most important office in the country. As Maestro Ormandy mounted the podium, he looked at us and said, "Millions of people around the world wish they could do something today. We can." He lifted his baton, and we sang our hearts out.

It was both humbling and satisfying to be able to participate in a small way at this time in history. But most of all, I was grateful to be able to join with the country in this expression of deepest sorrow. In retrospect, it moved me from being a bystander to being a more active part of the world around me. Though technically still a teenager, I was no longer an adolescent.

—Evelyn Brenzel (DC '66)

and Wellesley College among others. School spirit and commitment to excellence mark every performance. The real attraction for those in the audience may well be the sheer joy the members manifest in every performance of the school songs they have sung hundreds of times before as well as the new, often challenging music they receive commissions to perform.

Rutgers University Choir performing with the Philadelphia Orchestra the day after President John F. Kennedy was assassinated, 1963.

The grease trucks—yesterday and today…

The Cap and Skull Society

Founded in 1900 to acknowledge the most accomplished leaders in the senior class at Rutgers College, the Cap and Skull Society continues to seek out talent and to welcome as members the women and men from all the Rutgers–New Brunswick campuses who are deemed by their actions to be the most outstanding, selfless leaders in their communities and who can be counted on to continue to support Rutgers in a meaningful way throughout their lives. After a hiatus in the 1970s, the organization emerged stronger than ever—perhaps because alumni members remain involved to advise current undergraduates, and no doubt also because membership is drawn from the entire diverse community that is Rutgers today. Today's skulls are black, white, Latino, and Asian and have excelled in academics, the arts, governance and political action, athletics—and often all of the above.

"Ever Changing Yet Eternally the Same"

That lyric from "In a Quaint Old Jersey Town"—a Rutgers song written by E. J. Meeker (RC 1896), a member of the college choir, and arranged by F. Austin ("Soup") Walter—is still the motto of the Glee Club and faithfully describes student life at Rutgers University. Accounts of pulling all-nighters vary only in the setting depending on the decade: the Owl's Roost on College Avenue, the "tombs" classrooms on the lower level of the River Dorms, Alexander Library, the Douglass Library, computer centers, and residence hall rooms and lounges everywhere. Only students of the past decade remember the midnight breakfasts served by the deans of students and their staff in the dining halls, but multiple generations recall cheesesteaks at Greasy Tony's or the fat sandwiches at the grease trucks and the late—or early—hours when they were consumed. And the concerts: Linda Ronstadt at the Rutgers Athletic Center, Bruce Springsteen at the Ledge (now the Student Activities Center), Joan Baez in the College Avenue Gym, Kanye West at Rutgersfest, and Ravi Shankar at Voorhees Chapel.

Below left: The "Ledge" on George Street now known as the Student Activity Center.

Below: Joan Baez performed a civil rights benefit at the College Avenue Gym, aka "The Barn," in 1964.

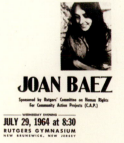

CIVIL RIGHTS BENEFIT CONCERT

JOAN BAEZ

Sponsored by Rutgers' Committee on Human Rights
For Community Action Projects (C.A.P.)

WEDNESDAY EVENING
JULY 29, 1964 at 8:30
RUTGERS GYMNASIUM
NEW BRUNSWICK, NEW JERSEY

Tickets $4, $3 and $2. Mail orders to
169 Neilson St., New Brunswick, N. J. · Tel. 545-7711

CHECKS TO CIVIL RIGHTS BENEFIT CONCERT

The Best of Times, the Silliest of Times

Every generation has its memory of the silliest-ever event at Rutgers, courtesy of Rutgers student committees:

- The annual Rutgers cremation exercises held in the late 19th century at the end of the academic year, during which the textbook voted the most despised by the sophomore class was burned in an elaborate nighttime ritual.
- The most people dressed as Teenage Mutant Ninja Turtles so that Rutgers could break the *Guinness Book of World Records* in 2008.
- The night Rutgers students broke the world record for the most people (1,052) dressed as Waldo in the "Where's Waldo" event that packed the State Theatre on April 2, 2009 (the entrance fee was a new children's book, and because of a matching program from a charitable organization, over 2,000 children's books were collected and given to a local charity).
- The Bugs Bunny Film Festival that was insanely popular in the late 1980s.
- The showing of the 1925 silent film classic, *The Phantom of the Opera*, starting Lon Chaney at Kirkpatrick Chapel with the organ playing in the background on Halloween night.
- Hot Dog Day, held every April and featuring music, and free hot dogs and ice cream—and students dressed up as condiments.
- Homecoming festivities on all three campuses that range from parades and bonfires to the more recent charity bed races on College Avenue that feature wildly decorated beds on wheels pushed by teams that have collected books or toys for a local charity in order to participate.
- And everyone on the New Brunswick campus seems to have an Ag Field Day story: did you eat the chocolate-covered ant? Did you see the cow with the window in its stomach? Did you pet the sheep?

The people of Rutgers—from every campus, in every decade, regardless of curriculum, gender, ethnicity, religion, or political persuasion—hold fond memories of friendships formed, leadership skills developed, knowledge of the world deepened, and social awareness fine-tuned. Whether you met your life partner at Rutgers or learned to run a meeting while serving in the student government or other student organization, Rutgers changed your life forever. That power, "eternally the same," is the most profound part of the Rutgers story.

—WILLIAM WETZEL (ENG '66)

Right: Participants in a charity bed race on College Avenue.

Below: The Marching Band and Wind Ensemble in the mid-1960s. At some games, there were so few members that they could only spell out R-U-T-G-E-R-S one letter at a time.

Below right: Students on an old truck at Ag Field Day, established in 1906 and still celebrated each spring.

Concerts

Erika Gorder

"This is ours, I think." The soft strains of a dreamy waltz fill the great gymnasium with an inspiriting and inviting harmony… Those who rail against dancing have no poetry in their souls…let us not forget to pity those others who go through life minus the pleasure normally excited by music and motion.

— "The Junior Ball," *Scarlet Letter* 1896

Live music has been an integral part of the collegiate landscape in the United States since at least the mid-19th century—and Rutgers is no exception. Concerts "on the banks" have been a tradition almost as long as classes themselves and certainly as long as athletic competition. From the small concerts of the 1860s to the massive outdoor festivals of the 2000s, Rutgers students and staff have organized musical entertainment that has included home-grown talent—local bands and student choral groups—as well as world-renowned music-makers—classical musicians like Eugene Ormandy and the Philadelphia Orchestra, folk musicians like Judy Collins, rappers like Kanye West. Some musical performances were planned as part of university-administered programs such as the University Concert Series or the Voorhees Assembly Board; others were organized by students. The earliest musical events were student dances and balls put on by students in individual class years; later concerts were sponsored by student organizations such as the Rutgers College Program Council, Ramblin' Rose,

Animal Sounds at Cook College, and LOCO—Livingston's Own Concert Organization. Still others were organized by semiformal groups of students, dormitory clubs, and the Interfraternity Council.

Musical performances at Rutgers could not happen without an infrastructure to support them—most importantly, space. Certainly, the growth of the student body ensured an audience, but the physical expansion of the college enhanced its ability to draw larger crowds and attract national acts. Winants Hall (1890) was the first building devoted solely to students: at once a dormitory, post office, bookstore, cafeteria, and social space. It was a symbol of the growth of student life activities, and a more cohesive and robust student identity. But it was not until Ballantine Gymnasium was built that the college saw the sort of activities we now associate with student life flourish. From 1894 to 1930, Ballantine Gym was the primary locale for dances and concerts as well as military and athletic functions. Most concerts that took place at Rutgers were under the auspices of such highly popular dances as the Military Ball, the Sophomore Hop, the Junior Ball and Junior Prom, and the Senior Ball. By the early 20th century, with the establishment of the University Concert Series in 1915 by the Rutgers Music Department and Professor Howard McKinney, outside musical performances that were open to the public became common.

Above: Nelson Eddy (baritone). Poster advertising Nelson Eddy's performance at the Gymnasium, March 6, 1935.

Below left: Junior Prom at the old Ballantine Gym, 1913.

Below: Gerry Mulligan Quartet (featuring Chet Baker) at the Gymnasium, ca. 1958.

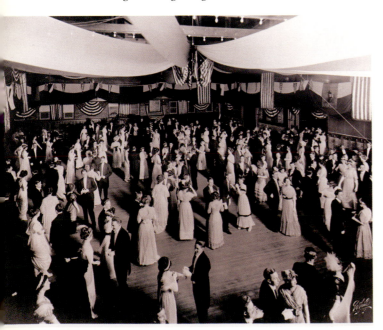

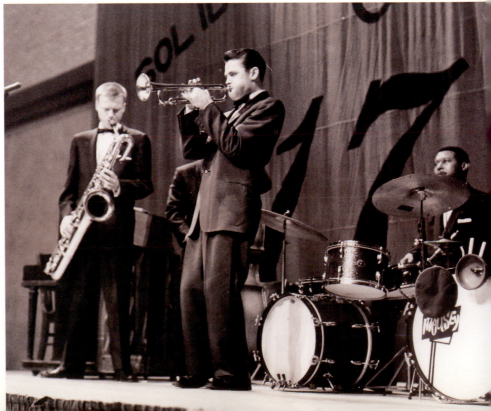

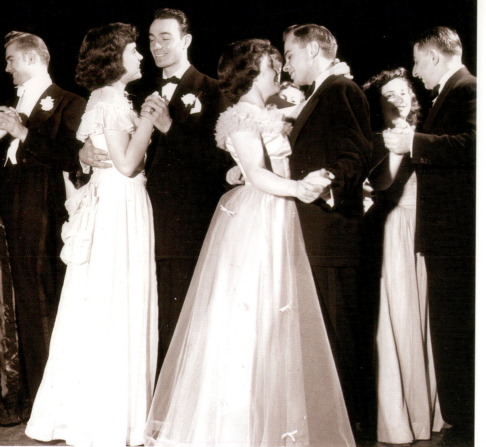

Spring dance, 1957.

The New Jersey College for Women—established in 1918—sponsored its own concerts in Voorhees Chapel as well as social events and musical clubs. Ballantine Gymnasium was partially destroyed by fire in 1930, and the College Avenue Gym was constructed in 1932 to replace it. "The Barn" quickly became the hot spot for concerts, dances, and social events for students and the general public.

Musical acts that visited the campus in the early to mid-20th century included various orchestras, Fernando Germani, Rudolph Ganz, Nelson Eddy, Sergei Rachmaninoff, Bennie Krueger's Splendid Dance Orchestra, Edith Lorand and her Hungarian Orchestra, Red Nichols, and Duke Ellington. Then the Second World War intervened, and although there was a drop in name acts performing at Rutgers, there was no shortage of dancing. The Sophomore Hop, Sophomore Jamboree, Christmas festivities, and Dance in December were still going strong.

By the mid-1960s, concerts and musical programs at Rutgers exploded. This was in part due to the exponential growth of the student body; also, the expansion of campus facilities—especially the construction of buildings dedicated to students, such as the River Dorms and "the Ledge" in 1956—provided more venues for music. Certainly, too, the music industry and popular culture were changing. Tapping into the new youth market, college campus tours became common for musical groups—and Rutgers, located squarely between New York and Philadelphia, was perfectly situated.

By the late 1960s, the musical performances at Rutgers spanned jazz to folk to rock to R&B, and the performers appearing on campus ranged from Count Basie to Ravi Shankar, from Pete Seeger to Bob Dylan, from Odetta to The Supremes, and from Ray Charles to the Lovin' Spoonful.

Throughout the 1970s and 1980s, concerts at Rutgers continued to reflect increasing diversity and range. The influence of college radio stations, including WRSU, played a role in the frequency and style of concerts: not only did Rutgers host national acts, but it also became part of an alternative underground musical network. And the blossoming of diverse student organizations allowed new music to flourish on campus, with social and activist groups such as Student Afro-American Society and CISPES (Committee in Solidarity with the People of El Salvador) organizing benefit concerts as part of their mission. The venues were equally diverse, taking place at the Barn, the Rutgers College Student Center, the Cook College Center, the Busch Student Center, Demarest Hall, and Scott Hall, among others. Most concerts, from the alternative to the big budget, continued to be open to the public and markedly influenced the New Jersey and tri-state area cultural landscape.

Into the 1990s and 2000s, Rutgers student organizations continued to book concerts at the university, most notably large open-air festival events such as Deinerfest, Springfest, and Rutgersfest. The bands and performers during these years included Beastie Boys, Busta Rhymes, Good Charlotte, Ludacris, Method Man & Redman, OK Go, N.E.R.D., and Pitbull. The festival concert events had drawn nearly 40,000 concertgoers from among students and the general public alike. Unfortunately, in 2011, several violent incidents occurred in New Brunswick in the aftermath of Rutgersfest, leading the university to cancel the 30-year-old event. While no Rutgers students were involved, it had become clear to the university and the City of New Brunswick that such large-scale events open to all could be untenable. This cancellation notwithstanding, the fact remains that concerts and music at Rutgers are an indelible part of the undergraduate student experience and occupy a special place in the memories of Rutgers alumni.

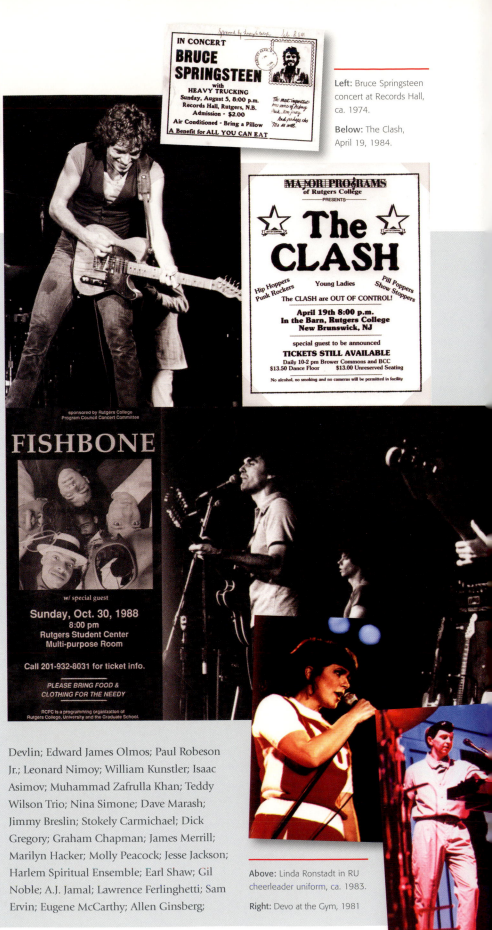

Left: Bruce Springsteen concert at Records Hall, ca. 1974.

Below: The Clash, April 19, 1984.

Right: Bruce Springsteen performance in 1976 at the Gym featured in the *Scarlet Letter*, 1977. (Springsteen also performed at the Ledge in 1971, 1974, and 1978.)

Now appearing at Rutgers…

Jefferson Starship; Jerry Garcia Band; Warren Zevon; Bruce Springsteen & the E Street Band; Harry Chapin; Gene Roddenberry; Alan Alda; Hall & Oates; Smokey Robinson; Gabe Kaplan; Dan Fogelberg; The Kinks; Jackson Browne; Phoebe Snow; Billy Joel; Arlo Guthrie; Brewer & Shipley; Renaissance Caravan; Souther Hillman Furay; Curtis Mayfield and the Impressions; Hot Tuna; Earth, Wind & Fire; Ohio Players; Blood, Sweat & Tears; Doobie Brothers; Albert King; Cymande; Don McLean; Jane Fonda; Tom Hayden; Orleans; Bonnie Raitt; Howdy Doody and Buffalo Bob; Laura Nyro; Melanie; David Bromberg; Ralph Nader; Jerry Rubin; Abbie Hoffman; Royal Philharmonic; Country Joe and the Fish; Mountain; Itzhak Perlman; Isaac Stern; Main Ingredients; The Chambers Brothers; Bill Russell; Utah Phillips; Sha Na Na; Dame Judith Anderson; Eric Anderson; Janis Ian; Edmund Muskie; Vladimir Ashkenazy; The 5th Dimension; The Turtles; Cannonball Adderley; Muddy Waters; Simon & Garfunkel; Vladimir Horowitz; Judy Collins; Pittsburgh Symphony; Norman Mailer; The Critters; The Lovin' Spoonful; Boston Symphony Orchestra; Dionne Warwick; Tommy James & the Shondells; Norman Thomas; William F. Buckley Jr.; The Kingston Trio; Barry Goldwater; Louis Armstrong; Godfrey Cambridge; The Brothers Four; Serendipity Singers; The Four Tops; The Temptations; Flip Wilson; The Young Rascals; Bob Dylan; Count Basie; Soupy Sales; Miriam Makeba; Trini Lopez; Jackie Mason; Dave Brubeck; The Crystals; Gary U.S. Bonds; Ben E. King; The Drifters; The Marvelettes; Len Barry; Little Anthony & the Imperials; London Symphony; Ian & Sylvia; Odetta; Woody Allen; The Tarriers; Pete Seeger; Shelley Berman; Bo Diddley; The Coasters; Ray Charles and the Raelettes; Malcolm X; Strom Thurmond; Johnny Mathis; Adlai Stevenson; The Flamingos; Sammy Kaye; Jean Shepard; Hubert Humphrey; Clive Barker; James Dickey; Julian Bond; Margaret Mead; Ann Coulter; Spike Lee; Ray Bradbury; Benjamin Spock; Avery Brooks; Kurt Vonnegut; Stan Lee; Cornell West; Danny Glover; Nora Ephron; Linda Chavez; Bernadette Devlin; Edward James Olmos; Paul Robeson Jr.; Leonard Nimoy; William Kunstler; Isaac Asimov; Muhammad Zafrulla Khan; Teddy Wilson Trio; Nina Simone; Dave Marash; Jimmy Breslin; Stokely Carmichael; Dick Gregory; Graham Chapman; James Merrill; Marilyn Hacker; Molly Peacock; Jesse Jackson; Harlem Spiritual Ensemble; Earl Shaw; Gil Noble; A.J. Jamal; Lawrence Ferlinghetti; Sam Ervin; Eugene McCarthy; Allen Ginsberg;

Above: Linda Ronstadt in RU cheerleader uniform, ca. 1983.

Right: Devo at the Gym, 1981

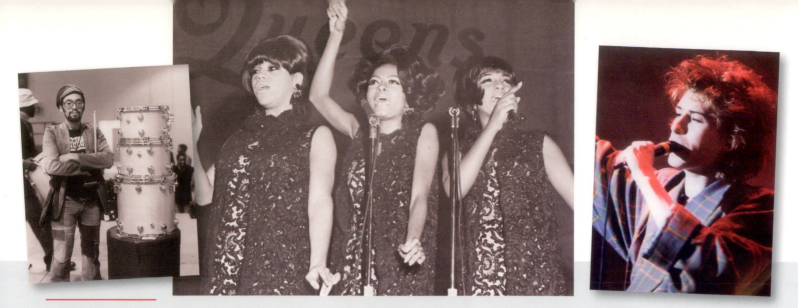

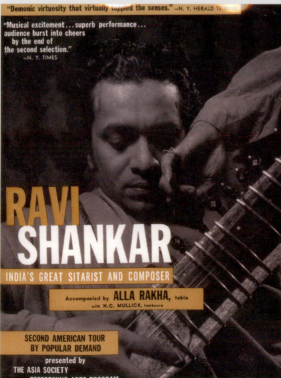

Above: Gil Scott-Heron.

Above middle: The Supremes appeared at the Junior Prom, February 21, 1966.

Above right: Psychedelic Furs at the Gym, ca. 1985.

Below: Talking Heads, 1977.

Geraldo Rivera; Alex Haley; John Anderson; Kevin Smith; Arthur M. Schlesinger Jr.; Nikki Giovanni; Michael Moore; Ralph Abernathy; Bruce Campbell; Bob Woodward; Pat Croce; William Proxmire; Bill Bradley; Angela Davis; Andrew Young; Nat Hentoff; Mark Lane; Lani Guinier; Todd Rundgren; Vanessa Carlton; Patti LaBelle; Steve Forbert; Richie Havens; Ben Folds; Maroon 5; Meatloaf; CeCe Winans; Gil Scott-Heron; Burt Bacharach; Julie Harris; William Windom; James Whitmore Jr.; Kevin McCarthy; Ruby Dee and Ossie Davis; Vincent Price; Andrew Dice Clay; Bill Cosby; John Belushi; Penn & Teller; Richard Lewis; Jay Leno; Robert Klein; Lily Tomlin; Margaret Cho; Jim Belushi; Tommy Davidson; Steve Landesberg; Bill Maher; Mark Russell; Zach Galifianakis; Arthur Rubinstein; Skitch Henderson; J. Robert Oppenheimer; Woody Herman; Louis Kentner; The Shirelles; Linus Pauling; Jesse Owens; Philadelphia Orchestra; Steve Lawrence; Duke Ellington; Lawrence Welk and His Orchestra; Arthur Godfrey;

Aaron Copland; James Michener; Anna Russell; Vincent Lopez; Thurgood Marshall; Robert Frost; Mel Tormé; Leonard Bernstein; Rudolf Serkin; Gene Krupa; Tommy Dorsey; Sergei Rachmaninoff; Ozzie Nelson; Paul Robeson; Van Morrison; Parliament Funkadelic; Lou Reed; Fairport Convention; 10cc; OK Go; Herbie Hancock; Boston; The Grateful Dead; Talking Heads; Elvis Costello; Patti Smith; The Ramones; Supertramp; Joe Jackson; XTC; Gang of Four; Cheap Trick; The Pretenders; Chic; 3rd Eye Blind; Peter Gabriel; R.E.M.; Billy Idol; A Flock of Seagulls; Squeeze; The Psychedelic Furs; PiL; The Alarm; The Clash; Echo and the Bunnymen; They Might Be Giants; Siouxsie and the Banshees; Fishbone; Bert Ross and His Warner Brothers Vitaphone Orchestra; Red Hot Chili Peppers; Ween; The Replacements; Hüsker Dü; Fernando Germani; Rudolph Ganz; Nelson Eddy; Bennie Krueger's Splendid Dance Orchestra; Red Nichols; Duke Ellington; The Gerry Mulligan Quartet; Joan Baez; The Supremes; Ravi Shankar; Sum 41; Beastie Boys; Less Than Jake; Busta Rhymes; Good Charlotte; Kanye West; Everclear; Sugar Ray; Guster; Goldfinger; Ludacris; Reel Big Fish; Method Man & Redman; Fuel; Hawthorne Heights; N.E.R.D.; Pitbull

Left: Ravi Shankar performed at Voorhees Chapel, October 12, 1964.

Below left: PiL (Public Image, Ltd.) featuring John Lydon (formerly of the Sex Pistols) at the Student Center, 1984.

Below: Elvis Costello at the Student Center, February 6, 1978. (He also appeared at Rutgers in 1981 and September 1983.)

"Demonic virtuosity that virtually toppled the senses." —N. Y. HERALD TRIBUNE

"Musical excitement...superb performance...audience burst into cheers by the end of the second selection." —N. Y. TIMES

RAVI SHANKAR

INDIA'S GREAT SITARIST AND COMPOSER

Accompanied by **ALLA RAKHA**, tabla
with N.C. MULLICK, tamboura

SECOND AMERICAN TOUR BY POPULAR DEMAND

presented by
THE ASIA SOCIETY PERFORMING ARTS PROGRAM

VOORHEES CHAPEL—DOUGLASS COLLEGE
Monday Evening, October 12 at 8:30 P.M.

All Seats: $2.50 (Students: $1.50)
Write or Call University Concerts, CH 7-1766, ext. 6591.

How the Scarlet Knights Got Their Name

In 1954, Rutgers took me in and gave me innumerable gifts—a national scholarship, caring administrators, brilliant faculty, and extracurricular activities to enjoy. In return, I made a gift to Rutgers school spirit.

From 1954 to 1958, I played football, basketball, and baseball. We didn't excite many crowds in those days, but we tried. In my first year, I was surprised to find that we really had no sports mascot, unless you liked the Chanticleer. We were just "the Scarlet," sometimes "the Queensmen."

In 1955 I represented my class on the Student Council, and I had an idea: the great Army teams I grew up with were known as the Black Knights of the Hudson. Why shouldn't the Queensmen be known as "the Scarlet Knights" (of the Raritan maybe)? I presented this motion to council president Kevin Featherstone (RC '56) and the others, who liked the idea, and felt we should put it to the student body in a referendum. We did so—and the rest is history.

—WILLIAM J. WHITACRE (RC '58)

Introduced in 1955 as the mascot, the Scarlet Knight in red armor leads the football team out onto the field at each home game.

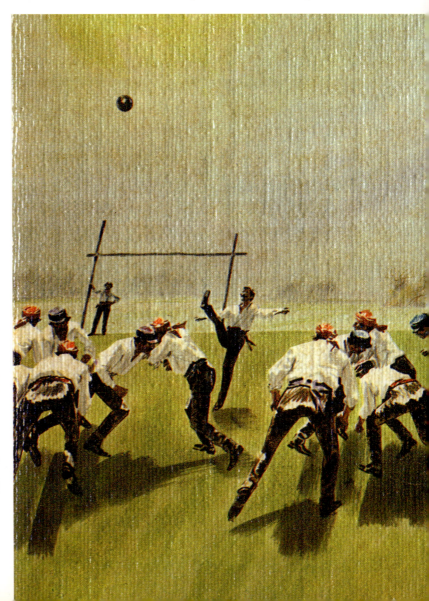

An early 20th-century football jersey.

Intercollegiate Athletics

MARYBETH SCHMUTZ

RU, Rah, Rah;
RU, Rah, Rah,
Whoo-Rah, Whoo-Rah;
Rutgers Rah

Up Stream Red Team
Red Team Up Stream
Rah, Rah, Rutgers Rah
 —"THE BELLS MUST RING"
 (UNIVERSITY FIGHT SONG)

The centennial football game of 1969 was cause for national celebration including a commemorative United States Postal Service stamp, commemorative plate, several paintings, and a televised football game against Princeton on September 27, 1969. Rutgers won, 29–0, and the Rutgers captains and coach appeared on television on *The Ed Sullivan Show*.

On a cold November day in 1869, 25 Rutgers students met on a field along College Avenue in New Brunswick with students from nearby Princeton. They would play what is now recognized as the first-ever intercollegiate football game in the nation's history and arguably the most famous game in Rutgers' history. In another historic first, the Rutgers players wore scarlet "turbans" to differentiate themselves from the opposing team. Scarlet has remained the official school color ever since.

Altogether, there are now 22 Scarlet Knights teams. They include football, men's and women's basketball, men's and women's lacrosse, men's and women's golf, women's swimming and diving, wrestling, men's and women's cross country and track and field, baseball, softball, women's volleyball, women's tennis, men's and women's soccer, field hockey, women' rowing, and women's gymnastics.

Early Powerhouse Sports and Players

To this day, the phrase "Birthplace of College Football" is prominently and proudly displayed in the Rutgers football stadium, and within two decades of this first football game, the Rutgers Scarlet would take on other collegiate opponents, including Columbia, Stevens Institute of Technology, Yale, University of Pennsylvania, and Lafayette. But it was a baseball game with Princeton in 1866 that has the distinction of being the first intercollegiate game at Rutgers. Other sports played at Rutgers during these early years included crew, tennis, and basketball, whose team went to the national championships in 1920; shortly after these

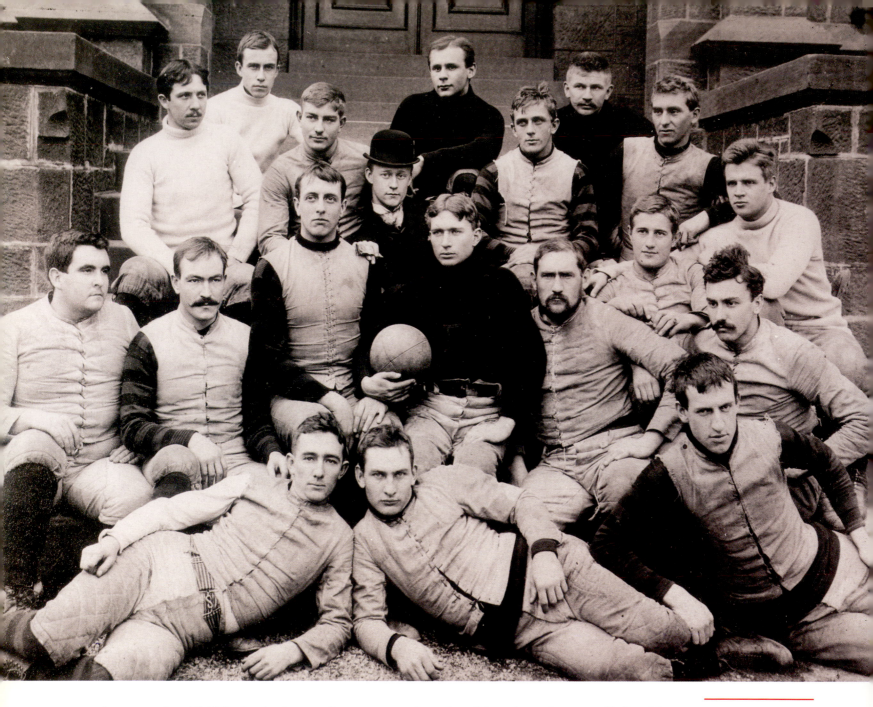

came lacrosse, track and field, fencing, boxing, wrestling, water polo, and soccer.

In these early years, as the number of teams at Rutgers proliferated, student enthusiasm for athletics grew to such an extent that a concern arose among the faculty that sports were interfering with student academic performance. In 1901, the faculty moved to become involved in the student-run Athletic Association that financed the teams and scheduled the games. Now the association would include not only students, but faculty and alumni representatives. The faculty representatives began to regulate the number of games that could be played, and students whose work suffered because of their participation in sports were prevented from playing at all.

Over time, the control and funding of athletics at Rutgers would be increasingly administered by the university and

prominent alumni. It was just such a group of influential alumni who in 1913 formed "the Syndicate," Rutgers first athletic booster club. With a stated goal of turning Rutgers into a national football power, the group encouraged the hiring of the college's first big-name coach: George Foster Sanford. Not only would Sanford, in his 10 years as head coach at Rutgers, put the team on the map nationally with a record of 56-32-5, he would also coach one of Rutgers' greatest scholar-athletes, Paul Robeson (RC '19).

Paul Robeson was the son of an ex-slave and pastor from Princeton and Somerville, New Jersey. A brilliant high school student, he received a four-year scholarship to Rutgers College, arriving on the New Brunswick campus in September 1915—the only African American in a student body of approximately 500. During his four years at Rutgers,

The 1891 football team; the team's opponents included Navy, Army, and NYU. They finished the season at 8-6.

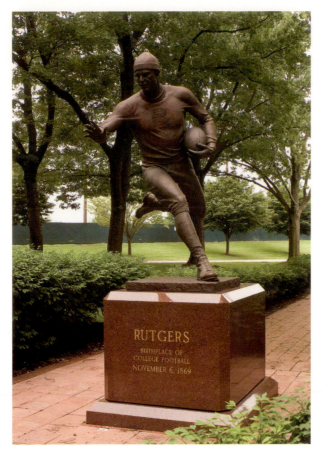

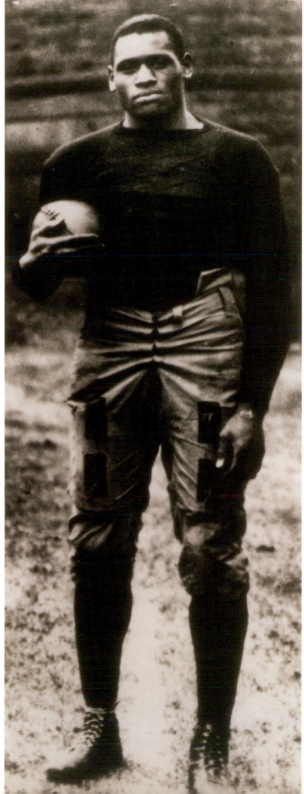

Left: *The First Football Game Monument*, a talisman touched by players before home games. The sculpture, by Thomas Jay Warren, stands outside the football stadium as a reminder that Rutgers is the birthplace of college football.

Below: Robeson of Rutgers.

there was only one other African American enrolled, Robert Davenport (RC '20) of West Orange; he and Robeson roomed together at the Winants Hall dormitory.

Robeson was an excellent student, elected to Phi Beta Kappa in his junior year and to Cap and Skull in his senior. He was the star of his debating team and at graduation delivered a commencement address while also receiving prestigious class prizes for extemporaneous speaking. And his athletic skill was unparalleled: he earned All-American honors in football twice and a total of 14 letters in football, baseball, basketball, and track and field. But prejudice was rampant, and he suffered much humiliation and abuse, particularly in the beginning. At his first practice, he was met with open hostility from the other players, and was badly roughed up by them, with his nose intentionally smashed and his shoulder injured. During a subsequent scrimmage, a player deliberately stomped on Robeson's hand with his cleated shoe, ripping off several fingernails. Eventually, though, his teammates became his close friends, and he had the strong support of Coach Sanford, who became a surrogate father after Robeson's own father died.

Another important sport at Rutgers in the early part of the century was lacrosse, which was established in 1887. Under Coach Fred Fitch, the lacrosse team shared

The Paul Robeson Award

The Paul Robeson Award is presented annually to the "senior whose performance, leadership, and dedication, on and off the field, during his varsity career had the greatest impact on Rutgers football." Paul Robeson has had a long-lasting impact on Rutgers football. His legacy not only lives on through stories, awards, and records, but in the great courage he exhibited both on and off the field. Paul has been a role model for generations and will continue to be so as Rutgers continues its rich football tradition in the Big Ten. Paul Robeson's sacrifice and relentless pursuit of his dream have made the award that bears his name the most coveted among the players in the program. His journey has been well documented, but his impact has been even more powerful. Former and current players continue to pay homage to Paul Robeson's legacy by proudly representing the block R as he had done throughout his life. It is incredibly humbling to receive the Paul Robeson Award, but an even greater honor to be recognized as someone who embodies his values.

—WILL GILKISON (RC '07), RUTGERS DIRECTOR OF FOOTBALL OPERATIONS AND RECIPIENT OF THE 2005 PAUL ROBESON AWARD

PAUL ROBESON AWARD
PRESENTED BY RUTGERS TOUCHDOWN CLUB

"Presented annually to the senior whose performance, leadership, and dedication, on and off the field, during his varsity career had the greatest impact on Rutgers Football."

WILLIAM GILKISON
2005

Coach Fred Hill

In January 2014, one of Rutgers' most respected and beloved baseball coaches retired in his 30th year. A New Jersey native, Fred Hill arrived on the banks in 1984 as the 11th baseball coach in Rutgers history. During his long career here, he posted 941 wins and took his teams to 11 NCAA tournament appearances, 12 regular season conference championships, and eight conference tournament titles. Coach Hill developed 20 All-Americans, and 72 of his players have gone on to play professional baseball, including Todd Frazier, David DeJesus, Eric Young (LC '89, RBS '89), and Mike Bionde (LC '11). Under Hill, Rutgers baseball consistently appeared in national rankings, including a high of 14th in 2000, the year the team won the Big East regular season and tournament championship. The 2007 team tied the school record for victories (42) and established a new school record for home runs (63).

the national championship in 1928 with Johns Hopkins, Maryland, and Navy. Fitch posted a 106-7-1 record in his 25 years at Rutgers. He was inducted in the Lacrosse Hall of Fame along with two of his players, George Latimer (RC '32) and Joseph "Frenchy" Julien (RC '32). In 1955, the team won the Laurie Cox Division Championship, a title it shared with Hofstra.

Baseball

Since the first intercollegiate contest against Princeton, baseball has been an important sport at Rutgers. The baseball team played in the College World Series in 1950. Under pitcher "Big" Herman Hering (ED '50, GSED '61), the team finished at 17-4-1 and fell to the University of Texas.

As a catcher on the Scarlet Knights baseball team, Jeff Torborg (ED '63) set both Rutgers and National Collegiate Athletic Association (NCAA) records for batting in 1963, the same year he won All-American honors. Torborg would go on to a distinguished professional career that would include seven years with the Los Angeles Dodgers and three with the California Angels, during which he caught for three no-hitters including Sandy Koufax's perfect game on September 9, 1965. Torborg's number was retired in 1992—a first for Rutgers baseball—and he was entered into the Rutgers Olympic Sports Hall of Fame in 1994.

Below: The 1890 baseball team. The first intercollegiate game at Rutgers in any sport was played by the baseball team in 1866.

Right: Coach Fred Hill and players

Below right: The 1987 baseball team.

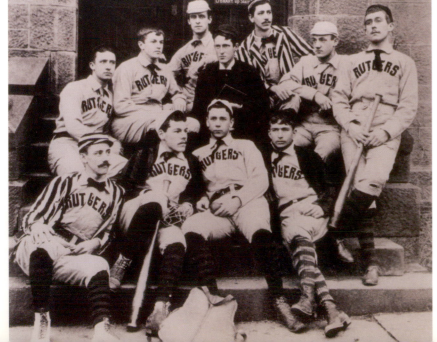

The 1897 crew team in front of Ballantine Gymnasium.

Crew

Since two Rutgers rowers took gold in the 1952 Olympics—senior Chuck Logg (AG '53) and freshman Tom Price (AG '61)—beating the competition by almost three seconds, Rutgers has had a long line of Olympic oarsmen. In recent decades, several Rutgers crew alumni have been on the U.S. national or Olympic teams including Fred Borchelt (ENG '76, GSNB '78), a three-time Olympian; Charlie Butt (RC '83), on the 2000 Olympic coaching team; Robert Kaehler (CC '86), another three-time Olympian; Sean Hall (CC '05, RBS '14), a member of the 2000 Olympic team; William Porter (RC '91), a Pan American Games gold winner; Jeffrey Klepacki (LC '91), one of the U.S. men's eight that won a gold medal at the 1994 World Championships; Tom Terhaar (LC '92), who coached the U.S. women's eight to a world record and silver medal at the 2004 Olympic games; Jim Neil (LC '92), a 15-time national team member; and David Collins (ENG '92), who earned a bronze at the 1996 Olympics. Women's crew, added to the program in 1974, went to the NCAA championships in 1997, 1998, and 2001. They also have numerous alumni on the U.S. national and Olympic teams, including Maite Urtasun (RC '01), who won the 2002

World Championship as a member of the women's eight; and Jennifer Dore-Terhaar (RC '93, GSNB '08, GSED '10), a 10-time national team member and two-time Olympian.

Rutgers had both men's and women's crew teams until 2007, when the men's team was eliminated as a varsity sport—although it continues to maintain a strong presence as a club sport. Both men's and women's teams compete at the highest levels both nationally and internationally. Men's crew traveled to England to compete at the Henley Royal Regatta in 1984, 2000, and 2003, with the men's heavyweight crew advancing to the final in that year. In 2014, the men's team raced in the Head of the Charles Regatta in Boston, the world's largest two-day rowing event.

Swimming and Diving

Since its beginning in 1915, the Rutgers swimming and diving program has enjoyed much success and achievement. Early Rutgers swimmers and divers who participated in the Olympics were George Kojac (RC '31), who won two gold medals in 1928, and Walter Spence (RC '34), who won a medal in 1932. In the 1970s, Rutgers women's swimming started up, with Judy Melick (DC '77) the first member of the team. A former Olympian, she led the team to three consecutive undefeated seasons.

Below left: Modern era women's crew team on the Raritan River.

Below: Jennifer Betz, star diver on the 2011 Scarlet Knights swimming and diving team.

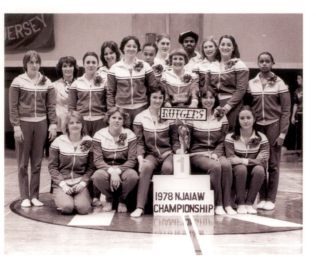

The New Jersey Association of Intercollegiate Athletics for Women championship basketball team, 1978.

Grentz as the first full-time women's basketball coach in the nation. In her 20 seasons on the banks, Grentz achieved an overall record of 434-150 and took her team to nine postseason appearances.

Grentz coached the great Sue Wicks (CC '88), a three-time All-American, winner of the prestigious Naismith Award, three-time Atlantic 10 player of the year, and a member of the U.S. team that won the gold medal in the 1987 Pan Am Games. During her time at Rutgers, Wicks achieved a scoring record of 2,655 total points. In 1997, she joined the fledgling Women's National Basketball Association (WNBA) and was a crowd and team favorite of the New York Liberty for five years.

Enter the Women

In 1972, two events occurred that changed Rutgers athletics forever. In that year, Title IX legislation was passed as part of a broader federal bill that banned discrimination based on gender at institutions of higher education, and Rutgers College admitted women for the first time. Rutgers moved quickly to develop a women's intercollegiate sports program; by the end of the decade, it had teams in basketball, softball, track and field, tennis, field hockey, swimming, gymnastics, crew, golf, fencing, and volleyball. Soccer was added in 1985.

The women's athletics program went on to produce some of Rutgers' greatest coaches and athletes, notably in basketball. Right from the start, in 1974, the women's intercollegiate basketball team won its first game against Princeton, 76–60. Two years later, Rutgers hired Theresa

Below: Theresa Grentz was inducted into the Women's Basketball Hall of Fame in 2001.

Below right: Wearing #23, the great Sue Wicks.

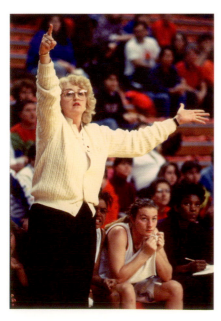

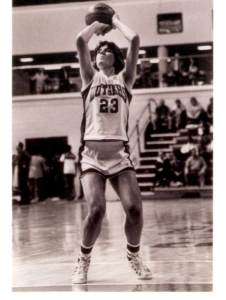

Title IX in Action

As a child of immigrants, I am a first-generation college graduate. I arrived at Rutgers when Title IX of the Education Act of 1972 was being implemented, providing me with the opportunity to participate in women's sports at the collegiate level. I was very fortunate to be a member of the first Rutgers women's track and field team coached by Sandra Petway. The team competed against other inaugural women's programs from Trenton State, Montclair, Salisbury, Springfield, Temple, LaSalle, East Stroudsburg, Southern Connecticut, SUNY at Albany, Towson, University of Maryland, and Penn State. I was one of nine track and field athletes who had the honor of earning the first varsity certificates and blazers awarded to Rutgers' women athletes at the first Women's Intercollegiate Athletic Award Presentations held on the lawn at President Bloustein's house on May 28, 1975. During my days at Rutgers, I developed friendships that have lasted for more than 30 years, as well as a love for education that continues to this day, as I work in an academic setting, hoping to create an environment where students take away wonderful college memories and experiences similar to those I have from Rutgers.

—ELEONORA CIEJKA DUBICKI (DC '77, SCILS '78, RBS '84)

Left: Tasha Pointer, a women's basketball all-time great, holds Rutgers records—men's or women's—in assists (839) and steals (292). Pointer returned to Rutgers as an assistant coach in 2007.

Below: C. Vivian Stringer savors a moment at the RAC.

"Whether she's a starter or someone who plays half an hour all year, I'll make her feel like she's part of something important, and she'll look within to find whatever she can give to make it better."

—C. Vivian Stringer

The Power of a Mentor's Words

With only 10 seconds left in a 1998 NCAA tournament game against Iowa State, down by one point, and with the ball in my hands, I was fouled. Iowa State immediately called a timeout to ice me. During the timeout, Coach Stringer began to draw up defensive sets for our team. All I could hear her say was "After Tasha hits these two free throws, this is what we will do." She said it more than once, but never even looked at me. Her point was to put no pressure on me, no fear, no anxiety—because I was going to make them. And I did! We went on to win the game and go onto the Sweet Sixteen. That timeout taught me that words have an amazing power to comfort, affirm, and encourage. I am blessed to have been mentored by one of the best teachers of all time.

—Tasha Pointer (RC '01, SC&I '01, GSED '03)

Wicks was inducted into the Rutgers Basketball Hall of Fame in 1994; her jersey was retired in 1998.

C. Vivian Stringer, Rutgers' fourth women's basketball coach, brought the team its greatest successes, leading it to the Sweet Sixteen in 1998, the Elite Eight in 1999, the NCAA Final Four in 2000, and the Final Four and national championship game in 2007. In 2014, her team won the Women's National Invitation Tournament (WNIT) championship. She has sent 15 players to the WNBA, including Cappie Pondexter (RC '06), who scored over 2,000 points during her Rutgers career and was later named one of the top 15 players in WNBA history; Essence Carson (RC '08), a 2008 seventh-round pick, who played for the New York Liberty and would go on to become a successful recording artist; Kia Vaughn (RC '09), a 2009 eighth-round pick; and Tasha Pointer (RC '01, SC&I '01, GSED '03), one of Rutgers' greatest point guards, who led the team to its first-ever Final Four appearance in 2000—and who is now assistant basketball coach under Stringer. In 2013, Stringer won her 900th game, making her one of the most successful coaches in women's basketball history and a member of the Naismith Memorial Basketball Hall of Fame.

Another standout woman athlete at Rutgers is All-American Carli Lloyd (RC '06), a former member of the women's soccer team. Lloyd's feats in 2008 and 2012 made her the only woman in history to score the winning goal in two separate Olympic gold medal matches.

The women's basketball team's dignified response to radio host Don Imus's hateful remarks attracted worldwide acclaim in 2007.

Right: Eddie Jordan now: Head coach of the Scarlet Knights men's basketball team.

Below: Eddie Jordan then: "Fast Eddie" lay-up.

Below right: Phil "The Thrill" Sellers, the leading scorer on the 1976 Final Four team.

The Greatest Team

For anyone who follows college basketball, the 1976 Rutgers season was historic. The season began with high expectations, and we didn't disappoint. By the time we had won our 16th straight game, we were receiving national attention with a four-page article in *Sports Illustrated*. We continued to win, and at 31–0, reached the impossible, the Final Four, where we would play for the national championship. And even though we lost our last two games, we thoroughly enjoyed the ride and shared every minute of it with the Rutgers community.

My education at Rutgers can easily be lost in the 1976 story, but that would be a big mistake. Yes, I was part of a team—a historic team—but that's only part of the story. I was incredibly blessed to work with an amazing group of men who came together from diverse backgrounds with a single goal, to represent the university at the highest levels on and off the court and to win. We did both. I am most proud of my *team*. Each and every one on the team has achieved a level of success, some playing and coaching at the professional level, some leading Fortune 500 companies, serving in law enforcement, or teaching and coaching the next generation of Rutgers students. They are good men. They are my teammates, my friends, my brothers, and all loyal sons of Rutgers University.

—MARK J. CONLIN (RC '77)

Men's Basketball

In 1976, the undefeated men's basketball team made it to the Final Four under coach Tom Young, who had come from American University in Washington, D.C., to put Rutgers basketball on the map. In his first year, he coached Rutgers to a National Invitation Tournament (NIT) bid; the next year, he had a 22-7 season and the team's first-ever NCAA invitation.

One of Young's standout players on the team, "Fast Eddie" Jordan returned to the banks in 2013 as head coach after a career as an NBA player and coach of the Washington Wizards. Other players on the 1976 team included Mark Conlin (RC '77), Mike Dabney (RC '76), Jeff Kleinbaum (RC '76), Mike Palko (RC '76), Bruce Scherer (RC '76), and Phil Sellers (LC '76). Together, they formed the nucleus of the squad that would take the team to the Final Four.

Alexi Lalas's 26-Year Plan

In May 2014, I graduated from Rutgers University. It had taken me 26 years.

I arrived on the banks of the Raritan in the fall of 1988. I'd grown up in Michigan and I'd never been to New Jersey, let alone to Exit 9 off the Turnpike. Rutgers was, to say the least, a big change. This was not the Midwest; this was another world. I slowly adjusted to the vastly different behavior, attitude, and even language of my new home. In time, I became more comfortable with my surroundings and started to appreciate the differences I was encountering. Over the next three years, I spent much of my time playing soccer, going to school, and making music. At Rutgers, I was exposed to a high-level soccer program, a diverse educational environment, and a vibrant music scene. I drank it all in and milked it for all it was worth.

I left Rutgers in 1991 to become a professional soccer player. I traveled the world and had wonderful adventures. But wherever I went, I carried many of the lessons and skills that I'd learned and developed during my time at Rutgers. I also carried a pang of regret for not having completed my degree. In 2013, as a long-since-retired soccer player, a husband, and a father of two, I reenrolled at Rutgers. In 2014, my "26-Year Plan" came to an end. I'm proud that I finally graduated, but I'm even prouder that I graduated from Rutgers. Rutgers took a chance on me many years ago, and for that I will always be grateful. You can travel far and wide, but Rutgers will never leave you. In that sense, I suppose all roads lead back to Jersey, even for a kid from Michigan.

— Alexi Lalas (RC '13)

Rutgers soccer standout Carli Lloyd finished her Rutgers career in 2004 as the all-time leader in points and goals. As a member of Team USA, Lloyd won gold medals in both the 2008 and 2012 Olympics, scoring the winning goals in each year.

Soccer

Under Bob Reasso, head coach from 1981 to 2009, the Rutgers men's soccer team went to 13 NCAA tournaments, three Final Fours, and six league titles. Reasso coached 15 All-Americans, including the international soccer star Alexi Lalas (RC '13). Lalas led his team to the NCAA Final Four in 1989 and to the national championship game in 1990. A year later, he won the Hermann Trophy, U.S. soccer's version of the Heisman.

Below left: Alexi Lalas on the field.

Below: Soccer head coach Bob Reasso.

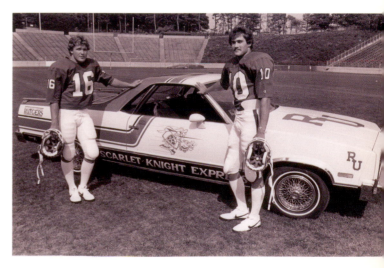

Right: The undefeated 1961 team.

Below: "Flinging Frank" Burns.

Below right: Quarterbacks Jacque LaPrarie (left) and Eric Hochberg pose with the "Scarlet Express" in 1984.

Football

The 1976 undefeated football team was coached by Frank Burns (RC '49, GSED '64), Rutgers' winningest football coach ever. "Flinging Frank" Burns was a former Rutgers quarterback and linebacker who led his team to a 27-7 record and who became head coach in 1973. By the time he left 10 years later, he had coached his team to eight winning seasons, compiled a record of 78-43-1, and coached the second undefeated season in Rutgers history. (The first was under Coach John "Dr. John" Bateman in 1961.) The final game of the 1976 season was played against a ranked Colgate at Giants Stadium on Thanksgiving night. The score was 17–9. In an unforgettable scene, the fans in the stadium exploded, and Burns was carried off the field by a jubilant team. He would go on to take the Scarlet

Knights to their first bowl game, the now-defunct Garden State Bowl.

Just prior to the heralded 1976 season, a decision had been made by the university administration to begin moving toward "big-time" sports. The Board of Trustees gave its support to a set of recommendations drafted by a subcommittee headed by alumnus David A. "Sonny" Werblin (RC '31), then owner of the New York Jets; these included recommendations for a new field house and grants-in-aid and scholarships for the football and basketball teams. Although an internal committee on the future of athletics gave only qualified support, the die had been cast. Rutgers entered a new era, one which would see its teams take on stronger opponents, gradually upgrade its facilities—including a newly expanded football stadium in Piscataway—and in 1995 join the Big East Conference for all sports.

The Big Time

The decade of the '90s brought great hope to the Rutgers football program. The hiring of Doug Graber, who brought his talents from the NFL, along with the emergence of the Big East Conference, had given Rutgers an instant sense of arrival to big-time college football. A noticeable change in schedule and attitude helped convince top local prospects not to leave New Jersey for out-of-state schools. I was one of those who had been convinced this was the place for me. Doug Graber's constant demand to challenge his players to be great had an everlasting effect on me and many of my teammates.

—Marco Battaglia (RC '96)

The '90s and Doug Graber

In the first home football game of the 1994 season, against Kent State, the players ran onto the field of their new 42,000-seat stadium for the first time. Rutgers would go on to win this game 28–6. Under head coach Doug Graber, the talented team included tight-end and All-American Marco Battaglia (RC '96), who would later play for the Cincinnati Bengals; quarterback Ray Lucas (RC '96), who would go on to play for the New York Jets and New England Patriots; tight-end Tim Pernetti (RC '93, SC&I '95), who would become athletic director at Rutgers; running back Bruce Presley, who would play for the Indianapolis Colts; and running back Terrell Willis, who also would go to the New York Jets. Rutgers football was on its way.

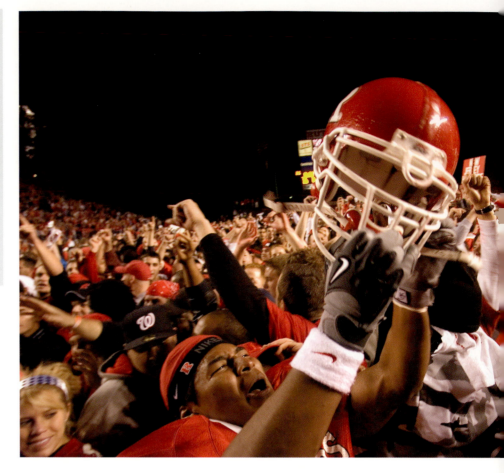

Right: 1990s head football coach Doug Graber.

The Greg Schiano Era

In 2000, Rutgers would hire the coach who would once and for all establish Rutgers as a "big-time" football team.

A New Jersey native, Greg Schiano would go on to coach some of Rutgers' most dominant players, including Kenny Britt, later a wide receiver for the Tennessee Titans and St. Louis Rams; Kaseem Green, who was named All-American by ESPN and would go on to play with the Chicago Bears; Brian Leonard (RC '07), known for the

Above: "Pandemonium in Piscataway!" Fans celebrating Rutgers historic win against Louisville, November 2006.

2000s head football coach Greg Schiano.

A View from the Quarterback: What College Football Is All About

By the Tuesday before the Louisville game, we knew this would be different. When I went to class, everyone was talking about the game and students were camping out for tickets. When we came out of practice, there were more TV cameras waiting outside than I had ever seen—Channel 7, ESPN, CBS, NBC.

Even though there was excitement about the game everywhere we went, Coach Schiano would tell us that once we walked in the door, we had to leave all distractions outside and just focus on the task at hand. It had started getting dark during the afternoon practices, and I remember that during the week before the game, we kept screwing up a particular play. Coach had us stay on the field until we got it right. As it happened, in the second quarter, we used this play to fly to a touchdown. That week leading up to the game was the coolest experience of my life—the whole state had gotten behind us, and there was such pride in our team. This was something I had dreamed of my whole life. Even the Empire State Building was lit up in red and white.

We spent the night before the game in a hotel in New Brunswick. When we left to get on the bus to the game, people were lined up outside like it was a bowl game. We had a police escort to the stadium, and as we drove down Route 18, traffic was at a standstill, but the police got us through. People were honking their horns and waving the whole way as we passed them.

That night on the field, I had never felt such electricity. During the game, the entire crowd stayed on its feet, even when we were down, waving white rally towels—42,000 white towels. The noise was deafening. I thought that this was what college football was all about. The crowd stayed with us the whole way; they seemed to know we would find a way to win this game.

After the game, after the on-field celebration and meeting the media in the locker room, I made it out to the tailgate area to spend time with my family. At 3:30 or so in the morning, I was physically and mentally exhausted (in a good way) and I just wanted to get home. The roads leading into College Ave. were blocked by the police—hundreds of students were still celebrating on the street. I stopped and rolled my window down to ask the police officer to let me through. He recognized me and said, "Hey, you're the quarterback." Within 10 seconds, there was a crowd surrounding my truck. People were taking pictures, coming over to say hello and shake my hand. As I finally made my way up the street to Easton Ave., looking toward Old Queens, I saw people everywhere—not just students and alumni but New Jersey people, fans who had finally gotten what they had been waiting for and what they deserved.

—Mike Teel (UCNB '09)

Right: Quarterback Mike Teel ended his Rutgers career as Rutgers' all-time leader in passing yards (9,398) and touchdowns (59). He played a leading role in Rutgers' spectacular win over Louisville in 2006. Teel returned to Rutgers as the wide-receivers assistant coach in 2014.

A Night to Cherish

Something great was about to happen, and it was happening *to us*. The barbs taken, all those times when wearing Rutgers apparel would attract ridicule, they all seemed worth it. Rutgers was about to be the epicenter of the sports universe. And it felt real. Wow.

As a play-by-play announcer, you dream of getting the chance to call the big moment, and you pray you don't screw it up. So, while at practice that week, I settled on "Pandemonium in Piscataway," assuming it was appropriate. Suffice it to say, it was.

Sports fans understand, but Rutgers fans understand better than most. There is a fulfillment, a sense of satisfaction, from being able to pound your chest at the success of your alma mater. Some get a chance to do it all the time; others, every once in a while. With that game, Rutgers fans and alums at last got to do it too.

—Chris Carlin
Rutgers Football, Play by Play

Brian "Leapin'" Leonard holds the game ball up to the crowd at his final home game. A standout fullback, Leonard rushed for 2,731 yards and 1,862 receiving yards and was known for his ability to leap over his opponents.

famous "Leonard Leap," with which he'd hurdle over tacklers, and winner of the Draddy Award (now the William V. Campbell Trophy) given by the NCAA to the player with the best combination of academics, community service, and on-field performance; and Mohammad Sanu, the 2011 winner of the Homer Hazel Award as Rutgers football's most valuable player who would go on to play with the Cincinnati Bengals. Schiano would send his team to six bowl games, winning all but one of them.

Schiano and running back Ray Rice will probably be best remembered for the 2006 game against the Louisville Cardinals, at the time the third-ranked team in the nation.

Rutgers entered the game 15th ranked at 8-0. Led by quarterback Mike Teel (UCNB '09), the Scarlet Knights came from behind to win 28–25. Fans and students stormed the field. Sportscaster Chris Carlin proclaimed it "Pandemonium in Piscataway!" The game attracted national attention, and Rutgers received a bid to the Texas Bowl in Houston—which it won with a score of 37–10, its first bowl victory. The Scarlet Knights ended the season ranked 12th, the highest ranking ever for a Rutgers football team in the modern era. Six different awards committees named Schiano national coach of the year.

Number 52: Eric LeGrand

On October 16, 2010, defensive tackle Eric LeGrand (SMLR '14) took the field at Met Life Stadium against the Black Knights of Army. During a collision with Army's kick-off returner, LeGrand sustained a spinal cord injury that paralyzed him from the neck down. With the dedication and support of his mother, Karen LeGrand, Coaches Schiano and Flood, and his teammates, LeGrand has become a national symbol of the human spirit rising above adversity. Never losing hope that he will one day walk again, LeGrand continues to inspire through his tireless perseverance and spirit. He has won numerous awards, including ESPN's prestigious Jimmy V Award and the New Jersey Hall of Fame's Unsung Hero Award.

LeGrand resumed his studies in 2011, taking many of his classes by Skype; in 2014, he received his degree in labor studies and, along with former New Jersey governor Tom Kean, addressed the commencement class. LeGrand also provides color commentary for all Rutgers home football games. Today, he is deeply involved with Team LeGrand, part of the Christopher & Dana Reeve Foundation, which works to raise funds for research to find a cure for paralysis. In this effort, he works closely with acclaimed Rutgers neuroscientist Wise Young, a leading expert on spinal cord injury. In 2013, LeGrand published *Believe: My Faith and the Tackle That Changed My Life*.

Support from Rutgers has continued unabated, and Rutgers intercollegiate athletics continues to raise money for LeGrand and his family through its Believe Fund. In 2013, his number, 52, was retired—the first number retired by Rutgers football in its history.

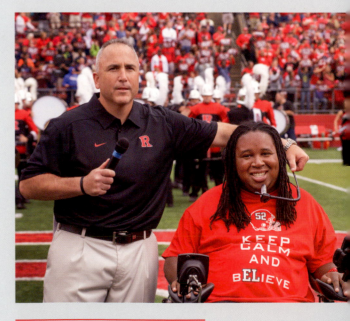

Head football coach Kyle Flood with Eric LeGrand.

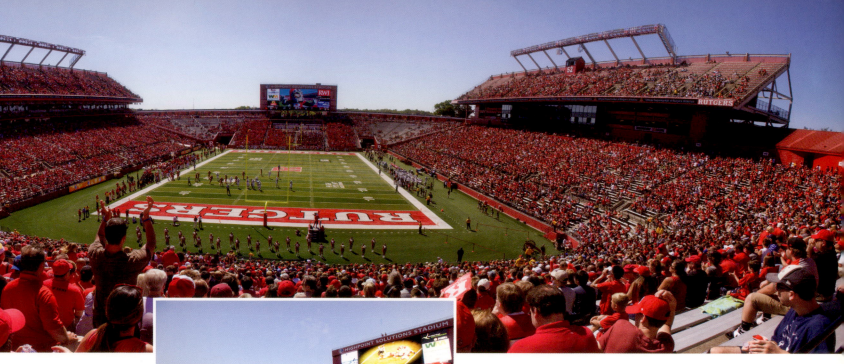

Above: High Point Solutions Stadium.

Right: The phrase "Believe 52" has become associated with Eric LeGrand, who has never given up hope that he will one day walk again.

Right: Members of the Rutgers–Newark women's softball team.

The Big Ten

In November 2012, Rutgers–New Brunswick announced its entry into the Big Ten collegiate athletic conference. The prestigious Big Ten is the oldest athletic conference in the country, and its members are top research universities with high standards of academic excellence. Membership in the Big Ten puts Rutgers where it belongs: in the company of the best public research universities in the country.

The football coach who is leading the Scarlet Knights into the Big Ten is Kyle Flood. In his first head coach season, Flood took the team to its first Big East (now American Athletic Conference) championship and was awarded Big East Coach of the Year honors. Under Flood, Rutgers posted an unexpected 8–5 winning record in its augural Big

Ten year. And, in keeping with Rutgers' strong commitment to academic excellence for its players, in 2014 the football team once again earned a top 10 national ranking in the NCAA Academic Progress Report—the only state university to be ranked in the top 10 nationally for seven consecutive years.

Rutgers–Newark

Perhaps the most remarkable story about Rutgers–Newark athletics—maybe even the most remarkable in the history of Rutgers athletics—is how in just a few years a club sport would emerge to become the campus's only Division I program, a powerhouse team that would go on to five NCAA Final Four tournaments. That team was men's volleyball, established in 1975 by a Rutgers–Newark history professor, Taras Hunczak. By 1976, the team had won the East Coast championship and placed second in the National Association of Intercollegiate Athletics (NAIA) national championship.

"Power volleyball," as the game was then known, was a far cry from the volleyball played on beaches and suburban

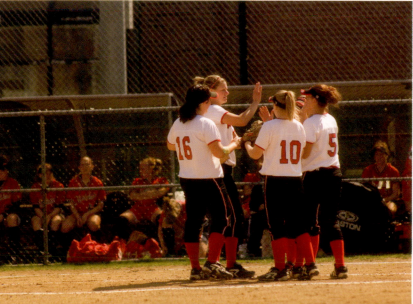

backyards. Rutgers–Newark volleyball greats include Ihor Akinshyn, a 1992 All-American, Rutgers–Newark Male Scholar-Athlete of the Year and inductee in the Rutgers–Newark Athletics Hall of Fame; Jeremy Hoff (NCAS '02), the top point producer with 1,797.5 career points; Nestor Paslawski, 1977 All-American; and Michael Richards (NCAS '88), who in 1988 led his team to one of Rutgers' most spectacular wins in a special tournament when rival Penn State was ranked number 1 in men's Division I volleyball.

Hunczak would establish a women's volleyball team in 1977. Its first coach was Christine Kogut, and the team would post five New Jersey Athletic Conference championships, obtaining its first NCAA Division III championship berth in 2003. Outstanding players on the women's team included Irene N. Darmochwal (NCAS '82), Rutgers–Newark's first female recipient of a full athletic scholarship; and Domini Lanzone (NCAS '04), who set an NCAA scoring record for kills in her first year and went on to lead her team to its first NCAA tournament in 2003.

Today, Rutgers–Newark Scarlet Raiders have eight men's sports and eight women's sports. They have fielded numerous exceptional athletes, including Jason Celentano (NCAS '95) and David Monisera (NCAS '95), who together formed a baseball infield combination ranked among the best in the nation; Brian Dena (NCAS '00), baseball, who hit a career .394; Burton Geltzeiler (NCAS '50), the first basketball player in Rutgers–Newark's history to score 1,000 points; and Stephanie Jackson (NCAS '83), who was the first Rutgers–Newark woman to pass the 1,000-point mark in basketball and the first woman to win the Rutgers–Newark outstanding athlete award. For its part, the men's basketball team has moved from a record losing streak in the mid-1980s to perennial postseason contention under current head coach Joe Loughran, with the first two NCAA Division III championship tournament berths in the program's history in 2010 and 2013.

Above: The Golden Dome Athletic Center at Rutgers University–Newark.

Below: Brett Pickens, Newark men's volleyball.

In 1977, the Golden Dome opened its doors for the first time, giving the Newark campus its first "all-athletics" venue. Arguably the most iconic and recognizable building on the campus, it is the headquarters for Rutgers–Newark athletics and recreation. The striking geodesic dome covers the main arena, which seats 1,002. All men's and women's basketball and volleyball home games are played at the Dome. Alumni Field opened in 1990, giving the Scarlet Raiders an on-campus home field for men's and women's soccer, softball, and baseball. The baseball team moved its home games to the nearby Bears & Eagles Riverfront Stadium in 1999. In 2007 and 2009, the field underwent major renovations to ensure year-round playing capacity. The Dome has also been refurbished.

The person overseeing these additions and refurbishments is athletic director Mark Griffin. One of the most well-known and recognizable figures on the Rutgers–Newark campus, Griffin has probably done more for campus athletics than any prior director. He came to Rutgers–Newark in 2004, and under his guidance, Rutgers–Newark added men's and women's varsity programs for cross country and indoor and outdoor track and field. During his tenure, athletics has achieved a visibility and fan base unparalleled in Rutgers–Newark's history. The Rutgers R is displayed prominently across the campus, a symbol of the new sense of school spirit Griffin has done so much to help create.

Rutgers–Newark athletic director Mark Griffin.

Baseball's Best Year at Rutgers–Newark

I attended Rutgers–Newark from 1986 to 1990 and was a four-year starter for the baseball team. It was a great time—especially 1990, the best year the team has ever had. Even so, for our first two years, we had no home field. We practiced in certain parks in the area, and our home games were at a local field. My junior year, we finally had a field built right outside our gym, which became Alumni Field. It wasn't the greatest, but it was home. We maintained the field pretty much ourselves. When we had double headers and there was rain the night before, our team, including the coaches, were at the field by 5:30 a.m., working on it, removing water, putting down diamond dry—you name it, we did it, to have the field playable. There was a lot of dedication on our 1990 team. We finished the year 26-14, and were ranked 10th in the country. We made it to the regionals, and fell just one game short of going to the College World Series.

—J. FREDO (NCAS '92)

Rutgers–Camden Athletics

In 1950, the College of South Jersey and the South Jersey School of Law merged with Rutgers University to form Rutgers University–Camden. The College of South Jersey brought with it a men's basketball team; in 1951, a baseball team was added. Other Division III teams soon followed, including men's golf (1957), men's soccer (1958), men's tennis (1965), men's cross country (1972), and men's outdoor track (1974). In line with colleges and universities across the country after the passage of Title IX, a women's basketball team was formed in 1974. Other women's sports followed: softball (1979), tennis (1980), cross country (1988), and soccer (1998). Over the next dozen years, an explosion of new offerings were developed on the campus, including women's volleyball (2000), women's rowing (2004), men's and women's indoor track (2006), women's lacrosse (2008), and women's tennis (2011). Men's tennis had dissolved in the early 1990s, but was restored in the spring of 2012. These additions have brought the current NCAA sport sponsorship to 19 men's and women's programs.

Early on, the athletic programs at Rutgers–Camden were known as the Pioneers. In 1998, the Pioneers gave way to the Scarlet Raptors, giving a scarlet consistency across the university's athletic programs.

In a testament to the grit and perseverance of the Rutgers–Camden athletic teams, men's basketball changed the course of history for the program and the department. In 1997, while holding the longest losing streak (117 straight games), the team defeated Bloomfield College 77–72. It was not a title or a championship win, but it was hugely significant to the Rutgers–Camden community, and the future of the athletic department. The victory was all the sweeter since only the year before, the team had actually been eliminated by then-provost Walter Gordon. This action provoked such an outcry from students and alumni that Gordon reversed his decision, explaining that he had not understood the high level of support for the team, and adding, "I started out as a nonbeliever and they made a believer out of me."

In 2003, the women's basketball team became the first Rutgers–Camden team to win a New Jersey Athletic Conference (NJAC) championship and compete in an NCAA tournament. The team won its first-ever NCAA tournament game before being eliminated in the second round. In 2004, the women's softball team got in on the postseason action by winning its first NJAC championship and competing in the NCAA regional tournament. After several years of championship

contention, the softball team ran the table in 2006. That year, it went undefeated in NJAC regular season play, won the NJAC championship tournament, and—by winning the NCAA East Regional tournament—was propelled into the national tournament. With only eight teams remaining alive in the country, Rutgers–Camden went undefeated and captured the university's first NCAA national championship title by defeating Minnesota's St. Thomas University 3–2.

In 2011, the men's soccer team started a string of NJAC championships that has not ended as of this writing. Three straight NJAC titles and three NCAA tournament appearances culminated in 2013 with a trip to the NCAA Final Four and a shot at a national title. On a cold December day in San

Camden men's basketball team playing Rowan University, 2007.

Far left: Women's basketball, Rutgers–Camden vs. Rowan University, 2007.

Left: Rutgers–Camden 2006 women's softball team celebrating their first-ever NCAA Division III national championship title.

Head soccer coach Tim
Oswald.

Tim VanLiew:
Goalie and Javelinist

In 2012, Tim VanLiew (CCAS '12, GSC '13), one of the
best athletes to ever compete for Rutgers–Camden, won
the Division III national javelin title. He won his second
title in 2013, setting an NCAA Division III record of 75.55
meters/247-10 and earning him his third All-American honor
for track and field.

But the javelin was a sport VanLiew took up only to
stay in shape for soccer. As goalie of the Rutgers–Camden
men's soccer team, he started every game from 2008 to 2011,
earning All-American honors in 2013 after he led his team to
its first NJAC championship.

In 2012, VanLiew graduated with a degree in psychology.
He returned in 2013 to earn another degree in sociology and
complete his eligibility in track and field. VanLiew is training for
international competition, including the Pan American Games,
the 2016 World Championships, and the 2016 Olympics.

Antonio, the Scarlet Raptors men's soccer team was playing in
the final game of the year against Messiah College. Rutgers–
Camden and Messiah dueled through an entire 90-minute
game with no conclusion. Two overtime periods were needed
to determine the winner. With just a few minutes left in the
second overtime period, Messiah was able to squeeze a shot
past the Rutgers–Camden goalie to end the season. The Raptors
ended with 23 wins—a school record—and a national second-
place ranking. A proud New Jersey state legislature passed a
special joint resolution on January 14, 2014, honoring the
team and its stellar season, and citing the team's "talent and
exemplary efforts in seeking and achieving athletic excellence."

One of the most successful coaches in Rutgers–Camden's
63-year history is Tim Oswald, who has posted a career record
of 122-39-22. In his tenure at Rutgers–Camden through 2014,
he has brought the men's soccer team to three consecutive
NJAC championship titles and four NCAA tournament
appearances, which included an appearance in the 2013
National Championship game. Perhaps the most iconic figure
throughout the history of Rutgers–Camden athletics is Wilbur
"Pony" Wilson. Serving as athletic director from August 1969 to
February 1998, Wilson guided the athletic department through
the transition from NAIA to the NCAA while introducing
women's athletic programs to the Camden Campus. An
outstanding administrator, coach, ambassador, and mentor,
the late Wilson was among the inaugural class inducted into
the Rutgers–Camden Athletic Hall of Fame in 2005.

Standout athlete
Tim VanLiew.

Opposite: **1.** Julie Hermann, Athletic Director, New Brunswick **2.** Scarlet Knights swimmers **3.** C. Vivian Stringer, Head Women's Basketball Coach **4.** Scarlet Knights baseball, 2002 **5.** Head Football Coach Kyle Flood **6.** Mark Griffin, Athletic Director, Newark **7.** Eddie Jordan (SMLR '15), Head Men's Basketball Coach **8.** Track and Field star Asha Ruth **9.** Jeff Dean, Athletic Director, Camden **10.** High Point Solutions Stadium with silhouette of colonial cannon team **11.** Tim Pernetti (RC '93, SC&I '95), Athletic Director, New Brunswick, 2009–13 **12.** Bob Mulcahy, Athletic Director, New Brunswick, 1998–2008 **13.** The Camden Scarlet Raptor and the New Brunswick Scarlet Knight **14.** Men's soccer game, 2003.

Wrap-up

Since that first game in 1869, Rutgers athletics has had a rich and storied history, full of big games, heartbreaking losses, and talented coaches with larger-than-life personalities. But the story of athletics at Rutgers is really about the students—the talented young student-athletes who come here to acquire a first-class education, play the sport they love, and be part of a team.

And it's about the students who proudly wear the Rutgers R as lifelong fans of their Rutgers Scarlet Knights, Scarlet Raiders, and Scarlet Raptors teams. As head football coach Kyle Flood recently said about Rutgers students:

When I drive through campus during the week, our student body is dressed in scarlet from head to toe and the Rutgers R is visible at every turn. On game day, 10,000 students pack the south end zone at High Point Solutions Stadium to cheer on our Scarlet Knights… Our team feeds off the excitement our students bring…and that is what a home-field advantage should be. The energy of the entire stadium starts with our students; they truly are our 12th man!

Rutgers Scarlet Knights faithful cheer on their team.

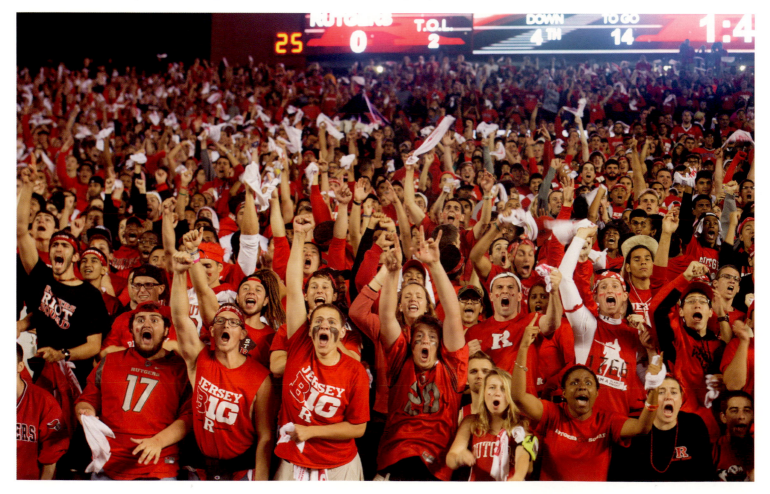

Legends and Lore

MARIE LOGUE

The Cannon War

Who does not remember the night of April 26, 1875? That night the light brigade charged "into the jaws of death, into the mouth of Hell," and came back, the next morning fully armed with "cannon to the right of them, cannon to the left of them, cannon before them." That morning when the Old Gun was brought back, was a joyous time for all…

—1877 SCARLET LETTER

It all started when the British left two cannons behind on the Princeton battlefield during the Revolutionary War. Later, the larger was given to New Brunswick at the residents' request as a means of defending themselves against the British anchored at Sandy Hook during the War of 1812. But the Princeton men worried that New Brunswick would want the small cannon also, so they buried it along a creek. When, after several years, the New Brunswick-based cannon was not returned, the Princeton militia came to reclaim it to place on the Princeton campus in 1859, occasioning Princeton boasts that they had taken it from Rutgers.

After suffering these taunts for over 15 years, Rutgers students retaliated by stealing the smaller cannon. The theft sparked a near riot at Princeton. Rutgers president William Henry Campbell ordered that the stolen cannon be removed from the grounds, but asked Princeton president James McCosh that either the cannon taken from Rutgers be returned, or that Princeton stop boasting that it stole it.

The citizens of each town lined up behind their college. Editorials proposed many solutions, including one that involved melting down the iron, selling it, and purchasing beer to be shared by all. A joint faculty committee met for arbitration, but Princeton students grew impatient and came to the Rutgers campus under cover of night; not finding the cannon, they broke into the museum and stole 21 muskets

The "Cannon Class" of 1877 was commemorated in 1927.

used in cadet drills. All agreed that events were now out of hand. Rutgers students turned the stolen cannon over to the New Brunswick police, who returned the cannon to Princeton; Rutgers renounced any claim to any cannons at Princeton.

But the war didn't really end there. In 1946, some Rutgers students tried to uproot the cannon with a vintage Ford and a heavy chain. This resulted in great damage to the Ford and the spilling of several cans of red paint—brought along to decorate the Princeton gates—on both the Rutgers men and the Princeton men who had discovered them. The *Targum* of October 11, 1946, took the position that Rutgers students should "grow up" and stop the "foolishness." But some Rutgers students do not seem to heed that advice: reports persist to the present day of Rutgers students traveling to the Princeton campus just before graduation to touch up the paint on one of the Princeton cannons—with scarlet.

Nine members of the Rutgers Scientific School Class of 1877 (forever after called the "Cannon Class") donated the cannon that today graces the Rutgers campus, and Rutgers remains very fond of cannons. Traditionally, clay pipes were smashed on the cannon in front of Old Queens the night before graduation to signify leaving behind the dissipations of youth (some say, pipe dreams). Rutgers College continued

Above: Graduation tradition of smashing clay pipes on the cannon in front of Old Queens.

Below: Line drawing of 19th-century students pulling the cannon on a cart.

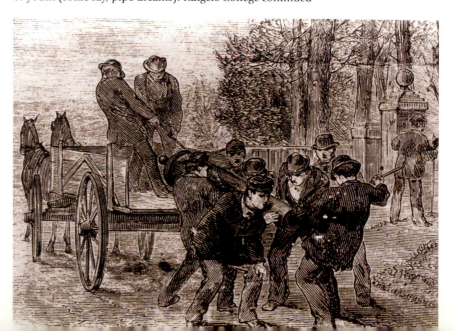

Right: Willie the Silent in his early days on campus when roadways traversed Voorhees Mall.

this tradition right up to its last graduation in 2010. And, of course, we continue to celebrate every Rutgers score on the home gridiron with the firing of a cannon.

Old Queens Bell

The bell in the cupola of the Old Queens Building was a gift from Colonel Henry Rutgers in 1826 and was rung to summon students to mandatory chapel at 9 a.m. to start the school day. More recently, the bell was rung at commencement ceremonies; today, it is rung by order of the president to mark special occasions or accomplishments. The walls of the closet housing the rope pull three stories below the cupola are filled with the initials of the students, faculty, staff, and honored guests who have rung the bell.

William (Willie) the Silent

On the Voorhees Mall between the Graduate School of Education and Van Dyck Hall stands a 13-foot-tall, 2,000-pound cast bronze statue of William the Silent, Count of Nassau, Prince of Orange—a gift of the New York Holland Society in 1928 to remind Rutgers of its Dutch roots, and the

only copy of the Lodewyck Rowyer original in The Hague. The real William the Silent earned his nickname after a 1559 hunting expedition with King Henry II of France, with whom he was mediating the Spanish-French War. Henry told the Prince of Orange that he wished to crush all the non-Catholics in France. Willie did not disclose the information right away but remained silent, waiting for the most opportune time, thus saving many lives. Student lore says that the reason Willie has remained silent all these years is that he will whistle only when a young virgin walks by.

The Queens Campus Gates

Four distinctive wrought iron gates, named for their class benefactors, fringe the perimeter of the original campus property: the Henry Rutgers Baldwin Gateway, the Class of 1882 Gateway, the Class of 1883 Gateway, and the Class of 1902 Gateway. Legend has it that students passing through the 1882 gateway during their college career are doomed to failure. In the 19th century, freshmen were not permitted to use the front gate at George Street (the Class of 1883 Gateway), and instead had to walk all the way around the block to use another gate; to flout this rule ensured retaliation from upperclassmen. And up until the early 21st century, superstitious Rutgers College students would avert potential doom by not passing through the Class of 1902 Gateway until graduation, when the entire graduating class would go through the gate on its way to Voorhees Mall.

The Alexander Hamilton Sign

Standing in Parking Lot #1 next to Kirkpatrick Chapel is a sign reminding all that New Jersey and Rutgers were at the crossroads of the American Revolution. On November 30, 1776, General George Washington and the Continental Army stopped to rest on the banks of the Raritan after having been routed by the British in battles at New York and Fort Lee. On December 1, Redcoats were spotted on the other side of the river, and Washington was forced to retreat. To cover Washington's withdrawal, Captain Alexander Hamilton,

then a 20-year-old artillery commander, fired on the British and Hessian troops—unfortunately not from the site of the sign as reported, but actually two blocks north at the higher hill overlooking the Raritan at the corner of George Street and Bishop Place. Hamilton joined the rest of the army in Pennsylvania. Just a few weeks later, the Continental Army crossed the Delaware and won the Battle of Trenton.

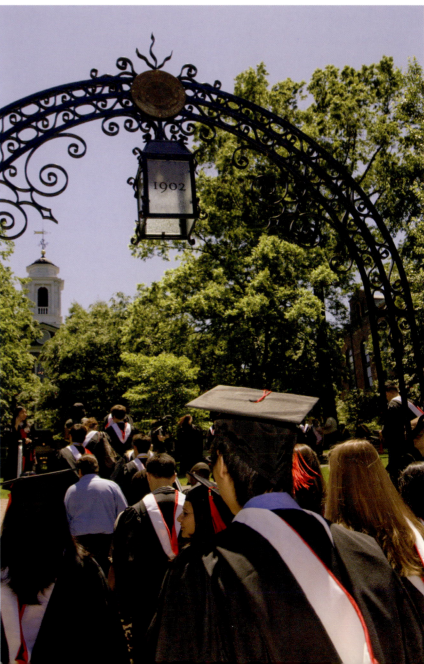

Graduates walk through the Class of 1902 Gateway on Hamilton Street on the Old Queens Campus.

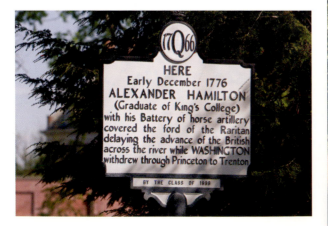

Passion Puddle: Is it on the Cook Campus or the Douglass Campus? Depends on whom you ask.

Sacred Path

This tradition began in the earliest days of Douglass College when students and faculty gathered in the spring to celebrate the "moving up" of the classes. At the first ceremony, first-year students became sophomores as they were escorted down Sacred Path by upperclasswomen. The Sacred Path tradition has continued unbroken to the present day.

Passion Puddle

In the middle of the green space between the Douglass and Cook Campuses lies a scenic pond known to generations of Rutgers students as Passion Puddle. On warm fall or spring days, the lawn surrounding the puddle is filled with students studying, lounging, or people-watching under the trees. But Passion Puddle's claim to more universal fame is the belief that the person with whom you walk around the puddle three times is the one you will marry. Some versions of the legend say this applies only to Douglass women and Cook men, and that the wedding will take place within a year. Fact or fiction? All we know is that there are an awful lot of marriages between sweethearts who met at Rutgers. We are less sure of the role played by Passion Puddle.

Douglass women have celebrated the Yule Log ceremony for nearly 100 years.

Yule Log

Yule Log began in 1918 when the students of the New Jersey College for Women asked to light a tree and burn a Yule log in the foyer fireplace of College Hall. The students stood with candles on the curved staircase and sang Christmas carols. Today, Yule Log, held in Voorhees Chapel, includes many diverse cultures, religions, and traditions in its seasonal celebration. Douglass students still hold candles, sing songs, and read passages that celebrate the campus community and the winter season.

Rutgers on Broadway: Nobody Ever Died for Dear Old Rutgers

"Nobody ever died for dear old Rutgers,/Nobody ever had a life to give./When you're clipped by someone in the rear,/You hear a mighty cheer,/But you're laid up for a year…"

Composed by Jule Styne to lyrics by Sammy Cahn for the 1947 musical *High Button Shoes*, "Nobody Ever Died for Dear Old Rutgers" jauntily parodies extreme school spirit. Famously sung by Phil Silvers, the lyric invokes the 1892 football game between Rutgers and Princeton during which Frank "Pop" Grant (RC 1895) is said to have exclaimed that he would "die for dear old Rutgers" as he was carried from the field with a broken leg. John Thomas, the popular janitor of Winants Hall who was present at the game, said that what Grant really said was "I'd die to win this game." Others said Grant said, "I will die if somebody doesn't give me a

Below: Cover of *Life* magazine, 1929—"I'd die for dear old Rutgers".

cigarette." This much is certain: Grant's leg was broken, John Thomas helped nurse Grant back to health, and a great story of football heroics and a great parody of football heroics—which the Rutgers University Glee Club has added to its repertory— were born.

The RU Screw

We have to be honest. Campus life at Rutgers—especially in New Brunswick—comes with its share of disappointments. Closed courses. Housing lotteries that don't always yield a student's first or even second choice. Crowded buses. Parking tickets; more parking tickets. U.S. soldiers in World War II had a name for it—SNAFU: Situation Normal All F___ed Up. Rutgers students have their own name for it: the RU Screw.

Campus life in Camden and Newark must be prone to less drama, because students there report that only the New Brunswick campuses seem to suffer from this phenomenon. It may have a lot to do with scale.

The RU Screw is understood to be at work when the last course you need for graduation to satisfy a major requirement is suddenly canceled. Or when the parking pass you are issued is for a campus other than where you live. Or when your work study eligibility is mysteriously withdrawn. Or when the only sections open for the course you need are first period or Friday afternoon. Or when the bus driver takes what appears to be an unscheduled 10-minute break when you are already late for class or an exam.

The RU Screw has been used to describe the ironic, the iconic, the patently unfair, and the ridiculous. All its survivors are proud to remain standing. Rutgers seniors boast, "I can deal with any bureaucracy now." That's public education at its best: teaching critical life skills and mental toughness.

Fraternities and Sororities

**AMY VOJTA, ASSISTANT DEAN,
FRATERNITY AND SORORITY AFFAIRS**

Fraternity Life Comes to Rutgers

The story of Rutgers University fraternity life is really the story of Rutgers University. Fraternity members played a role in founding many of the oldest institutions within Rutgers and many of the traditions. The membership of the fraternities and sororities reflected the growing diversity of the student body as Rutgers evolved from a private college for white men from New Jersey and New York to a public research university with a land-grant mission drawing women and men of an extraordinary range of cultural and ethnic backgrounds from New Jersey and around the globe. As the university celebrates 250 years, the Rutgers Greek community looks back at over 170 years of influence on the banks.

The university's first fraternity, Delta Phi, was founded in 1845. Daily life for a student at Rutgers was then very

Where's my bus? The question asked by generations of New Brunswick students.

Members of the Delta Upsilon fraternity in 1882. Seated second from the right is Irvin Upson (RC 1881), the first full-time administrator at Rutgers who served as college librarian, registrar, secretary to the faculty, treasurer, and secretary to the Agricultural Experiment Station—many of which he served simultaneously.

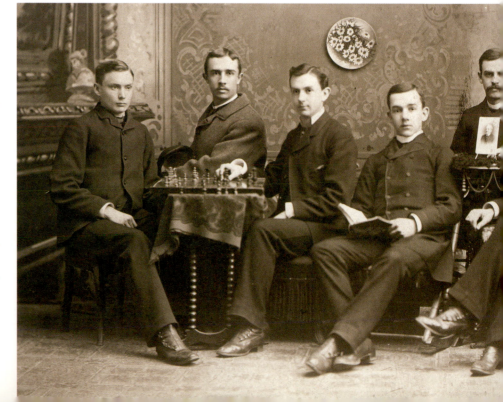

Class of 1893 emblem in *Scarlet Letter* yearbook.

Above: Brothers of the Sigma Alpha Mu fraternity in front of 18 Union Street, left to right, are Bob Fish (RC '63), Eric Gerst (RC '62), Dave Wax (RC '62), Terry Jeck (RC '62), Bob Tucker (RC '62), Mike Hagler (ENG '62), and Irwin Zazulia (RC '63).

Right: Zeta Psi around 1890.

prescribed—classes in Greek, Latin, theology, and oratory took place under the watchful eye of faculty. Students looking to share ideas outside the classroom had created literary societies on campus, but the Delta Phi social fraternity provided a student voice on campus happenings, extended membership beyond the college years, and provided fellowship and support.

At the time, many alumni, administrators, and faculty members were opposed to the concept. Some were so disturbed by Delta Phi they labeled it subversive and forced many men to take their membership underground. The majority of faculty members, however, were favorably disposed, because so many of the best students were members. And in any case, most thought the novelty would wear off.

That did not happen, however. Within a year of its founding, Delta Phi membership grew from 12 to 19–25 percent of the student body in those days. As time passed,

fraternities slowly gained acceptance—particularly as younger faculty members were hired, many of whom were fraternity alumni members themselves.

By the end of the 1880s, the ability of fraternities to enliven the campus had been firmly established. Fraternity men created and founded campus athletics (crew, baseball, and the first intercollegiate football game), student publications (the *Daily Targum* and the *Scarlet Letter*), musical ensembles (the Glee Club), and student government.

In 1887, Delta Phi became the first fraternity organization to build its own house, laying the cornerstone on June 21. Although partially destroyed in a fire in 1929, the house is today the Office of the Dean of the School of Arts and Sciences at 77 Hamilton Street.

The Changing Face of Greek Life

As Rutgers grew and evolved from colonial college to land-grant college to university, the fraternity community grew and evolved as well. Just as social fraternities were created to provide students with an outlet from the rigors of academic work, professional fraternities were created within specific majors to support students in that work and after graduation in the workforce. The university welcomed its first professional fraternity in 1930 when Lambda Kappa Sigma International Professional Pharmacy Fraternity was founded to support the men—and the women—at the Rutgers School of Pharmacy.

By the 1940s, the fraternity community had expanded to roughly 27 new chapters, and fraternities had become such an accepted part of not just campus life but society in general that their alumni were sought-after and distinguished leaders. William H.S. Demarest (RC 1883), Delta Phi, was the first alumnus to become president of Rutgers College. President Philip Brett was also a Delta Phi alumnus. The fraternity community produced several other prominent alumni—Bishop, Carpender, McKinney, Mettler, Metzger, Neilson, Scott, Silvers, and Voorhees—whose names every undergraduate in New Brunswick recognizes from eponymous buildings on campus today.

During the second half of the 20th century, the divisions that existed within the Rutgers student body

Let's Keep Dancing

The lasting vigor of the annual Dance Marathon may be one of the best indications of the health of the Rutgers fraternity/sorority program. Now the largest student-run philanthropic event in all of New Jersey, the Dance Marathon in 2014 raised over $622,000 for the Embrace Kids Foundation, a not-for-profit organization supporting the nonmedical needs of children with cancer and blood disorders. Over 1,000 people are involved in this yearlong effort to raise funds and awareness. Students dance for 30 hours; alumni, faculty, staff, and state officials come to offer encouragement. The event outgrew the College Avenue Gym and took place in the Rutgers Athletic Center in 2014. Dance Marathon's mission is to create a legacy of service, caring, and community involvement at Rutgers; it has spawned RU4Kids, which matches participating student organizations with the families of patients from the Bristol Myers Squibb Children's Hospital so that students can directly interact with the kids and develop strong relationships with them and their families. Any marathoner will tell you: it's all "for the kids."

reflected the divisions within higher education and society as a whole. In brief, this meant that professional fraternity membership was generally denied to women and that most fraternities limited membership based on cultural, religious, or racial differences. The color barrier of fraternity life was finally broken in 1950, when Alpha Phi Alpha Fraternity, Inc., became the first African-American men's group on campus. Twenty-five years later, Alpha Kappa Alpha Sorority, Inc., a historically African-American women's organization, took up residence at Rutgers College as well.

The evolution of Greek life continued in part due to student activism, especially among students of color. In the spring of 1979, a group of Latino students began talking about creating an organization that would represent their needs, help students achieve their goals, and provide a sense of family to those away from home. The Latino Social Fellowship was thus established in 1979 on the Livingston Campus as Lambda Sigma Upsilon. It was the catalyst for three other Greek letter organizations subsequently founded at Rutgers: Chi Upsilon Sigma National Latin Sorority, Inc., in 1980; Mu Sigma Upsilon Sorority, Inc., in 1981, as the first Multicultural Greek Letter Society; and Omega Phi Chi Multicultural Sorority in 1988.

Fraternity/Sorority Life Today

As the fraternity and sorority community at Rutgers continued to grow, it saw the arrival of its first Asian-interest organization, Alpha Kappa Delta Phi Sorority, and South-Asian Greek letter organization, Iota Nu Delta Fraternity. By 2013, the Greek community at Rutgers comprised over 80 men's and women's organizations with roughly 3,800 members.

Many Greek communities were, in the early 1980s, enjoying the best of times, in terms of growing membership— and the worst of times, in terms of risky behaviors. As the Rutgers Greek community recovered from the death of one of its own as a result of alcohol abuse, policies were put in place to both minimize risky behaviors as well as ensure that fraternity and sorority chapters conducted activities that complemented the mission of the university.

This increased sense of accountability shifted the focus toward more purposeful programming by the Panhellenic and Interfraternity Councils, and led to the formation of the Office of Fraternity and Sorority Affairs. Scholarship dinners, leadership development programs, new member education, and community service initiatives were all designed and delivered in an effort to take the present-day fraternal organizations back to their roots of leadership, scholarship, service, and friendship for life. Fundraising and hands-on service to local agencies like the Embrace Kids Foundation, as well as service to national organizations like Autism Speaks and the Susan G. Komen Breast Cancer Foundation, demonstrate the fraternity and sorority community's commitment to others.

Phi Sigma Sigma sorority sisters at 2013 Commencement.

Sorority sisters sell cotton candy at Rutgers Day on Busch Campus.

Above: A game of Ultimate Frisbee. Rutgers is the birthplace of collegiate Ultimate Frisbee.

Below right: Rutgers Cricket Club president Hardik Jogani (ENG '12).

Intramurals

Diane Bonanno, Executive Director of Recreation, Rutgers–New Brunswick

The first attempt at providing an organized recreational sports opportunity for the men of Rutgers College began in 1867, when a group of students formed the Rutgers Boating Association. While it began as a social activity, it soon took on a competitive nature and attracted the attention and support of the student body. Crew eventually became an athletic team, as did so many of the sports students started informally to compete against other colleges or against other student groups on campus. Some that were started in the late 1800s, such as ice hockey, which debuted in 1892, still exist today as one of the 54 sport clubs the Recreation Department supports.

The most famous of the Rutgers clubs is Ultimate Frisbee. The first collegiate game of Ultimate Frisbee was held November 6, 1972, when Rutgers played Princeton—on the very same ground where, 103 years before, these schools had met to play the first intercollegiate football game ever. Rutgers won the Frisbee game 29-27. The media and close to 1,000 people attended the event. According to Dan "Stork" Roddick (GSNB '74, '78), a Rutgers alum who is still involved with the sport, it was magical.

Like ice hockey and crew before them, today's sport clubs develop as a result of student interest. They are student led and member funded, which make them among the most important leadership opportunities at the university. The listing of recognized clubs fluctuates with changing student interests. Quidditch, for example, made popular by the Harry Potter books and movies, became a club in 2011. It is one of the most unusual sports—a list that also includes cricket, capoeira, and eskrima—while baseball, basketball, soccer, and lacrosse are staples that reflect students' desire to continue to participate in a sport they played in high school or on a traveling team.

Over the years, the competitive nature of the clubs has changed as well. Where once an officer of the club made arrangements to compete with another school by calling his or her counterpart at that institution, many clubs today belong to a league whose governing body handles the scheduling.

The success of these student enterprises is underscored each year when some 10 or 12 teams qualify for their regional or national competitions. The Equestrian Club, for instance, had women qualify for its regional competition for 10-plus years; men's ice hockey qualified for its nationals in 2011, 2012, and 2013; and the Ski Club qualified for regionals for the past five years and sent seven members to the nationals in those years.

The first building on campus that housed intramurals and club sports was Ballantine Gymnasium. After a fire partially destroyed the building, it was replaced in January 1932 with a state-of-the-art facility on the field where the first football game was played. The completion of the College Avenue Gym, or "the Barn" as it was nicknamed, opened the door for an expansion of intramurals and physical education classes, creating the foundation of what is available at Rutgers today.

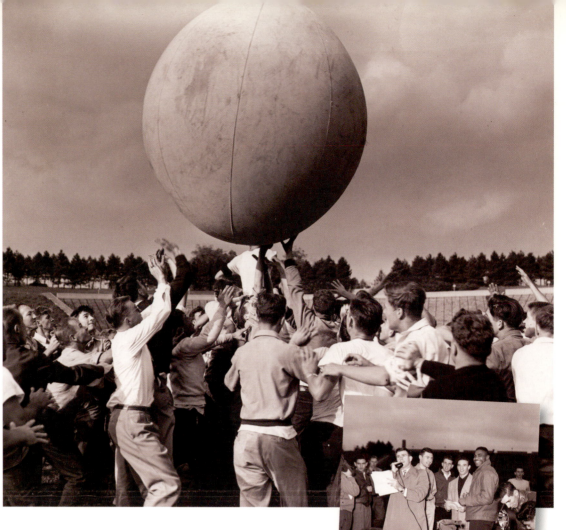

Another event facilitating this expansion was the introduction of the Keller Trophy, named after Professor Henry Keller (ED '49, GSED '50), who donated the trophy in 1933. Keller determined that the trophy should go to the "living group" that gained the most points throughout a year-long intramural competition. Throughout its history, the event has featured competition in basketball, flag football, baseball, and softball. The sports that comprise the competition change with student interest. Today, you are likely to see dragon boat racing, a mud run, and dodgeball listed for points; while in the '70s and '80s, you would have found arm wrestling, cross country, billiards, and darts.

While Professor Keller envisioned his trophy as motivating all groups to become involved in competition, it eventually became a league for fraternities only. Delta Upsilon won the cup in 1933, its inaugural year—a victory that was soon eclipsed by the men of Delta Kappa Epsilon, who won the trophy the next six years in a row. Over its history, the cup has been won by 15 different fraternities and remains a source of pride for those who compete.

The Miers Cup, named for Earl Schenck Miers (RC '33), a former editor-in-chief of the *Targum*, Civil War historian, and founding director of the Rutgers University Press, was developed to promote competition among the residence halls and off-campus living groups, but that faded away in

the early 1980s and was replaced by open leagues that made it possible for commuters and students who lived off campus to form teams with on-campus residents. Removing the restrictions strengthened the leagues and promoted mixed teams. Today, the intramural program features over 50 leagues. You will find neon dodgeball, where the lights are turned out and the players and the balls glow in the dark; or sink the battleship, which is played in canoes that are launched in the pool—the object of the game is to fill your

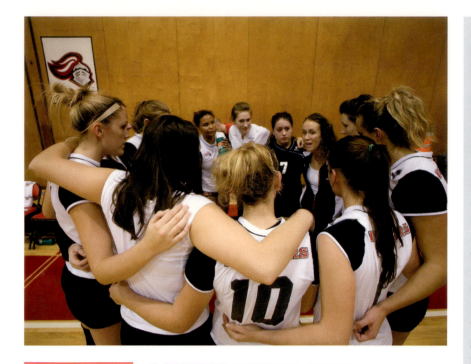

Women's Volleyball Club, 2006.

A Brief History of Gym Class at Rutgers

Compulsory physical education goes all the way back to 1886 when freshmen and sophomores were required to participate in one hour of class instruction and three hours of individual exercise each week. In the 1940s, reflecting a physical education requirement imposed by the Board of Governors to support the war effort, the men of Rutgers College were required to enroll in three hours of physical education classes after completing a physical examination and an aptitude test that helped them decide which of the courses to select. If the student did not qualify physically, he would be required to take corrective exercise that hopefully would lead to his eventual inclusion in the regular program. Freshmen were also given a swimming test that consisted of a 50-yard swim, a front dive, and good "watermanship." If they did not acquire these skills, they were enrolled in a swimming course until they could pass the test. Some took all four years to meet the criteria.

The student today faces no such challenges, though they can choose from over 300 classes a semester. There are few, if any, prerequisites beyond the desire to participate. Students can get their scuba diving certification, learn to dance, practice several different forms of yoga, take a massage class, and improve their health with "Zumba," "Grit," "Spinning," "RU Fit," "Bodycombat," and a number of other popular courses.

—Diane Bonanno,
Executive Director of Recreation

opponents' canoe with water until they sink below the surface and yours is the only canoe afloat. For decades, students have also been playing inner-tube water polo, under-six-foot basketball, and futsal, a type of soccer played indoors.

In addition to its intramural leagues, Rutgers has had scores of special competitive events. Some have been more raucous than others, like the 1963 cage ball game, which attracted 600 sophomores and freshman. They played on a field behind the College Avenue Gym, each team trying to force the cage ball over their opponent's goal. Eventually the sophomores walked off the field, giving the freshmen a victory.

As the country as a whole has become more fitness conscious, so too have Rutgers students, as reflected in their special events. The RU Muddy, the Color ME RU, and Illuminate the Knight are three races that gather almost 2,000 students each year. These races are complemented by RU Strong, Twilight Yoga, Tour de Rutgers, Yoga in the Park, and many other events that bring students together to participate in fitness and stress-reducing activities.

And there are also those special events that have become a tradition at Rutgers, like the Trivia Bowl born at Cook College in the 1980s, which continues to attract some 250–300 players each year; and the Big Chill. This unique race is one of the largest 5Ks in the state, signing up more than 8,000 runners in 2014. What makes it unique is that there is no monetary entrance fee. Instead, participants are asked to bring a toy for a needy child. In its 10th year, the race collected over 10,000 toys, which were donated to 17 different charities.

Life at Douglass

When I was a student at Douglass (1965–69), we had to wear skirts to dinner every night. I lived on Gibbons, so we walked to Cooper Dining Hall for meals. On cold nights, we'd wear skirts over our pants. After one snow storm, Marjory Foster, our dean, gave us permission to wear pants. It was a revelation to all of us! We never looked back… and were able to wear pants after that. I also remember freshman orientation and meeting President and Mrs. Gross at the president's house. We were told to wear white gloves so we could shake their hands. Since most of us didn't own white gloves, we'd pass them down the line before going through the reception line.

Afterwards we had "boxed" dinners on the lawn with Rutgers freshmen … our first introduction to the Rutgers "men." It's where I met my first Rutgers boyfriend!

—Terre Martin (DC '69)

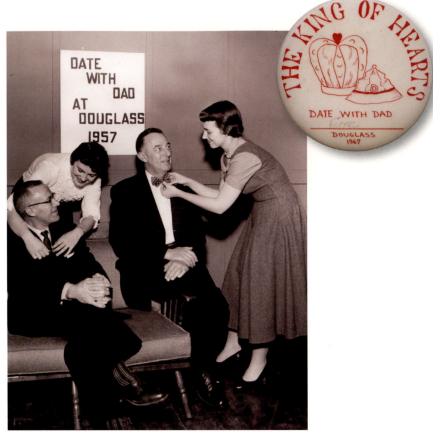

Coming of Age at Rutgers in the 1970s

Gail Walker (DC '73)

Campus and student life was changing radically during my Douglass years. Yes, we still were required to wear white gloves to the Dean's Tea. But 1969–70 was the first time students were not required to wear skirts at dinner. And in May, a coalition of students and faculty joined together after the Kent State shootings, and Douglass became one of the first colleges to go on strike for peace. The next year, 1970–71, was the first time students were allowed to have phones in their rooms, had no rules about signing in or out of the dorms, had no curfew, and were free to invite male visitors into their rooms any time of day (or night). Also,

the Government Association (GA) succeeded in getting student representatives to participate in faculty meetings. A peer counseling center was established in 1971–72, which was staffed by trained student volunteers, and the first "Psychology of Women" course was offered.

Marjorie M. Trayes, the dean of students when I arrived, was telling students to "Keep your feet on the ground and your eyes on the stars." I translated that to mean "Neither lose sight of reality as it is now, nor be limited by it."

Douglass changed almost as much as I did during my years there, as it explored its mission as a women's college and its methods to empower students to expand their sense of professional and personal possibility. In 1970, a joint student-faculty committee chaired by Mary Howard and Elaine Showalter released a comprehensive report on "The Education of Women" that identified both curriculum changes, such as courses in women's studies and a first-year orientation focus on the goals of women's education, and student life goals, such as granting the same freedoms as those enjoyed by students at Rutgers College.

Douglass had always been considered the state school that gave the advantages of a Seven Sisters school approach to people of all classes and races. Friends I made at Douglass had been accepted at Radcliffe, Smith, and Mount Holyoke. Many

Douglass students were the first in their families to attend college, and the validation of achievement for women was pivotal. As the culture in the country focused more on issues of race and class, Douglass responded both in coursework and campus activities catalyzed by the student-faculty report "Ethnic Race Relations of Douglass College." There were campus tensions, and I recall difficult conversations across races both in classes and in dorms. Now I notice at reunions that the Class of 1973 seems to have the most racially mixed attendees, perhaps because we had those conversations.

The Voorhees Assembly Board offered weekly programs that brought dynamic movers and shakers to campus—Gloria Steinem, Dick Gregory, Kate Millett. Contemporary issues of feminism, race, politics, science, art, music, and culture were offered to the students by prominent outsiders as well as by our Douglass faculty.

During my years at Douglass, I was involved in the GA as a representative, one of the first student representatives to the faculty, and finally as president in my senior year. I was a house chair in Katzenbach my junior year and also

one of the first peer counselors. These roles allowed me to interact with deans and faculty and taught me lessons about speaking truth to power that have been essential in my career. I especially recall Dean Margery Somers Foster and dean of students Nancy Richards. I'd found both of these women formidable, and my stomach was in knots before my earliest interactions with them, but over time I was able to relate to them as people. Most important of all, through these interactions and experiences, I saw strong women in roles of authority, wisdom, and power and learned to question—and change—the status quo.

Campus life combined the vibrant energy of social change and challenge with lively Douglass traditions. There were formal traditions such as Sacred Path, Yule Log Ceremony, Date with Dad, International Weekend, the green freshman dinks, Pixie Week, and house meetings which provided a sense of continuity with the alumnae who had preceded us. There were programs for commuters and for Sophia (nontraditional) students, residential language houses, and the Black Student Congress. Then there were the times of hanging out at Passion Puddle, picnics on Antilles Field, conversations by the mailboxes or snack bar in the Douglass College Center, in dorm lounges or the NJC lounge, and up on the third floor of the Student Center for those of us active in GA, the Judicial Board, *Caellian* (the student newspaper), the *Redbook Handbook* of information for students, and *Quair* (the college yearbook). There were athletic activities through the Recreation Association before Title IX was passed in 1972. There were music and theater groups such as the Voorhees Choir and the Douglass College Weepies, and performances by students and faculty.

And connecting it all was the sense that there were already successful and powerful alumnae in the world who served as role models and potential allies. Being a Douglass woman meant immersion in an enriched environment during college years and a promise of future support, connection, and inspiration. When I have returned to campus in the 40 years since I graduated, I have been inspired by the passion and potential of today's Douglass women and have great hope for the future of the Douglass brand.

Saved your dimes, called collect, and hoped that someone would answer the phone when your important call came in. Those were the days when most dorms had one phone per floor. Most students today would find it prehistoric!

College, Campus, Community

Lea P. Stewart, Livingston Campus Dean

During the most recent reorganization of undergraduate education at Rutgers, there were countless discussions of what became known as the "Big R" versus the "Little Rs"—whether Rutgers–New Brunswick would maintain smaller communities (the Little Rs) within a large university (the Big R). Many worried that, without the Little Rs, students could get lost in a vast, difficult-to-navigate institution. It was decided that it was important to maintain campus-based identities within a larger university setting. Many people worked very hard to ensure that the Livingston Campus found an identity that both honors the Livingston legacy of the past and is poised for the future.

Livingston has always been a place that fostered creativity and educational innovation, supported student engagement, and relied on the resilience of students to succeed in often unexpected ways. From the founding of Livingston College to the present-day campus, Livingston has been synonymous with educational innovation, encouraging nontraditional academic engagement. Students designed their own majors, negotiated grades with faculty members, and had a voice in all important committees including admissions. Innovations continue today, with Quad 2 serving as the home of the Social Justice Living-Learning Community as well as the Discovery Houses, which provide in-depth study in business, health and medicine, law and political science, and psychology for first-year students. And, of course, there's the new Rutgers Business School building, designed by noted architect Enrique Norten.

For the early Livingston College students, the Great Hall in Tillett served as the student center and was the site of dances, tabling by student organizations, and other social events.

SpringFest was an annual ritual at Livingston that changed in shape and form to match the culture on the campus and the spirit of the times. In its early days, students enjoyed free beer and spent their time tossing Frisbees. Later incarnations featured student organization tables, DJs, bonfires, and inflatables. No matter what the form, SpringFest signaled the beginning of warmer weather and the anticipation of the end of the semester.

From an AM station that could only be received in Livingston residence halls to a modern FM station partnering

Livingston College students Gary Warren (LC '75), left, and Anthony Sloan (LC '76), center, edit tapes in Livingston College's Urban Communications Teaching and Research Center while director and professor Jerome Aumente (NCAS '59) looks on.

The Livingston Theatre Company

When I arrived at Rutgers, I was disappointed in the absence of the performing arts on Livingston Campus. Gathering some fellow students together, I soon founded what has become one of the hallmarks at Rutgers University in the fall of 1998. The Livingston Theatre Company is a universitywide student-run performing arts organization/learning community that involves over 100 students each academic year. Although artistic excellence has been a core part of its mission since its inception, the benefits of student development and leadership have been the anchor of its success. As Rutgers University's premier musical theater organization, the group has produced both classic and forgotten musicals of all sizes and scope for thousands of patrons.

—Jason Goldstein (LC '02, RBS '05)

Livingston Lives On

In every week of my life since I graduated from Livingston, I have wrestled with ideas, ideals, and questions that were part of my education at the college. That's partly a testament to the course I set for myself when I applied to Livingston: I was drawn to a school that embraced urban issues, creative learning, and making higher education more democratic. Once there, I learned many of the things that have sustained me as a journalist, historian, professor, and public-minded citizen. But it is also a sign of how Livingston, if you took it seriously, could get under your skin. My college years are long past, and when I visit the campus, the school I went to is increasingly difficult to recognize. But the causes we pursued there, students and faculty alike, are still with me. Livingston is an important part of my past, but is also part of my present.

Livingston was about active learning: you had to read, write, and talk in class. There were very few big lecture courses that let you hide in the back of the room. I'm not saying that every student came to every class prepared, but if you wanted a school where you could have your say with your own ideas, Livingston was a great place.

Some students came to Livingston because they thought its flexible requirements were just right for people who didn't know what they wanted to do. Such folks often wound up floundering. But if you knew what you wanted

to do—and I did—it was a tremendous opportunity. The faculty really encouraged you.

Livingston's facilities were lonely and underdeveloped, but like many students, I was tremendously proud of jazz at Livingston and enjoyed how it was a constant presence on our campus.

Equally important to me were the Livingston woods, now the ecological preserve. Being able to walk out of my dorm and into the forest was a great break from campus life. I ran there, swung on a rope that hung from a tree there, and a few times built little campfires so my friends and I could sit back and look into the flames, "dreaming the fire," in the wonderful African phrase.

As a student at Livingston, I had an acute sense that the rest of Rutgers looked down on us. I often joked to friends that Rutgers played the British empire to Livingston's Ireland. But even though we often felt dissed, I felt then—and now—that what we were trying to do at Livingston had tremendous value.

I was sad to see Livingston disappear in centralization. But I take great pride in the good work done by Livingston faculty and administrators who went on to serve Rutgers at large. The good things they have accomplished for the entire university are proof that Livingston accomplished things of value—yesterday and today.

—Rob Snyder (LC '77)

Above: Livingston College catalog cover from the 1970s.

Below: Painted in 1973 by "People's Painters"—a largely student-run group established under the guidance of professor James Cockcroft and his wife, Eva Cockcroft, a noted muralist—this Livingston Campus mural celebrates the idea of "Strength through Diversity."

with Piscataway High School to reach 1 million potential listeners, 90.3 RLC-WVPH FM (known affectionately as 90.3 the Core) embodies the spirit of the Livingston student—someone who has a dream and makes it a reality. In 2007, students raised over $20,000 to build the "Tower of Tomorrow" that increased the station's broadcast area.

Another student dream, the Livingston Theatre Company, celebrated its 15th anniversary in 2013. Began by

an undergraduate who thought it would be fun to put on a musical, the company has served as an inclusive community for students from throughout the university.

And, of course, who could forget the mud? The first Livingston College newspaper was even named the *Mudslide* in honor of the state of the landscaping at the time. Current visitors to the campus will have a difficult time imagining the challenges faced by students over the years as they negotiated their way around various construction sites, but we can all be thankful they did. Today Rutgers Recreation creates muddy paths so students can run through the ecological preserve for a fun run.

Much has changed at Livingston, but much remains the same. Although there is certainly less mud, there is still a spirit that unites the campus and contributes to an inclusive community that strives to change the world one student at a time.

An early home of the predecessor of Rutgers Business School on James Street in Newark, 1940.

Campus Life at Rutgers University–Newark

Jack Lynch, Professor of English,
Rutgers–Newark

A Streetcar University

Large numbers of Rutgers–New Brunswick students have lived in college housing since the late 19th century, but Rutgers–Newark has always served more commuters than residential students.

In its early days, the Newark colleges formed one of the Progressive Era's "streetcar universities," where working-class and immigrant students depended on public transportation to travel from the surrounding suburbs and around the city. Even today, after a number of dormitories have been built for both undergraduates and graduate students, less than a quarter of Newark's students live on campus.

This had consequences for life at Rutgers–Newark. In 1934, more than half a century before the first dormitory was opened, the student paper complained of "the absence of real campus life." Though the Newark schools—the New Jersey Law School, the Seth Boyden School of Business, and Dana College—were still young and small, they resolved to address this absence, and to provide a coherent college experience to the students they served.

When the Newark colleges were founded, the city was bustling. Newark's population was about 400,000 in the 1920s, making it the 15th largest city in the United States; some said the intersection of Broad and Market Streets was the busiest in the country.

Though Newark had a handful of mansions built by the super-rich in the Gilded Age, most of the city was working class, and immigrants and migrants dominated. About half of Newark's residents were born outside the United States, and the mix of ethnicities—Italians, Greeks, Jews, Russians, and English—was rich and diverse.

A Workers' Institution

Newark's students have rarely come from backgrounds of privilege, and for most of them going to college involved struggle and sacrifice. In 1930, the student newspaper noted

that, "Unlike most colleges, Dana College is primarily a workers' institution." Financial aid was a rarity in those days. The university gave out a few small loans, and ethnic communities in Newark raised money to send students to the university. But most of the students had to find part-time or even full-time jobs if they wanted to keep going to class. About 60 percent worked to put themselves through college, including almost 80 percent of the night students—numbers that were unheard of at colleges with more privileged student bodies.

This has meant that campus life in Newark has never been what it is at many other colleges: commuters who work

Sharing a moment between classes on the New Street Plaza on the Newark Campus during the 2014 spring semester.

"Newark… One of the richest veins of creativity, productivity, human diversity that we have in the United States."

—Clement A. Price (GSNB '75)
Board of Governors
Distinguished Service Professor of History

full-time jobs simply don't have the time for the clubs and sports that define college life elsewhere.

Still, there has always been a distinctive culture in Newark. And by the 1930s there were already in place the sorts of traditions that give a campus its character. The *Scroll*, a handbook published in 1937, offers advice to first-years: they were to wear green bow ties (men) or green hair ribbons (women), and to address juniors and seniors as "Sir" or "Miss." They were also to be sure to carry matches at all times, in case their elders asked them to light a cigarette.

Student Associations

All the Newark colleges founded their own student associations, and much social life on campus revolved around these. Soon the male-dominated groups were joined by the Girls' Activities Association, which offered "bridges, afternoon

Below right: Women fencing at Newark in 1953.

Reflections on Night School

It was five years after the end of World War II. I was just out of high school. I joined the many veterans of that war and enrolled at Rutgers' Night School in Newark.

Fortunately for me, the Night School had an open admissions policy; otherwise, having graduated in the bottom quarter of my high school class, I would not have been admitted—and likely would not have obtained a college education at all.

I needed to support my sister and my parents, so I worked at an insurance company in Newark during the day and went to college two nights a week. I took three courses but, one semester, I decided to take four in order to speed up the process, so I went to New Brunswick to take "New Jersey History and Government" on Saturday mornings. The problem was that I couldn't afford the train fare. So I borrowed a friend's rail pass. When the conductor punched the ticket for my ride, I picked up the punch and stuck it back in the hole in the card using the tip of a ballpoint pen. I did the same for the return trip—all semester long!

I became a much better student at Rutgers once I found that I liked to learn and that I was actually good at it. The dynamics of the classroom, associating with veterans older and wiser than I was, and the stimulation of great teachers made all the difference. I came to appreciate the importance, and satisfaction, of achievement. With my classmates, I was serious, focused, and thankful for the opportunity to learn—and, not least by any means, to create a foundation for a career.

I transferred from Night School to Day School, graduated Phi Beta Kappa, received a full scholarship to the School of Law at Rutgers—and then had the temerity to go to Harvard Law School instead, graduating in 1957.

Rutgers' Night School opened the door to a life I would not have even thought of having, let alone realizing. And I am happy now to pay full fare on NJ Transit.

—Sanford M. Jaffe (NCAS '54)

teas, and the like" in the early 1930s; after a reorganization as the Girls' Association, their offerings expanded to include swimming, basketball, and fashion shows.

The honor societies, like Pi Mu Epsilon and Alpha Mu Epsilon (founded in the 1930s), enhanced campus life further. The two most important honorary business societies, Delta Sigma Pi and Beta Gamma Sigma, opened Newark chapters in 1937 and 1942, respectively; a Rutgers–Newark chapter of the most famous academic honor society, Phi Beta Kappa, followed in 1958. Along with honor societies came fraternities and a vigorous debate over their promotion on campus in the early 1930s; it was settled with the establishment of houses near campus. Fraternities—some residential, some not—have been part of the Rutgers–Newark experience ever since.

Student Publications, Performance, and Sports

Newark's first student paper was the *Barrister*, published by the School of Law beginning in 1927. The School of Business followed with the *Administrator*, founded in 1929, covering not just "subjects strictly of a business nature," but also "classroom gossip, student activities, personalities, and student literary endeavors." The newspaper of the prelegal department of the New Jersey Law School—the ancestor of the arts and sciences college—was the *Troubadour*, which was reestablished as the *Chronicle* in 1930, and eventually as the *Observer*.

The *Observer* has been part of Newark campus life for more than 80 years. World War II shut the paper down in 1942, but a mimeographed-and-stapled wartime edition, the *Observer, Jr.*, appeared in 1943. The paper was back to full strength in 1945, and it was winning awards from the Associated Collegiate Press in 1956. In 1969, during the turmoil associated with the protests and the Conklin Hall occupation, the *Observer* switched to a twice-weekly publication schedule.

A literary magazine, *First Flight*, was published by the college's literary society, Pegasus, in the late 1930s; and a series of special magazines—and, today, websites like the Newark Metro—have reflected student talents and passions.

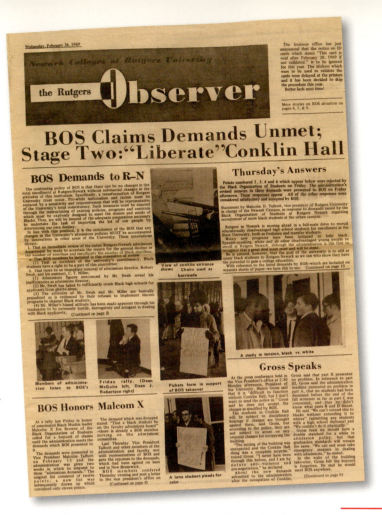

The *Observer*, the student newspaper in Newark, has been part of campus life for over 80 years.

Performance has always had a prominent place in Newark. The Mummers, a popular drama group, was founded in spring 1930, and put on several plays—classic drama, new one-acts, and original works for the stage and radio—every year for decades. Today, the theater program at Rutgers–Newark, in cooperation with the New Jersey Institute of Technology (NJIT), remains one of the most successful performing arts activities on campus. The campus radio station, WNRU, opened at the end of the '60s, offering an eclectic mix of rock, jazz, folk, and classical music, along with news and sports. Musical ensembles, ranging from string quartets to jazz bands to hip-hop, have been at the heart of campus life since the beginning, as have dance troupes like Ehsaas, the South Asian fusion dance group. Most visible is the Rutgers University Chorus, which has been active since 1947, and has attracted international recognition. The chorus, open to students, staff, and faculty, offers a well-attended holiday choral concert every December and an alumni spring concert in April, featuring both traditional choral fare and more obscure works, including Latino folk songs and songs from Indian movies. The chorus has traveled to France, Germany, Great Britain, the Netherlands, Italy, and the Czech Republic.

There was faculty resistance to sports in the early days of Rutgers–Newark. Dana College faculty passed a resolution: "Higher education can and must stand on its

own feet, and cannot afford to depend on circuses for its support." Intercollegiate sports would be tolerated only if they were carried out on "a truly amateur basis and designed to represent a natural and healthy culmination of a sound physical education program." Still, a basketball team was fielded in 1928; tennis followed in 1931, wrestling in 1932, and golf and track and field in 1933.

Students outside 40 Rector Street, Newark.

The next year, the campus Athletic Council rented the YWCA gymnasium for the use of female students, and the YMHA for male students. ("It was not necessary," the college therefore concluded, "to make a separate appropriation for intramural sports.") Later came club football, with practices either in Branch Brook Park or "Rutgers Field" at Arlington and Wakeman Avenues, and games on the field of St. Benedict's High School. Newark didn't have its own sports facilities until much later, when the Golden Dome Athletic Center—with its two gyms, five tennis courts, four racquetball courts, exercise studio, and eight-lane pool—opened in 1977, with Alumni Field right across the street. Today, the Scarlet Raiders have teams in 14 Division III sports. There are also intramural events in bench press, kickball, tennis, soccer, volleyball, flag football, dodgeball, basketball, and swimming.

Social Justice and Activism

Social activism has always been at the heart of Rutgers–Newark's identity, and the faculty, staff, and students have included many fighters for social justice. In 1927, for instance, the Liberal Club was founded by students in business and the liberal arts, and became one of the most successful societies in the early days of the Newark colleges. Its stated purpose was "to get students to think intelligently, independently, and with unbiased acumen." The club organized a lecture series in conjunction with the American League against War. What strikes modern eyes is the university's daring degree of openness to radical politics: the Liberal Club, for example, invited a speaker from the American Workers Party to discuss an American approach to Marxism as a cure for the Great Depression. A few weeks later, the secretary of the American Communist Party was on campus to discuss "orthodox Communist ideas." The club engaged in more than lectures: in 1932, it raised money and sent clothes and food to coal miners in West Virginia.

The pattern continues throughout Rutgers–Newark's history. The American Student Union, founded in 1936, participated in a "peace strike" and debated the Spanish

The Rutgers–Newark Campus under construction in the mid-1960s.

Civil War while that conflict was still raging. It called for "denunciation of trustee domination of faculty, abolition of the R.O.T.C. in schools, equal rights for Negroes, [and] anti-war policies." In the 1950s, Students for Democratic Action (SDA) had a Newark chapter, and Rutgers–Newark students even served on the national SDA board. Student advocacy groups were at the forefront of the civil rights movement in the 1960s and '70s, especially the Black Organization of Students. There was a Young Americans for Freedom group, and a Conservation Club was founded just as environmental awareness was spreading across the country. And the protests against the Vietnam War sometimes closed the campus.

Today, the number of groups committed to social justice is one of the defining features of the university: Active Minds, promoting mental health awareness; Amnesty International; the New Jersey Public Interest Research Group; RU PRIDE, campaigning for LGBTQA rights; and the Rutgers Student Veterans Organization. A particular hotbed of social justice activism is the law school, which hosts the Public Interest Law Foundation, the Women's Law Forum, the Christian Legal Society, the Environmental Law Society, and Law Students for Reproductive Justice. And not all the societies are left-leaning; the conservative Federalist Society for Law and Public Policy Studies is one of the most active groups on campus.

Campus = City

As University of Newark President Frank Kingdon put it around 1938, "Our campus is the city crowded with experience. What a campus it is! There is no moment day or night when it is still, and in its restless life move the forces making the civilization of tomorrow." And when he said "Our campus is the city," he meant exactly that. Until the late 1960s, the Rutgers–Newark "campus" was more of an idea than an actual place.

The university's first permanent home in Newark, purchased in 1927, was Malt House No. 3 at 40 Rector Street, formerly the Ballantine Brewery. The floors sloped slightly to allow for beer drainage, and students from that era recalled the faint smell of hops that pervaded the building. Over the next 40 years, the colleges acquired a

number of buildings of their own and leased space in others, but there was not a coherent campus.

By the early 1960s, there were classes and offices in dozens of buildings throughout Newark. Academic buildings were scattered between 40 Rector Street, near the Passaic River, and 151 Washington Street, half a mile away. Philosophy and anthropology classes took place in 18 Washington Place,

Students taking a break on the concrete plaza. Years later it would be turned into an inviting green space named for former provost of the Newark Campus for 20 years and acting university president Norman Samuels.

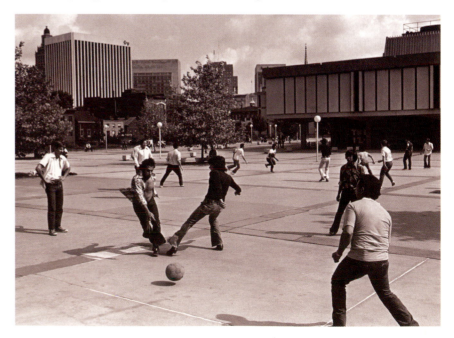

a building shared with the Veterans Administration. Large lectures in history, psychology, and the sciences took place in the mirrored ballroom of the Military Park Hotel. Physics classes were held in an old razor blade factory, and art and music were taught in a carriage house on the grounds of the Newark Museum. Many of the science lab classes took place in the brewery, and offices occupied some of the brownstones on James Street. The dispersed campus meant students had to dash across much of downtown Newark in the 10 minutes allowed to get from one class to another. When the weather was bad, many ran through the upscale Hahne's department store, getting dirty looks from the salespeople. (Those who were especially proficient learned to scurry while seeming to be shopping as they went.)

Largely because there was no academic center, the university was very much part of the city of Newark in those days—a great attraction for the students. Before Newark's economic decline in the 1960s, the downtown was thriving. It was home to a number of department stores—Hahne & Company, Bamberger's, S. Klein, Kresge, Ohrbach's—and a half-dozen movie theaters, showing films all day for 50 cents. Especially famous were the jazz clubs: the Piccadilly Club on Waverly, the Key Club on Halsey Street, Club 83 on Warren Street, the Front Room on Broadway. Newark students could hear jazz legends—Duke Ellington, Billie Holiday, Miles Davis, Dizzy Gillespie, John Coltrane, Sarah Vaughan (Newark was her hometown)—at local theaters and clubs.

There was also a real café society in the downtown. Newark got its first cafeteria in 1949, but before the opening of the Paul Robeson Campus Center, most students looking for somewhere to eat turned to the cafés that filled the city. In the 1940s, Nedick's at Broad and Market Streets served famous hot dogs and orange drink. In the late 1940s and '50s, Rector's Tavern was the place where students gathered. In the 1960s, Rosie's, on Washington Street, was a beloved dive that offered cheap food and a jukebox. Max and Rachel's Luncheonette was a favorite for quick bites and leisurely conversations—as one alumna remembers, "That was the Rutgers student center if ever there was one." Max was notorious for serving skimpy sandwiches, while his wife, Rachel, would sneak in a little extra tuna or pastrami with a wink: "Don't tell Max!"

The 21-and-older set has long found a home at McGovern's Tavern on New Street, founded in 1936—80 years later, still a favorite hangout. *Esquire* magazine declared it one of the best bars in America, the only one in New Jersey to receive the honor. Rutgers, NJIT, Essex, and Seton Hall students sit at the bar next to journalists, lawyers, police, and firefighters. The tavern was founded by Frank McGovern, and is now co-owned by his grandnephew Sean McGovern, a 1989 NCAS graduate.

Many alumni remember the days when professors and students met in these and other cafés, restaurants, luncheonettes, and bars around the city. In all of them there was constant talk, sometimes about schoolwork, sometimes about literature and philosophy, sometimes about civil rights and the Vietnam War.

A Real Campus Is Born

Maybe the biggest single physical change in the history of Rutgers–Newark came when it was transformed from buildings scattered all over the city to a coherent campus with purpose-built facilities. The new campus did much for academics, but its effect on student life was even greater. Rutgers–Newark was no longer just an idea, but a place.

Newark administrators, faculty, staff, and students had been calling for a real campus for many years, but there simply wasn't much land available. A university in a city founded in 1666 had little room to grow. But in the early 1960s, Rutgers–Newark obtained 23 acres targeted for urban renewal.

Below: Modern recreation facilities inside the Golden Dome at Newark.

Newark's radio station, ca. 1980.

Even so, it took years to draw up acceptable plans and get approval to start building. City officials were as eager to break ground as Rutgers administrators, but finding the money was difficult because Newark was losing influence in the state, as demographic shifts gave more power to the suburbs. Within Newark, there was concern that neighborhoods would be knocked down and people driven from their homes. Although the architectural firm Grad & Grad proposed a high-rise university that would require a small street-level footprint, a more sprawling plan won out. Eventually 35 acres of urban tenement and warehouses, mostly between Plane Street (now University Avenue) and High Street (now Dr. Martin Luther King Jr. Boulevard), were demolished, and building of the modern campus finally began.

The academic buildings—Boyden, Conklin, the Dana Library, and so on—were important, but what most people remember from those days is the student center. When the Paul Robeson Campus Center—the first of several Rutgers buildings to be named for one of the university's most distinguished alumni—opened, it provided what one alumnus called "a whole new setting for college life. The faces of fellow students became familiar through closer, more frequent contact." On the other hand, another writer said the new building "moved the life of the school off of the side streets of Newark and onto our own concrete plaza."

Student organizations devoted to ethnicities and cultures have been part of Rutgers–Newark since the 1930s, but as the ethnicities and cultures represented on the campus have changed, so have the societies. Where there was a thriving Dante Society for Italian-Americans in the 1940s and a Ukrainian Club in the early 1960s, there is now an Indian Students Association, a Filipino Student Association, a Korean Students Association, and Os Lusiadas, the Portuguese Club, reflecting the high concentration of Portuguese and Brazilian students in Newark. In the law school is the Association of Black Law Students and the Asian/Pacific-American Law Students Association, while the Rutgers Business School hosts the National Association of Black Accountants.

Faith-based groups, too, have been part of Rutgers–Newark since the earliest days. The Newman Club, for the

"fostering of the spiritual, intellectual, and social interests of the Catholic students of the Newark Colleges," was one of the most active campus organizations in the 1930s and '40s, hosting everything from prayer breakfasts and scholarly lectures to dances and mixers. Always the spirit was ecumenical: the Newman Club welcomed not only Roman Catholics but Protestants, Jews, and others. Just as the ethnic- and culture-based clubs have changed with the times, the same has happened with the faith-based organizations. Today, the Newman Club has been joined by a thriving Muslim Students Association and a Coptic Society.

Below: Alumni Field is the campus site for NCAA softball and soccer games and the practice field for the Scarlet Raiders baseball team. This lighted outdoor facility, located immediately across the street from the Golden Dome, gives the Rutgers–Newark community a year-round surface for athletics and intramurals and an excellent venue just steps from classrooms and dormitories.

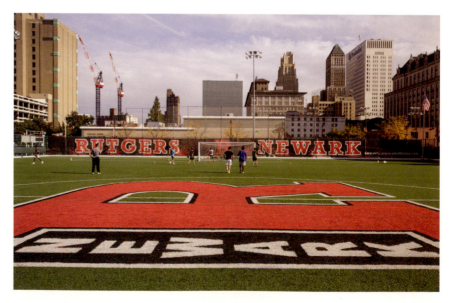

Below: One Washington Park is home to Rutgers Business School in Newark. The building showcases a soaring glass pavilion with a Times Square-like news ticker scrolling across the outside that dominates the north end of Washington Park next to the Newark Public Library.

Above: Students enjoy a spring day on the New Street Plaza at Rutgers University–Newark.

In the City, of the City

The development of a coherent campus center was much celebrated at the time, but it may have come at a price: a withdrawal from the city. Rutgers–Newark became for a time much more inward-looking than it had been. When the Newark colleges were founded, residents of the city constituted the bulk of the student body. By the 1960s, the students were increasingly commuting from the suburbs, and when they had a campus center, they found little reason to engage in the rest of the city. Rutgers was in Newark but, some argued, no longer of it.

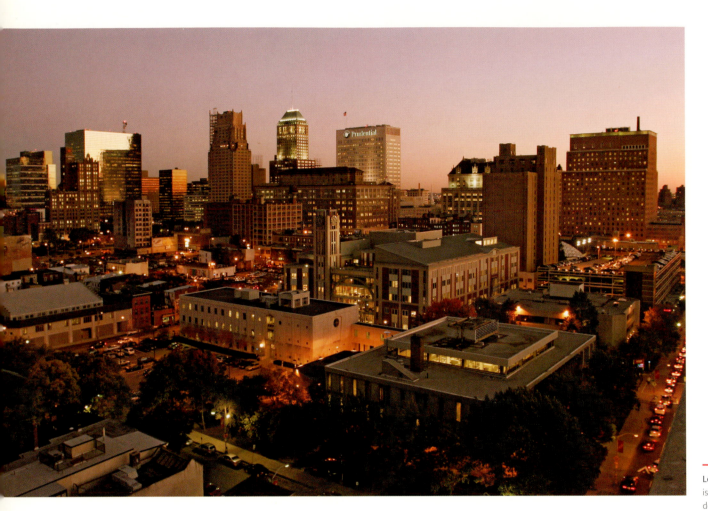

Left: The Newark Campus is nestled in the heart of downtown Newark, New Jersey's largest city.

Below: Rutgers University–Newark graduation ceremonies at the New Jersey Performing Arts Center.

The building of the first dormitory in Newark, Talbott Apartments for graduate students, in 1987 marked a reversal of course. It was followed in 1990 by the construction of Woodward Hall, the first undergraduate dormitory. And since that time there has been a concerted effort to keep Rutgers–Newark an integral part of the city in which it is located.

Concerted efforts to reengage with Greater Newark's public, private, and nonprofit sectors and its residents were undertaken by Norman Samuels and Steven Diner, who lead Rutgers–Newark in the 1990s and 2000s. Today, under the leadership of Chancellor Nancy Cantor, the university's distinctive mission as a public good—a diverse, urban, public research university—is being intensively cultivated with the institution's first-ever strategic plan—"Rutgers University–Newark: Where Opportunity Meets Excellence." As she says in the foreword to this plan:

Our visioning process has shown that for Rutgers University–Newark, excellence lies at the intersection of commitments to boundary-crossing scholarship,

diverse talent cultivation, and engagement as an anchor institution in the world through collaboration—all of which are precisely what the public increasingly is demanding of higher education in the 21st century.

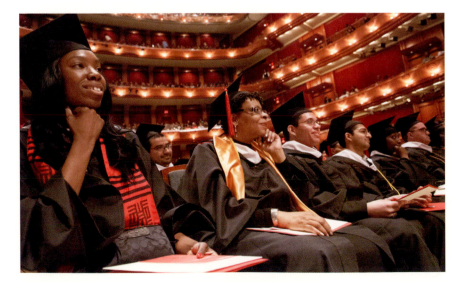

Twentieth-century views of the city of Camden.

Campus Life at Rutgers University–Camden

JEN A. MILLER (CCAS '04)

The roots of Rutgers' southern campus reach back to 1926 and 1927 with the opening of the South Jersey Law School and College of South Jersey, respectively. They became part of the Rutgers community in 1950 after the law school failed to gain accreditation, which meant their graduates would not be admitted to the New Jersey bar.

The first undergraduate class included matriculating students from the College of South Jersey and transfers from other regional schools, including the New Jersey College for Women. At the time, the campus was small, with only six buildings.

The college became a four-year school by the 1951–52 school year. The first issue of the *Gleaner*, the campus newspaper still active today, was published in 1951. The college also added a yearbook, the *Mneme*, the Student Council, Glee Club, and groups interested in photography, theater, the outdoors, and the humanities. Students held an annual prom and garden party, and Greek life came to campus. The school added sports, including basketball, baseball, cheerleading, and, later, bowling.

Freshmen were required to wear a dink, a hat that they bought with their class books, and to always have a

match on them to light upperclassmen's cigarettes. They also had to be able to sing the school's alma mater on demand (these practices ended in the late 1960s).

The school didn't have housing, so residential life was limited to Greek housing just off campus and to late nights at a bar/restaurant called The Grill—whose bartenders weren't entirely strict when it came to making sure students were of legal drinking age. The fraternity and sorority houses hosted regular socials, and counted faculty and staff as frequent guests.

Until the mid-1960s, the core of the school was housed in 16 converted row homes. Student organizations had offices in what was once part of the now-closed Bellevue Hospital, and the biggest meeting area was in the basement of a Presbyterian church that the Student Government tried

Below: Left to right: Rutgers President Mason Gross, Arthur Armitage Sr., founder of the South Jersey Law School that merged with the College of South Jersey and later became Rutgers–Camden, with the first dean of Rutgers–Camden, W. Layton Hall, at the opening of Armitage Hall in 1968.

Far right: The School of Law–Camden's beginnings date back to 1927. Here it's shown in the 1970s.

to buy before it was torn down to make way for a Burger King (it's now a faculty parking lot).

Armitage Hall opened in 1968. The next year, the School of Law in Camden became an independent school, not a branch of the Newark law school. The gym and then the Fine Arts Theater (today the Walter K. Gordon Theater) opened soon after. Lily Tomlin played the theater's first sold-out show in 1975.

The campus began to feel more like an actual campus when, in 1971, a $21 million project began to close Penn Street between Third and Fourth Streets and between Fourth and Fifth Streets, thus cutting off vehicular traffic and forming the walkable campus hub you see today. In the 1980s, Fourth Street was closed, completing the quad.

By 1970, 1,787 undergraduates were enrolled at Rutgers–Camden, many of them nontraditional students: older adults going to college on the G.I. Bill, and men and women coming back to school years after graduating high school. In 1981, the school opened the Graduate School–Camden with programs in biology and English, and an MBA program (the Rutgers School of Business–Camden would open in 1988). In 1986, the Camden Apartments opened, finally adding on-campus residential options for students.

The Rutgers–Camden tower followed three years later.

Through the 1990s and 2000s, the campus continued to grow through an added library, classroom, office, and study space. The Rutgers–Camden Community Park, with 5.5 acres of on-campus playing fields for softball and soccer, hosted its first games in 2001.

In 2002, Starbucks came to campus, making Camden the first campus at Rutgers with the trendy coffee chain. In 2010, a new law school building was added; and in the fall of 2012, the first graduate dorms opened, with a glowing R on top, proudly displaying Rutgers' continued presence in the city of Camden.

Rutgers University–Camden now has over 6,500 students. The school is home to dozens of clubs covering everything from anime to philosophy, 18 Greek organizations, and 19 sports teams. It's come a long way from a two-year college and an unaccredited law school clustered in six buildings in the downtown. Today, it truly is Rutgers in South Jersey.

For commuters and residential students alike, the Rutgers–Camden Campus Center is a comfortable place to relax.

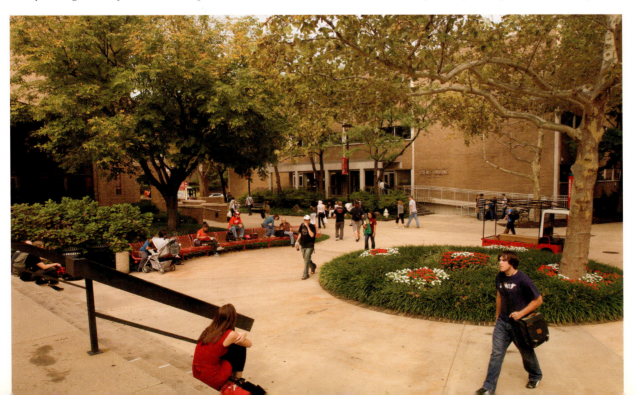

Rutgers–Camden is the preeminent institution of higher learning in southern New Jersey.

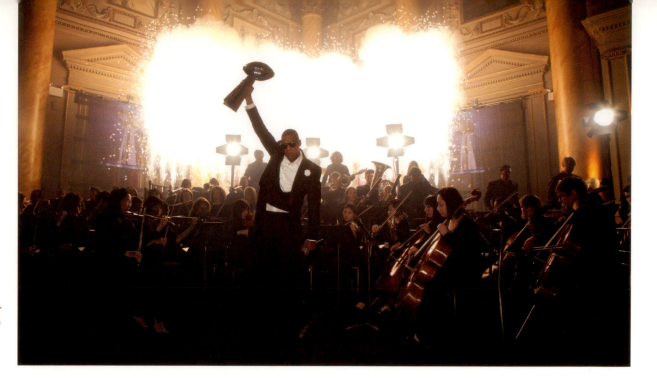

Rutgers Symphony Orchestra and Jay-Z on CBS's Super Bowl XLIV Kick-off Show in 2010.

Rutgers on the Big and Small Screens

Rutgers has a long history of appearing in movies and television. An early reference to Rutgers was in the 1947 James Cagney movie *13 Rue Madeleine*, about the training of agents with the Office of Strategic Services (the predecessor of the CIA) during World War II. A main character in the movie was supposed to be an alumnus, but also a Nazi spy.

Barefoot in the Park, a 1967 movie based on the Neil Simon play, with Jane Fonda and Robert Redford, mentions that Redford's character's sister was dating a Rutgers student. In *Goodbye, Columbus* (1969), based on the Philip Roth novel, Richard Benjamin played a character named Neil Klugman, a Rutgers University–Newark graduate. New Jersey native Kevin Smith refers to fictional Rutgers alumni in *Mallrats* (1995) and *Chasing Amy* (1997). *The Cookout* (2004) features a character named Todd Anderson, a Rutgers graduate who signs up to play professional basketball with the New Jersey Nets. A character in *Garden State* (2004) is said to be a criminal justice major at Rutgers.

Fictional alumni are not the only Rutgers people in movies. Russell Crowe and Denzel Washington starred in *American Gangster* (2007), in which Crowe portrayed Richie Roberts, a Rutgers University–Newark alumnus and real-life detective who took on drug kingpin Frank Lucas in the 1970s.

Scenic locations at Rutgers have appeared in many movies. College Avenue's Bishop House was used as a backdrop in 1982's *The World According to Garp*. *Rounders* (1998) had scenes that were shot at the School of Law–Newark. The action movie *Live Free or Die Hard* (2007) showed Lucy McLane, the daughter of Bruce Willis's

character, John McClane, running to her Rutgers University–Camden residence hall.

Rutgers is no stranger to television, either. The inspiring Rutgers Marching Band has made numerous television appearances. Band members played during Super Bowl XLVIII and also helped open the 2014 Victoria's Secret Fashion Show. In addition, they performed with the epic rock band U2 on top of New York's Rockefeller Center during the premiere of *The Tonight Show Starring Jimmy Fallon*. The Rutgers Orchestra accompanied rapper Jay-Z during Super Bowl XLIV. In 1963, the Rutgers University Choir performed with the Philadelphia Orchestra in a national broadcast to honor John F. Kennedy, who had been assassinated in Dallas the day before. And of course, the long-running public television program about public policy, *The Open Mind*, was created and hosted by Rutgers professor Richard Heffner.

Several television series portrayed fictional characters that were said to be Rutgers alumni. Aaron Sorkin's short-lived comedy-drama *Studio 60 on the Sunset Strip* included a character named Harriet Hayes, played by Sarah Paulson, who was supposed to be a Rutgers alumna. *The Sopranos* had multiple characters and episodes that mentioned Rutgers. But perhaps the most well-known fictional alumnus of the university was Mr. Quincy Magoo. Voiced by Jim Backus, the character first appeared in a 1949 cartoon and continued through the 1950s and early 1960s.

—JAMES R. STAPLETON (CC '98, SCILS '05), INTERIM SENIOR DIRECTOR, CAMPUS INFORMATION SERVICES

PART 4

STUDENTS & ALUMNI

EILEEN CROWLEY

The Respectable Public is hereby informed…a Seminary of Learning was opened at New Brunswick, last November, by the name of Queen's College…Any Parents or Guardians who may be inclined to send their Children to this Institution, may depend upon having them instructed with the greatest Care and Diligence in all the Arts and Sciences usually taught in public Schools, the strictest Regard will be paid to their moral Conduct, (and in a word) to every Thing which may tend to render them a Pleasure to their Friends, and an Ornament to their Species." —New York Journal and General Advertiser, April 30, 1772

The Voorhees Mall on Rutgers' New Brunswick campus is crowded with memorials to the people and events that shaped the university. A statue of William the Silent, a reminder of the school's Dutch roots, stands at the western end while he contemplates the remarkable 250-year evolution of the school into The State University of New Jersey.

Further down the mall is a memorial commemorating the Rutgers students who fought and died in WWII. Immediately adjacent to Scott Hall, the memorial was unveiled to great fanfare in 2008. But just steps away, tucked anonymously into a semicircular brick bench, are artifacts from the birth of Rutgers at an earlier time of blood and chaos—stones from a colonial-era tavern called The Sign of the Red Lion. The tavern was the meeting place of the original Rutgers student body, taught first by Frederick Frelinghuysen and then by John Taylor, who would become a colonel in the Middlesex County militia. Their handful of soldier-scholars would go on to become some of the most prominent names in post-Revolutionary War America. But during their time at Rutgers, they set the standard for strength, community, and responsibility upon which the university built itself—just as the stones of their erstwhile classroom daily support a current student body they would scarcely recognize.

Through incremental steps, the makeup of the student body at Rutgers has shifted and changed. And so too has Rutgers the institution in responding to its students' needs and interests. It has been a fascinating dynamic over two and a half centuries, with the students leaving their mark on the school just as surely as that school has made a lifelong imprint on them.

Roots of Diversity

Today Rutgers prides itself on the ethnic, religious, sexual, and socioeconomic diversity of its student body, but had photography existed in the mid-18th century, the students enrolled during the university's first two decades might have found their class portraits in dictionaries next to the definition for homogeneity. Like the students of the other seven colonial colleges founded before theirs, they were all male, all white, mostly of the same religious denomination, and mostly the sons of well-to-do families from New Jersey, New York, and the other mid-Atlantic states.

Rutgers' first steps toward the inclusiveness that is its present-day hallmark were taken in 1812. Struggling

The World War II Memorial on Voorhees Mall honors Rutgers men and women who fought and died in the war. The war had a devastating effect on the university; 5,888 Rutgers men and nearly 200 Rutgers women served their country. By war's end, 234 men and two women had lost their lives, including the son of then Rutgers President Robert Clothier.

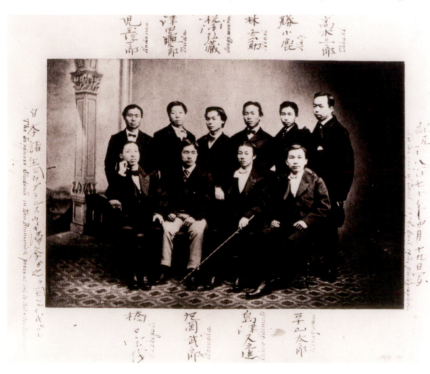

Above: Samuel Judah, the first Jewish student.

Below: Group of early Japanese students, 1870, and **(far right)** Kusakabe Taro.

to keep its doors open after financial and military crises caused them to shut for 12 years beginning in 1795, the school placed advertisements claiming that prospective students "may expect to be treated with becoming Candor, without any Discrimination with Respect to their religious sentiments." Whether it was in response to those ads, or simply because of its proximity to his family, Samuel Judah, the first Jewish student to graduate from Rutgers, became a member of the Class of 1816.

The son of a doctor and one of nine children, Samuel went on to become a lawyer and moved to Indiana, where he served as a state representative and was appointed U.S. district attorney for Indiana by President Andrew Jackson. Samuel could hardly be said to have opened the floodgates to the diversity that characterizes the university today: the next Jewish graduate didn't enroll until 1880. But he was the first outsider to become a member of the Rutgers community, which is now home to students from every state in the union and from 115 other nations. He was also the first non-Christian to graduate from a university that now boasts more than 40 organizations devoted to various religions and 25 recognized chaplaincies, including the 2009 addition of a humanist chaplain for students whose religious choice is "none of the above."

In 1867, the door that Samuel Judah had cracked was kicked open with a bang when a brilliant young samurai from Fukui, Japan, Kusakabe Taro, joined the sophomore class (*see next page*).

In 1892, some 20 years after Kusakabe Taro had attended Rutgers, James Dickson Carr (RC 1892) became the university's first African-American graduate. The son of a Presbyterian minister, Carr enrolled to study classics. Slight of build and blind in one eye, he was active in the Philoclean Literary Society, the Republican Club, the Rutgers Temperance Association, and Phi Beta Kappa. A gifted student and compelling speaker, Carr later studied law at Columbia and went on to a successful legal career that culminated in an appointment as assistant corporation counsel of the New York City Law Department.

A year before Carr's death in 1920, he castigated the university's administration for its capitulation to bigotry in excluding Paul Robeson (RC '19) from a 1916 football game because the other team objected to his race. His genteel rebuke, though far removed from the fiery rhetoric of the Rutgers civil rights fighters to come

Rutgers University and Japan

A special relationship has existed between Rutgers University and Japan dating from the mid-19th century. The institution's connection with the Dutch, who had retained a trading post in Nagasaki during Japan's period of isolation, made Rutgers a destination for some of the first Japanese to study in the United States.

The first to attend Rutgers College was the young samurai Kusakabe Taro, who sought to "fulfill my duty to the Imperial realm by clarifying the defects in the relations between us Japanese and the foreigners in the light of the international law of all nations and universal principles." Ranked number one in his class, Kusakabe became the first Japanese to graduate from Rutgers, the first to become a member of Phi Beta Kappa, and, along with Joseph Hardy Neesima at Amherst, the first to graduate from an American college. Tragically, he died of tuberculosis on April 13, 1870, only weeks before commencement. He is buried in the Willow Grove Cemetery in New Brunswick along with seven other young Japanese.

Many of those who studied at Rutgers returned to Japan to become leaders in education, industry, and commerce. Hatakeyama Yoshinari, who studied at Rutgers in 1871, went on to become director of Tokyo University during its foundational period. Hattori Ichizo (RC 1875), a samurai who also studied science, served as governor of three prefectures and in 1903 was appointed to Japan's House of Peers. In all, 25 Japanese students have been documented as enrolled at Rutgers between 1868 and 1926.

Meanwhile, Rutgers faculty and alumni found positions as educators, advisors, and missionaries in Meiji Japan. Rutgers professor of astronomy and mathematics David Murray was invited to Japan in 1873 to serve as superintendent of education, where he played an important role in organizing a Western-style educational system. William Elliot Griffis (RC 1869) introduced Western science education in Fukui, and then spent the rest of his life writing and lecturing about Japan. His friend and classmate Edward Warren Clark (RC 1869) taught at the Shizuoka Clan's school and at the forerunner of Tokyo University, while Martin N. Wyckoff (RC 1872) served as Griffis's successor in Fukui. Wyckoff later returned to Japan as a missionary and wrote the influential textbook *English Composition for Beginners Prepared for Japanese Students* (1885).

The relationship between Rutgers and Japan understandably lapsed during the war period, but was rediscovered in the late 1950s by Rutgers professor of political science Ardath Burks. By that time, Rutgers had evolved into a major public research university. In the ensuing years, the university has developed courses on Japanese language, literature, history, film, and culture. Today, over 100 students study the Japanese language each year and participate in the Rutgers Organization of Nippon Students. Rutgers maintains exchange programs with several Japanese universities, and the city of New Brunswick has active sister city relationships with Fukui, the home of Kusakabe Taro, and Tsuruoka.

—Fernanda Perrone (SC&I '95),
Archivist and Curator of the William Elliot
Griffis Collection, Rutgers University Libraries

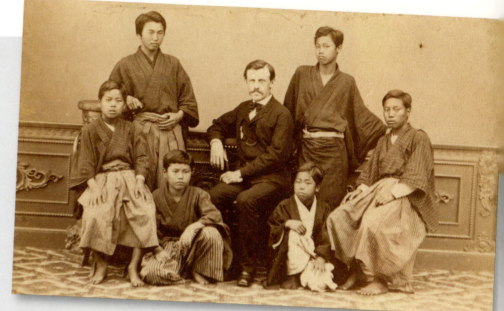

After the restoration of the Meiji emperor in 1868, Japan became increasingly centralized. William Elliot Griffis was one of the many people who moved to Tokyo seeking greater opportunities during this period. He is pictured here with six of his students from Fukui. Photo taken at Uchida Studios, Tokyo, 1872.

Left: James Dickson Carr (RC 1892), the first African-American graduate of Rutgers.

Below: Paul Robeson, left, and other members of Cap and Skull, 1919.

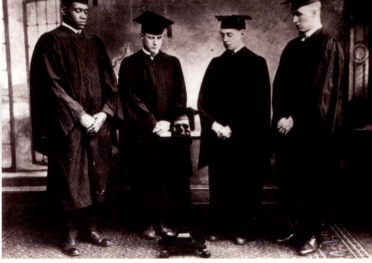

The letter at left:

City of New York
Law Department
Bureau for the Recovery of Penalties
Municipal Building, Fifteenth Floor

WILLIAM P. BURR
CORPORATION COUNSEL

June 6, 1919.

President William H. S. Demarest, LL.D.,
Rutgers College,
New Brunswick, N.J.

Dear Sir:-

During the celebration of the one hundred and fiftieth anniversary of Rutgers College, a statement appeared in the public press that Washington and Lee University, scheduled for a football game with Rutgers, had protested the playing of Paul Robeson, a regular member of the Rutgers team, because of his color. In reading an account of the game, I saw that Robeson's name was not among the players. My suspicions were immediately aroused. After a considerable lapse of time, I learned that Washington and Lee's protest had been honored, and that Robeson, either by covert suggestion, or official athletic authority, had been excluded from the game.

You may imagine my deep chagrin and bitterness at the thought that my Alma Mater, ever proud of her glorious traditions, her unsullied honor, her high ideals, and her spiritual mission, prostituted her sacred principles, when they were brazenly

The second letter page:

June 6,1919.

and that she preferred the holding of an [...] tenance of her honor and her principles?

[...]is protest by a similar action of the [...] of Pennsylvania, heralded in the public press less than two weeks ago. Annapolis protested the playing of the Captain of one of the athletic teams of the University of Pennsylvania, a Colored man. Almost unanimously his fellow athletes decided to withdraw from the field and cancel the contest. In this, however, they were overruled by the athletic manager, who ordered the games to proceed. One of the University's premier athletes on the side lines because of his color! Such prostitution of principle must cease, or the hypocrisy must be exposed.

The Trustees and Faculty of Rutgers College should disavow the action of an athletic manager who dishonored her ancient traditions by denying to one of her students, solely on account of his color, equality of opportunity and privilege. If they consider an athletic contest more than the maintenance of a principle, then they should disavow the ideals, the spiritual mission and the lofty purposes which the sons of Rutgers have ever believed that they cherished as the crowning glory of her existence. May we ever fervently pray that the Sun of Righteousness may shine upon our beloved Alma Mater, now growing and blossoming into the full fruition of her hopes.

Very respectfully yours,

Rutgers '92.

James D. Carr

Carr's letter to President Demarest condemning Rutgers' decision to exclude Paul Robeson from a football game because of the bigotry of the opposing team, Washington and Lee University.

some 40 years later, is no less impassioned or committed. "You may imagine my deep chagrin and bitterness," he wrote President William H.S. Demarest (RC 1883),

> *at the thought that my Alma Mater, ever proud of her glorious traditions, her unsullied honor, her high ideals and her spiritual mission, prostituted her sacred principles, when they were brazenly challenged, and laid her convictions upon the altar of compromise… May we fervently pray that the Sun of Righteousness may shine upon our beloved Alma Mater, now growing and blossoming into the full fruition of her hopes.*

The African-American presence on campus that began with the matriculation of James Dickson Carr in 1888 became high profile when Paul Robeson graduated in 1919 with honors and went on to a distinguished career in theater, music, and civil rights and peace activism. One near contemporary of Robeson at Rutgers was Vermont Edward Allen, an African-American member of the Rutgers College Class of 1925. Under his picture in the *Scarlet Letter* yearbook, which featured a short profile of each graduate, is a particularly cringe-inducing caption referencing his "sooty" complexion. All of the graduates have similar, teasing captions under their pictures, and several would be out of bounds by today's standards, including one that pokes fun at a chubby graduate's weight, and another that tags a foreign language major with the nickname of "Wop." In any case, Vermont Edward Allen's profile indicates that although his race was not necessarily held against him, it didn't go unnoticed. By the 1920s, the size of the student body at Rutgers had more than doubled, and had seen an appreciable change in its makeup. At Rutgers College, in spite of restricted enrollments, Jews made up nearly 20 percent of the student body, and Roman Catholics accounted for another 15 percent. Even more diversity existed in Newark.

The Nation's Most Diverse University

The Newark campus was founded to serve the residents of its city, and especially in the early days, the city provided the bulk of the students. In the 1930s, before the various Newark colleges had been integrated into Rutgers, about half of all first-year students came from Newark, with another quarter from Essex County and the remainder from elsewhere in northern New Jersey. And those students showed the same diversity as the city as a whole. They were mostly first- and second-generation students of European descent, with Russian, German, and English predominating.

In 1937, nearly half the student body was Jewish—44 percent—with 28 percent Protestant and 25 percent Catholic. Jewish immigrants had been settling here since the 1830s, but the 1930s saw a huge influx of refugees from Hitler's Germany. By 1948, Newark had more than 40 synagogues and the seventh-largest Jewish population in the United States. This Newark is captured in the novels of Philip Roth, the great American writer who started his college education at Rutgers University–Newark.

Other ethnicities were at the Newark colleges, at a time when minorities were hard to find at most other schools. A 1935 state survey of New Jersey's colleges and universities showed virtually no African-American men enrolled at Rutgers or Princeton, and very few African-American women. But Dana College's first tiny graduating class in 1933 had several African Americans, including the senior class vice president, Releford "Mac" McGriff, of Newark's East Side High School. As his senior yearbook put it, "He takes a special interest in race problems and professes to enter the educational field to propagate the liberal philosophy

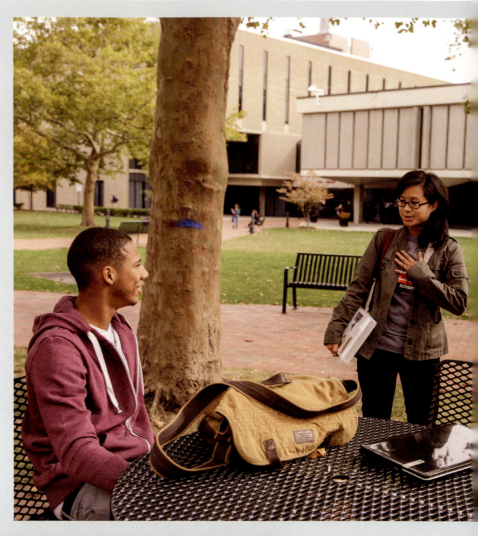

Far left: Elizabeth Blume-Silverstein, member of the graduating class of New Jersey Law School in 1911 (later becoming Rutgers School of Law–Newark in 1946), was the first woman to actively practice law in New Jersey.

Left: Releford McGriff, standing second from left, with other founding members of the Jacksonville, Florida-based Colored Lawyers Association, predecessor of the D.W. Perkins Bar Association. McGriff was a notable figure in several high-profile cases that illuminated injustices of the Jim Crow South.

and ideas acquired at Dana." McGriff did not enter the educational field, but he continued his interest in race and did his alma mater proud: he went on to enlist in the U.S. Army in October 1942 before becoming a successful attorney in Jacksonville, Florida, a partner in a prestigious African-American law firm. He lived until 1988.

Newark's diversity has always meant more than race and ethnicity. The New Jersey Law School opened its doors in 1908; in 1910, Laura Mayo Wilson was the first woman to graduate, at a time when women were rare in the nation's law schools. She went on to a long and successful legal practice in Newark. A year later, Elizabeth Blume took her law degree; in 1918, she became the first woman to defend a client for murder. (In 1936, she and her husband were among the cofounders of the World Jewish Congress.)

The Newark Institute began admitting women to its degree programs in 1917; and in the early 1930s, the business school actively sought out women students—albeit to train them as secretaries. But things were changing. By 1937, one in six business students was a woman, and some had left the secretarial certificate behind for the bachelor's program.

In 1997, Rutgers–Newark was designated the most ethnically diverse national university in the United States by *U.S. News & World Report*—a distinction it has retained every year since. Today, around 40 percent of first-year students come from a household where English is not the primary language, and close to 100 countries are represented by first- and second-generation immigrants.

—Jack Lynch, Professor of English, Rutgers–Newark

Above: Today's student population reflects the rich multiculturalism of America's most diverse university as ranked by *U.S. News & World Report*.

Right: Across the street from the Golden Dome is Alumni Field, a popular destination for team and club sports.

Learning Beyond the Bell

A good deal of what I gained from college came from experiences that I never expected. Much of that was unique to the locale and exceptional culture of Rutgers University–Camden at the time. Forty years on I believe that culture still exists.

In 1973, Rutgers–Camden was exclusively a commuter school as there were no dorms on campus, although some students lived in fraternity or sorority houses mostly on Cooper Street. Most of us worked to pay tuition, and many like me worked full-time jobs and managed our class schedules to go to school full time as well. Numerous students were also first-time college attendees within their families.

The Vietnam War had just ended, and many returning soldiers were coming to campus with a perspective that most of the rest of us had no possible context for. Add to that a smattering of international students, mostly from Nigeria, who brought a view of America from beyond our borders and traditional Western culture, and you create a layer cake spiced with some very unexpected ingredients.

Discussing world politics in the context of American post-WWII foreign policy with men and women who had lived through the consequences of that in Southeast Asia was matchless. Evaluating the influence of wealth and voting patterns on American cities and school funding in the midst of a city that was politically abandoned at the time provided illumination beyond what any textbook could provide.

But it was the interaction with this multiplicity of people and their experiences in discussions "beyond the bell" that educated us past our expectations. Our professors knew who we were and where we came from. They knew the environment and what it could teach us beyond the classroom. They didn't recoil from it: they embraced it and used it to educate us. The times were exciting, as change was in the air and the diversity on campus prepared us for a growing global environment where American culture was not the only culture and the world was indeed shrinking and we needed to learn how to thrive in the midst of that global change.

—Ed Kiessling (CCAS '77),
Vice President of Commercial Insurance Operations,
Frank Crystal and Company

Coeducation

As surprised as the founders of Queen's College might have been to see Samuel Judah, Kusakabe Taro, or James Dickson Carr on the student roster, they would have been amazed at the influx of another group in 1918. During the postwar decade that came to be known as the Roaring Twenties, women finally became a major presence at Rutgers. A few women had enrolled in the Agricultural School short courses beginning in 1913, but with the rapid growth of enrollment at the New Jersey College for Women (NJC)—later to be known as Douglass College—nearly 300 female scholars took up residence just a mile and a half from the main campus. Until that time, the social lives of the men of Rutgers College revolved around the students at a girl's school on Bayard Street, the young women who lived in town, and girlfriends from home who came to campus to attend formal dances, concerts, and student theatrical and variety shows. Ironically, just as suffrage was being achieved, the lives of the students at NJC were controlled just as tightly as those of their male counterparts had been 60 years earlier. There were three designated quiet times a day, chapel was mandatory twice a week, students were admonished to keep off the grass, and were required to wear hats in public at all times. The strictness of the rules was offset by the maternal care extended to the students by Dean Mabel Smith Douglass, who personally nursed several of them through the 1918 influenza pandemic before falling ill herself. It was said that during her tenure she knew every student by name, and if they walked past her office without stopping to speak to her, she would call them back to chat.

While NJC offered plenty of extracurriculars for its students, including dances, plays, glee clubs, theatrical societies, and student government, the students appeared to be just as interested in socializing with their brothers at Rutgers. The 1922 Redbook student handbook reminds students to "not offset the good influences of your college training with thoughtless action when dancing." A later edition warned against unchaperoned driving, smoking, and drinking. That their elders' pleas for decorum occasionally fell on deaf ears is demonstrated in a poem in a 1926 edition of the Rutgers satirical literary magazine, the *Chanticleer*, titled "Not So Bad":

I'm a wild, wild woman,
I pet, I drink, I smoke,
I'm a wild, wild dam-sel
And I always make men broke.
I'm a wild, wild maid-gin
I'm bad, an' I wanna man.
I'm a wicked, wicked bimbo,
I'm mad, and don't give a d—n.

Completed in 2011, artist Ricardo Basilio Coke's mural on the portico of the Center for Latino Arts and Culture depicts all the cultures of Hispanic America.

Cultural Centers

Realizing that a one-size-fits-all approach to student life wouldn't work at one of the most diverse universities in the nation, Rutgers has, over the past four decades, opened four cultural centers on its New Brunswick campus to better serve the members of its ever-changing demographic.

Paul Robeson Cultural Center (PRCC). Founded in 1967 as the university was buffeted by civil rights and antiwar protests, the PRCC is one of the country's oldest cultural centers. Under director Prosper Godonoo, who also teaches in the Department of Africana Studies, the PRCC provides "educational, cultural, and social programs and services that reflect the experiences and aspirations of minority students, with an emphasis on African Americans. Among the center's current activities are the Paul Robeson America Reads and Counts Tutoring Program, a K–12 school outreach program, and the annual Rites of Passage graduation celebration for African-American and Latino students. Says Godonoo, "It was established… to give students of color a home away from home. Here at Rutgers, we have taken that mission so seriously that we have woven it into the fabric of student life to ensure that diversity is not only celebrated in the books, but is an integral part of research, teaching, learning, and the recruitment and retention of students."

Center for Latino Arts and Culture (CLAC). The CLAC opened its doors at 122 College Avenue in 1992 under the direction of Isabel Nazario, former associate of the Museum Program at the New York State Council on the Arts and an accomplished visual artist. Key initiatives under Nazario's leadership were the widely recognized Artists Mentoring Against Racism, Drugs and Violence: Healing Through the Arts Summer Camp (established in 1996), Visual Imaginary of Latino Artists in New Jersey (2001), and the Transcultural New Jersey Program (2004), a statewide program of exhibitions and residencies developed in partnership with the Jane Voorhees Zimmerli Art Museum. In 2005, folklorist and ethnomusicologist Carlos Fernandez was appointed director of the CLAC. Since then and in partnership with other academic and student affairs offices, the center has embarked on an ambitious offering of programs designed to enhance Latino student recruitment, retention, and success. Programs include student leadership conferences and retreats; exhibitions, film screenings, and performances; academic courses and service learning programs; and alumni mentoring and career development.

Center for Social Justice Education and LGBT Communities (SJE). Founded in 1992 under the direction of feminist, scholar, and activist Cheryl Clarke, the SJE provides educational, social, policy, and leadership development programs and activities for lesbian, gay, bisexual, transgender, and queer students, faculty, staff, and allies. One of the oldest campus-based LGBT centers in the country, the SJE's overall mission is to teach students—including but not limited to members of historically underrepresented communities—the histories and legacies of social and institutional change. Under the leadership of director Zaneta Rago, the center conducts over 50 social justice trainings a year, hosts 80 programs and events, and conducts outreach to potential students through an annual high school Gay-Straight Alliance summit in collaboration with the student community. Located on the Livingston Campus, the SJE promotes students' exploration as whole people with multiple identities by creating educational and social opportunities around issues of gender, sexuality, race, ethnicity, nationality, disability, and economic status.

Asian American Cultural Center (AACC). Located on the Livingston Campus, the AACC was founded in 1999. Its primary goal is to provide a safe and supportive environment for all students, encouraging development in academic excellence, identity awareness, community building, and leadership. The center's staff and students work closely with over 60 Asian-interest student organizations, as well as with a number of student affairs and academic units and community-based organizations to promote the accomplishments of Asians and Asian Americans through cocurricular, collaborative, educational programs, exhibits, performances, lectures, and seminars. Notes AACC director Ji Lee, "These centers exist because students recognized the need for a place that would celebrate and embrace their identities in ways that other spaces cannot offer. Today, many students come to our center to study, socialize, meet with other students, rehearse dance routines, and hold events. Students will even sleep over at the center when it is open 24 hours during finals. It is a spirit-filled space that students make into their own."

The *Chanticleer* may have had a jaded view of the NJC student body, but Dean Douglass told a critic in 1922 that she had "absolute faith in the fundamental goodness of my girls," and insisted that they be exposed to the same sort of liberal arts education as their male peers, rather than being force-fed a curriculum leading primarily to teaching degrees. The first students at NJC were, in fact, initially instructed by the faculty of Rutgers College, most of whom donated their time.

In 1955, NJC was renamed Douglass College for its founding dean, who had retired in 1932 and drowned a year later at the age of 56 at Lake Placid, New York. For over a decade, Douglass remained the primary place for women at the campus.

In 1969, Livingston College—the first coeducational liberal arts college for full-time students in New Brunswick—opened its doors in Piscataway. The move to admit women

Move-in day at Douglass.

Julia Baxter Bates

Julia Baxter Bates (DC '38), the first African-American graduate of Douglass College, was initially encouraged by school officials to enroll at another college where she would be "more comfortable." She had been admitted to the college in error: an admissions officer had assumed the light-skinned Bates was white from her photo. But Bates persevered and went on to become a magna cum laude graduate of Douglass. That same tenacity stood her in good stead as she embarked on a career. When she couldn't find a New Jersey school district that would hire her to teach because of her color, she joined the faculty of Dillard University in New Orleans. Subsequently, she accepted a position with the legal research staff of the National Association for the Advancement of Colored People (NAACP). During her tenure there, she worked with civil rights leaders W. E. B. Du Bois, Walter White, and future Supreme Court Justice Thurgood Marshall, with whom she worked on the brief that won the groundbreaking civil rights case *Brown v. Board of Education*. Later in life, she finally landed a teaching position in New Jersey: in Newark, as director of adult and special education at an alternative school; she later took on an administrative position at Essex County College. In 1992, the Associate Alumnae of Douglass College established a fellowship in her name, and four years later she was inducted into the Rutgers Hall of Distinguished Alumni. When she passed away at age 86 in 2003, Congressman Rush Holt memorialized her in the *Congressional Record* as "one of New Jersey's most significant daughters."

"My Rutgers experience has been truly an amazing one. I have so many memories that I've made over these last four years, albums full of photos in an attempt to immortalize them all. I've had the best of everything. An incredible school in my home state, an intimate college in Douglass, and the large university experience, all this at Rutgers. From King Neptune Night to the Scarlet Day of Service and everything in between I can't choose my favorite moment here, there's too many! Thankfully I can look back on them, at all those photos fondly that I've collected over my four years, remembering all those treasured memories that I've made here at Rutgers."

—Elisa Mendez (SAS '15)

Marching On

When I came to Douglass College in the fall of 1970, I encountered three restrictions: (1) men were only allowed in the dorms during certain hours, (2) we had a curfew, and (3) I was not allowed to join the all-male Rutgers Marching Band. That last bothered me the most. I had been in a marching band playing piccolo since middle school. When I went to the season's first football game and saw the band on the field, I was so upset it was the last football game I went to for the next two years.

The first two restrictions were gone by the time sophomore year began. But it was junior year when the big change happened. Rutgers College went coed. Women would be allowed to march.

The men in the band were not exactly happy about all this. They called themselves the Marching 100, and they marched in a style called high-stepping. For each step, the knees come up high, the thigh is parallel to the ground, and a right angle is formed with the lower leg, toes pointed down. To march fast in such a position while playing an instrument is very exhausting. The men felt the women could not possibly keep up.

I think there were about 14 women who joined the band that fall. Most were from the new first year class at Rutgers College, but a few of us were from Douglass. Although we were not welcomed with open arms, the band director, Scott Whitener, announced that "a band member is a band member," and that the women were to be treated the same as the men.

We women had to prove ourselves the first few days of band camp. We learned to march, despite the 90-degree heat, and we learned to move downfield at tempo 150 (150 beats per minute equals 150 steps per minute) playing "Colonel Rutgers" on our various instruments. We had to show the men that we could not only march like they could, but that we could help make the Marching Band a better organization. I know we succeeded. I was thrilled when I finally was able to put on a uniform (a man's uniform because no one bothered to order uniforms in women's sizes) and march out onto the field to perform. And in my senior year, I was elected president, the first woman president, of the Rutgers Marching Band.

Today's Marching Band is twice the size as the one I joined, the high-step is gone, and the ranks are filled with women. I am still great friends with many of the women who were in that class of First Ladies (as we now call ourselves). I think we played a little-known but important part in a piece of Rutgers history.

—Jacqueline Fesq (DC '74, GSE '80, '95)

Memories of a Pioneering Coed

To be among the first class of women admitted to Rutgers College was to be ecstatic, frustrated, complimented, challenged, triumphant—often all on the same day. In short, the women of RC '76 were like first-year college students everywhere, except that we were under a microscope. The next four years would offer many opportunities in and out of the classroom to analyze books and ideas. In coeducation's intense atmosphere, friendships with like-minded students bloomed easily. My new pals and I discovered foreign movies. We'd disappear into the Student Center for *Jules and Jim* or *Lola Montès*, then stay up past midnight earnestly chatting about the film, usually over pizza at Patti's.

When the traditional journalism major morphed into mass communications, too abstract for me, I switched to English. Looking back, it's remarkable that so many incoming women opted for traditional programs (indeed, Rutgers College hastened to add an education major for us) and that so few took up business or engineering (less than 7 percent, according to figures compiled when we were juniors). No one ever suggested to humanities majors that we try, say, an economics class. But I believe our liberal arts educations benefited us. They certainly prepared me well for a career in writing and publishing. And they provided those occasional epiphanies for which many of us hungered. I still remember vividly the moment I *understood a poem for the first time.* It was "The Sick Rose," William Blake's eight-line masterpiece.

I was privileged to take several classes with a young professor named Barry Qualls, who addressed us women as "Miz" in his charming Southern accent. We called him "Mr. Qualls." He was as staunch a feminist as anyone I met at Rutgers or Douglass. We kept in touch for a few years. Then life took over. Decades later, he emailed me. His signature line contained his then-title, Dean of Humanities. "Rutgers did something exactly right," I rejoiced. Our friendship resumed, as have others from those years.

Acceptance by the men in our own class was rarely a problem, but upperclassmen could be thorny. When I eagerly arrived at the offices of the *Daily Targum* to volunteer, the prevailing group of editors consisted of guys who had attended an all-male high school, chosen an all-male college, and didn't seem thrilled about coeducation. They gave me my first assignment: to report to a room in the Student Center and "write about what was going on." It turned out to be the office of the nascent Student Homophile League, itself still all-male. No big deal; they'd have to try a little harder to rattle me. A few times, they succeeded. But the *Targum* itself was a great training ground. As a general reporter and theater editor, I learned how to interview people, focus on key details, and write something at least marginally publishable every day—skills I've used ever since.

Remember that the country was churning then, too. George McGovern was fighting an uphill battle to unseat Richard Nixon as U.S. president. I was among a cluster of idealists who campaigned for McGovern; his massive defeat hit us hard. The Vietnam War raged on. My high school boyfriend, a year older than I, had dropped out of Livingston College to join the Army Reserves as a preemptive strike when his draft number came up in the top 10. While he was away, I fell in love with a fellow freshman. The second guy broke my heart, which colored my remaining college years, but that's another story.

In the diary I kept, an entry dated April 19, 1973, reflects the optimism and openness of the experience of being one of the first women at Rutgers: "I am acutely aware of the year's ending. Everything—the weather, RU housing, the playwriting muse, Bob—has contributed to a very intense, mystical, peaceful feeling in the past few weeks. The sky seems to say drink it in, with all its foibles and beauty, because it'll never be like this again."

—Marian Calabro (RC '76)

Below left: Marian Calabro with professor Barry Qualls.

Below: Marian Calabro, right, and fellow alumna Karen Rhodes were members of the first class of women to graduate from Rutgers College in 1976.

to Rutgers College took another few years, triggered by a nearly unanimous faculty vote in favor of the switch, which eventually led the Board of Governors to approve the change in 1971. History professor Richard P. McCormick was appointed to lead a committee to handle the logistics of the transition. "It turned out that wasn't a very big problem," he told interviewer Michael Birkner in 1996.

You had to change some urinals to something else, decide on patterns of housing, predict enrollments, and so on. So in September of 1972 we admitted our first cohort of women… We were the last nonmilitary men's college in a public institution in the United States—that is, Rutgers College—to go coeducational. But that was a fun fight.

On move-in day in September 1972, some 600 women joined 4,800 men in turning Rutgers into their home for the next few years. By the time two years had passed, 37.5 percent of the students at Rutgers College were female. Two years later, that number rose to 44 percent. Women currently make up 53 percent of the university's student body.

Working Students and Working-Class Heroes

The democratization of education has been evident throughout Rutgers' history. While its initial graduates were of prominent families, subsequent cohorts have been increasingly drawn from the middle and working classes. This has profoundly affected the study opportunities offered on its various campuses.

In the 1920s, a sizable cohort of students was working its way through college. Then came a 1929 termination of state scholarships—and the Great Depression. Rutgers and NJC coped as well as they could, scrambling to find employment for students whose families were hardest hit. In 1934, the Federal Emergency Relief Administration gave the school money to put some 200 students to work, earning as much as $15 per month. One year later, fully 12 percent of the student body was working through a National Youth Administration (NYA) program that paid up to 40 cents an hour.

One of those students was Alexander Gordeuk (AG '41), a Hunterdon County farm boy who came to Rutgers on a state scholarship, with $70 in his pocket realized by the sale of one of his family's pigs. He told the Rutgers Oral History Project that his money was soon spent on lodging, books, and equipment for school. "Then I went to work, NYA saved my neck. You talk about a government program!" Gordeuk was put to work digging a six-by-four-inch trench in the basement of the engineering building with "a diamond chisel and a five-pound hammer… That was the hardest work I ever did in my life… But that was the NYA, 25 cents an hour. That gave me, believe it or not, probably the margin as to whether I stayed in school or not."

Hard times didn't mean that students weren't having fun. "The social calendar had never been more crammed with events," wrote Professor McCormick. Contrary to the situation during the previous decade, in which extracurricular clubs tended to enhance the curriculum and ignore what was going on outside of Rutgers, the 1930s saw a burgeoning of interest in political issues and societies, including the Liberal Club, the League of Independent Political Action, the League for Industrial Democracy, and the Socialist Party. In 1935, some 300 students representing more than 20 student organizations attended a "peace strike" near the theological seminary. Later in the decade, in response to what was going on in Europe, the student body was debating war, fascism, and compulsory enrollment in the ROTC.

In the classroom, there was a marked upsurge in interest in courses that were more likely to lead to employment directly after graduation. Enrollment at the Agriculture School grew by more than 250 percent, and more than doubled at the School of Education and in the chemistry and ceramics departments. Even at the College of Arts and Sciences, students were shifting away from the liberal arts toward business administration and journalism. In 1934, Rutgers established University College, an arm of the school that allowed working adults—including women—to pursue their degrees by studying part time in the evening. Some 1,000 students enrolled at the University Colleges in New Brunswick and Newark in 1935.

Twin Success Stories: George and Washington Hill

George Hill: When our family moved to Camden in 1951, it placed us in a community where we would be able to gain leadership skills, receive mentoring, and develop a hardworking attitude. The city was more diverse than our previous home and provided more role models. James Drew, at the time a research scientist at the Franklin Institute, organized the Sigma Rays, a group of young Camden black men bonded together by their desire to attend and succeed in college and represent their families and race with pride. We would meet in Mr. Drew's home and discuss how we could be successful. Mr. Drew was a driving force in making success happen and an incentive to remember to always give back.

Washington Hill: When I finished Camden High School in 1957, my mother, a domestic, and my father, a post office worker in Philadelphia, gave me two career options: (1) go into the army and become a soldier; or (2) go to college. The army sounded scary, so the decision was easy.

GH: We always knew that it was expected that we would go to college. It was a message that we heard often and emphatically: "you are going to college."

WH: I suggested several to my dad, but they did not make the cut because he thought they were too "wild, and had too many parties."

GH: In 1956, Washington and I were selected to attend the American Legion Jersey Boys State program, an annual weeklong event held at Rutgers University–New Brunswick with representatives from all state high schools, only a few of whom were black. We learned about leadership and how government worked. Toward the end of the week, the director of the program, Harold Eaton, asked what college we would attend, and encouraged us to apply to Rutgers–Camden, where he was director for admissions. In the spring of 1957, Washington and I received a letter from Mr. Eaton offering us scholarships. We had limited family resources; this scholarship provided us a ladder to opportunity.

WH: I was so proud when George and I entered Rutgers College of South Jersey in 1957. We were some of the first few minority students enrolled. What I remember most during my stay were the many buildings being constructed, including a new library. I became a Greek, a member of Sigma Epsilon Phi. I enjoyed the Greek social life. My two

Son of a Sharecropper's Daughter

My mother would have loved it. She had worked her entire life to get all three of her children through college, an amazing feat for a woman who had put all her savings together to get away from her family's sharecrop farm, to take the bus as far north as the money would carry her. Now her oldest boy was standing in front of the graduating class at Rutgers–Camden, all duded up in academic robes.

Looking out on the students, I could feel her pride and her presence. Looking out on those faces that represented every ethnic group that had come to New Jersey, faces that shone with the joy of being the first person in the family to graduate from college, faces that reminded me of the frightened 16-year-old who had come to Rutgers so long ago.

It was not the beautiful little tree-shaded campus it is now. It was converted row houses and an old church that had something sort of like a student union in the basement. I loved it immediately, even though I knew hardly anything beyond the hard-working world my father had provided us by carrying a lunch pail every day to the New York Shipbuilding Co., and the contents of the paperback books I bought with my newspaper delivery and laborer money.

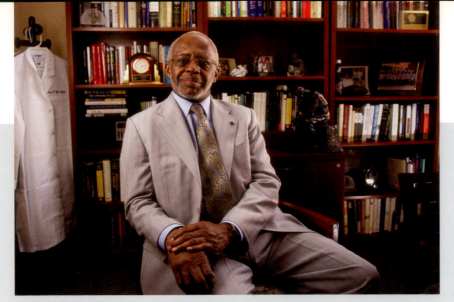

George Hill was inducted into the Rutgers Hall of Distinguished Alumni in 2012; his identical twin, Washington, who is younger by three minutes, was inducted in 2006.

best memories of it are volunteering to paint the fraternity row house one weekend and pulling the carriage with others during Greek Week while some big brothers rode in it.

GH: We were among two of the first black students to attend Rutgers–Camden. I entered as a history major, but became excited about research in biology and parasitology. The campus also expanded my network of friends and provided leadership opportunities. I served as class treasurer, vice president, and representative to the student government.

WH: After graduating, I chose medicine as my career path and attended Temple University Medical School. I am today practicing maternal-fetal medicine at Duke University's School of Medicine.

GH: On graduating, I attended Howard University, receiving a master's in biochemical parasitology; I then obtained a doctorate in biochemistry from NYU. The seeds for these pursuits were planted at Rutgers.

WH: We will forever remember our educational opportunities, social life, time in the library, and days spent at Rutgers–Camden. I am honored to have been named, along with my brother, to the Rutgers Hall of Distinguished Alumni. Rutgers provided my brother and me the stellar educational opportunities that we would not have had elsewhere, and it laid a firm foundation for future endeavors that continue. We therefore wanted to give back and help Rutgers–Camden establish the Hill Family Center for College Access; it provides underserved students in Camden and South Jersey—like us—the opportunities to have the same education that we had.

—GEORGE HILL (CCAS '61), DISTINGUISHED PROFESSOR EMERITUS OF PATHOLOGY, MICROBIOLOGY AND IMMUNOLOGY, AND MEDICAL EDUCATION AND ADMINISTRATION, VANDERBILT UNIVERSITY MEDICAL CENTER; AND WASHINGTON HILL (CCAS '61), DUKE UNIVERSITY SCHOOL OF MEDICINE, DEPARTMENT OF OBSTETRICS AND GYNECOLOGY, MATERNAL-FETAL MEDICINE

Richard Aregood, center, with *Philadelphia Daily News* editor Gil Spencer, left, and Jesse Jackson, 1984.

Rutgers did what it was supposed to do. It opened a world—at a price my parents and I could afford. Writing compositions continuously (and frequently on a procrastinator's deadline) gave me the suspicion that I could write some and maybe make a living at it. A U.S. history course ignited a fascination that has only deepened over some 50 years of reading.

I would have sunk quickly out of sight at a place like Princeton, where swells gathered and probably wore tweed undershorts. The hordes at a big university like Wisconsin would have overwhelmed me. Rutgers–Camden was just right. Professors, even administrators, were reachable and helpful. That was a good thing because I was what one might call a late bloomer, having once managed to achieve the daily double of being on academic and social probation simultaneously.

All along, I was learning to write. I was writing a column in the *Gleaner* on a regular basis and covering stories. Writing was the way I came to understand my coursework, to synthesize the ideas in them so that they made sense in 1,000 words. And seemingly by accident because I took courses on whim as much as design, I was acquiring the knowledge any credible writer needs.

My mother, a sharecropper's daughter with a third-grade education, used to say, "People may think I'm stupid. I'm not. I'm just ignorant." She dedicated her life to making sure that her children were not ignorant, that they had a chance at life just like the rich folks. Rutgers made that happen for me. I am forever grateful.

—RICHARD AREGOOD (CCAS '65), PULITZER PRIZE WINNER FOR EDITORIAL WRITING AT THE *PHILADELPHIA DAILY NEWS*, VISITING PROFESSOR, FACULTY OF ARTS AND SCIENCE, RUTGERS–CAMDEN

Below: ASTP student studying. | **Right:** Army Thanksgiving service, 1944.

the draft. Many of them had enrolled in the enlisted reserves, hoping to complete their degrees before being called up, but by January 1943 they were being mobilized regardless of academic status.

Enlistment and conscription hollowed out the Rutgers student body in the earliest years of the war. But the government chose it as one of the pilot schools for its new Army Specialized Training Program (ASTP) in 1943 and changed the school color from scarlet to khaki almost overnight.

The program allowed Army enlisted personnel to take courses in defense-related areas including engineering and foreign languages, and later in premed and predental disciplines as well. Some 1,300 ASTP participants showed up on campus in the program's first year, leading to a total enrollment at Rutgers College of 1,855. In 1945, an Army Specialized Training Reserve Program for students under 18 attracted an additional 400 participants, driving total enrollment to 3,877. Rutgers was stuffed to the rafters with ASTP participants, some of whom were originally Rutgers students, and some of whom were randomly assigned to Rutgers for their studies. They became an overwhelming presence on campus, taking over the dorms, most fraternity houses, and much of the rental housing stock in New

Brunswick. The College Avenue Gym was turned into their mess hall, and they even fielded their own football team.

Nicholas Filippone (ENG '45), recalls an "adversarial" feeling between the civilian students who remained on campus and the ASTP participants. "The presence of the ASTP on campus, here, was really overwhelming, because they took over pretty much everything," he said. "Of course, these poor guys had to march to class and all, and we would stand up on the roof of the porch of Kappa Sig and throw snowballs at them." Classmate Paul Jennings (RC '45), on the other hand, remembers that the influx of ASTP students prevented furloughs of Rutgers faculty, in particular that of soil microbiologist Selman Waksman (RC '15, '16). "If you're given a leave of absence, you're not going to sit around and do nothing," he said of Waksman. "You're going to find another job. And of course, the more richly endowed colleges were going around, gathering up the great minds of the country… So I think the ASTP may have been the economic salvation of Rutgers. It gave faculty somebody to teach."

And teach they did. In order to enable the ASTP students to earn their degrees in just 18 months, classes shifted from a standard academic year to a schedule of four 12-week terms, with no summer break for either ASTP or

civilian students. Classroom space at New Brunswick was at a premium, so the civilian students squeezed into classes at NJC. When they had some rare free time, students, male and female, were involved either in working in defense-related industries or in volunteering with organizations like the USO or the Red Cross.

The ASTP students were pulled out of their classrooms and dispersed into combat units in the spring of 1944 as the allied powers prepared for the invasion of Europe. Once they were gone, Rutgers suddenly felt empty, but its experience in pushing its own and its students' boundaries as part of the war effort would serve it well in peacetime as a tidal wave of students threatened to engulf the newly christened State University of New Jersey.

In all, 6,061 Rutgers students, alumni, faculty, and administrators served in the armed forces in World War II. That figure included 1,700 undergraduates, 173 women, and 36 percent of all living alumni. Of that number, 234 men and two women lost their lives, including Frank Holden, Class of '39, who was killed at Pearl Harbor, and President Robert Clothier's own son, Arthur, an Air Cadet killed in a training exercise.

As the war was winding down, Congress passed the Servicemen's Readjustment Act of 1944, better known as the G.I. Bill, which provided education benefits for G.I.s who had served at least 90 days during the war and weren't dishonorably discharged. Some 9,000 used their benefits

to enroll at Rutgers. The funds undergirding the veterans' enrollments made possible a building and merger campaign that established Rutgers as one of the nation's largest universities by the end of the decade.

President Clothier committed Rutgers to accepting "all qualified veterans and high school graduates for whom it is possible to provide, not just those whom it is convenient to take." In September 1945, the men's colleges at Rutgers had an enrollment of just 750 undergraduates. Two years later, it had a student body of 4,200.

The physical reception of the first wave of postwar veterans to hit Rutgers was made easier by the university's 1946 merger with the University of Newark to form Rutgers Colleges at Newark, which boasted a College of Arts and Sciences, a Law School, a School of Business Administration as well as a College of Pharmacy, which had become part of Rutgers in 1927. Four years later, the former College of South Jersey and the South Jersey Law School in Camden merged with Rutgers to give the university a presence in that region of the state as well.

In New Brunswick, the new students were stuffed into three dorms, 17 frat houses, some apartments on the University Heights (now Busch) campus, and New Brunswick's rental housing. Beginning in 1947, they also occupied former Army barracks at Camp Kilmer on what is now the Livingston Campus, prefab housing units and classrooms on George Street in New Brunswick, and the Hillside Trailer Village for married students living with their wives and children. More than one-third of all students were shut out of housing entirely and forced to commute.

By 1948, fully 70 percent of the university's student body was made up of veterans. On the whole, the veterans were "a stabilizing factor in undergraduate life; more mature in judgment than the average student, more philosophical in their approach to problems, more tolerant in attitude and better self-regulated," according to Dean Earl Reed Silvers (RC '39).

In April 1965, the simmering conflict in Vietnam spilled onto the Rutgers campus. The United States had been tangentially involved there since the end of World War II, and in 1955 had begun sending American advisors to the region

Today, Rutgers is home to active Air Force, Army, and Navy ROTC programs. Navy ROTC was established at Rutgers in 2012. Here, Marine Corporal Casimero Tanseco (RBS '13), a Navy veteran, stands at attention during a 2011 Veterans Day ceremony at Kirkpatrick Chapel.

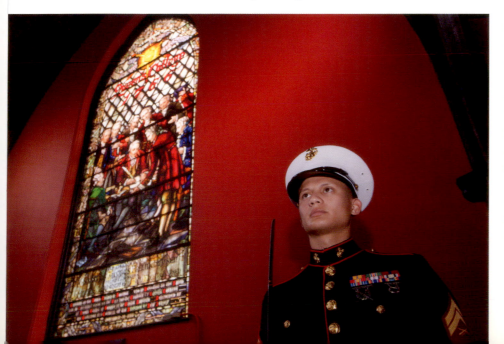

Sanctioned Nonconformism at Rutgers

Small, everyday acts of personal resistance and nonconformance by students in Rutgers' early years, such as skipping mandatory chapel services or refusing to wear first-year clothing assigned by upperclass students, were precursors of significant change with respect to the range of students' personal liberties and decision making.

Particularly after the U.S. Supreme Court had invalidated institutional *in loco parentis* (*Dixon v. Alabama*, 1961), students challenged a number of institutionally sanctioned behavioral constraints. For example, in the late 1960s, Douglass College women challenged their restrictive curfews and intrusive bed checks in part to respond to perceptions of broad political apathy among "Coopies" (the nickname is from Douglass College's old Cooper Dining Hall). Douglass College dean Margery Somers Foster, after due consideration of traditional standards for a "residence college for women," approved installing locks on students' dorm rooms and permitted beer to be brought onto campus—within limits. The remaining curfew and alcohol restrictions (for students of age) at Douglass College were eventually discontinued.

In 1968, the *Targum* staff announced that the *Targum* would be an "activist newspaper" to inform debates as well as to express its own collective viewpoints. Rutgers dean Arnold Grobman published an open letter to parents that underscored the educational value of dissent, demonstration, and protest for participants as well as nonparticipants. President Mason Welch Gross led Rutgers during much of this era and developed a general reputation for being respectful and reluctant to involve law enforcement and other external groups in addressing campus protests.

The results of a 1968 campus survey indicated that two-thirds of Rutgers students were "occasional" or "frequent" marijuana users, and the new student center on College Avenue was widely known as a place to buy and sell drugs. Dean of men Howard J. Crosby Jr. and dean of student affairs Earle Clifford Jr. both rejected inviting undercover narcotics agents on campus as an answer; they instead prohibited access to the student center by non-Rutgers persons in a bid to limit access to off-campus suppliers. Although both deans actively discouraged students from using marijuana and other drugs, students' rights to make free and informed—albeit illegal—choices were respected.

Principled nonconformism segued at some point into intemperance. In 1973 the state legislature lowered the drinking age to 18. By 1975, incoming first-year students attending spring orientation stood in one interminable line for their ID cards, then stepped three paces to the right to stand in another for their pub cards. Beer was everywhere: in dorms, in on-campus pubs, at local bars, and occasionally in 18-wheelers bristling with spigots at Ag Field Day or at Livingston's Spring Weekend. Marijuana, though illegal, was almost as freely available. With the advent of coeducation, sex became an option for a lot more students, one exercised with great frequency and enthusiasm in the years after the Supreme Court's *Griswold v. Connecticut* and *Roe v. Wade* decisions, and before the advent of HIV/AIDS. The New Brunswick campuses, at least, were hotbeds of poor man's hedonism, with cheap eats available almost all night from the grease trucks that roamed the campuses; a remarkable undefeated season for the men's basketball team in 1976; appearances by now-legendary acts including the Talking Heads, Bruce Springsteen, Linda Ronstadt, and the Allman Brothers; and showings every weekend of *The Rocky Horror Picture Show* at the Art Cinema.

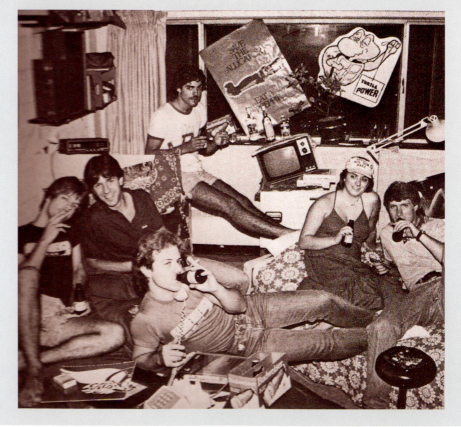

A slice of dorm life from 1983.

A staple on the College Avenue Campus since 1963, Scott Hall, though dreary, has been the site of countless lectures and classroom discussions.

Frost told Dumont, "I'm a Rutgers student, I'm in ROTC, I'm going to serve my country, and I'm a history major, and I was there and I heard him say it... I disagree with it, but he had the right to say it, and you shouldn't be trying to get rid of him."

Subsequent teach-ins at Rutgers led to a literal slap-fight between some students and the mother of a Coast Guard lieutenant stationed in Vietnam, a screaming match between several professors that ended with a wristwatch being smashed against a podium, and a "teach-out" featuring picketers urging the state to "Rid Rutgers of Reds."

In the following years, Rutgers antiwar protests escalated, as did American involvement in the war. An ongoing series of demonstrations, walk-outs, sit-ins, and building blockades culminated in 1970 in the first use of the New Brunswick city police against students on campus, and in 1972 in the firebombing of the ROTC building on College Avenue.

Closely tracking the growth of the Rutgers antiwar movement was the rise of the school's black student protest movement. In 1968, Rutgers University had a total enrollment of more than 10,500 students, only 289 (or 2.7 percent) of whom were African American. In the months following the 1968 assassination of the Reverend Martin Luther King Jr., African-American students across the country began to organize on their campuses. At Rutgers, the center of African-American activism was the Newark campus.

In May 1965, the Rutgers chapter of the Students for a Democratic Society organized a so-called "teach-in" on the war at the newly built Scott Hall. That evening, history professor Eugene Genovese stood up and said that, as a Marxist, "I do not fear or regret the impending Vietcong victory in Vietnam. I welcome it." Suddenly, Rutgers was at the center of a national debate over the war, when President Richard Nixon and New Jersey Republican gubernatorial candidate Wayne Dumont publicly called for Genovese's dismissal.

Rutgers president Mason Gross stood behind Genovese's right to express his opinion on the grounds of academic freedom. Perhaps more surprisingly, so did a young Republican ROTC candidate named John Frost (RC '67). He had a chance to challenge Wayne Dumont at a fundraiser after Dumont used the event to call again for Genovese's dismissal.

Puerto Rican Organization

The Puerto Rican Organization (P.R.O.) at Rutgers–Newark in 1971. The members included Cuban and Dominican students as well as Puerto Ricans and between 1969 and 1972, as many as or more women than men. Its president in 1971 was Melba Maldonado (top row, center).

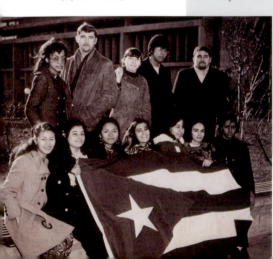

The Puerto Rican population in New Jersey grew enormously in the immediate post-World War II era, but few of the migrants or their children attended the State University during the 1960s and 1970s. In the wake of the Newark disturbances in 1967, community organizers made efforts to recruit more minority students to attend Rutgers. Some of these organizers and students were Puerto Rican, and they were greatly assisted by Maria DeCastro Blake in the Newark admissions office. For more than a generation, she helped Latino/a students trying to negotiate the university's elaborate bureaucracy and acquire financial aid. At Rutgers, in 1969, Puerto Rican students formed the P.R.O. and, a few days before black student protesters occupied Conklin Hall, the Puerto Rican students had presented the Newark administration with their own set of demands.

In spring 1971, frustrated by slow progress in improving the admission and recruitment of Puerto Rican students, activists in Newark, New Brunswick, and Camden simultaneously made new demands on their respective campus administrations. This was followed by a coordinated sit-in in the office of acting president Richard Schlatter, led by spokesperson Gualberto "Gil" Medina, a Camden history major. The demands led to changes in recruitment policies and curriculum options on each campus. The most notable change occurred at Livingston College. There, a well-organized group of Puerto Rican students lobbied successfully for the development of a Puerto Rican studies program. Organized by Hilda Hidalgo, an urban studies professor and Puerto Rican activist, the program became a department, initially chaired by María Josefa Canino. The initiative's legacy is the current New Brunswick Department of Latino and Hispanic Caribbean Studies and smaller studies programs at Camden and Newark.

—PAUL CLEMENS, PROFESSOR OF HISTORY, SCHOOL OF ARTS AND SCIENCES

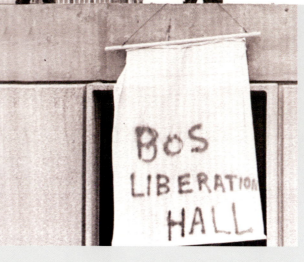

Tension at Conklin Hall

In July 1967, intense racial confrontations broke out in Newark. When an African-American cab driver, John Weerd Smith, was stopped for a traffic offense, he was taken to the 4th Police Precinct, where he was beaten. Rumors quickly spread that he had been beaten to death, and long-building tensions exploded in violence and looting. These were grim times for Newark, whose demographics had changed considerably since the early part of the century. By 1967—the year the phrase "white flight" entered the English language—the predominantly middle-class white residents were moving out of the city and into the suburbs. At the same time, African Americans were arriving in the city in ever-larger numbers, making Newark one of the first majority-black cities in the United States.

Those racial tensions made their way from the larger city to the campus in the late 1960s, coming to a head in February 1969. That's when a group of African-American students, most from the Black Organization of Students, took over the recently opened Conklin Hall.

The situation had been brewing for some time. Rutgers–Newark was still a largely white institution—by some estimates as high as 95 percent white, with just 2 percent African-American students—even as 75 percent of the students in the Newark public schools were of African-American descent. Rutgers–Newark, whose students once looked like the city they were part of, by this time had become an island of white suburbanites. On February 13, 1969, the Black Organization of Students submitted a list of demands to the administration, calling for more minority representation among both the students and the faculty. For 72 hours, the students held the building, and banners were rolled out to declare Conklin Hall had been renamed Liberation Hall.

Douglass Women and the ERA

The New Jersey College for Women was founded by a group of prominent social reform activists who sought to open educational and career paths that had been closed to women. For largely political reasons, they had avoided advancing women's rights and suffrage rationales for establishing the college, but generations of Douglass College women have advocated for women's rights in political, educational, and social arenas. In 1972, New Jersey was among the 14 states that ratified the Equal Rights Amendment (ERA) within the first month after its passage. The late Millicent Fenwick (**right**), the four-term congresswoman from New Jersey generally believed to be the inspiration for the *Doonesbury* cartoon character Lacey Davenport, remarked, "I have talked to girls in Douglass College at home and you can see them lighting up at the idea that they can go to law school and become senators! You can't get a boy to light up like that, because he takes it for granted…"

But where so many campus actions like this turned out so badly in the 1960s, the Conklin Hall occupation was one of the high points in Rutgers–Newark's history. Both the students and the administration negotiated in good faith, with Rutgers Board of Governors member and civil rights activist Bessie Nelms Hill taking the lead role for the university. Rather than shutting the protests down, the university listened, and agreed to increase minority representation at the university.

The effect was rapid and profound. What had been a largely white institution in a largely nonwhite city was transformed in the wake of the Conklin Hall occupation, and the call for increased numbers of minorities on the campus succeeded beyond what anyone could have imagined. Through the 1970s and '80s, the student body changed radically. Newark has always been an immigrant city, but once nearly all of the early immigrants came from Europe; now they came from all over the world. The influx of students from Central and South America, the Caribbean, South Asia, East Asia, and Africa was amazing to those who witnessed it, and the effects are with the campus still.

—JACK LYNCH, PROFESSOR OF ENGLISH, RUTGERS–NEWARK

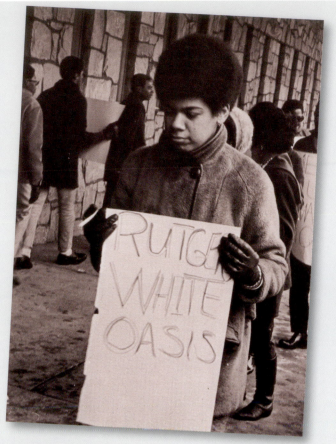

Right: All the way from South Africa, Camden students voice their objections to the proposed Rutgers–Camden merger with Rowan.

As the Vietnam War drew to a close and the race riots that had set some of the nation's major cities ablaze were turned down to a simmer, things began to calm down on Rutgers' three campuses as well. Although the student activism that was a hallmark of the previous decade had abated, it hadn't died out altogether. Rutgers students protested in Trenton against an increase in fees and tuition, and were among the leaders in the anti-apartheid protest movement. In 1978, activists were successful in convincing the university to divest from companies that didn't adhere to the Sullivan Principles outlining antidiscriminatory practices for entities doing business in South Africa. When the university later reinvested some funds with companies that had brought themselves into compliance, total divestment from companies doing business in South Africa became the goal. In October 1985, six months after activists took over the College Avenue Student Center for three days in April, the university agreed to divest $6.4 million from companies doing business in South Africa.

One recent high-stakes protest action engaging Rutgers students and faculty was the proposal for higher education restructuring in New Jersey that advised merging Rutgers–Camden with Rowan University in Glassboro, and incorporating most units of the University of Medicine and Dentistry of New Jersey (UMDNJ) into Rutgers University. The proposal, originating from a governor's advisory committee, was regarded by many as a political deal offering Rutgers University a medical school and related units in exchange for Rutgers–Camden. Soon after details of the restructuring plan surfaced in late 2011, Camden students and faculty immediately organized to defeat the proposal using a sustained, multilayered approach including public rallies and demonstrations; political lobbying; social media campaigns; guest essays, editorials, and blog posts; and assessments of potential legal strategies. In time, the Rutgers Boards of Governors and Trustees asserted their corporate authority over decisions regarding Rutgers campuses, and the Camden-Rowan merger did not take place.

Reaction to Rutgers-Rowan Merger

I was on the River Line on my way home from class during my first year when I read about the merger plan to sever Rutgers–Camden and give it to Rowan. While there had been some rumors about a higher education plan from the governor's office, the announcement came as a complete shock to the students at Rutgers–Camden and was followed by a near-unanimous negative response from the student body and alumni.

Reaction on campus was swift and unified. Student and faculty groups organized seemingly overnight, Facebook groups were created as a platform to exchange information quickly and efficiently, a Change.org petition was circulated that received 5,000 signatures in the first week alone, rallies were held, and T-shirts were made, all to emphasize our Rutgers pride.

Three weeks after the proposal was announced, the Rutgers Board of Governors held their regularly scheduled meeting on the Camden campus. The 650-seat Gordon Theater was filled to capacity. State Senate president Stephen Sweeney, a key architect of the plan, and state senator Donald Norcross were in attendance, and when Sweeney told students that if they didn't like the plan, they should simply vote against him, he was booed out of the auditorium. Professors in the law school immediately debunked the state's purported legal authority to unilaterally carry out the merger over Rutgers' objections, and along with student leaders, testified at legislative hearings on the matter and published op-eds in major state newspapers.

When the Rutgers Board of Trustees overwhelmingly asserted its authority over the matter and rejected the merger proposal, there was a near-universal sigh of relief. The result in the end was the best of all possible outcomes, but it was one that was far from certain at the outset. Rutgers–Camden

Walt Whitman statue on the Camden Campus adorned with Rutgers garb in solidarity with protests to save Rutgers–Camden from a merger with Rowan.

remained a fully integrated part of Rutgers, The State University of New Jersey. There was short-term damage for sure. Law school enrollment and applications plummeted, and many students considered transferring to other law schools. The independence of the university from political pressure was severely shaken. Fortunately, the integrity of the academic mission and the core value of an integrated university system once tested proved to be resilient.

Throughout the debacle, the entire Rutgers–Camden community was unified and spoke with one voice. I think the biggest challenge we faced was not to appear as anti-Rowan. Simply put, we were not anti-Rowan; rather, we were proud to be Rutgers. For me personally, I am the third generation of my family to attend a school at Rutgers University. I wanted to be able to continue that tradition.

—Jordan Hollander (CLAW '14)

Another recent example of student activism resulting in change universitywide stemmed from tragedy. In September 2010, freshman Tyler Clementi jumped to his death from the George Washington Bridge after accusing his roommate of using a webcam to surreptitiously view him kissing another man. Students organized a Black Friday memorial for Tyler and worked with the administration to formulate new policies that would make the university a safer, more welcoming place for lesbian, gay, bisexual, transgender, queer, and ally (LGBTQA) students. In response, Rutgers made available

Left: Students walked out of classes to protest the fourth anniversary of the war in Iraq in March 2007.

Rutgers University, which promotes interdisciplinary research that focuses on examining and improving the experiences of youth in transition in the digital age. In response to Rutgers' improved resources for LGBTQA students, Campus Pride gave the university its top five-star rating for inclusiveness. Campus Pride also named Rutgers one of the Top 25 Most LGBTQA Friendly Campuses in 2013.

And on to the Future

The traditional Rutgers student experience has been full-time enrollment and living on or near campus for four (or five) years. Increased enrollments of adult students, part-time students, and students who sit out one or more terms continue to change the ways in which students experience Rutgers. Current and future incorporation of distance education, online course delivery, and hybrid learning opportunities at Rutgers

Above: Mourners hold a candlelight vigil in memory of first-year student Tyler Clementi in front of Brower Commons on a rainy October evening in 2010.

Right: Members of the Rainbow Perspective special-interest housing that opened to meet the needs of the LGBTQA community.

gender-neutral housing that would enable students to pick their roommates regardless of gender and set aside an LGBTQA special-interest housing section called Rainbow Perspectives. It also expanded the Center for Social Justice Education and LGBT Communities and opened the Tyler Clementi Center at

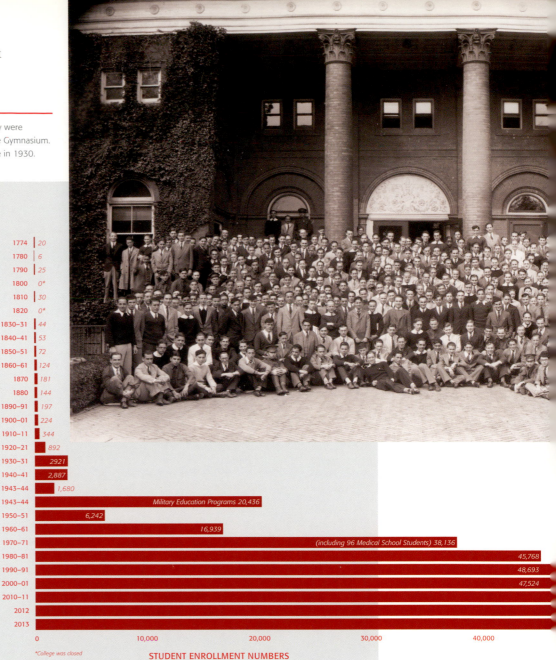

The Class of 1932 posed when they were underclassmen in front of Ballantine Gymnasium. The gym would be destroyed by fire in 1930.

Students by the Numbers

When the first commencement of the institution that would become Rutgers University was held in 1774, there were 20 students in attendance, one graduate, and one tutor comprising the faculty. Growth was slow at first. The 1789 graduating class numbered 10 men. There were multiple suspensions of operations in the early 19th century when funds were scarce, but by 1871 the *Scarlet Letter* yearbook listed 165 students: 114 from New Jersey; 45 from New York, two from Pennsylvania, and one each from Virginia, Kansas, Washington, D.C., and Japan. Growth halted somewhat for disastrous world events. On the eve of the financial crash of 1929, there were 1,401 undergraduate men enrolled at the various colleges, and 1,159 women. By 1933, men's enrollment would drop to 1,200, and women's enrollment reached a low point of 940 one year later. Today, students from every state and more than 115 countries are studying at Rutgers. That enormous growth happened in leaps and bounds in the 20th century.

YEAR	STUDENT ENROLLMENT NUMBERS
1774	20
1780	6
1790	25
1800	0*
1810	30
1820	0*
1830–31	44
1840–41	53
1850–51	72
1860–61	124
1870	181
1880	144
1890–91	197
1900–01	224
1910–11	344
1920–21	892
1930–31	2921
1940–41	2,887
1943–44	1,680
1943–44	Military Education Programs 20,436
1950–51	6,242
1960–61	16,939
1970–71	(including 96 Medical School Students) 38,136
1980–81	45,768
1990–91	48,693
2000–01	47,524
2010–11	
2012	
2013	

*College was closed

Many alumni—especially those who graduated between 1955 and 1985—remember housing waiting lists, closed courses, construction sites, muddy pathways, and lines in dining halls, bookstores, buses, and administrative offices like financial aid and student accounting. The dramatic increases in enrollment explain why lines were inevitable. With a dip only between 1950 and 1955, from 1946 through 1980 Rutgers enrollment increased every five years by well more than 20 percent. The student body overall grew by 22 percent between 1946 and 1950 as Rutgers welcomed military veterans returning after World War II. In 1948–49, nearly 70 percent of all enrolled students at Rutgers (excluding the women enrolled at the New Jersey College for Women) were military veterans. On-campus housing was inadequate to serve them; veterans lived in a trailer village called Hillside on the Busch Campus and barracks at Raritan Arsenal, now the campus of Middlesex County College in Edison. Enrollments increased even more dramatically between 1955 and 1960 (38 percent) and between 1960 and 1965 (42 percent). Another 37 percent growth spurt occurred between 1965 and 1970 with the birth of Livingston College, and yet another 31 percent between 1970 and 1975 with the introduction of coeducation at Rutgers College. The Busch Campus burgeoned in the 1960s, and by the 1980s housed more students in on-campus apartments and residence halls than any other campus. Many remember the double rooms that became triples, the lounges that were turned into additional rooms, the housing waiting lists and lotteries.

In May 2013, Rutgers awarded its 500,000th degree; today, total enrollment exceeds 65,000.

Right: The Class of 2016, the 250th Anniversary Class, marks the beginning of their Rutgers education at the September 2012 convocation held at the football stadium.

56,868

58,788

65,512

000 60,000

have the potential to drastically alter the student experience in terms of nature and location. It is unclear whether or how future students, and especially students with only virtual experiences of Rutgers, will relate to Rutgers as "alma mater" or form the kinds of meaningful connections that result in lifelong friendships and networks. Virtual connections may become more critical when geographic, cultural, and interpersonal differences are more difficult to bridge.

Above: Students in Ford Hall, 1936.

Left: Students on campus, 2007.

Student Voices

Rutgers Lovers and Loyalists

Lifelong relationships are forged at Rutgers: not just with friends, mates, and spouses, but also with the institution itself. And the best of these relationships are true perennials, spanning multiple generations.

Grandpa, Football, and Me
Pamela Zysk (DC '73)

My first recollection of Rutgers does not occur during my years there but as a child attending football games with my grandfather, Herman Kuchen. He was chief cashier in Winants Hall, and he would always take me to the games. We sat in the end zone of the old stadium and cheered. Fast forward to 1969 and I am again sitting in the end zone as a freshman at Douglass. I was cheering for the Scarlet Knights at the centennial game against Princeton. I am sure my grandfather was there in spirit.

Going to the Chapel
Danielle Oviedo (LC '02) and M.K. Tsui (RC '02)

In 1997, we met in our first year on Busch Campus. We couldn't have been more different—Danielle loved reggae and rom-coms, while M.K. was all about hip-hop and video games. There was no love connection, and we were both dating others. But a genuine friendship sparked that day, and whenever we crossed paths, smiles and laughter followed. We lost contact for a few years after graduation as Danielle's life and career took her to North Jersey. Meanwhile, M.K. welcomed the opportunity to remain at RU as a staff member, where he now works at the Office of Student Accounting. We reconnected in 2008 via social media, and decided to meet to reminisce and catch up. Interestingly enough, we discovered that in the years apart, we had developed so much in common…and wouldn't you know, we both happened to be single this time. Our friendship blossomed into romance, and along the way, Danielle got a job working for the university as well, at the Rutgers Business School. In 2013, we tied the knot in Kirkpatrick Chapel. We felt honored to have our marriage take place in such a beautiful and historic location, surrounded by members of our Rutgers family, past and present. We both came to Rutgers for our education, but ended up receiving so much more—lifelong friendships, fulfilling careers, even true love. We are grateful for what the university has given us. Rutgers has been, and will continue to be, the cornerstone of our love and our lives.

Rutgers on the West Coast
STEVE (RC '70) AND CYNDE (DC '72) MAGIDSON

It was the beginning of the '68 school year, and my frat brothers and I decided to attend the first Douglass mixer of the year at the Student Center. The band was playing one of my favorite songs, "Mustang Sally," so I turned and asked the girl behind me if she would like to dance. Fortunately for me she said "yes," or this would be a very short story. Cynde and I danced to "Mustang Sally," and the next song, and the next one as well. We exchanged names and chatted. I was definitely smitten (and hoped she was too). I asked her to several events over the next few weekends, and the rest, as the expression goes, is history. Cynde and I were inseparable for the next two years at RU, and have continued to be so for the past 40-plus years. On June 27, 1971, the year after I graduated, Cynde and I were married in Voorhees Chapel. It was a very special place for us, and cemented Rutgers as an integral part of our lives together. In 1973, Cynde and I moved to California for business, and it wasn't too long before we found out about the Rutgers Club of Southern California (RCSC), and got involved—in a big way. In 2001, we received a Meritorious Service Award for our work with RCSC, the first time a couple received this award as well as the first time it was awarded for work with a regional alumni club. We have continued our strong relationship with RU over the years, even as we moved to Bend, Oregon; Rutgers is in our blood. In fact, we had the plane that Cynde and I used to fly (yes, we are both instrument-rated private pilots) painted in Rutgers colors with our beloved Scarlet Knight on the tail. We are proud to be alums of Rutgers University, and we want everyone to know it!

Romance Blooms in the Gardens
ARIEL (SAS '11) AND LIRAN (SAS '11) KAPOANO

My husband Liran Kapoano (SAS '11) and I met through Rutgers Hillel in the fall semester of 2010 during our last year at Rutgers. We began dating during the spring of 2011 and met each other's families for the first time at the political science graduation ceremony at Douglass on graduation day. We've visited the Rutgers Gardens together several times and always hike to a beautiful place on the wooded trail down by the river. On one occasion, Liran carved our initials into a tree at our place. On September 22, 2013, Liran led me to the gardens and asked me to marry him; of course, I said yes! Rutgers is the reason we met, and the school will be part of our story forever. We are football season ticket holders right now, and I fully expect to return for many years to come with our children!

STUDENT VOICES

A Reluctant Applicant
Sattik Deb (LC '01, GSED '11)

When I originally applied to Rutgers University, I was a reluctant applicant, sharing a story typical of many New Jersey students who were eager to attend college elsewhere. I was forced to apply by my parents and, upon my admission to Rutgers, knew that my eventual attendance was highly likely. Soon after getting admitted, I was invited on campus to interview for the Livingston College Honors Program. In an effort to sabotage my admission into the program—and possibly by extension open up the possibility of exploring some of the other universities to which I had been admitted—I arrived at the interview dressed in denim shorts and a T-shirt, and the first thing I told Dean Barbara Zonitch when the interview started was that I didn't really want to be there. Much to my chagrin, several days later I received a phone call from the dean to let me know that they were very interested in having me in the program. My fate was sealed, and I was destined to attend Rutgers. It only took a week on campus for me to realize that coming to Rutgers was the best decision I had ever made (or had made for me, depending on how you look at it), and as graduation approached, I never wanted to leave. Eight years later, I returned to start my graduate work at Rutgers, and I now have the pleasure to work here. My wife—a Douglass graduate—and I even got married on campus at Voorhees Chapel. Our rehearsal dinner was held at Brower Commons. And now, our 2-year-old daughter proclaims that Rutgers is her favorite team.

Couldn't Be More Proud
Jaclyn Bradley-McFarlane (CCAS '09, EJB '12)

I came to Rutgers University–Camden as a transfer student in 2007. I was immediately impressed by the faculty and their passion and dedication to revitalizing Camden. In 2010, I chose to continue my studies at Rutgers University–New Brunswick, obtaining a master's in city and regional planning from the Edward J. Bloustein School of Planning and Public Policy. When I was hired by the university, I knew my academic life was not over. I am now working toward a doctorate in public affairs-community development at Rutgers–Camden. I couldn't be more proud to be an alumna, employee, and, once again, student at Rutgers University. The people I've met, the knowledge I've acquired, the experiences and memories that I'll keep with me… they make Rutgers University my home.

All in the Family

I spent 50 years (1958–2008) as a Rutgers faculty member, during which time I served two terms as engineering department chair and graduate director, two terms on the Rutgers Board of Governors, and one term on the Rutgers Board of Trustees. I am proud that my daughter Ava (DC '72), my son Robert (ENG '83, RBS '88), and his wife Lanfen (RBS '88) are Rutgers alumni.

—Edward Nawy

My son Ian (RC '08) graduated from Rutgers College in 2008 with a dual degree in history/political science. He is currently a law student at Rutgers–Camden. My other son, Jay (CCAS '15), is a junior theater major at Rutgers–Camden. I just graduated in 2013 with an MBA from Rutgers–Camden and am now employed by Camden's School of Business. Rounding out the family, my husband Mike is the sports information director at Rutgers–Camden.

—Beverly Ballard (SBC '13)

After graduating from the Camden Campus in 1965, I went on to receive a master's degree in engineering and, during 35 years of working for defense agencies, became executive director of engineering. My wife, two grown children, and I have a total of five degrees from Rutgers and are all successful professionals. Since retiring, I have been teaching part time at the Camden Campus. I'm thankful for the interactions with the students and having a chance to make a difference. I have also established a family scholarship to honor my parents (More Family Scholarship).

—Paul More (CCAS '65)

Paul More and family with their Rutgers degrees.

Dream Job
KIM PRZEKOP

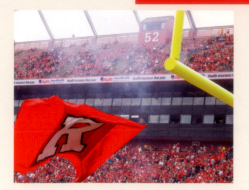

I obtained my dream job just one week before the Rutgers merger with UMDNJ: Assistant Professor in Clinical Laboratory Sciences. One of the main reasons I was so excited was that I would be able to enjoy the big-college Rutgers community—research opportunities, networking with other disciplines, even attending football games! I am pursuing a doctorate at SHRP and my son is getting a BS. Go Scarlet Knights!

A Rutgers Diary
STEVEN A. MILLER (RC '79)

Saturday, August 30, 1975. The day my father parked in front of Frelinghuysen Hall and told me to unload my worldly possessions from his car. Little did I know that I would spend most of my adult life roaming the classrooms and offices of this great, beautiful, and sometimes awe-inspiring university.

Tuesday, September 2, 1975. Scott 135. My first class: "Development of the United States." The Professor: Rutgers College dean, New Jersey state historian, and university icon Richard P. McCormick. Years later, I am teaching in the School of Communication and Information and Dean McCormick's retirement office is down the hall from mine. He is a great source of information, a wonderful conversationalist, and a great colleague.

Later that first year, basketball fever engulfed the campus. The Scarlet Knights are ranked in the Top 20, but so is Princeton. A limited number of tickets go on sale for the game that will be played at the College Avenue Gym. Students take their flimsy mattresses to "the Barn" and sleep there. They want tickets for this unprecedented battle between two New Jersey powerhouses. The ducats are purchased and we wait with bated breath for the contest. But Mother Nature intervenes: an ice storm makes many of the roads hazardous and impassable. I can still see all of Frelinghuysen 4 sitting in the lounge listening to the radio, reacting to each play.

Sunday, September 2, 2001. I have received the highest honor of my academic career: I have been selected as the keynote speaker welcoming new students to campus. I look out over the throng of first-years sitting on the grass of Old Queens and take it all in. In my speech, I try to entertain them and allay their fears as best I can. After I am done, I am honored to be asked to ring the Old Queens Bell and sign the door. I stand there feeling a part of the same continuum as Henry Rutgers, Paul Robeson, and all the greats who stood in that same place.

Sunday, May 15, 2011. This is my most vivid memory. My daughter Caryn is part of the first graduating class from the newly reorganized university. She is one of so many in our family to have graduated from or attended Rutgers on one of its three campuses. My brother and sister-in-law. My mother. My father-in-law and my mother-in-law. Both of my brothers-in-law. Uncles and cousins. I can still see her standing in line, wearing her Cap and Skull pin and honors cords, waiting to be recognized. I am filled with pride. A father's pride. Rutgers pride. Like my education both inside and outside the classroom, it's an image that will stay with me for the rest of my life.

Revered dean and professor Richard P. McCormick and his son, Richard L. McCormick—who would go on to serve as Rutgers' 19th president—co-teach a class on American history in 1979.

Rutgers Students in a World Context

Rutgers students are from all over, and go all over.

International Students. Rutgers College celebrated its centennial 1870 period in part by inaugurating a cultural exchange program with Japan and welcoming its first international students. Rutgers subsequently became a popular destination for Japanese students seeking a Western education, and students who studied science and mathematics here during the early 20th century are credited with helping to lead Japan's rapid economic and technological modernization. Mid-20th century *Targum* issues (and its WWII replacement, the *Cannon*) often published profiles of individual international students from Europe, Asia, and Africa, highlighting their academic majors and future plans. Rutgers University today enrolls just under 5,000 international students, approximately 57 percent of whom are from Asian and South Asian countries.

Peace Corps. In 1961, on the orders of President John F. Kennedy, the first 62 volunteers of the Peace Corps—Colombia I—spent the summer training and living at Rutgers, which had been designated the program's first training site. After rigorous physical conditioning, as well as instruction in Spanish and Colombian culture, the volunteers left for Colombia that fall for a two-year mission. In 2010, some 30 members of that first group came back to Hegeman Hall and dedicated a plaque commemorating the start of the Peace Corps at Rutgers. As of that 50-year anniversary, over 550 Rutgers graduates had served in 108 countries with the Peace Corps. The program remains a popular one. In 1987, Rutgers–Camden established the Master's International Program, which integrates graduate study and Peace Corps service. Following Rutgers' lead, more than 80 universities now offer the Master's International.

Fulbright Fellowships. Various alumni and students of Rutgers have ventured to countries all around the world to study, work for private enterprises, governments, nongovernmental organizations, and local communities. Fulbright Fellowships are some of the most competitive as well as prestigious awards for work or study abroad. Rutgers students and alumni have received over 200 Fulbrights. In fact, we were ranked third among top-producing Fulbright universities in 2013, with only Michigan and Harvard receiving more that year.

—Elijah Reiss (SAS '17)

Above: Douglass College seniors comparing Peace Corps destinations, 1963.

Below left: During the summer of 1961, the first 62 Peace Corps volunteers trained at Rutgers for their upcoming assignment in Colombia.

Below: Matt Cortland (SAS '11) has traveled the world as a recipient of numerous prestigious fellowships. Here he is at Angkor Wat in Cambodia, serving as Rutgers' first Luce Scholar.

Some Notable Alumni...

JOHN CIFELLI (CC '09) AND CINDY COHEN PAUL (RC '81)

From (nearly) 250 graduating classes, Rutgers has produced more than its fair share of notable alumni across a vast expanse of fields. Search for the pioneers and leaders in any profession, and you are likely to find a Loyal Son or Daughter among them! Rutgers alumni are Nobel laureates, Super Bowl champions, governors, senators, chiefs of surgery, Iron Chefs, industry magnates, bandleaders, Supreme Court justices, best-selling authors, Olympians, Grammy-winning artists, and champions of social and political activism. Simply put, Rutgers graduates succeed, and they are everywhere! Here is but a grain of sand on the beachhead of Rutgers alumni accomplishments.

Matthew Leydt (QC 1774) was the first graduate of Rutgers. Like many of the earliest students, he was the son of a noted figure, the Reverend Johannes Leydt of New Brunswick, an original signer of the Queen's College charter. Matthew followed in his father's footsteps, serving as a Dutch Reformed minister in New Jersey and Pennsylvania.

Garret Augustus Hobart (RC 1863) was the 24th vice president of the United States, under William McKinley. He died in office in 1899. Theodore Roosevelt replaced Hobart as vice president and would go on to the presidency after McKinley's assassination in 1901.

Garret Augustus Hobart was the 24th vice president of the United States.

Philip Van Doren Stern (RC '24), an editor, writer, and historian, wrote *The Greatest Gift*, the short story on which the holiday film classic *It's a Wonderful Life* is based.

Cartoon character **Quincy Magoo (RC '28)** was at the center of countless animated features and movies, his signature baritone brought to life by actor Jim Backus. Given his regular attendance at football games and his frequent appearances donning a Rutgers sweater, Mr. Magoo never forgot his alma mater, which was chosen for him by his creators because they wanted him to be "a college alumnus who was still fired up with the old school spirit, and [they felt] Rutgers was the embodiment of the 'old school tie' in America."

David A. Werblin (RC '31) was a titan in the entertainment and sports world in the 1950s and '60s. In fact, "Sonny" bought the New York Titans in 1963, renamed the team the New York Jets, and in 1965 drafted quarterback Joe Namath.

Milton Friedman (RC '32) won the Nobel Prize in economic sciences in 1976, the culmination of a long career espousing noninterventionist practices by government in the economy. He served as the president of the American Economic Association, taught at the Chicago School of Economics, and was an economic advisor to Ronald Reagan.

Oswald "Ozzie" Nelson (RC '32, NLAW '30) was one of Rutgers' most recognizable alumni in the mid-20th century. In his *Scarlet Letter* yearbook, next to a face recognized by much of the world, it states, "Ozzie! Who has not heard of that name?" A participant in sports, college activities, and a member of Cap and Skull, it was perhaps in his college days as a musician and band leader that he first used the original melody of "Loyal Sons," which was to become the radio theme song of Ozzie Nelson and His Orchestra. In 1932, he hired Harriet Hilliard to be the singer with his band, and they were married two years later. In 1944, Ozzie and Harriet began their iconic family comedy *The Adventures of*

Big man on campus, Ozzie Nelson, left, with classmates in the mid-1920s in front of Old Queens.

Ozzie and Harriet on radio. In 1952, the radio show moved to television, and ran for 14 years.

Ray Stark (RC '35), Hollywood agent and producer, discovered Barbra Steisand and cast her in the play and film *Funny Girl*, one of two movies he made about his mother-in-law, vaudevillian Fanny Brice.

Martin Agronsky (RC '36) won Emmy and Peabody awards during his rich career as a journalist. Recognized for his fearless coverage of the Pacific theater during World War II, he later pioneered the "talking head" format of news casting.

William T. Cahill (CLAW '37) was one of seven Rutgers alumni who have served as governor of New Jersey. After his landslide victory in 1969, Cahill's notable accomplishments included the creation of the state Department of Environmental Protection.

Peter Rodino (NLAW '37), a United States Congressman from New Jersey representing Newark's North Ward, chaired the House Judiciary Committee that deliberated the impeachment of Richard Nixon. During the Watergate hearings of 1974, Rodino's quiet dignity and fairness won him respect and admiration.

Richard P. McCormick (RC '38, GSNB '40), historian and Rutgers professor and dean, was a pivotal figure in many of the most high-profile Rutgers events in the mid-20th century, from contesting the dismissal of faculty caught up in the 1950s Red Scare to advocating for African-American students following the protests of the 1960s to helping orchestrate Rutgers College's admission of women in 1972. Rutgers' official university historian, he wrote *Rutgers: A Bicentennial History*, the definitive history of Rutgers of its time. He is the father of Rutgers' 19th president, Richard L. McCormick.

Al Aronowitz (RC '50), who was called "the godfather of rock journalism," introduced the Beatles to Bob Dylan at the Hotel Delmonico in New York on August 28, 1964. According to the *Washington Post*, "the meeting proved musically fruitful, because it led both the Beatles and Dylan in new directions."

Judith Viorst (NCAS '52) is an Emmy Award-winning and best-selling author. Her children's book *Alexander and the Terrible, Horrible, No Good, Very Bad Day* is a perennial favorite among parents, children, teachers, and librarians.

William Rasmussen (RBS '60), along with his son Scott launched in 1979 the Entertainment Sports Programming Network (ESPN).

David Stern (RC '63), commissioner of the NBA, expanded the league's popularity and franchises and oversaw the heyday years of Larry Bird, Magic Johnson, and Michael Jordan. Credited by the NBA with building "the model for professional sports in league operations, public service,

Left: Best-selling author of the Stephanie Plum series, Janet Evanovich.

After the House Judiciary Committee passed three articles of impeachment against President Nixon, committee chair Peter Rodino, second from right, said he went to a back room, called his wife, and cried.

Clockwise from top: NBA commissioner David Stern, Rock and Roll Hall of Fame president Terry Stewart, and FBI director Louis Freeh.

Among his many other accolades, Clement Price was named New Jersey Professor of the Year in 1999.

upon his retirement in 2012: "Stewart is Rock Hall's longest-serving leader, and in his 14-year tenure has turned the nonprofit museum into a solid institution and tourist draw that reportedly generates $100 million annually for the city of Cleveland."

Louis Freeh (RC '71, NLAW '74) was FBI director from 1993 to 2001 and presided over well-known cases such as the arrest of the "Unabomber," the Branch Davidian siege at Waco, Texas, and the arrest of Robert Hanssen, a 25-year FBI veteran who spied for the former Soviet Union.

Walt MacDonald (CCAS '74, GSNB '83) is president and CEO of the Educational Testing Service, the company responsible for the GRE, PRAXIS, TOEFL, and other standardized tests.

Joy Ogwu (NCAS '74, GSN '75) is Ambassador and Permanent Representative of the Federal Republic of Nigeria to the United Nations and has served as Foreign Minister of Nigeria.

global marketing, and digital technology," he was enshrined in the Naismith Memorial Basketball Hall of Fame in 2014.

Richard Aregood (CCAS '65) is a Pulitzer Prize-winning editorial writer who served as editorial page editor of the *Star-Ledger* and the *Philadelphia Daily News.* Today he is a professor at the University of North Dakota and a published columnist.

Janet Evanovich (DC '65) has brought the fictional "Jersey Girl" character Stephanie Plum off the book pages and into the lives of countless readers in her best-selling Plum novels. Evanovich has published over 50 books.

Terry Stewart (ENG '69, ED '69), president of the Rock and Roll Hall of Fame, was lauded in the *Cleveland Plain Dealer*

Clement Price (GSNB '75), historian and Rutgers professor, had been named Newark City Historian just months before his untimely death in November 2014. One of the first African Americans to earn a doctorate in history from Rutgers University–New Brunswick, Price would go on to teach, research, write, and inspire at Rutgers. His scholarship, gentility, and encyclopedic knowledge of the city of Newark earned him fans and admirers near and far. In 2008, Price was tapped to chair President Barack Obama's 2008 transition team for the National Endowment for the Humanities and in 2011 he was appointed by President Obama to serve as vice chair of the President's Advisory Council on Historic Preservation.

Right: James Gandolfini and Mario Batali remained close friends after meeting as Rutgers undergraduates.

Below: Elizabeth Warren, twice a *Time* 100 world influencer.

Elizabeth Warren (NLAW '76), United States Senator from Massachusetts, has twice been named by *Time* magazine as "one of the 100 most influential people in the world." A law professor at Harvard for 20 years, Warren, "in the aftermath of the 2008 financial crisis, served as Chair of the Congressional Oversight Panel for the Troubled Asset Relief Program (TARP)." Of her years at Rutgers, Warren told the *Star-Ledger* in 2009 that Rutgers School of Law–Newark "took a poor kid from Oklahoma and kicked open a thousand doors for me."

Mario Batali (RC '82) can't be missed when flipping through food programming on television. The *Iron Chef* star owns Michelin star-rated restaurants such as Babbo in New York and has written 10 cookbooks.

James Gandolfini (RC '83) gained international acclaim for his Emmy Award-winning role as Tony Soprano, the angst-ridden head of a fictional crime family in HBO's wildly popular show *The Sopranos*. Gandolfini, who died at age 51 in 2013, starred in numerous films and devoted considerable energy to causes ranging from veterans to his alma mater.

Lt. Gen. Flora D. Darpino (CLAW '86) became the first female Judge Advocate General of the Army and began serving as the 39th Judge Advocate General of the U.S. Army, September 4, 2013. The Judge Advocate General of the U.S. Army serves as the senior uniformed attorney in the Army.

Sue Wicks (CC '88) was a standout Rutgers Scarlet Knights scorer and a pioneer in professional women's basketball. A

Below left: Judge Advocate General of the Army Flora D. Darpino.

Below: Women's basketball trailblazer Sue Wicks, right, with women's basketball coach C. Vivian Stringer.

Walter Seward was a classmate of such Rutgers luminaries as Paul Robeson and Selman Waksman. At the time of his death in 2008 he had only missed six alumni reunions.

forward for the New York Liberty, beginning in the inaugural year of the WNBA in 1997, she was inducted into the Women's Basketball of Fame in 2013. Wicks holds Rutgers records in scoring (2,655 points) and rebounding (1,357) that are records for a male or female player at Rutgers.

Junot Díaz (RC '92) is a best-selling author, professor at MIT, and MacArthur "Genius Grant" recipient. His novel *The Brief Wondrous Life of Oscar Wao*—much of it set at Rutgers–New Brunswick—won the Pulitzer Prize for fiction in 2008. Of his years at Rutgers, Díaz said in the *New York Times*: "Rutgers, honestly, it was like a wonderland for me, like going from the black and white of Kansas to the Technicolor of Oz. I had never been around the density of so many smart, beautiful people."

Khalil Gibran Muhammad (GSNB '02), author and historian, is director of the acclaimed Schomburg Center for Research in Black Culture at the New York Public Library, which has been called "one of the world's leading research facilities dedicated to the history of the African diaspora."

Devin (UCNB '10) and **Jason (UCNB '09) McCourty**, identical twins, are among the many Scarlet Knights who have found success in the NFL. The McCourtys, who both had outstanding careers at Rutgers under head coach Greg Schiano, devote personal time to their Tackle Sickle Cell charity, "a campaign that aims to educate the public, increase blood donations, and raise money and awareness for the fight against sickle cell disease."

Walter H. Seward (RC '17) was Rutgers' oldest living alumnus, oldest resident of New Jersey, and third-oldest man in America before he died in 2008 at age 111. A true Rutgers Loyal Son, Seward volunteered in many capacities in support of his alma mater. He earned a Harvard law degree and practiced law into his 90s.

More Alumni and their Most Notable Life Achievements
Arts, Literature, and Entertainment
Paul Robeson (RC '19), singer, athlete, actor, activist.
Robert Pinsky (RC '62), three-time U.S. Poet Laureate.
Joan Snyder (DC '62, MGSA '66), painter and printmaker.
George Segal (GSNB '63), sculptor.
Walter Liedtke (RC '67), curator of European Paintings, Metropolitan Museum of Art.
Avery Brooks (LC '73, MGSA '76), actor, *Star Trek: Deep Space Nine, Spenser: For Hire*; professor at Mason Gross School of the Arts.

Far left: Twins Devin, left, and Jason McCourty of the NFL.

Left: Avery Brooks, celebrated actor.

Sheryl Lee Ralph (RC '75), Tony Award-nominated actress and singer.

William Yossess (GSNB '78), executive pastry chef at the White House.

Joseph DiPietro (RC '84), Tony Award-winning playwright and lyricist.

Kurt Sutter (RC '86), screenwriter, creator of *Sons of Anarchy*.

Kristin Davis (MGSA '87), actor, *Sex and the City*.

Calista Flockhart (MGSA '87), actor, *Ally McBeal, Brothers and Sisters*.

Bill Bellamy (LC '89), comedian.

Robert Pulcini CCAS '89), screenwriter and director, *American Splendor, Cinema Verite*.

Athletics and Sports

Jimmy Valvano (RC '67), sportscaster and cofounder, The V Foundation for cancer research.

James Bailey (RC '79), NBA.

Deron Cherry (CC '81), co-owner, Jacksonville Jaguars.

Shaun O'Hara (LC '99), NFL.

Gary Brackett (CC '03), NFL.

Carli Lloyd (RC '06), Olympic Gold Medalist Soccer, twice scoring gold-medal-winning goal; United States Women's National Team.

Cappie Pondexter (RC '06), Olympic Gold Medalist, WNBA.

Alexi Lalas (RC '13), professional soccer player and sport analyst.

Eric LeGrand (SMLR '14), sportscaster, spinal cord injury research advocate.

Business, Industry, and Philanthropy

Bob Kriendler (RC '36), co-owner, "21" Club.

John J. Heldrich (UCNB '50), J&J executive; founding chair, New Brunswick Tomorrow.

John J. Byrne (RC '54), CEO, GEICO.

Bernard Marcus (PHARM '54), cofounder, Home Depot.

Gary Rodkin (RC '74), CEO, ConAgra Foods.

Greg Brown (LC '82), CEO, Motorola Solutions.

Mark Fields (RC '83), CEO, Ford Motor Company.

James P. Kelly (UCN '73), CEO, UPS.

Rana Kapoor (RBS '80), founder, managing director, and CEO, Yes Bank.

Lisa Gersh (NLAW '83), CEO, Goop, Gwyneth Paltrow's lifestyle company.

Sheri McCoy (RBS '88), CEO, Avon.

Ralph Izzo (RBS '02), chair and CEO, PSEG.

Joseph Rigby (SBC '79), chair, president, and CEO, Pepco Holdings Inc.

Government, Politics, and Law

James Schureman (QC 1775), member, Continental Congress.

Joseph P. Bradley (RC 1836), Supreme Court Justice.

Frederick Frelinghuysen (RC 1836), U.S. Senator, Secretary of State.

William Newell (RC 1836), White House physician, N.J. Governor, U.S. Congressman.

Clifford Case (RC '25), U.S. Congressman, U.S. Senator.

Richard Hughes (NLAW '31), N.J. Governor.

William J. Hughes, (RC '55, CLAW '58), U.S. Congressman, Ambassador to Panama.

Hazel O'Leary (NLAW '66), U.S. Secretary of Energy.

James Florio (CLAW '67), N.J. Governor.

Susan Ness (DC '70), Commissioner, FCC.

Donna Lieberman (NLAW '73), executive director, New York Civil Liberties Union.

Ratemo W. Michieka (CC '74, GSE '75, GSNB '78), director general, National Environmental Management Authority of Kenya.

Health Care and Medicine

George (CCAS '61) and Washington (CCAS '61) Hill; George, microbiologist and tropical disease expert; Washington, physician, fetal-maternal medicine.

Ernest Mario (PHARM '61), CEO, Glaxo.

Michael Gottlieb (RC '69), physician, first to report AIDS.

Donna Wong (NUR '70), co-creator, ubiquitous Wong-Baker FACES Pain Rating Scale.

Fredric Brandt (RC '71), celebrity dermatologist.

James Oleske (NJMS '71), pediatrician, discovered pediatric AIDS, New Jersey Medical School professor.

Miriam H. Labbok (RWJMS '73), UNICEF, Infant and Young Child Feeding.

Kathryn Holloway (CCAS '80), neurosurgeon, Hunter Holmes McGuire V.A. Medical Center.

Above: Author and White House executive pastry chef, William Yosses.

Left: Greg Brown, Motorola Solutions CEO.

Grace Chang (RWJMS '82), medical director, U.S. Department of Veterans Affairs.

Oxiris Barbot (NJMS '91), first deputy commissioner, NYC Department of Health and Mental Hygiene.

Jeffrey Brenner (RWJMS '95), founder and executive director, Camden Coalition of Healthcare Providers.

Ella Watson-Stryker (RC '02), health worker as part of Doctors Without Borders and *Time* 2014 Person of the Year: The Ebola Fighters.

Military

Charles Henry Van Wyck (RC 1843), Civil War Brigadier General, N.Y. Congressman, Nebraska U.S. Senator.

George H. Sharpe (RC 1847), 1850 Civil War colonel, created Bureau of Military Information, considered father of U.S. military intelligence.

Col. Jack H. Jacobs (RC '66, GSNB '72), Medal of Honor Recipient, MSNBC military analyst.

News and Media

Jerry Izenberg (NCAS '52), *Star-Ledger* sports columnist.

Bob Braun (RC '67), *Star-Ledger* columnist.

Bernard Goldberg (RC '67), journalist, Emmy Award-winning reporter for HBO's *Real Sports*.

Mike Taibbi (RC '71), Emmy Award-winning TV journalist, NBC News.

David T. Sloan (NCAS '76), executive producer, ABC News *20/20* and *Primetime*.

Kathy Ryan (DC '78), director of photography, *New York Times Magazine*.

Mike Emanuel (SC&I '90), chief congressional correspondent, Fox News.

Michele Promaulayko (RC '93), editor-in-chief, Yahoo Health.

Natalie Morales (RC '94), co-anchor, *Today* show.

Science and Technology

John Von Nostrand Dorr (RC 1894), pioneered use of white lines on road shoulders to decrease accidents.

Selman Waksman (RC '15, '16), Nobel Prize-winning microbiologist, "Father of Antibiotics."

René Dubos (GSNB '27), microbiologist/environmentalist, coined "think globally, act locally."

Lester Brown (AG '55), agronomist, environmentalist.

C. Reed Funk (GSNB '62), plant biologist, turfgrass authority.

Renee Weisman (DC '69), director of engineering, IBM.

Candy Torres (DC '76), NASA software engineer.

Dennis J. Higbie (CC '80), director of horticulture, Walt Disney World.

Terry Hart (GSNB '87), NASA astronaut.

Stacy Cusack (ENG '95), NASA scientist.

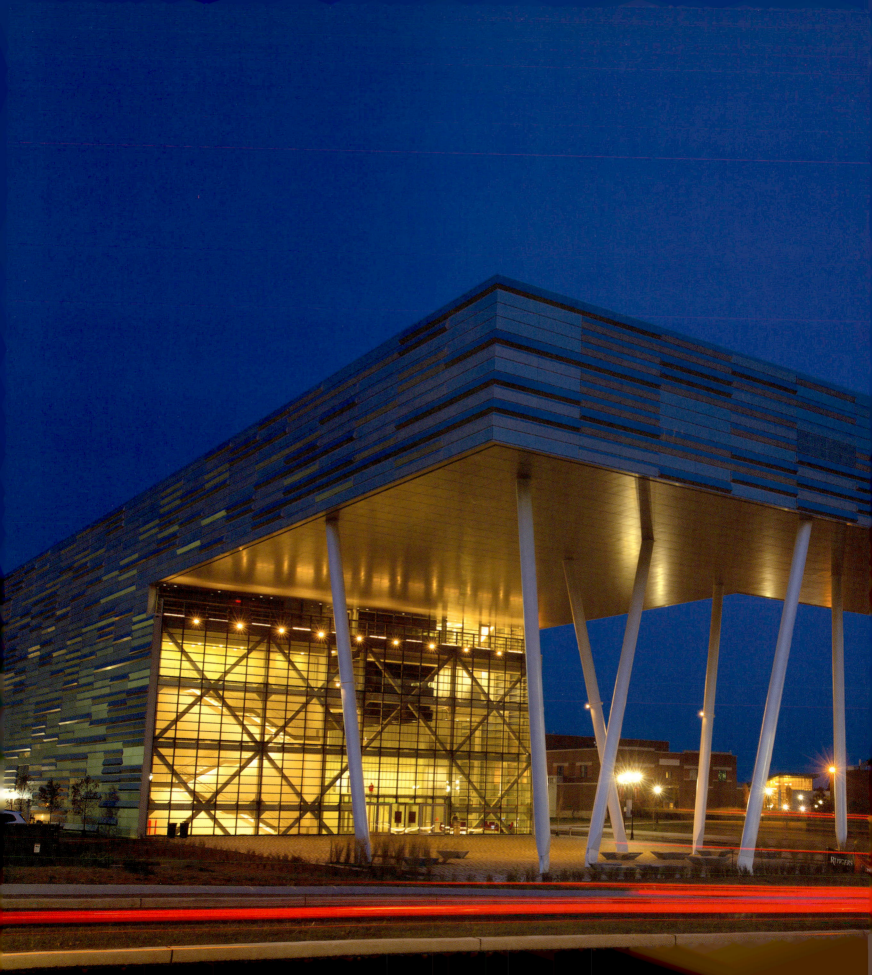

RUTGERS &
THE WIDER
WORLD

LINDA STAMATO

The story of Rutgers is one of continuity and change—and of a pervasive potential to disrupt and to build. To disrupt— as it did in creating one faculty of arts and sciences in New Brunswick, and then, two decades later, despite fierce resistance, completing the consolidation by creating one institution, the School of Arts and Sciences. To build—as it bridged divides and created common purpose when the "Ag" School became Cook College, and later the School of Environmental and Biological Sciences. Along the way, Rutgers has embraced bold ventures, including the 1985 establishment of a Center for Molecular and Behavioral Neuroscience in Newark, unique for its time, where scientists and physicians today work on understanding the mechanisms underlying basic brain function and developing therapies for neurological and psychiatric disorders.

A professional psychology school in New Brunswick was created four decades ago, a first, to advance the practice and field of applied psychology, a program with a special commitment to direct community involvement and underserved populations. The

Douglass Developmental Disabilities Center established in 1975 fulfills a similar purpose, providing services for people with autism spectrum disorders, their families and schools. As a final example, Rutgers has created a discovery informatics institute to broaden access to state-of-the-art computing technology that enables large-scale data analytics, computational modeling, and simulations that anticipate applications to the life sciences, material sciences, astrophysics, combustion, fusion, and geosciences. The institute collaborates with researchers across Rutgers, in other universities, and in industry.

Rutgers has nurtured sensibilities in art and music. The university has built museums and created gallery spaces. In the Mason Gross School of the Arts, it has invested in a conservatory to train students at all levels and to offer countless artistic opportunities to the student body, staff, faculty, and citizens. With new, state-of-the-art facilities, top-ranked programs, off-campus collaborations in New Brunswick, New York, and London, and pioneering online offerings, the school ranks among the best in the country.

Over the last century, Rutgers provided educational opportunities and community services in the state's major cities to meet critical needs. It has turned challenges into benefits by exploiting the density and diversity of its host cities and local firms, infrastructure, and resources to create learning laboratories that strengthen its schools of business, criminal justice, law, education, social work, and planning and public policy, and provide assets for struggling cities.

Rutgers is likely to play a prominent role as its host cities transition to more resilient economies, satisfying the need for quality jobs in innovative, clean, and global industries, for example, and creating incubators to deepen innovation capacity, but also offering services—advocacy on behalf of children or legal and medical clinics for adults—and providing spaces for civic engagement and cultural reward.

To be sure, Rutgers' presence adds considerable potential to what cities aspire to and can do, but for Rutgers in Camden, Newark, and New Brunswick, it's more than a fair deal, for each campus gains a more vital and sustainable city for its home.

Expectations are also grounded in Rutgers' agricultural heritage. Advances in food production, safety, and security are high priorities given stresses from climate change, conflict, and poverty. Rutgers faculty will be on the front lines seeking to aid agricultural productivity. They will also be looking to understand and develop treatments for infectious diseases, improve air and water quality and food security, and assess vulnerabilities to an array of natural and manufactured hazards and recommend ways to minimize future harm to the coast and bay areas of the Jersey shore. And, as it trains the next generation of scientists, Rutgers will be prompting discoveries in laboratories here and elsewhere that may well improve prospects for life on earth.

It will also be educating students to become writers, as well as teachers, nurses, doctors, community developers, engineers, policymakers, planners, and leaders of institutions small and large. Rutgers alumni hold—and will continue to occupy—positions of influence. Given their numbers, their liberal education, and their professional preparation, their potential impact is immeasurable. They are the producers of culture, the innovators of change, the informed citizens of their communities. They are, in short, a resource to New Jersey and to the world and a source of strength and support for Rutgers.

Exploring ideas that seem beyond the imagination and taking the risks to pursue them—this is what Rutgers does, and it brings students into the enterprise, from first-year undergraduates to postdoctoral fellows, in the process

Previous pages: Rutgers Business School on Livingston Campus.

Left: IBM Blue Gene/P Supercomputer, a cornerstone of the Rutgers Discovery Informatics Institute.

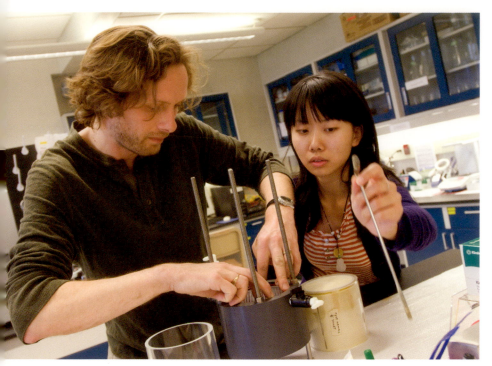

Below: Livingston Theater production of *Once On This Island*, November 2006.

Above: Professor and geophysicist Lee Slater and student in Newark lab.

Below: The atrium of the Life Sciences building on the Busch Campus.

creating exceptional conditions for learning. Rutgers has a passion for its traditions and holds fiercely to its core beliefs, embracing a commitment to people, to the diverse and talented societies at home and abroad from which its students, faculty, and staff come, and to the cities that are home to its campuses.

The promise of Rutgers—given its willingness to seize opportunities and engage with talent, energy, and conviction—is virtually limitless.

But Rutgers strains to keep the whole of its parts together. It is being pulled in separate directions by twin forces: the desire for autonomy and the need for connection. Mergers add, budgets divide. Fighting over who gets what is not desirable at any time but especially not when state support is declining. Rutgers needs greater collaboration to achieve economies of scale and synergies of scope.

A sense of urgency should drive its will to stay a single university, one with aligned priorities and seamless connections, despite challenges of geography, history, and campus autonomy. The recent integration of the seven units of the University of Medicine and Dentistry of New Jersey (UMDNJ) has resulted in one of the country's largest and most comprehensive university-based centers for studying and improving human health and health care. Students and faculty consequently have opportunities that would not otherwise be available.

Challenges to access and affordability loom large, requiring Rutgers to cultivate additional sources of funding. As it has in the past, it must deftly navigate political shoals and maintain the support of the public it serves.

The next several decades will be a test of fortitude, wisdom, and leadership. Nonetheless, it's likely to be an exciting, even exhilarating, time for Rutgers.

The Future of Rutgers: Opportunities and Challenges

In his inaugural address to the Rutgers community in 1971, Edward J. Bloustein exhorted his audience to see service to society, teaching, and research as complementary functions, each reinforcing the other.

At Rutgers' watershed 250th anniversary, reflection is essential. What is the role of the public university in the coming years?

Supporting cutting-edge work in the sciences is likely to be high on any list of priorities, but no less compelling is an understanding of the world and learning the lessons of history; knowing how to formulate and implement public policy and guide ethical practices; developing an appreciation for music, literature, and the visual and performing arts; and producing good, well-informed, even activist citizens.

What you know matters far less than what you can do with what you know. The capacity to innovate—the ability to solve problems creatively or bring new possibilities to life—and skills like critical thinking, communication, and collaboration will become far more important in the years ahead. This circumstance underscores the essential value of the humanities, and aligns with the very abilities business leaders say they look for in those they hire.

Rutgers will struggle with multiple and complex claims for attention and support from departments and schools. It may need to sharpen and deepen its commitments to those most critical to its mission and core values. Criteria must be developed to make budgetary decisions, along with strategic planning that accommodates—indeed, relies upon—engagement by faculty, staff, students, and the voices in the public and private sectors that play a part in setting the future course of the university and bear some responsibility for it.

The challenge is not for the fainthearted.

Rutgers will remain, must remain, at the top of its game with respect to how it prepares and motivates undergraduates. Basic knowledge must be acquired, and expanding opportunities for research, service, and civic engagement is essential. The university is also an engine driving research, research that enriches teaching and

enhances the institution's capacity to serve its students, the state, the nation, and indeed, the world. To realize its full potential, it needs to recruit and retain the strongest faculty, build research facilities to support first-class graduate education and research, optimize technology, and create partnerships that transfer knowledge to improve life.

And, of course, the university's work will need to generate support from diverse sources without compromising its commitments to basic research, to teaching, to public scholarship and service.

Above left: Samia Bouzid in the Robert A. Schommer Astronomical Observatory atop the Serin Physics building.

Above: A digital filmmaking class.

Below: Students conducting field research in New Jersey's Barnegat Bay.

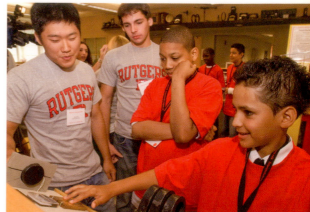

Rutgers students work with Rutgers Future Scholars middle schoolers and help deliver donated food and supplies for the Rutgers Against Hunger (RAH) Adopt-a-Family Program that supports at-risk families during the holidays.

Scholarship in Action, Service to Society

The idea of "scholarship in action" envisions scholarship as a public good and requires collaboration between the university, as the anchor, and partners from the government, private, and not-for-profit sectors to serve the needs of society.

Part of that responsibility for Rutgers includes addressing the needs of the cities where the university has its primary locations. It is not a coincidence that our campuses are in cities; cities are centers of sociability, creativity, and interdependence—and critical mass—where collaboration is more easily undertaken and encouraged.

And Rutgers is very much an urban university, in the nation's most urbanized state, and as such it will remain positioned to benefit from the trends that reinforce concentrated development. Thus can research, partnering, teaching, and service meld to change the face of a city and improve the welfare of the citizens in and beyond it, and, not least the students who are part of the ventures because they work—and learn—alongside their teachers.

To make the most of its locations will require investment in, among other facilities, interactive spaces where researchers at Rutgers can interact with researchers from companies, hospitals, and institutes linked to collaborative networks. It will need physical space, laboratories, clinical trial space, and treatment space, manifesting a centralizing trend that will be compounded by the need for places for the face-to-face contacts that are often essential to creativity and innovation. Open space incubators for prospective entrepreneurs to gather, to work, to share ideas are a part of this new world—one in which collaboration both blossoms from physical proximity and thrives over distance given the closeness that new technologies provide.

To add to the vibrancy, sustainability, and attractiveness of its host cities, Rutgers will need to work with them to improve schools and infrastructure and offer opportunities to their citizens. An outstanding experiment is the Rutgers Future Scholars Program, which promises a Rutgers

Above: Dental students at Rutgers Day on Busch Campus.

Below right: Reception at the Center for Law and Justice at Newark.

education to the children of its campus cities, preparing and motivating them and helping them to succeed. The program's first cohort will graduate in 2017. Rutgers has the capacity to help teachers improve their teaching, and devise ways to leverage financing for improvements in city life. That is what a progressive university can do and what this

one will be expected to do. These efforts will not drain the university; they will add renewed purpose, confidence, and vitality and create incomparable living laboratories in which students and faculty can learn and serve.

The arts and humanities add value to and draw support from the cities as well. With creativity and sensibility, university-based activities enrich the life of cities—and the cities' populations enable such enterprises to thrive. Consider, for example, the Institute on Ethnicity, Culture, and the Modern Experience on the campus at Newark—an interdisciplinary academic center that, through public partnerships and programming, fosters discussion of the arts and culture; urban life and development; diversity and race relations; and local, national, and transnational history. It educates through lectures, fellowships, symposia, film

Right: Dance rehearsal at Newark.

Far right: Dean Matt Matsuda confers with students in "Business of Doing Good" class.

screenings, performances, and exhibitions, and promotes intercultural understanding, civic and historical empathy, and community engagement as crucial elements in the development of civic life in Newark and beyond. Not long ago, it launched a fellows program for Newark's civic leaders who are deeply involved in the city's revitalization. It remains a jewel in the crown of Rutgers in and for Newark.

Additional creative collaborations are likely. The Center for Historical Analysis (CHA) and the Center for Cultural Analysis (CCA), both founded in the 1980s, have paved the way in New Brunswick. The CCA pursues a broad mission to address problems that lie across the traditional disciplines of the humanities, the social sciences, and the natural sciences. The CHA brings together internationally distinguished scholars, the university community, and the New Jersey public to engage in research, education, and public service on historical topics of broad community relevance. Both centers hold seminars and host a variety of public conferences and related cultural events. The CHA sponsors an Institute for High School Teachers and currently houses the Rutgers Oral History Archives, which is rated one of the top oral history archives on World War II.

The innovative Mid-Atlantic Regional Center for the Humanities on the Camden Campus serves as a focal point for highly collaborative humanities research and programming across New Jersey, New York, Pennsylvania, Delaware, Maryland, and Washington, D.C.

The proposed merger of the law schools in Newark and Camden holds the promise of creating a single powerhouse law school, greater than the sum of its parts, with an impressively comprehensive and innovative curriculum as well as direct access to two of the nation's largest legal markets. City residents stand to gain from the presence of a network of legal clinics. At the same time, by fostering connections with natural allies in public policy, planning, engineering, workforce development, and law enhances Rutgers' capacity to engage, adding to the efforts of such partners as the Voorhees Center at the Edward J. Bloustein School of Planning and Public Policy. It provides opportunities for students to become involved in the direct, complex, and critical links between academic theory and the daily challenges in housing, transportation, and food security that face families, communities, and governmental units in the city, state, and nation.

Rutgers is planning a "healthy cities initiative" that inspires people with design and analytical skills to come together with public health and planning professionals, epidemiologists, sanitary engineers, civil engineers, landscape architects, and physical design planners much as they did in the last century to alleviate the ills of industrializing cities. In the 21st century, social work, public health engineering, education, communication, and public policy have much to add to this venture.

And, Rutgers, through its own commitments and practices, can serve as a positive presence in what it studies,

disseminates, and models (e.g., ecological preservation, green buildings, nutritious food in dining halls, energy efficiency, mitigating environmental hazards, networks of foot and bicycle paths). Through its faculty, staff, and students, and with private partners too, Rutgers can contribute to improving the lives of the inhabitants of its campus cities and beyond through this initiative. With increasing numbers of students declaring an interest in public health, the initiative is likely to yield valuable changes in the way we live and work in cities.

Rutgers has a significant presence beyond its campus cities already. Its faculty members have developed drugs that cure disease on a global scale; they have produced seeds that yield disease-resistant crops, developed sustainable agriculture projects, and helped small-scale farmers grow and bring their produce to market; modeled community-driven planning processes to minimize climate hazards from economic development; and helped design governing structures to establish the rule of law in war-torn and conflict-ridden societies.

Student organizations may increasingly play important roles. Rutgers' Engineers Without Borders chapter hints at the potential scope and impact. With water projects in Thailand, Kenya, and Guatemala designed in partnership with the members of host communities, and with commitments of five years, the organization's international efforts are designed to meet basic human needs—in this case, accessible clean water. The student group has domestic projects as well. One, a collaborative venture involving Rutgers University–Camden law students, partners with a local not-for-profit agricultural coalition. Students are showing the way past disciplines and across borders, to demonstrate what it means to integrate teaching, research, and service, with enthusiasm and impact.

Teaching

Is it too far-fetched to imagine that in 10 years' time every university student will have unrestricted access to all that humans have ever recorded? What is the impact of that likelihood on the undergraduate curricula? Take the humanities. Their mission includes introducing students

to content and increasingly providing them with guidance on how to filter information, practice discernment, and live with ambiguity and uncertainty. If we are in a new age where every laptop is a personal printing press with the power to distribute information instantly and globally, then the humanities have to move into "the cloud," and humanities faculty must assist students in seeing how technology is transforming both what it means to be human and what humans can do—for good and for ill.

Similarly, the need to navigate and understand the nation's legal system is not solely the province of lawyers; for example, workers in the knowledge economy need to understand new forms of intellectual property and who owns them, and how laws and the regulatory environment can affect goals and strategies in their fields. With Rutgers' planned consolidation of its law schools and urging faculty to connect with colleagues in other schools, opportunities to provide legal knowledge to other disciplines will emerge, such as health

Above: Rutgers Engineers without Borders students work to bring a reliable source of sanitary water to Kolunje, Kenya.

Left: The WeatherWatcher Living-Learning Community, a partnership between RU-tv and the School of Environmental and Biological Sciences, located on G.H. Cook Campus, provides students, like Teresa Sikorski (SEBS '13), with an opportunity to deliver daily campus forecasts, while learning meteorology and broadcasting.

Opposite: An Alexander Library reading room.

"Super lettuce" developed in professor Ilya Raskin's laboratory has a much higher nutritional value than conventional lettuce varieties.

care policy, artificial intelligence, public affairs, planning and policy, and environmental science. Beyond luring faculty out of traditional departmental silos to participate more fully in the life and broader purpose of the university, the objective is to add value and perspective to the legal training of students and enhance their employment prospects in an increasingly competitive job environment. Rutgers may well become a pioneer in widening the approach to legal education.

We need to benefit from what recent research is telling us with respect to joint degrees and double majors: that students gain an advantage by acquiring the vital skill of integrative thinking. Students who master multidisciplinary approaches to generate fresh and original ideas are the creative thinkers, the people who can connect across subjects and employ different intellectual perspectives—the people, in short, society must have.

Students will need to learn beyond the campus, abroad, in institutions and on sites, how to cope under different living conditions even as they develop a practical knowledge of their discipline. And they will need to learn how to communicate what they learn—how to convey a message effectively. Rutgers students, engineers, and scientists did just this when the Scarlet Knight, a robotic underwater glider, made the first trans-Atlantic crossing of the ocean; they recorded the data the

robot gathered for science, while digital filmmaking students captured the drama of the voyage for public consumption and university pride and visibility.

How do we make public scholarship and service learning a given for students? How do we get students to pay attention and really care about their work? How can student work be more relevant to the world off campus? We've made some first attempts: in planning, by offering studios on creating sustainable food sources in cities; in engineering, by making it possible to build a model home that provides its own source of energy; in business, by turning experiments into successful businesses. The Intersect Fund, for example, a company headquartered in Newark, helps small businesses get started with small loans; it was the brainchild of undergraduate students working in an incubator off campus.

Below left: As undergraduates, Rohan Mathew (SAS '09), left, and Joseph Shure (RC '09), pictured at the French Street Farmers Market in New Brunswick, founded the Intersect Fund to provide educational and business services to low-income local entrepreneurs.

Below: Scarlet goes green. Solar panels on the roof of a bus stop on Livingston Campus.

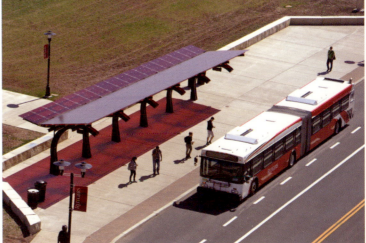

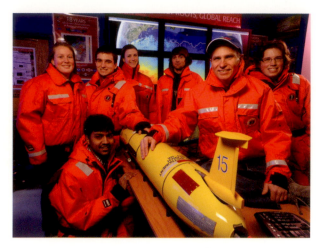

Marine and coastal sciences professor Scott Glenn with some of the students on the team responsible for the world's first successful Atlantic crossing of a sensor-laden undersea robotic glider.

Rutgers has an appetite for innovation and welcomes change, but it should embrace opportunities with careful, incremental, and measured experimentation. Change will be driven in good measure by our talented, curious, and persistent Rutgers students. Shifts in student services, for example, are already reflecting a desire for more seamless transition between school and work. Rutgers students are willing to take risks as they gain new knowledge and skills, spurred by a spirit of independence and initiative, to develop in an increasingly entrepreneurial culture to see innovative ideas come to fruition and understand why they may not. Mistakes are crucial learning experiences as well: in the classroom, in the laboratory, and in virtual space.

A Rutgers education entails conversations about ideas, ideals, and aspirations; helps to shape and sustain one's sense of self; and insists on keeping its public purpose in clear view. We look to Rutgers students to become scholars, teachers, professionals, and entrepreneurs with vision and heart.

Mechanical engineering students build a drone called Microrapter.

Research

Research is and will increasingly be a collaborative affair because it is a way that people from different disciplines, training, experience, and perspectives can—while seeing different aspects of a problem—constructively explore those differences and search for solutions that go beyond their own limited vision. By collaborating, they share responsibility, authority, and accountability for getting something done. Questions to be investigated regarding sustainability, for example, may invite engineering, biology, history, food, and environmental science, among other disciplines. Solving problems that exist in the spaces between schools and departments will unlock the potential of neuroscience, and address challenges posed by life in the digital age.

We need to think about creating clusters of excellence, interdisciplinary networks of chemists, physicists, biologists, and engineers to work together in research areas of major scientific interest. Clusters will attract industrial partners and funding, helping create the next generation of cross-disciplinary-trained scientists, defraying expensive equipment costs, and leading to the successful transfer of technology and knowledge.

Given the transforming work of the current faculty—in schools and in scores of research centers and institutes—Rutgers' impact on the world is significant, and will become even more so in the years ahead, judging by current research commitments.

Rutgers starts in a good place. Research dollars continue to grow. New buildings, academic and residential, are being added to meet its needs and strengthen its competitive position. It will have a new chemistry and chemical biology building on the New Brunswick campus, for example, that is envisioned as a collaborative laboratory space to best complement what faculty and researchers are doing.

Climate change challenges a variety of Rutgers faculty, not only physical scientists but also economists who examine vulnerabilities and adaptation to change domestically and globally. Understanding the relationship between extreme climate and human conflict involves collaboration with archaeologists, criminologists,

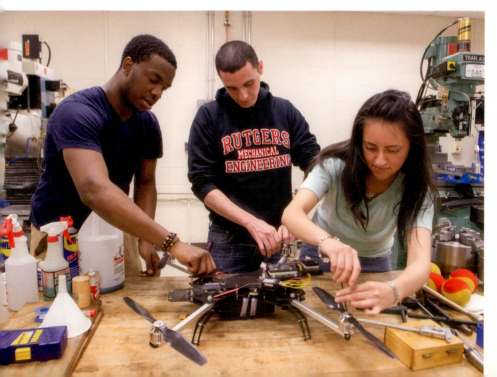

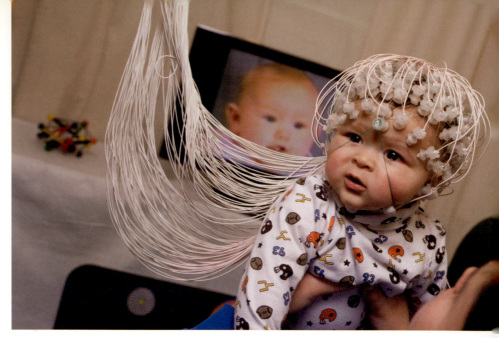

sociologists, geographers, historians, political scientists, and psychologists as well. And understanding past human response to environmental change can inform current thinking about human adaptation, resilience to climate change, and the unpredictability of natural resources.

The nation's need for alternative sources of energy involves more than research on and analysis of new methods for extracting natural gas, such as hydraulic fracturing. Such inquiries should include faculty in the schools of communication, environmental and biological sciences, engineering, law, and public policy and planning to consider issues relating to safety, public acceptance, and regulation.

In these and other contexts, we are poised to transition from past technologies to those that sustain economic growth and preserve the integrity of the environment. Rutgers will contribute, in full measure, to such work.

Global health challenges are not confined to the fields of medicine or international affairs. Problems as wide ranging as obesity and HIV/AIDS, not to mention mental health issues, need solutions from across cities, continents, disciplines, professions, academic units, industries, and service organizations. Drawing on intellectual strengths in the humanities, the social and life sciences, business, law and education, planning and policy, and the care professions, along with the biomedical sciences and related health professions, Rutgers is in a superb position to participate fully in finding solutions.

New collaborative research projects investigating multiple sclerosis; the effects of environmental toxins on the nervous system, memory, learning, and brain cell development; and the causes and effects of traumatic brain injury and spinal cord regeneration are just some of the initiatives being undertaken by an expanding community of Rutgers scientists. And with the pioneering PharmD/MD program launched at Rutgers Biomedical and Health Sciences, we see not only an immediate return from the recent merger but also the future power and promise of collaboration bringing pharmacy in closer alliance with medicine.

How we organize to teach and engage in research will continue to evolve. A recent such evolution is the coming together of three centers of excellence that will pursue novel approaches to detect, treat, and prevent a wide range of diseases caused by infectious agents and inflammation. The resulting Institute for Infectious and Inflammatory Diseases, located within the International Center of Public Health, an advanced research facility of Rutgers Biomedical and Health Sciences, should be a springboard to further develop this already strong area of research at Rutgers.

Expanding the reach and potential of Rutgers will be its engagement with the Committee on Institutional Cooperation, the academic consortium of top-tier universities through which member institutions can share expertise, leverage resources, and collaborate on innovative programs. Working on everything from improving outcomes for those injured in war and cleaning up nuclear waste to developing more efficient electronics and searching the globe to identify promising biopharmaceuticals, Rutgers looks to both add value and gain from this relationship.

Since many problems do not have fixed boundaries, the university needs to aggressively encourage collaboration across disciplines, schools, and functions. And it needs to develop ways to connect academics to policymakers and to make Rutgers research relevant to, and understood by, the public.

Above: A baby in the Infancy Studies Laboratory where the mysteries of the infant brain are studied.

Below: Graduate students in a materials science and engineering laboratory.

Access, Affordability, and Funding the Future

Fundamental to a Rutgers education is the notion that a democracy is a commonwealth where equality is an ideal and education is a possibility for everyone. Tomorrow's high school graduates will be more racially and culturally diverse and may have less income than those attending today. Diversity is an asset, and has significant implications for jobs, workforce development, and education. Rutgers has to keep up, balancing institutional striving with public need.

The cost of obtaining a degree is rising steeply. As a consequence, an increasing amount of debt is being borne by students, leaving the current generation with a financial burden that stretches into their middle age. Attainment rates bespeak another challenge. Just over a third of U.S. 25- to 29-year-olds hold a four-year bachelor's degree. The salary advantage of a college education remains significant, however, and the economy's need for an educated workforce is likely to intensify. There is a public, civic, and

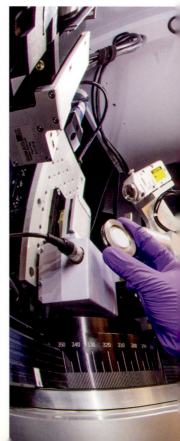

"It is the convergence of the known and the unknown that is the essence of the university experience because it is that convergence that engages the human imagination."

—Linda Stamato

Professor Francis Barchi, left, discusses research conducted by public health and biological sciences student Musunga Mulenga at the 2012 Global Health Fair.

social interest in an educated citizenry. It is abundantly clear that we need to encourage young people to attend college and to ease their passage in so doing. To do otherwise undermines our commitment to the American dream and to the nation's welfare.

But funding for the university, unless attended to very soon at both state and federal levels, will compromise our best efforts to maintain access to an affordable Rutgers education. We need to think differently. We need to expand resources that can be generated from within, such as online, continuous education, and certificate programs where advances are already in the works. External support has to be vigorously pursued as well. Rutgers is an incubator for talent, particularly within its professional schools, for law and engineering firms, hospitals, and businesses and

corporations. Why not seek patrons for our up-and-coming artists? Why not think about "paying it back" programs, creating seed funds for future employees? Or seek corporate and industry support to create excellent conditions for researchers in incremental investments of five to seven years? Scientists trained in such exceptional circumstances will become the next generation of researchers in business and industry. Our economic prosperity is at stake: investing to seed the future makes perfect sense.

The vital importance of universities to the nation may well prompt a shift in attitude and funding. Political leadership—too often absent in this regard—is critical. The citizens of the state should expect solid performance from their state university. But they should recognize as well that Rutgers must have the means to do what they expect of it. Perhaps now, fully a century and a half after the creation of Abraham Lincoln's "public's universities," we need to renew the covenant between the people of New Jersey and their public land-grant university, Rutgers.

* * *

Rutgers bears a heavy responsibility and carries it well. With other public universities, we educate the bulk of the nation's scientists, engineers, social workers, teachers, and citizens. Rutgers opens access and rewards merit, on a significant scale, producing the dynamism that has made it distinctive. Carved in the Jefferson Memorial are these words: "As new discoveries are made, new truths discovered and manners and opinions change, with the change of circumstances, institutions must advance also to keep pace with the times." And so we have and, with confidence and zeal, so we shall. What will not change, though, what must not change, is the importance of public education—the very existence of the state university and its capacity to deliver on its promise. It is in public education, after all, where the American dream continues to take shape.

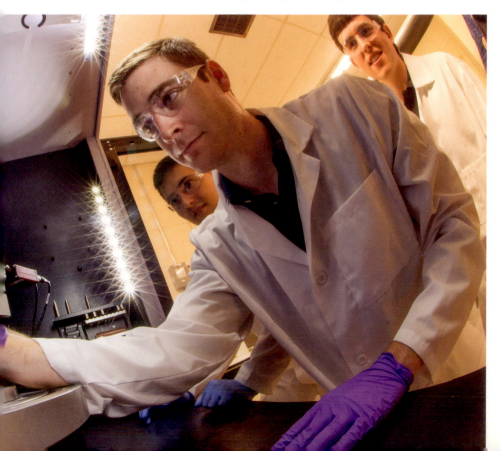

RUTGERS TIMELINE | THOMAS FRUSCIANO

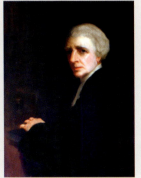

1777
British troops occupy New Brunswick

Queen's students relocate to North Branch in Somerset County

1774
College holds first public commencement

1793
Queen's College trustees narrowly defeat proposal to merge with College of New Jersey at Princeton

1811
Students and faculty occupy partially completed Old Queens

1771
New Brunswick selected as home of Queen's College

1783
Queen's College awards first honorary degree

1786
Jacob Hardenbergh becomes first president of Queen's College

1795
Collegiate instruction at Queen's College suspended

1810
Reverend John Henry Livingston appointed as fourth president

1770 · · · 1780 · · · 1790 · · · 1800 ★ · · · 1810

1766
Royal governor William Franklin signs charter establishing Queen's College

1791
Reverend William Linn appointed as second president

1794
Reverend Ira Condict selected as third president

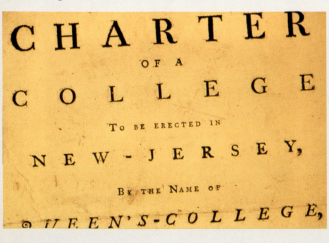

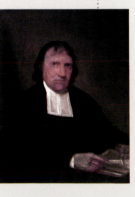

1809
Construction begins on Old Queens
(shown here are the original latch and hinge hardware from the building)

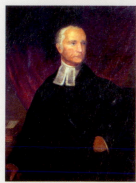

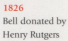

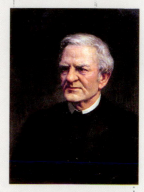

1826
Bell donated by
Henry Rutgers

Henry Rutgers
donates $5,000
bond to Rutgers
College

1825
Reverend Philip
Milledoler selected
as fifth president

1831
Rutgers College Alumni
Association holds first
meeting

1845
Delta Phi becomes
first Greek letter social
fraternity

1862
William H. Campbell
appointed as eighth
president

1820 · · · 1830 · · · 1840 · · · 1850 · · · 1860

1816
Financial troubles force
suspension of instruction
a second time

1825
Instruction commences at revived
college, now known as Rutgers College,
in honor of Trustee Henry Rutgers

Philoclean and Peithessophian
Literary Societies established

1830
Henry Rutgers dies at age 85

1840
Abraham Bruyn
Hasbrouck inaugurated
as sixth president

1850
Theodore Frelinghuysen
inaugurated as seventh
president

1864
Rowing becomes
first organized
sport at Rutgers

Rutgers Scientific
School established

Rutgers College
selected as state's
land-grant college

1847
Cornerstone of
Van Nest Hall laid

THE TARGUM.
VOL. I.—No. 1. RUTGERS. TERMS—75 Cents a Year.
NEW-BRUNSWICK, N. J. "Sol Justitiæ et Occidentem Illustra." JANUARY, 1869.

1869
First issue of *The Targum* published

Rutgers Phi Beta Kappa chapter organized

Scarlet adopted as school color

1900
Cap and Skull secret honorary society established

1892
James Dickson Carr becomes first African-American to graduate from Rutgers

New Jersey College of Pharmacy founded in Newark

"I'd die for dear old Rutgers," allegedly mumbles injured Rutgers football player Frank "Pop" Grant, giving birth to a Rutgers legend

Rutgers defeats Princeton, 6-4, in first intercollegiate football game

1873
Kirkpatrick Chapel dedicated

Rutgers Glee Club first performs "On the Banks of the Old Raritan"

1880
New Jersey Agricultural Experiment Station is established

1890
Winants Hall, Rutgers' first dormitory, completed

RUTGERS

1870 1880 1890 1900

1866
Rutgers baseball team defeated by Princeton, in college's first intercollegiate athletic event

1871
First issue of *The Scarlet Letter* published

1872
Geological Hall completed

1876
Supreme Court Justice Joseph P. Bradley (RC 1836) casts deciding vote making Rutherford B. Hayes president of United States

1882
Merrill Edward Gates becomes ninth president

1896
Garret Hobart (RC 1863) elected U.S. vice president under William McKinley

1894
Ballantine Gymnasium completed

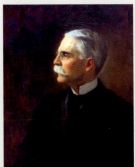

1891
Austin Scott elected as 10th president

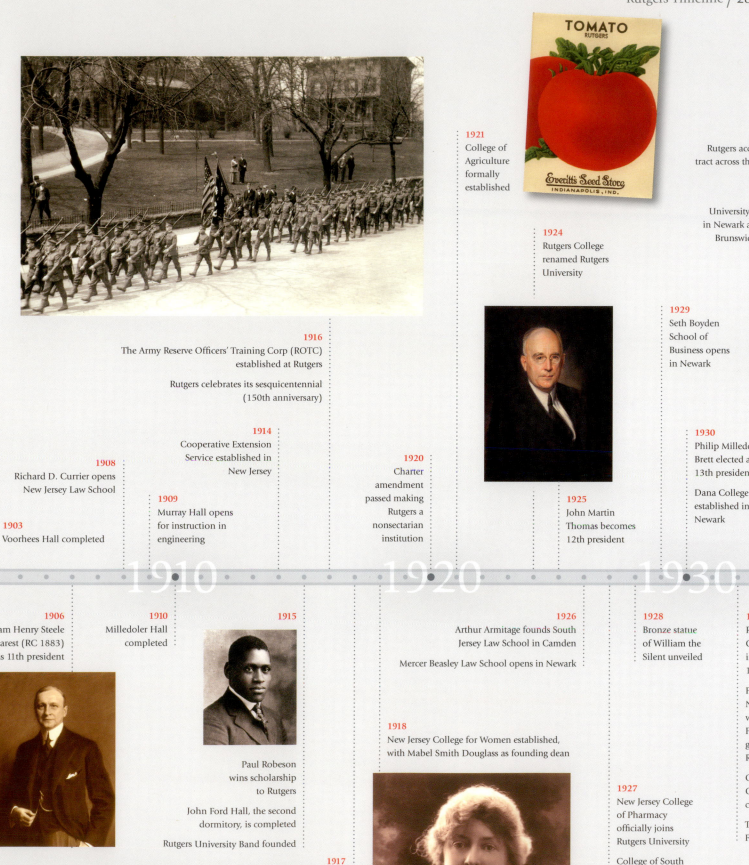

1921
College of Agriculture formally established

1935
Rutgers acquires 256-acre tract across the Raritan River

1934
University College in Newark and New Brunswick opens

1924
Rutgers College renamed Rutgers University

1916
The Army Reserve Officers' Training Corp (ROTC) established at Rutgers

Rutgers celebrates its sesquicentennial (150th anniversary)

1929
Seth Boyden School of Business opens in Newark

1914
Cooperative Extension Service established in New Jersey

1908
Richard D. Currier opens New Jersey Law School

1920
Charter amendment passed making Rutgers a nonsectarian institution

1930
Philip Milledoler Brett elected as 13th president

Dana College established in Newark

1909
Murray Hall opens for instruction in engineering

1925
John Martin Thomas becomes 12th president

1903
Voorhees Hall completed

1910 1920 1930

1906
William Henry Steele Demarest (RC 1883) elected as 11th president

1910
Milledoler Hall completed

1915

1926
Arthur Armitage founds South Jersey Law School in Camden

Mercer Beasley Law School opens in Newark

1928
Bronze statue of William the Silent unveiled

1932
Robert Clarkson Clothier inaugurated as 14th president

Future economics Nobel Prize–winner Milton Friedman graduates from Rutgers College

College Avenue Gymnasium completed

The Graduate Faculty is formed

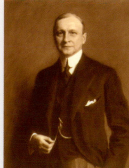

Paul Robeson wins scholarship to Rutgers

John Ford Hall, the second dormitory, is completed

Rutgers University Band founded

1918
New Jersey College for Women established, with Mabel Smith Douglass as founding dean

1927
New Jersey College of Pharmacy officially joins Rutgers University

College of South Jersey in Camden launched

1917
Rutgers Scientific School declared State Agricultural College

1956
Rutgers College of
Nursing established

State University
Reorganization Act affirms
Rutgers as The State University
of New Jersey and creates the
Rutgers Board of Governors

1948
WRSU radio station presents first broadcast

1957
Rutgers Preparatory
School severs its ties to
Rutgers University

1936
University of Newark
created through a
merger with existing
schools in the city

Rutgers University
Press founded

1945
Rutgers designated the State
University of New Jersey

1943
Selman Waksman and Albert
Schatz discover streptomycin

1951
Lewis Webster
Jones selected as
15th president

1952
Selman Waksman
receives Nobel Prize

1940 1950

1938
Rutgers football team
defeats Princeton, 20-
18, at dedication of new
Rutgers Stadium

1946
Seton Hall (later New Jersey) College
of Medicine and Dentistry founded

University of Newark merges
with Rutgers University

1947
Institute for
Management and
Labor Relations opens

1950
South Jersey Law School and
College of South Jersey merge
with Rutgers University

1955
New Jersey
College for
Women renamed
Douglass College

1958
700 Rutgers
students march on
Trenton to protest
state's lack of
financial support

1969
Members of Black Organization of Students barricade themselves in Conklin Hall on Newark Campus

Classes begin at Livingston College in Piscataway

Rutgers Student Homophile League established

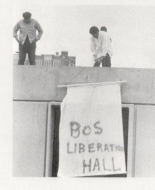

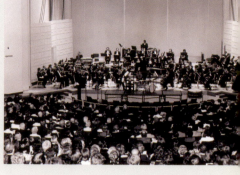

1959
Mason W. Gross elected 16th president

1963
Rutgers University Choir performs nationally broadcast memorial concert for President Kennedy day after his assassination

Donald S. Harris (RC '63) seized and jailed in Americus, Georgia, following participation in a voter registration drive

1971
Busch Campus is named for Charles L. Busch, who bequeathed Rutgers $10 million for biological research

Faculty women in Newark win lawsuit about inequalities on the job and discrimination against female faculty

Rutgers Medical School separated from university to become part of the New Jersey College of Medicine and Dentistry

1975
Fine Arts Theater on Camden Campus opens with concert by the New Jersey Symphony Orchestra

1976
Rutgers men's basketball team concludes regular season undefeated (31-0) and reaches the Final Four

Theresa Grentz named Rutgers' first full-time women's basketball coach

Rutgers completes second undefeated football season

School of Creative and Performing Arts (later Mason Gross School of the Arts) founded

$66 million higher education bond issue approved by voters

1965
First "teach-in" on the Vietnam War held in Scott Hall

1972
Rutgers College becomes coeducational

1960 · 1980

1961
Rutgers completes first undefeated football season

Rutgers Medical School founded

1964
Federal government turns over Camp Kilmer in Piscataway to Rutgers

1966
U.S. Supreme Court Justice William Brennan challenges the Rutgers Law School–Newark to diversify the composition of its students

Rutgers celebrates its bicentennial and creates a university shield

1971
Edward J. Bloustein becomes 17th president

1974
Rutgers defeats Princeton, 76-60, in its first-ever women's Division I intercollegiate basketball contest

1980
Board of Governors approves plan for academic reorganization of Rutgers–New Brunswick

1981
The Graduate School–Camden is founded

Arts and sciences faculty of Rutgers, Douglass, Livingston, and University Colleges at Rutgers University–New Brunswick are combined, strengthening the academic departments

1994
12-year-old Hannes Sarkuni becomes youngest matriculated student to enroll at Rutgers

$28.9 million renovated Rutgers Stadium in Piscataway dedicated

1983
Jane Voorhees Zimmerli Art Museum opens

1987
Survey on sexual orientation at Rutgers reports that many lesbians and gays feel harassed on campus

Rutgers Hall of Distinguished Alumni created

1988
School of Business–Camden established

1991
Francis L. Lawrence inaugurated as 18th president

1990

1982
Rutgers' women's basketball team wins AIAW National Championship

1985
Students stage month-long takeover of Rutgers Student Center to protest university's South African investment policy

Board of Governors votes to divest all holdings in companies doing business with South Africa

1989
Rutgers invited to join Association of American Universities (AAU)

1990
Winants Hall rededicated following two-year, $9.4 million restoration

1991
Rutgers celebrates 225th anniversary

1992
Office of Diverse Community Affairs and Lesbian and Gay Concerns established under first director Cheryl Clarke

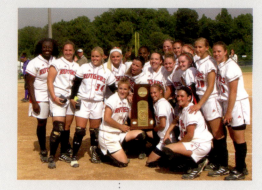

2001
Campbell's Field opens along with the Rutgers–Camden Community Park

2006
Rutgers–Camden women's softball becomes first Rutgers team to win NCAA title

University approves plan to transform undergraduate education at the New Brunswick Campus

School of Public Affairs and Administration opens at Rutgers–Newark

2000
Rutgers University Television Network (RU-TV) begins operation

Rutgers becomes one of the first research institutions to connect to Internet2

2003
Richard L. McCormick inaugurated as 19th president

2004
Rutgers campaign raises $615 million, surpassing $500 million goal

2007
First U.S. doctoral program in childhood studies debuts at Rutgers–Camden

2000

1997
Rutgers–Newark recognized by *U.S. News & World Report* as the most diverse national university

2003
Rutgers–Camden women's basketball team wins its first NJAC team championship

Professor Evelyn M. Witkin receives National Medal of Science

2008
Rutgers–Newark celebrates 100 years of higher education

Rutgers alumnus Junot Díaz wins Pulitzer Prize for fiction

Inaugural class of Rutgers Future Scholars comes to campus for enrichment activities

1995
Board of Governors approves multicultural blueprint aimed at improving student life environment at Rutgers

2005
World-renowned spinal cord injury researcher Wise Young named one of *Esquire* magazine's "Best and Brightest of 2005"

2013

Most units of the University of Medicine and Dentistry of New Jersey (UMDNJ) are integrated into Rutgers

Rutgers joins the Committee on Institutional Cooperation

The Tyler Clementi Center founded to share knowledge on making the transition to college in the digital era

2009

First-ever Rutgers Day brings 50,000 visitors to campus

Eight-foot bronze sculpture of Walt Whitman unveiled in front of Camden Campus Center

The Scarlet Knight makes history as first underwater robot glider to cross the Atlantic

Women's basketball coach C. Vivian Stringer enshrined in Naismith Memorial Basketball Hall of Fame

2011

Jacob Soll, professor of history at Rutgers–Camden, named a MacArthur Fellow

Board of Governors approves creation of School of Nursing–Camden

2010

2010

Forbes magazine declares Rutgers–Newark the most racially and ethnically diverse campus in the nation

Suicide of first-year student Tyler Clementi sparks national discussion on cyberbullying and the struggles facing LGBT youth

Rutgers establishes universitywide Office of Veterans Services

2012

Robert Barchi named 20th president

Supporters of a $750 million higher education bond referendum succeed in passing the measure by a two-to-one margin

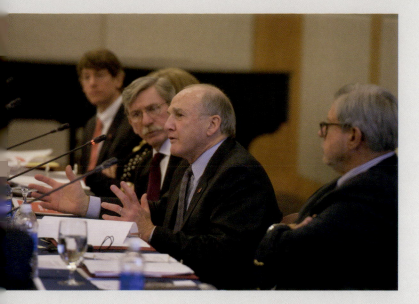

2014

Rutgers approves strategic plan for Rutgers University

Our Rutgers, Our Future campaign concludes, raising $1.037 billion

Scarlet Knights start competing in the Big Ten Conference

2016

2015

New facilities master plan for Rutgers University approved with goal of transforming the university by 2030

2016

Rutgers celebrates 250th anniversary

The Rutgers Shield

The Rutgers shield is a fundamental expression of the university's identity. Introduced in celebration of Rutgers' 250th anniversary, the shield honors Rutgers' roots, affirms its values, and provides flexibility as 21st-century iconography in pageantry, publishing, and promotion. The shield's three sections represent Rutgers' deep connections to New Jersey's three regions—north, central, and south—and denote its tripartite mission—teaching, research, and service.

The sunburst conveys illumination—light as metaphor for knowledge—and is the motif of Rutgers' seal and heart of its motto, "Sun of righteousness, shine upon the West also." It recalls Rutgers' Dutch heritage; both the seal and motto are variants on those of Utrecht University, the Netherlands, which guided Rutgers' Dutch colonial founders in its formative years. The crown represents the establishment in 1766 of Queen's College, named in honor of Queen Charlotte, wife of England's King George III who reigned over colonial America. Chartered in 1766, one of America's nine original colonial colleges, the college gave itself over to the cause of freedom when the American Revolution erupted a decade later. Three stars represent the State of New Jersey, the third state to ratify the U.S. Constitution. Rutgers is devoted to serving its home state as New Jersey's land-grant school and is proud to be The State University of New Jersey. The book is a timeless symbol of Rutgers' enduring commitment to teaching, learning, academic inquiry, and scholarship. Across generations and disciplines, at its core, Rutgers creates, shares, and applies knowledge for the betterment of individuals and society.

LIST OF SPONSORS

Key to School Abbreviations

AG–College of Agriculture
CC–Cook College
CCAS–Camden College of Arts and Sciences
CLAW–School of Law–Camden
DC–Douglass College
ED–School of Education
EJB–Edward J. Bloustein School of Planning and Public Policy
ENG–School of Engineering
GSAPP–Graduate School of Applied and Professional Psychology
GSBS–Graduate School of Biomedical Sciences
GSC–Graduate School–Camden
GSE–Graduate School of Education
GSM–Graduate School of Management
GSN–Graduate School–Newark
GSNB–Graduate School–New Brunswick
LC–Livingston College
MGSA–Mason Gross School of the Arts
NCAS–Newark College of Arts and Sciences
NJC–New Jersey College for Women
NJDS–New Jersey Dental School
NJMS–New Jersey Medical School
NLAW–School of Law–Newark
NUR–College of Nursing
PHARM–Ernest Mario School of Pharmacy
RBS–Rutgers Business School–Newark and New Brunswick
RC–Rutgers College
RSDM–Rutgers School of Dental Medicine
RWJMS–Robert Wood Johnson Medical School
SAS–School of Arts and Sciences
SB–School of Business
SBC–School of Business–Camden
SC&I–School of Communication and Information
SCILS–School of Communication, Information and Library Studies
SCJ–School of Criminal Justice
SEBS–School of Environmental and Biological Sciences
SHRP–School of Health Related Professions
SMLR–School of Management and Labor Relations
SN–School of Nursing
SNC–School of Nursing–Camden
SPAA–School of Public Affairs and Administration
SPH–School of Public Health
SSW–School of Social Work
UCC–University College–Camden
UCJC–University College at Jersey City
UCN–University College–Newark
UCNB–University College–New Brunswick
UCP–University College at Paterson

This book has been made possible through the generosity of the sponsors listed below.

Jose G. Abreu (RC '90, NLAW '94)
Haemee Ahn
The Allen and Joan Bildner Center for the Study of Jewish Life (SAS)
Emily Allen-Hornblower
Gregory Allen and Family (ENG '82, GSE '10, SAS '10)
Michael Alles (RBS '99)
Matt and Laura Alter (CC '06 / CC '07)
American Council on Education (United States)
Angela D. Amos (RCNB '01)
April Ancheta (SN '15)
Denise DeCillis Anderson (RC '83, GSNB '99)
Vincent J. Anderson (SB '94)
Michael Antoniades (SPAA '08)
Debbie Antosh (GSE '03)
Albert Appouh (NCAS '17)
Richard Aregood (CCAS '65)
Patricia Tully Armitage (GSC '00)
Joseph M. Arseneau (RBS '16)
Consuella Askew
Association of Public and Land-grant Universities (United States)
Vincent G. Auriemma, Jr. (RC '85)
Michael W. Azzara (RC '69)
Val Azzoli

Babeş-Bolyai University (Romania)
John C. Baker (RC '69, RBS '82)
Lauren M. (Skettini) Baker (DC '83)
Beverly Ballard (SBC '13)
Kathleen Mae Zamora Bansil (SAS '11, SC&I '11)
Stephen F. Barbieri (RC '03, SCILS '03)
Francis Barchi
Robert Barchi

Christopher H. Barfield (CC '11, RBS '17)
Stanko Barle (GSNB '96)
James C. Baroni (ENG '82)
Monica C. Barrett
Joann Newmeyer Barros (PHARM '90)
Herbert H. H. Bartron (ENG '51)
Linda Bassett
Stephen Bastedo (NCAS '73)
Marco Battaglia (RC '96)
Sandra M. Battle (CC '00, SPAA '12)
Alyssa Dawn Bauer (SAS '17)
Thomas D. Bazley III (RC '70)
Andrew Becker (UCC '14)
Benjamin R. Beede
Donald W. Beetham (SCILS '85)
Beijing Language and Culture University (China)
Lee Bellarmino (RC '70)
Daniel Berger (RC '71)
Edward Berger (NLAW '74)
LTC George D. Bertish (RC '58)
Tyron R. Bethea (SMLR '15)
Sanjib Bhuyan
Ann Bilbrough-Dooley
Bilkent University (Turkey)
Angeline M. Bishop
Patrick Bittner (RC '05)
David Bizenov (SAS '15)
Katherine Kuren Black (NUR '77)
Blackburn Family (RC '87, LC '87)
Pamela Blake (DC '74)
David Blanch
Michael G. Blasi (ENG '68)
Michael J. Blecker and Nan M. Blecker (RC '67)
Michael A. Blishak (RC '78)
Bluebond-Langner Family ('15)

Myra Bluebond-Langner
Robert J. Bluestone (RC '68)
Steve Bluestone (RC '87)
Pamela Blumenson
Robert M. Bochar (CC '82)
Vanessa Bodossian (SAS '16)
Joseph Boehler (RC '06)
Richard C. Bogatko II (CC '79)
Skyler Bolkin (SAS '18)
Sarah R. Boltizar (RC '00, RBS '03)
Diane Bonanno
Gloria Bonilla-Santiago (SSW '78)
Irfan Bora (NCAS '78, GSM '83)
Max Borghard (ENG '87, GSE '10)
Erik A. Botsko (SC&I '16)
Frances V. Bouchoux
Martha Reed Boughner (DC '71, GSE '86)
Glenn Bouthillette (SEBS '17)
George Boyan
Meredith Sullivan Boyan
Carol A. Boyer
Jeanne Boyle (DC '67, SCILS '68)
Robin Nancy Boyle
Jaclyn Bradley-McFarlane (UCC '09, EJB '12)
William B. Brahms (RC '89, SCILS '93)
Gary Branning
Brazilian Federal Agency for the Support and Evaluation of Graduate Education (CAPES) (Brazil)
Robert Breckinridge (LC '88)
James A. Breeding (RC '75)
Evelyn Brenzel (DC '66)
Kenneth J. Breslauer
Jennifer Russell Bridenbaugh and Eric Bridenbaugh (CC '91)
Franklin Bridges (SCILS '94, SC&I '10)
Thomas Brinkman (CC '12)
John V. Broggi (RC '67)
Daryl Brower (RC '88)
Christopher R. Brown (RC '81)
Diana Orban Brown and Michael Brown
James V. Browning
Joshua Bucher (RC '08)
David M. Bujese (RBS '88)
Jerry Nathan Bullock
Monica Buonincontri (DC '00)
William R. Burd (ENG '71, RC '71)
Grigore C. Burdea
Alessandra Burgos (SEBS '16)
Allen R. Burns (UCC '85)
Carl W. Burns (RC '64, GSN '73)
Gloria M. Burns (CLAW '79)
Ruth Ann Burns (DC '67, GSNB '75)
Scott M. Burns (RCNB '08)
Eve Burris (SCILS '02)
Dominick J. Burzichelli (CC '84)
Robert J. Burzichelli (RC '81)

Abena P. A. Busia
Jeffrey J. Byrd (CC '83)

Yangyang Cai (GSNB '14, RBS '15)
Marian Calabro (RC '76)
Antonio M. Calcado
Karen Caliciotti Pickering (DC '78)
Michael J. Callahan (RC '64)
Leo Campbell (GSE '81)
María Josefa Canino
Nancy Cantor
Barbara Ann Zetts Cantrell (DC '78)
Howard D. Cantwell (RC '61)
The Cap and Skull Society (RC '1900)
Tina M. (Gwalthney) Capano (NUR '90)
Joseph James Capo (LC '76)
Kristin Capone (SAS '15)
John A. Caputo (RC '64)
Joseph A. Carlani III (RC '84)
Chris Carlin
Elyse Carlson
Justin T. Carlson (SAS '11)
David J. Carter (LC '80, RC '76)
Neil J. Casey (RC '67)
Cashin Family (SAS '14, GSE '15)
Tania (Tani) Castaneda
William G. Castellano (SMLR '96, GSNB '10)
Jorge del Castillo (RC '70)
Vincent G. Catizone (GSNB '09)
Central European University (Hungary)
Centre National de la Recherche Scientifique (France)
Robert J. Cerosky (NCAS '66)
Angelo Certo (UCNB '92)
Michael J. Chalhoub (RC '03, RBS '16)
John Whiteclay Chambers II
Eve K. Chang (RC '86)
Mina Chang (LC '05)
Tzu Min Peter Chang (GSE '12)
Joseph Charette (CC '77)
Anthony Chattley (CCAS '02, EJB '06)
Cheikh Anta Diop University (Senegal)
Joshua Samuel Chelli (RBS '15)
Jianmin Chen (GSNB '07)
Jenya Chernenkova (RBS '16)
Elango Chidambaram (RBS '15)
Michael J. Christiaens (CC '00, GSBS '03, RBS '05)
Allison Linfante Christian (DC '98)
Linda A. Christian
John Cifelli (CC '09)
James Cipriano (ENG '16)
City University (United Kingdom)
Amber Clapsis (SAS '14)
Peter and Bernadette Clapsis
Rachel Clapsis (DC '18)
Paul G.E. Clemens
April Coage (UCN '00)

Michelle Cody
Hilary Cohen
Robert Cohen (RC '63, GSE '64, SSW '73)
Tasha Coleman-Tharrington (SC&I '14)
Jim and Maya Colitsas (RC '96, RBS '97 / GSE '00)
Michele Collins (NCAS '98)
Laurence J. Colton (ENG '85)
Michael Colvin (RC '31)
Commission for Educational Exchange between the United States of America and Brazil, Fulbright Commission (Brazil)
Committee on Institutional Cooperation (United States)
Joseph J. Condran (UCNB '93)
Confucius Institute of Rutgers University
Katherine Congelosi (SAS '12, GSE '14)
Mark J. Conlin (RC '77)
James J. Copeland
Myron Neal Corman (GSE '73)
Wilbur (Bill) R. Cornwell (CCAS '08)
Frederic Cosandey
Carlos Costa and Family
Roseanne Coston-McHugh (UCC '82, GSC '88)
Council on International Educational Exchange (United States)
Robert Darius Cravello (NCAS '66)
Eileen Crowley (RC '79)
Susannah Crowley (SC&I '11, '12)
Paul Culcasi (RC '90)
James H. Cummings (UCN '73, GSE '82)
Michael A. Curi (NJMS '98)
Edward Curley
Ian Robert Curry (SAS '16)
Robert and Suzanne Curry (CC '84 / RC '84)
Shane Louis Jack Curry (SAS '19)
Cuttington University (Liberia)
James J. Cuviello (RC '69)
Cytroen Family

James P. D'Alessandro (RC '71)
Mary Beth Daisey (GSE '87)
Dance Department—Mason Gross School of the Arts
Steven Darien (RC '63)
Alan Dattel (RC '80)
Henryk Daun
Kenneth P. Davie (RC '68)
Dennise Svenson De la Fuente (DC '04)
Patricia De Marco (DC '76)
Beth DeMauro
Bob DeAnna (ENG '84)
Sattik and Erica Deb (LC '01, DC '05, GSE '11)
Alice Debowski (SAS '14, GSE '15)
Len and Sue DeCandia (ENG '82 / RC '81)

Marie DeGulis (RC '75)
Alan Delozier (SCILS '99)
Department of Civil and Environmental Engineering
Department of Italian
Department of Jewish Studies (SAS)
Jessica DePaul (SC&I '17)
Steven C. DeRienzo (RC '88)
Debra Diller
Lee Ann Dmochowski (DC '88)
Edmund P. Doherty (RC '65)
Cathy Donovan (GSC '07)
James Gerald Doran (SAS '15)
Donna J. Dorgan (NLAW '94, GSN '95)
James F. Dougherty (RC '74, GSNB '75)
Douglass Residential College
John Dowd (RC '71)
Gerard and Peggy Drinkard (UCN '07)
John J. Drudy
Bochuan Du (PHARM '14)
Eleonora Ciejka Dubicki (DC '77, SCILS '78, RBS '84)
Michael J. Duffy (RC '97)
Matthew Dufner (SB '99)
In memory of Elizabeth "Betty" W. Durham (DC '22)
Joanne Dus-Zastrow

Henry L. D. Ebert (CC '79)
Norman H. Edelman
Richard L. Edwards
Lisa Elwood (DC '86)
Sanford Endick (NCAS '57, GSE '60)
Peter Englot
Norman Epting, Jr. (RC '76, NLAW '79)
Samuel J. Errera (ENG '49)
Tim Espar (SCILS '97)
Lisa Estler (SEBS '15)
Peter V. Evans
Douglas Eveleigh
Ewha Womans University (South Korea)

Christopher Anthony Faas
Arthur J. Falk (RC '66, GSM '90)
Richard S. Falk
James A. Falstrault (LC '97)
Jennifer A. Falstrault (DC '92)
Wen Fan (RBS '14)
Philip M. Farber (RC '73)
Tatiana Fech (SAS '14, EJB '14)
Bernard T. Feeney (UCN '77)
John T. Feeney (RC '65)
Bruce C. Fehn
Leslie Fehrenbach
Cecile A. Feldman
Leonard C. Feldman (SAS '67, GSNB '67)
Matthew B. Ferguson (UCNB '05, EJB '08)
Carlos Fernandez
Vivian Fernández

William and Sheila Fernekes (RC '74 / RC '76)

Michael A. Fernicola (RC '81)

Joseph Ferranti

Jacqueline Fesq (DC '74, GSE '80, '95)

Edward Filippazzo (RC '93, RBS '93)

William P. Finaldi (UCNB '92)

Darren Fink (SEBS '14)

James Fiordeliso (GSNB '93)

Timothy J. Fiorillo (SC&I '12, SAS '12)

Carolyn Flaherty (LC '87)

Holly Flaherty (SAS '19)

Elisabeth C. Flinsch (SAS '15)

Dan Flint

Emma R. Florentine (ENG '17)

Lea Curtis Florentine (CC '85)

Richard Florida (RC '79)

Dana Passariello Flynn and William Flynn (DC '87 / LC '86)

Matthew Flynn (SEBS '16)

Nicole Flynn (SAS '14, GSE '15)

Ethan Folz (SAS '17)

Phil and Marla Folz (SB '89 / RC '85)

Lora L. Fong (DC '79, NLAW '91)

Kenneth J. Forberger

Gloria Ingaro Forster (UCNB '68)

Lisa Fortunato

Margaret and Paul Fourounjian (SAS '80, SB '81 / NJDS '84)

David Fowler (GSNB '79, '87)

Peter Fowler (UCNB '62, GSNB '69)

Richard J. Fox (RC '97)

J. Fredo (NCAS '92)

Heather Dawn Free (SAS '07, '11)

Freie Universität Berlin (Germany)

Jay Friedman (RC '77)

Gustav W. Freidrich

Rae Frisch

Lawrence J. Froot (ENG '72)

Dan and Michele Frusciano (RC '03 / MGSA '03)

Doug and Alison Frusciano (RC '06 / UCNB '06)

Thomas and Linda Frusciano

Iris J. Fryzel (née Zwillman) (CC '75)

Haydee Fuentes

Erin and David Fulvio (RC '08)

Larry R. Gaines and Kristin R. Walker

Todd M. Galante (NCAS '83)

Adam Roy Gale (RC '79)

Jason Gambone (CCAS '99)

Chirag D. Gandhi (NJMS '00)

Edward Garber (NCAS '82)

Lloyd Gardner

Ron Garutti (RC '67)

Garzon Family (SB '00, ENG '12, SJC '15)

John and Deborah Gatlin (RC '78)

Barry and Marianne Gaunt

Robert E. Gearing II (RC '79)

Janice Geiger

Roberta George-Matalon (GSNB '90)

Karen and Patrick Gerini (NUR '79 / NCAS '82)

Will Gilkison (RC '07, GSE '08)

Angus Kress Gillespie

Paul Gilmore and Reid Cottingham

Frank A. Gimpel (ENG '49)

Stu Gittelman (RC '90)

Arnold Lewis Glass

John Scott Glouse (UCNB '88)

Propser Godonoo

Richard E. Goldman (RC '72)

Jason Goldstein (LC '02, RBS '05)

Diana Gonzalez (LC '07, GSE '16)

Allan E. Goodman

Robert M. Goodman

Sherry B. Goodrum (CLAW '97)

Seth Gopin (RC '79, GSNB '84, '94)

Erika Gorder (RC '91, SCILS '04)

Leila Gordon (SAS '17)

Ed Gorman (CCAS '13)

Jim Gormley (CCAS '69, GSNB '78)

Ayesha Gougouehi (SAS '13)

J. Michael Gower

Jeremy Grainger

Graz University of Technology (Austria)

Green Family (GSN '92, UCN '09)

Harry A. Green (RC '94)

Ryan Griffith (RBS '15)

Lauren Grodstein

Eric L. Grogan (NLAW '92)

Laura Gunderson (ENG '16)

Samuel Gunderson

Silvia Gunderson (SAS '17)

Arslan Gungil (SEBS '17)

Alice Hatkin Gunther (DC '71)

Harvey W. Gunther (RC '71)

Aparna and Vipul Gupta (GSNB '94)

Rajan Gupta and Sarah Greer

Brad Gurney (CC '78, GSNB '80)

David F. Gwalthney (CCAS '10)

David L. Gwalthney (CCAS '71, GSNB '76)

Rachel Hadas

Phoebe A. Haddon

Ledawn Hall (SCILS '01, RC '01)

Maria Hall

Bruce A. Hamilton (CC '60)

Carol and C. Judson Hamlin (DC '61)

Florence Hamrick

Elizabeth Hankerson

R. Leslie (Les) Hargrove (RC '57)

Wayne F. Harmer (LC '83)

Diane Wms. Harris (GSE '77)

Jane Hart

Carol Hartman (UCNB '96)

Jason Hartman (CC '96)

Mary Hartman

Michael Hartman (RC '92)

Kyle S. Hartmann (SAS '13)

Hatta-Sjahrir College of Marine Sciences and Fisheries (Indonesia)

Bob and Cathy Hawn (RC '89 / DC '85)

Kayti Hawn (NUR '15)

Donald C. Heilman (CC '76, GSE '07, '12)

Marjorie Hemmings (UCC '06)

Kenneth S. Hempel (RC '59)

Jordan W. Henry (EJB '12, SAS '12)

Paula Henry

Julie Hermann

David Hernandez

Jessica L. Herring (SAS '16)

Diane Hill (GSN '12)

George Hill (CCAS '61)

Kevin Hill (RC '76)

Washington Hill (CCAS '61)

Himalayan Health Exchange

Ronald James Hirsch (CCAS '91)

Ho Chi Minh National Academy of Politics and Public Administration (Vietnam)

Wayne H. Hoffmann (RC '68)

Erica Hofstetter (RC '99, SCILS '99)

Jordan Hollander (CLAW '14)

William L. Holzemer

Hong Kong University of Science and Technology (Hong Kong)

Stu Hothem (RC '95)

Barbara Howard

Cynthia Ross Howell

James M. Howson (LC '84)

Fiona Hu (SAS '13, GSE '14)

Eric J. Huff (CC '91)

Kathleen B. Hughes (RC '79)

Frank Brown Hundley (RC '86)

Richard Hurley (CC '83)

Craig Hynes (CCAS '03, GSC '12)

Nicole Hynes (CCAS '03, GSC '12)

Hyogo Medical College (Japan)

Theresa L. Hyslop (RC '15)

Michael C. Illuzzi (RC '77, GSC '81, GSE '82)

Michael B. Imerman (RBS '04, '11)

Karen Phelps Imperiale (RC '79, SCILS '81)

Indian Council for Cultural Relations (India)

Alexander John Inkiow (SAS '17, EJB '17)

Vera Inkiow

Institut Teknologi Bandung (Indonesia)

Institute at Palazzo Rucellai (Italy)

Institute of International Education (United States)

Institute of Primate Research at the National Museums of Kenya (Kenya)

Instituto Nacional de Enfermedades Respiratorias (Mexico)

International Christian University (Japan)

International University, Vietnam National University (Vietnam)

IREX (USA)

Jeff Isaacs (RC '90)

Jeffrey M. Isaacs (LC '84)

Nataliya Ivanchuk (RBS '14)

Ivane Javakhishvili Tbilisi State University (Georgia)

Gabriel and Rhoda Jacinto (ENG '95, RBS '01 / RC '98, RBS '04)

Faith Jackson (SC&I '15)

Matthew J. Jackson (RC '67, NJDS '71)

Timothy C. Jackson (RC '82)

Eve Jacobs (DC '74)

Yuri Tertilus Jadotte (NJMS '10, SN '16, GSN '16)

Sanford M. Jaffe (NCAS '54)

Romando James

Elizabeth N. Jaskiewicz (SAS '16)

Peter W. Jewell (RC '70)

Jilin University (China)

John Cabot University (Italy)

Shino and Alycia John (RC '00)

Kerri Johnsen (SAS '16)

James Turner Johnson

Jeremee Johnson (RC '97, SCILS '97, SC&I '13)

Kenneth R. Johnson (ENG '66)

Nathaniel Johnson, Jr. (NCAS '70, RBS '75)

Gary T. Johnston (RC '87)

James K. Johnston (ENG '88)

Robert Johnston (ENG '82)

James W. Jones

Frank Jordan

Lois De Julio (DC '69, NLAW '73)

Manuel Jusino (GSNB '15, GSN '12)

Benjamin Justice

Alyssa Beth Kahn (SAS '18)

Roberta Shulman Kanarick (DC '64, GSE '92)

Anita Kaplan

Harold J. Kaplan (RC '57)

Ariel Kapoano (SAS '11)

Norig B. Karakashian (RBS '15)

Kenneth M. Karamichael (RC '95, CC '95, GSE '15)

Peter and Barbara Karavites (RC '78 / RC '79)

Karolinska Institutet (Sweden)
Douglas Katko (UCNB '71)
Larry S. Katz and Barbara J. Tarbell
Charles Keeton
Ken and Julie Kendall
Charles J. Kenlan (RC '58)
Kenya Wildlife Service (Kenya)
Helynna Joy Kerr (UCNB '13, SC&I '13)
Adam Kertis (SC&I '14)
Alpha Epsilon Pi—Rho Upsilon Chapter ('56)
Nevin E. Kessler
Ann Marie Kestel (SBC '10)
John R. Kettle III (NLAW '85)
Herbert H. Kiehn, Jr. (RC '59)
Ed Kiessling (CCAS '77)
David M. Kietrys
Thomas A. Kietrys (RC '63)
Misun Kaitlin Kim (DC '09, GSN '11)
Carleton F. Kimber (UCC '86)
Gregg M. Klein (RC '96, GSM '98)
Lisa C. Klein
Michael R. Kletz (RC '80, NJMS '84)
Jennifer Klisch (SAS '15)
Daniel Kluchinski (CC '85)
Carolyn A. Knight-Cole
Matthew D. Knoblauch (SAS '12, GSE '13, NLAW '16)
Michael W. Knoblock (RC '95)
Rebecca M. Knoblock (RC '09)
Koç University (Turkey)
John F. Kocsis (RC '83, GSNB '85, '93)
Lou and Rita Koczela (ENG '61 / CCAS '63)
Kenneth Kolanko (RC '07, GSE '13)
Stan Kolasa
Marc C. Kollar (CC '95)
Jerry Komiskey (ENG '88)
Carol Koncsol (UCNB '96)
Dean Koncsol (ENG '93)
Eddie and Laura Konczal (RC '92 / UCNB '04)
Michael J. Kondrak (LC '87)
Korea Development Institute (South Korea)
Korea University (South Korea)
Kyle Kovats (SAS '13)
Matthew J. Kozak (CLAW '99, GSBC '04)
Brian Kramer (RC '94)
Daniel R. Kramer (RC '72)
Corey Kroll (SC&I '14)
Arnoud de Kroon (GSNB '93)
Peter J. Krukiel (NCAS '72)
Matthew Kuchtyak (SAS '13)
Saskia A. Kusnecov (SAS '15)
Paul I. Kuznekoff

Sheri La Macchia (SAS '15)
Bob La Tourette (RC '62)

William "Cory" Labbree (CCAS '11)
Alexi Lalas (RC '92)
Maureen Theresa Lamkin (CC '90)
Gerard LaMorte (NCAS '01)
Elizabeth Anne Langan (DC '11)
Noshir and Dinaz Langrana
Michael P. Lanyi (RC '73)
Kendall LaParo (SAS '11)
Jerome Laruccia (LC '05)
Robert and Sonia Laumbach (CC '92, RC '96 / RWJMS '97)
Wayne J. Lavoie (CC '82)
Kenneth and Sheila Lawrence (ENG '74, ED '79 / SAS '92)
Susan Lawrence
Veronica Leach (ENG '15)
Ji Lee
Leonard Y. Lee
Walter L. Leib (SAS '51, NLAW '53)
Richard Levao (RC '70)
Kenneth and Barbara Lew (RC '01 / DC '03)
Albert M. Lewis (UCNB '78)
Donald J. Lewis (RC '76, SCILS '80)
Jan E. Lewis
Jing Li
Ellen Sue Lieberman (SPAA '16)
Amy Lina (née Dick) (UCC '03, GSC '08)
Blerta Lindqvist
Janne Lindqvist
Ryan Lindsey (SAS '18)
John J. Linfante (RC '67, RBS '69)
Linköping University (Sweden)
Jason Lioy (GSM '99)
Paul and Mary Jean Lioy (GSNB '73, '75 / AG '72, GSNB '86)
Mary Ann Littell
Timothy J. Little (RC '78, CLAW '85)
Weiliang Liu (GSNB '06)
Livingston College Alumni Association
Anthony D. LoBocchiaro (SAS '18)
Marie Logue (GSNB '76, '83)
Arend D. Lubbers (GSNB '56)
Philip M. Lubik (ENG '13)
Richard D. Ludescher
Lawrence L. Lukenda (RC '71)
Marissa Lyna (SAS '14)
Matthew Lyna (SB '12)
Jack Lynch
Rosemary Lyons

Macquarie University (Australia)
Dale Madan (RC '08)
Cynde Magidson (DC '72)
Steve Magidson (RC '70)
Mary Ellen Maguire (DC '01)
David Major
Anna Mallory (SAS '18)

Steven Mandell (RC '77)
James Manning (RC '85, SCJ '09)
Kim Manning (RBS '90)
Charles S. Mansueto (RC '67)
Daniel C. Manuel (GSNB '19)
Rory "Cal" Maradonna (CCAS '74, GSC '79)
Peter March
Anthony Louis Marchetta (RC '71, GSNB '78, RBS '83)
Bruce E. Marich (RC '63, GSNB '65)
Michael J. Marion
John Casey Marr (RC '76)
Margaret Marsh (CCAS '67, GSNB '69, '74)
Richard P. Martielli (RC '01)
Douglas and Terrese Martin and Family (CC '67, DC '69, RC '94, '97, '01)
Mary Anjou Martinez (RC '05)
Nadine Marty (GSE '95)
Marie Paulette Matis (UCNB '94)
Thomas Matro (RC '62, GSNB '66, '75)
Matt Matsuda
M. John Matthewson
Matyash Family (SAS '13, SC&I '16, SEBS '17)
Patricia Mayer
Stephanie (Gwalthney) Mayernik (DC '95, GSC '05)
Aldo J. Mayro (SAS '16)
Courtney O. McAnuff
Dana McCallion
Richard L. McCormick
Christina G. McGinnis (DC '16)
Felicia E. McGinty
Edward M. McHugh (CCAS '70, '79)
Stephanie A. McHugh (CCAS '11)
Claire R. McInerney
Thomas McNamara
Susan "Susie" McNulty (MGSA '15, GSE '16)
Michael Meagher
Gerald D. Meccia
Douglas J. Mehan
Sherylanne Meisner (SAS '12, GSE '16)
Dominick R. Mellace (CC '71)
Richard Melnyk (RC '73)
Elisa Mendez
Matthew Menza
Daniel Meola (RC '05)
David C. Meskers (RC '77)
Paul B. Meskers (SAS '12)
Stanley B. Messer
Emily Micklasavage (SEBS '14)
Kara Lynn Millaci (UCNB '14)
Andrew Robert Miller (ENG '09)
Jen A. Miller (CCAS '04)
Jonathan H. Miller (RC '77)
Kenneth Miller (RC '78)

Lisa L. Miller
Richard T. Miller (RC '88)
Steven A. Miller (RC '79)
Renee Milton
The Mint (RC '98)
Mission Interuniversitaire de Coordination des Échanges Franco-Américains (France)
James K. Mitchell
Edmund F. Jon Moeller (RC '64)
Dennis Moffett (CCAS '00)
Gary E. Molenaar (RC '85)
Christopher J. Molloy (PHARM '77, GSNB '87)
Angelo Monaco (SAS '15, GSE '16)
Winnie A. G. Monk (CCAS '82, GSNB '84)
Karen Montalto
Gilda M. Morales (DC '96, SPAA '09)
Paul More (CCAS '65)
Jamie Morgan and Michael Allen (RC '02 / CC '02)
Morley-Puntorno Family (UCNB '96)
Tatiana Morozov (NCAS '14)
Linda Van Zandt Morris (RC '79)
Zachary A. Morrison (SC&I '14, MGSA)
Lesley M. Morrow
Mortalitas Praecellens
Robert E. Mortensen (ED '63)
Patricia Morton
Anne Mosenthal
Thomas J. Mueller (RC '91, CLAW '95)
Angela Mullis
Daniel Murnick (NCAS '88)
Daniel J. Murphy (RBS '15)
Patrick J. Murphy (MGSA '10)

NAFSA: Association of International Educators (USA)
Nanyang Technological University, College of Humanities, Arts, and Social Sciences (Singapore)
Michael Natale (RC '71)
National Autonomous University of Mexico (Mexico)
National Council for Scientific and Technological Development (CNPq) (Brazil)
National Taiwan University (Taiwan)
Ava Nawy (DC '73)
Edward G. Nawy
Robert Nawy and Lan Chu Nawy (ENG '83, SAS '83, MBA '97 / MBA '97)
Isabel Nazario
Mohammed Nazmussadad (SAS '11, SMLR '13)
New Jersey Center for the Book
Jason and Deborah Newcomb (CC '93 / CC '95)

Thu D. Nguyen
Robert A. Niederman
Richard Niedzwiecki (ENG '87)
Nieman Family (GSN '80, DC '80, SAS '11, '15)
Carola and Thomas Noji
Jennifer Marie Noji (SAS '17)
Michael Christopher Noji (SAS '15)
Robert B. Nolan
Elena Notaro-Heirholzer (RC '77)
Joel D. Nudi (RWJMS '14)

Edward K. O'Brien (NCAS '66)
Dan O'Connor (SC&I '16)
John-Casey O'Hara (LC '05)
Kathy O'Keefe-McGill (CCAS '81)
Debra A. Holston O'Neal (LC '87)
Jennifer O'Neill (DC '95, SCILS '03)
Peter Oates (SN '99)
OIT–Camden
Jon L. Oliver (RC '84, ENG '91)
Lillian Ordas (NCAS '62)
Rona Ostrow
Marja van Ouwerkerk (CC '75, GSNB '81, SHRP '97)
Danielle Oviedo and M.K. Tsui (LC '02 / RC '02)

Harry Pachkowski (SAS '64)
Richard W. Padgett
Marta V. Pàez-Quinde
Alfred R. Pagan (ENG '51)
Gilberto Pagán (GSNB '84)
April P. Pagano (UCNB '95)
Edward T. Palange, Jr. (RC '77)
James R. Palmer II (ENG '16, SAS '16)
Stephen I. Palmer (ENG '70)
Patricia A. Pannone (NCAS '74, PHARM '77)
Michael Parascando (LC '92, SCILS '92)
Julie Park (DC '09, SMLR '09, SC&I '17)
Kimberlee and Joe Pastva (RC '01, NLAW '04 / RC '02 GSE '03)
Cindy Cohen Paul (RC '81)
Jon Paulson (RC '64)
Natalka Pavlovsky-Weismantel (DC '85)
Kenneth Matthew Pawlowski (SBC '97)
Helen S. Paxton
William A. Paxton (ENG '08, GSNB '13, '15)
Peace Corps (USA)
John D. Pearson
Hébert Peck
August D. Pellegrini (RC '82)
Paul R. Pellino (UCNB '73)
Richard W. Pensak (ENG '66)
Angelo C. Penza (ENG '65)
Manuel A. Perez (RC '79)

Fernanda Perrone (SCILS '95)
Joanne and Al Perry (RC '78 / ENG '76)
Jacob Persily (EJB '16)
Jonathan and Michelle Persons (RC '88 / DC '91)
Petros Claudius Petrides (ENG '01)
Joseph Petrongolo (CC '87)
Francine Newsome Pfeiffer (RC '95)
Christopher Robert Pflaum (SAS '11, GSNB '13)
Daniel J. Phelan (RC '71, CLAW '80)
Charles H. Philibosian (RC '77)
Benedetto Piccoli
Rev. David J. Pickens (RC '82)
Michael Pignatello (NCAS '83, GSNB '94, GSNB '01)
Priscilla Pineda (SAS '10, SC&I '10)
Sofia F. Pinto-Figueroa (RC '05, SSW '08)
Kevin L. Pitt (RC '02)
Arthur E. Pizzano (RC '71, EJB '73)
Kenneth Pochank (UCN '70)
Pohang University of Science and Technology, Graduate Program for Technology and Innovation Management (South Korea)
Tasha Pointer (RC '01, SCILS '01, GSE '03)
Cathryn Potter
D. P. Pray (RC '69, DC '70)
Clement Price (GSNB '75)
Kim Przekop
Norbert and Sylvia Psuty
Robert I. Puhak
Sechang Pyo (ENG '09)

Yankuo Qiao (RBS '16)
Victor Qiu (ENG '86)
Barry V. Qualls

Samuel Rabinowitz (SBC '84)
Zaneta Rago
RCSB Protein Data Bank
Richard G. Reale (CC '79)
George and Monica Rears (RC '89)
Thomas E. Recchio (RC '76, GSNB '80, '82)
Frank J. Reda (LC '83)
Vanaja Sathyanarayana Reddy
Don Redlich
Joanna Regulska
Kurt Charles Reh (CLAW '16)
Amy Reilly
Michael J. Rein (LC '03, SMLR '12)
Elijah Reiss (SAS '17)
Richard Reiss and Paula Kaplan-Reiss
Renmin University of China (China)
Christopher R. Retzko
Pavel Ivanoff Reyes (ENG '12)

George G. Rhoads
Amanda D. Richards (SEBS '15)
Paul J. Rickerson (UCNB '89)
Anthony P. "Rip" Rippel (CC '62)
Ritsumeikan University (Japan)
Julia M. Ritter (MGSA '92)
Julie Rittger
Dudley Rivers, Jr. (RC '82)
Mark Robertson (ENG '78)
Mark Gregory Robson (CC '77, GSNB '79, '88)
Patricia Mykalosky Robson (GSNB '79)
Cory Rodriguez (RC '05)
Amanda L. Rohrman (SBC '14)
Nancy A. Rohrman (CCAS '87)
Steven D. Rohrman (CCAS '11)
Jean Roma (RC '89)
Mark Roma (CC '87)
Stephen J. Roma (RC '86)
Nick Romanenko
Edward Gulio Romano III (SAS '16)
Matteo Ronga (RC '73)
Paul R. Ropek (RC '78)
Damaris Rosado (DC '82)
Christopher Rose
Ilene Rosen (RC '82, GSE '97)
Joel Rosenbaum (CC '66, GSNB '72)
Joseph G. Rosenstein
Steven W. Ross (RC '68, GSE '72, GSE '01)
Todd and Tracey Rossi (PHARM '90 / RC '90)
Alexandra M. Roy (SAS '12)
Brent D. Ruben
Lawrence A. Rudnick (RC '69, NLAW '72)
Rutgers Business School—Office of Undergraduate Programs
Rutgers Club of New York City
The Rutgers Energy Institute
Rutgers Federal Credit Union
Rutgers School of Nursing
Rutgers University School of Engineering
Mark Rykala (CCAS '80)

Curtis Conrad Saal (CCAS '01, GSC '05, GSBC '11)
Curtis Walter Saal (CCAS '69)
Steve Sabel (NCAS '79)
Joseph B. Saldarini (CC '46)
Francine Samson (SAS '14)
Errol A. Samuels (NCAS '73, RBS '74)
Joseph R. Sanders
Alexander J. Sannella (NCAS '03)
Joaquin Santolaya (RWJMS '10)
Michael A. Santoro
Andrew Sapolnick (SAS '12, SC&I '12)
Elizabeth Scarpelli
Craig John Schaefer (RC '70)

Jean "Beaner" Scheaffel (CC '82)
Jorge Reina Schement and Nancy C. Kranich
George and Donna Scher (RC '61 / DC '62)
James Schmincke (CCAS '98)
Marybeth Schmutz (UCNB '86, SMLR '07)
Scholar Rescue Fund® (United States)
Louis Albert Schopfer, Jr. (CCAS '84, GSC '86)
Matthew Clark Schopfer (RC '16)
Robert Seton Schur (NCAS '74, RBS '79)
Mark Schuster
Carmella Schwab (SEBS '16)
Stephen and Rosanne (Cillo) Schwab (LC '86 / RC '86)
Hila Ziv Schwartz (RC '98)
Eric Charles Schwarz (LC '92, SCILS '92, '07)
Rusty and Rita von Schwedler (ENG '68 / DC '72)
Kim Sciallo (UCNB '97)
Sciences Po (France)
Lorie Seaman
James R. Seewagen (ENG '67)
Phillip J. Seibell (RWJMS '04)
Sidney D. Seligman (RC '71, SSW '75, NLAW '85)
Albert Semeniuk (RC '08)
Mia Sena
Ralph and Barbara Sena
Seoul National University (South Korea)
Michael Sepanic
Julian Alexander Seyal (SAS '14, EJB '14)
Chirag Shah and Lori Shah
Harsha and Ajay Shah
Shridevi Pandya Shah
Shakespeare's Globe (United Kingdom)
Aishwarya Sharma (RBS '16)
Peter M. Sharoupin (NCAS '12, NJMS '17)
William R. Sharp (GSNB '67)
Harold Shill (SAS '66)
Marty Siederer (LC '77)
Harold I. Siegel (RC '69, GSN '74)
T. Joseph Sikora (GSM '73, NCAS '72)
William E. Simon (RC '63)
Scott Sincoff (SEBS '14, SC&I '14)
Eric A. Singer
Sandra Paulison Singer (DC '66)
Amandeep Singh Ladhar (RBS '10)
Singh-Varma Family (RC '87, RWJMS '92, SEBS '18)
Kathryn M. Sinko (SEBS '16)
Noreen M. Sinko (PHARM '86)
Patrick J. Sinko (PHARM '82)
Adam Sirkus (SAS '18)
Wade Sjogren (CLAW '88)

Stuart A. Slamowitz (RC '84)

Todd Slawsky (CC '02, GSE '05, RBS '11)

Kathleen M. Slayton (ED '64, GSE '72, '77)

Dennis S. Sluka (RC '73, GSE '75)

Karen Smith

Laura Broad Smith (SSW '16)

W. Geoff Smith

Sidney C. Snead (NCAS '64, SSW '76)

Jennifer C. Sneed (RC '03, SCILS '03)

Robert Snyder (LC '77)

Gabby and Eric Soares

Pavel Sokolov (RBS '14)

Somers Family (CC '82, GSNB '89 / DC '84 / SEBS '11, ENG '13 / SEBS '16)

Charles J. Soos (RC '78)

South China University of Technology (China)

Anthony Andrew Spadaro (SMLR '14)

Jeffrey "Jay" Spamer (CLAW '97)

Kurt Spellmeyer

Emily J. Springer (DC '88, NLAW '99)

Bill Spych, Jr. (UCC '95, GSC '11)

Luke St. John and Sarah St. John (ENG '16 / SAS '18)

Linda Stamato (DC '62, SMLR '77)

Marius C. and Katherine I. Stan (RC '04)

Laura Stanik (GSN '10)

James R. Stapleton (CC '98, SCILS '05)

Jeanine Maras Stapleton (PHARM '00)

State University System of Oaxaca (Mexico)

George B. Stauffer

Jay Stefanelli (LC '03, RBS '11)

Thomas M. Stephens and James A. McClellan

Carrie Stetler

Eric J. Stewart (SAS '14)

Lea P. Stewart

Sandy J. Stewart (CCAS '81, GSC '87)

Leon E. Stillwagon (ENG '68)

Stockholm University (Sweden)

William S. Stoken, Jr. (RC '62)

Alexander Storoz (RC '82)

Danielle Stovall (UCNB '07, SAS '11, SPAA '14)

Dan Strafford (RC '03)

Tim Strafford (RC '95)

Striano Family (RSDM '15)

Brian L. Strom

Susanne Struebing (GSE '97)

Karen R. Stubaus (DC '72, GSNB '84)

Mary Sturdivant

Floyd G. and Rochelle D. Sumner (GSNB '73)

Kevin G. and Patricia S. Sumner (RC '85, SPH '94 / SCILS '05)

Sundack Family (CC '93 / CC '94)

Abram J. Suydam, Jr. (RC '51)

Lisa Swedler (UCNB '85, SSW '14)

Aronhirsz Swerdlin (RC '68, NJMS '72)

Syzonenko Family (DC '79, RC '81, ENG '10, ENG '16)

Taipei National University of the Arts (Taiwan)

Curtis Tao (RC '95, NLAW '99)

Tata Institute of Social Sciences (India)

Danny Taylor (MGSA '11)

Heather Mason Taylor (RC '89, RBS '89)

Shawn K. Taylor (SMLR '91, GSE '97)

Mike Teel (UCNB '09)

Pamela W. Temple (SMLR '10, '11)

David and Susan Thatch (CC '94 / NLAW '97)

Brian Thomas (PHARM '15)

Jan Newstrom Thompson (GSNB '80)

Jennifer M. Thompson (RC '10, GSE '11)

Courtney Thornton (CCAS '16)

Crystin D. Thornton (NUR '12)

Donna Thornton

Ronald Thornton

Erik Thuno

Brian N. Tobin (RC '96)

Barbara A. Tocco (GSE '96)

Matthew John Tocco (SAS '16)

Robert Patrick Tocco (ENG '12)

Vincent Richard Tocco (LC '10)

Ross J. Todd

Laura Tremper-Jones (RC '85)

Aimee Treutlein (CC '08)

Greg Trevor

Trinity Laban Conservatoire of Music and Dance (United Kingdom)

Paul Troy (ENG '51, GSNB '52)

William H. Trusheim (RC '70, GSE '87)

Ching-I Tu

Rebecca Lynn Turner

B. Drew Turock (ENG ' 83)

Betty J. Turock (SCILS '70, GSNB '82)

David L. Turock (SAS '81, GSNB '88)

Rachana Tyagi (RWJMS '07)

Nasir Uddin (ENG '10, GSNB '13)

United Nations Department of Public Information

United Nations Educational, Scientific and Cultural Organization (France)

Universidad Autónoma de Yucatán (Mexico)

Universidad CES (Colombia)

Universidad de Zaragoza (Spain)

Universidad Peruana Cayetano Heredia (Peru)

Universidad San Francisco de Quito (Ecuador)

Universidade Federal da Bahia (Brazil)

Universidade Nova de Lisboa (Portugal)

Universitas Gadjah Mada (Indonesia)

Universitas Nasional (Indonesia)

Universitas Padjadjaran (Indonesia)

Université de Montréal (Canada)

Université Paris 8 (France)

University College Cork (Ireland)

University College Dublin (Ireland)

University College London (United Kingdom)

University of Botswana (Botswana)

University of Dodoma (Tanzania)

University of Ghana (Ghana)

University of Graz (Austria)

University of Konstanz (Germany)

University of Liberia (Liberia)

University of Limerick (Ireland)

University of Manchester (United Kingdom)

University of Melbourne (Australia)

University of Oslo (Norway)

University of Parma (Italy)

University of Queensland (Australia)

University of São Paolo (Brazil)

University of St Andrews (United Kingdom)

University of the Western Cape (South Africa)

University of Valencia (Spain)

University of Yangon (Myanmar)

Uslay Family

Utrecht University (The Netherlands)

William J. Utrera (RC '66, ENG '66)

Carmen E. Valverde (GSE '87)

Russell and Maria Bonomo Van de Zilver (CC '00 / CC '01)

Cheryl K. Van Ness (DC '90, ED '90, GSE '12)

Frederick W. Van Ness (SB '65)

Vance Family (SAS '12, SC&I '12)

John VanCleaf

John J. and Joann C. Vander Zee (RC '85)

Timothy Verasca (CC '97)

Judge Eugene R. Verin (NCAS '78)

Ana Verma (RC '99, RBS '05)

Sarah M. Vogler (DC '02, SC&I '15)

Amy Vojta

William G. Wadsworth (RWJMS '93)

Alec Walen

Carole Walker

Gail Walker (DC '73)

Janet A. Walker

Jessica Walker (RC '07, GSNB '16)

Matthew J. Walker (RC '86)

Stacey L. Walker (CC '85)

Steven F. Walker

Susan Walker

Brian A. Wall (CC '04, GSNB '13)

Cheryl Wall

James P. Walsh (RC '63)

Grace You-Liang Wang (SMLR '00)

Kailong Wang (SAS '14)

Danielle E. Warren (RC '93, SB '93)

Cal and Lisa Wasdyke (PHARM '87, GSM '95 / RC '89)

Caryn L. Washington (UCNB '01)

Craig S. Washington (LC '02)

Kevin F. Washington (ENG '08)

Marlie Wasserman

Matthew and Lisa Waters (CC '94 / DC '93)

Jeanne Weber (UCNB '00, SCILS '00)

Danielle Weber-Soares

Steven C. Weiner (RC '66)

Leonid Lawrence Weismantel (MGSA '19)

Matthew J. Weismantel (CC '85, GSNB '90)

Jonathan Scott Werner (ENG '04, RC '04)

Stephen Wertheimer (RC '57, GSNB '63)

Mark Wertlieb and Esther Hurwitz Wertlieb (RC '77 / RC '78)

William Whitacre (RC '58)

John Peter White, Jr. (SAS '10)

Martin H. Whitehead (LC '89)

Matthew Wilk (RC '84, SCILS '08)

Ricardo Williams (RC '72)

Lauren Winogron

Nancy Winterbauer

David and Annette Wolf (RC '87 / ENG '86)

Randi Shalit Wolf (RC '78)

Ryan Womack (GSNB '15)

Patricia M. Woodin-Weaver (GSE '98)

John Worobey (RC '73)

Mengdi Xing (GSNB '15)

Chenju Yang (SEBS '13)

Ghassan Yehia

Yonsei University (South Korea)

Wenrui You (RBS '16)

Derek Lamont Young (RC '87)

Robert C. Young (CCAS '87)

Calvin Yu (GSE '08)

Martin J. Yudkovitz (RC '76)

Maria Yushina (RC '08, GSE '09, '13)

Christine Zardecki (RC '94)

Alan Douglas Zastrow (CC '10)

Lauren Marie Zastrow (SAS '14)

Mary E. Zeman (DC '82)

Jiaqi Zhou (GSBS '11)

Pamela Merrill Zysk (DC '73)

Rutgers University gratefully acknowledges the leadership support of the following donors during the historic *Our Rutgers, Our Future* campaign.

Anonymous Donors (24)

John W. Adams RC'65

ADP, Inc.

Joyce Kovatch Albers-Schonberg DC'65 and Georg Albers-Schonberg

Alfred P. Sloan Foundation

Allstate Corporation

American Chemical Society

American Heart Association

James D. Anderson

The Andrew W. Mellon Foundation

Mark A. Angelson

Yetta H. Appel‡

Lorraine Aresty‡ and Jerome Aresty RC'51‡

AT&T Foundation

Autism Speaks

Ronald W. Bainton RC'62 and Patricia A. Bainton

Bank of America

Bank of New York Me llon

Carole Ann Barham SC&I '75 and Norman Barham and the Carol Ann Barham and Norman Barham Family Foundation

Nancy H. Bartels and Henry E. Bartels ENG'45‡

BASF Corporation

William H. Bauer ENG'42, GSNB'47, '50‡ and Barbara M. Bauer NJC'46

Bayer AG

Robert W. Beardsley ENG'68 and Valerie Beardsley

Marc E. Berson RC'66, NLAW'68 and Randi Berson

Beyster Foundation/The Foundation for Enterprise Development

Leslie David Bialler RC'62

Bill & Melinda Gates Foundation

Bruce B. Bingham RC'68 and Lillian Bingham

Blanche and Irving Laurie Foundation

Bristol-Myers Squibb

Margaret Brogley‡

Greg Brown LC'82 and Anna Brown

Lester R. Brown AG'55

Charles L. Busch‡

John J. Byrne Jr. RC'54‡ and Dorothy M. Byrne and the Byrne Charitable Trust

Stephanie Meryl Cahn RC'79 and Charles M. Cahn RC'77

Robert E. Campbell RBSG'62 and Joan M. Campbell

Nancy Cantor and Steven R. Brechin

Celgene Corporation

Art Certosimo RC'77 and Terry Diaz-Certosimo

Raymond G. Chambers SB'64 and Patricia Chambers

Peter D. Cherasia ENG'84 and Peggy Cherasia

Duane M. Christ GSNB'98 and Lily E. Christ

Donald C. Clark CLAW'79 and Ellen Boates Clark SCLIS'77

Alan M. Cohen GSNB'76, NLAW'79 and Deborah M. Cohen

Steven Colson

Community Foundation of New Jersey

Community Solutions, Inc.

Ethel Schwarzler Cook DC'41‡

Dorothy M. Cooper‡

Corning Inc.

Jon S. Corzine Foundation

Dr. Charlotte M. Craig GSNB'64 and Colonel (ret.) Robert B. Craig

Marion Cutler‡

Daiichi Sankyo, Inc.

Susan Kinsley Darien DC'64, SSW'66 and Steven M. Darien RC'63

David and Lucile Packard Foundation

Delta Dental of New Jersey, Inc.

Charles A. DeMarzo SB'49‡

Dorothy Z. Denney GSNB'59

Nancy Ruyle Dodge and Norton T. Dodge‡

Dow Chemical Company

George A. Downsbrough RC'31, GSNB'33, '36‡

Robert Druskin RC'69 and Harriett Druskin

Eugene V. Du Bois RC'55, RBS'63‡

E.I. DuPont de Nemours & Co., Inc.

Estate of Elmer Easton

Joseph N. Eckert RC'36, GSNB'48, '61‡

Archie B. Edgar SB'49

Dina Karmazin Elkins

Madelyn Elling and Clifford L. Elling RC'48‡

Embrace Kids Foundation

Emil Buehler Perpetual Trust

Epic Management, Inc.

Estate of Lillian M. Sarfert

F.M. Kirby Foundation

Dennis M. Fenton GSNB'77 and Linda M. Fenton

Mrs. Charles H. Ficken DC'41‡

Fidelity Charitable Gift Fund

The Ford Foundation

Sigmund Freedman‡

Gustav W. Friedrich and Betty J. Turock SCLIS'70, GSNB'82

Albert R. Gamper Jr. UCN'66 and Janice Gamper

Ronald J. Garutti RC'67 and Joanna Garutti

Ralph G. Geiger‡

Geraldine R. Dodge Foundation

James G. Gibson and Jill R. Gibson and the Gibson Family Foundation

Peter W. Gibson and the Gibson Family Foundation

Al Giddings

Alan Goldberg ED'58 and Marjorie Goldberg

Goldman Sachs Gives

Michael N. Goodkind ENG'65 and Mary Goodkind

Google, Inc.

Gordon and Betty Moore Foundation

Roberta B. Grauert‡

Anthony Grillo RC'76 and Elaine Grillo

Nina J. Gruen and Claude Gruen

Steven D. Guttenplan ENG'71

Joyce Hinrichs Haas GSNB'71‡

William S. Haines Jr. CC'75

Sidney Handler SB'54 and Wendy Handler

Elvira Wurum Hart DC'39‡

Edwin M. Hartman and Mary S. Hartman

The Healthcare Foundation of New Jersey

John J. Heldrich UCNB '50‡ and Regina Best Heldrich and the John J. and Regina B. Heldrich‡ Foundation

Helene Fuld Health Trust

Alice B. Herman DC'70 and Arthur Rubinstein

Mark P. Hershhorn RC'71 and Charon L. Hershhorn

Herbert D. Hinkle CLAW'74 and Patricia D. Hinkle DC'78

Jane Bryan Hoerrner‡

Hoffmann-LaRoche, Inc.

Horizon Blue Cross Blue Shield of New Jersey

Huamin Charity Foundation

The Huber Foundation

Hudson River Foundation

James W. Hughes ENG'65, GSNB'69, '71 and Connie O. Hughes GSNB'76

Andrew Lewis Intrater ENG'85

Itau-Unibanco

Jacobs Foundation

James S. McDonnell Foundation

Jewels of Charity, Inc.

John E. Morgan Foundation, Inc.

John S. and James L. Knight Foundation

The John Templeton Foundation

Johnson & Johnson Family of Companies

Gretchen W. Johnson DC'63 and James Loring Johnson

Sharon Matlofsky Karmazin DC'67, SC&I'69 and the Karma Foundation

John Kazanjian RC'35‡

Barbara Ann Kennedy DC'80 and Kevin J. Kennedy GSNB'79, '81, '82

Frank E. Kinsey Jr. RC'50, UCNB'51, SC&I'60‡

Herbert C. Klein RC'51 and Jacqueline Krieger Klein and the Krieger Charitable Trust

Mary S. Klein DC'37‡ and Rudolph Klein ED'39‡

Phyllis Kornicker‡

William H. Kough‡

The Kresge Foundation

Stephen Lane PHARM'47 and Ruth Lane

Mary R. Lasser and the Elizabeth and Barets O. Benjamin Foundation, Inc.

G. Alan Laureyns RC'56 and Irene
 Messner Laureyns DC'58
Diane LeBow DC'61
Adam K. Levin and the Philip and
 Janice Levin Foundation
Carol S. Lidz and Howard L. Lidz in
 Memory of Isadore Schneider
Michael and Amy Lillard
Mildred Ceres Lipton DC'43‡
Joseph S. Lopez CCAS'64 and
 Loretta L. Lopez
Claud W. Lovelace‡
Kathleen W. Ludwig DC'75 and
 Edward J. Ludwig
Luminar, Inc.

Grace V. Macaluso NCAS'60‡
Helen Mackanics‡
Duncan L. MacMillan and
 Nancy S. MacMillan and the
 MacMillan Family Foundation
Steven R. Magidson RC'70 and
 Cynthia S. Magidson DC'72
Marc I. Malberg RC'67 and Alta
 Malberg
Ronald J. Mannino PHARM'74 and
 Suzanne Mannino
March of Dimes
Ernest Mario PHARM'61, Mildred
 Mario and the Mario Family
 Foundation
Reba Martin and Harold Martin RC'40,
 GSNB'47‡
Joshua W. Martin III CLAW'74 and
 Cynthia Martin
Lois D. Marzano‡
Victoria J. Mastrobuono UCNB'77‡
Max Kade Foundation, Inc.
Kate Bucklin McKnight DC'29‡
Merck & Company, Inc., The Merck
 Company Foundation and
 Schering-Plough
Annette Brafman Meyers DC'55
Paul S. Miller NCAS'60, NLAW'62 and
 Carol P. Miller
John V. Moore Jr. and
 David M. Reeves‡
Joseph A. Moroney ENG'94 and
 Sonya L. Moroney
David A. Morse RC'29‡ and
 Mildred H. Morse‡
Robert E. Mortensen ED'63

Nikos P. Mouyiaris GSNB'71
Don J. Musso and Lisa A. Musso

NARSAD Research Institute
National Fish and Wildlife Foundation
New Jersey Blueberry/Cranberry
 Research Council, Inc.
New Jersey Health Foundation
New Jersey State Bar Foundation
Eileen D. Newman NCAS'65
Rosalie Ngoc-Huong Nguyen DC'65‡
Bruce S. Nicholas ENG'49 and
 Phyllis Walker Nicholas
George E. Nixon III RC'62 and
 Linda Eulhardt Nixon DC'63
Lilly Novak‡
Novartis

Old Bridge Sayreville Rotary Club

Christopher Murray Papa M.D.
 NJMS'61 and Regina Cuta M.D.
Cecilia F. Pavlovsky‡
Brian D. Perkins RC'76 and
 Lois Perkins RC'76
The Pew Charitable Trusts
Pfizer, Inc.
Daniel J. Phelan RC'71, CLAW'80 and
 Victoria J. Phelan
Steven D. Plofker LC'78, NLAW'93 and
 Bobbi Brown-Plofker and the
 Plofker Family Foundation
PNC Financial Services Group, Inc. and
 the PNC Foundation
A. Donald Pray RC'69 and
 Penelope Bragg Pray DC'70
Edward W. Price RC'50‡
Paul V. Profeta
Prudential Financial, Inc. and the
 Prudential Foundation
PSEG Foundation

Barry V. Qualls

The Daniel J. Ragone Sr. Family
 Foundation
Nathaniel Ratner AG'30‡
Thomas A. Renyi RC'67, RBS'68 and
 Elizabeth M. Renyi
Timothy W. Reynolds and
 Caroline C. Reynolds
The Rockefeller Foundation

The Rodkin Family Foundation
Robert D. Rosenwasser RC'70,
 NLAW'75 and Marian Linder
 Rosenwasser RBS'84
Jeanne Weiss Rothstein DC'42‡
Benjamin F. Rush Jr.‡
Thomas J. Russell RC'57, GSNB'61 and
 Jean M. Russell
Beatrice Salvin
Robert Salvin ENG'49‡
Thea Samit
Gordon C. Sands RC'51‡
Sanofi-Aventis US LLC
Kenneth M. Schmidt RC'67 and
 Maria Rom-Schmidt
Adrian H. Schreiber RC'65, SCILS'78
The Schumann Fund for New Jersey
Harvey M. Schwartz LC'87 and
 Annie Hubbard
Richard R. Seidel RC'59, SCILS'65‡
The David K. Sengstack Foundation
 and Alice Sengstack
Michael Seul
Richard H. Shindell RC'57
Kathleen M. Slayton GSED'72, '77 and
 Robert Joseph Kilian
Ernest Sosa
Righteous Persons Foundation
Roderick H. Springer UCNB'51‡
St. Peter's Healthcare System
Gwendolin E. Stableford‡
StemCyte, Inc.
Hazel Stoddart DC'65, GSNB'69, '75
 and Christopher Stoddart
Beatrice O. Susman SCILS'61‡
Syngenta

Marion and Norman Tanzman
 Charitable Foundation
Jeffries Shein RC'62 and Rona Shein
 and Roy H. Tanzman RC'73,
 CLAW'76 and Brenda Tanzman
Steven H. Temares RC'80 and
 Amy Strongwater Temares
Marlene A. Tepper RC'80
The Bernard Osher Foundation
The Celia Lipton Farris &
 Victor W. Farris Foundation
The Ellison Medical Foundation
The Employee Ownership Foundation,
 Inc.
The Fund for New Jersey

The George & Helen Segal Foundation,
 Inc.
The Grove Foundation
The Heising Simons Foundation
The Nicholson Foundation
The Presser Foundation
The Robert Wood Johnson Foundation
The Wallace H. Coulter Foundation
John F. Tinsley RC1900‡
Helene A. Tischhauser DC'48, GSE'52‡
TKL Research, Inc.
Joyce Clarke Torio DC'56, GSNB'61, '65
Reed J. Tupper RC'64 and
 Rosemary D. Tupper
A. Walter Tyson ENG'52‡

Valent
John R. Vander Veer ENG'54‡
Kris Venkat GSNB'72, '77‡
Ford Foundation
Verizon Foundation
Victoria Foundation, Inc.
Luke Visconti CC'82 and the
 DiversityInc Foundation
Ralph W. Voorhees ED'48‡ and
 Barbara Voorhees‡

W.K. Kellogg Foundation
Walgreens Co.
Karen R. Walsh LC'88 and
 Frank E. Walsh and the
 Bayview Foundation
Audrey W. Warfield DC'42, GSE'61
Jane Francy Wase DC'64, GSNB'66, '70‡
Richard N. Weeks ENG'50
Judith D. Weiss GSE '78, '89 and
 Seymour Weiss NCAS'52
Wells Fargo & Co.
Daniel H. Wheeler RC'89, CLAW'92
 and Amy A. Fox
Whitehall Foundation, Inc.
Suzanne Wieme Whitlock DC'66,
 GSNB'70‡
The William Penn Foundation
H. Boyd Woodruff AG'39, GSNB'42 and
 Jeanette Whitner Woodruff‡ DC'41

Index of Names

SELECTED SOURCES ON RUTGERS UNIVERSITY

Bowers, Roy A. and David L. Cowen. *The Rutgers College of Pharmacy: A Centennial History.* New Brunswick, N.J.: Rutgers University Press, 1991.

Clemens, Paul G.E. *Rutgers Since 1945: A History of the State University of New Jersey.* New Brunswick, N.J.: Rutgers University Press, 2015.

Consoli, Joseph P. and Erika Briana Gorder. *Celebrating the Tradition: 30 Years of Queer Pride and Activism at Rutgers.* New Brunswick, NJ: Rutgers University Libraries, 2000.

Cooper, Melanie and Ruth J. Simmons. *"Resolved that I should be a man:" Rutgers College Goes Coed.* New Brunswick, NJ: Rutgers University Libraries, 1997.

Cowen, David L. *Medical Education: The Queen's-Rutgers Experience, 1792-1830.* New Brunswick, N.J.: State University Bicentennial Commission and the Rutgers Medical School, 1966.

Demarest, William H.S. *A History of Rutgers College, 1766-1924.* New Brunswick, N.J.: Rutgers College, 1924.

Douglass, Mabel Smith. The *Early History of the New Jersey College for Women: Personal Recollections.* New Brunswick, N.J.: New Jersey College for Women, 1928.

Fowler, David J. and Erika B. Gorder. *Benevolent Patriot: The Life and Times of Henry Rutgers.* New Brunswick, NJ: Rutgers University Libraries, 2010.

Frusciano, Thomas J. *Rutgers University Football Vault: The History of the Scarlet Knights.* Atlanta, Ga.: Whitman Publishing, 2008.

Gorder, Erika B. *Archival Assemblages: Rutgers and the Avant-Garde, 1953-1964 an exhibition.* New Brunswick, NJ: Rutgers University Libraries, 2001.

Holyoak, Sandra Stewart, Peter Asch, Stephanie Darrell, Shaun Illingworth, Nicholas Molnar, and Susan Yousif. *Witnesses to War: Voices from the Rutgers Oral History Archives.* New Brunswick, NJ: Rutgers University Libraries, 2005.

Illustra: A Portrait of Rutgers. New Brunswick, N.J.: Rutgers, the State University of New Jersey, 2001.

Lukac, George L., editor. *Aloud to Alma Mater.* New Brunswick, N.J.: Rutgers University Press, 1966.

McCormick, Richard L. *Raised at Rutgers: A President's Story.* New Brunswick, N.J.: Rutgers University Press, 2014.

McCormick, Richard L. *Transforming Undergraduate Education: President's Recommendations to the Rutgers Board of Governors Regarding Undergraduate Education on the New Brunswick/Piscatawy Campus.* New Brunswick, N.J.: Rutgers, the State University of New Jersey, 2006.

McCormick, Richard P. *Academic Reorganization in New Brunswick, 1962-1978: The Federated College Plan.* New Brunswick, N.J.: Rutgers University, 1978.

McCormick, Richard P. *The Black Student Protest Movement at Rutgers.* New Brunswick, N.J.: Rutgers University Press, 1990.

McCormick, Richard P. *Rutgers, A Bicentennial History.* New Brunswick, N.J.: Rutgers University Press, 1966.

McMahon, Ernest E. *The Chronicles of Colonel Henry.* New Brunswick, N.J.: Thatcher-Anderson Company, 1935.

Moffatt, Michael. *Coming of Age in New Jersey: College and American Culture.* New Brunswick, N.J.: Rutgers University Press, 1989.

Moffatt, Michael. *The Rutgers Picture Book: An Illustrated History of Student Life in the Changing College and University.* New Brunswick, N.J.: Rutgers University Press, 1985.

Pellowski, Michael. *Rutgers Football: A Gridiron Tradition in Scarlet.* New Brunswick, N.J.: Rivergate Books, 2008.

Rieman, William. *A History of Rutgers School of Chemistry.* New Brunswick, N.J.: Rutgers University, 1972.

Robbins, Allen B. *History of Physics and Astronomy at Rutgers, The State University of New Jersey in New Brunswick, New Jersey, 1771-2000.* Baltimore, MD: Gatewood Press, 2001.

Rutgers University–Camden Campus History: www.camden.rutgers.edu/page/campus-history

Rutgers Oral History Archives Program: http://oralhistory.rutgers.edu/

Rutgers University Archives Website: http://www.libraries.rutgers.edu/rul/libs/scua/university_archives/archives_main.shtml

Schmidt, George P. *Douglass College: A History.* New Brunswick, N.J.: Rutgers University Press, 1968.

Schmidt, George P. *Princeton and Rutgers: The Two Colonial Colleges of New Jersey.* Princeton, N.J.: Van Nostrand, 1964.

Sidar, Jean Wilson. *George Hammell Cook: A Life in Agriculture and Geology.* New Brunswick, N.J.: Rutgers University Press, 1976.

Tractenberg, Paul L. *A Centennial History of Rutgers Law School in Newark: Opening a Thousand Doors.* Charleston, S.C.: History Press, 2010.

Waller, Ingrid Nelson. *Where There Is Vision: The New Jersey Agricultural Experiment Station, 1880-1955.* New Brunswick, N.J.: Rutgers University Press, 1955.

Wechsler, Harold S. "Brewing Bachelors: The History of the University of Newark," *Paedagogica Historica*, Vol. 46, Nos. 1–2 (February–April 2010), 229–249.

PHOTO CREDITS

(continued from inside front cover)

New Jersey College of Medicine and Dentistry (1965)

Rutgers Medical School (1961)

Rutgers School of Dental Medicine (2013)

New Jersey College of Medicine and Dentistry (1965)

Seton Hall College of Medicine and Dentistry (1956)

School of Health Related Professions (1981)

School of Allied Health Professions (1976)

School of Nursing (2014)

School of Nursing, University of Medicine and Dentistry of New Jersey (1990)

College of Nursing, Rutgers–Newark (1956)

School of Public Health (1998)

Rutgers University–Newark (Joined Rutgers 1946)

Faculty of Arts and Sciences–Newark (1985)

Newark College of Arts and Sciences (1946)

University of Newark (1936)

Dana College (1930)

Newark Institute of Arts and Sciences (1910)

University College–Newark (1934)

Graduate School–Newark (1975)

School of Criminal Justice (1974)

Rutgers Law School (2015)

School of Law–Newark (1946)

University of Newark Law School (1936)

Mercer Beasley School of Law (1926)

New Jersey Law School (1908)

School of Public Affairs and Administration (2006)

Rutgers Business School–Newark and New Brunswick (2001)

Rutgers–Newark School of Management (1993)

Faculty of Management (1993)

School of Business–New Brunswick (1984)

School of Administrative Services (1981)

Graduate School of Management (1961)

School of Business Administration (1934)

Seth Boyden School of Business (1929)

Rutgers University–Camden (Joined Rutgers 1950)

Faculty of Arts and Sciences–Camden (1983)

Camden College of Arts and Sciences (1950)

College of South Jersey (1927)

University College–Camden (1950)

Graduate School–Camden (1981)

School of Business–Camden (1988)

Rutgers Law School (2015)

School of Law–Camden (1967)

South Jersey Law School (1926)

School of Nursing–Camden (2011)